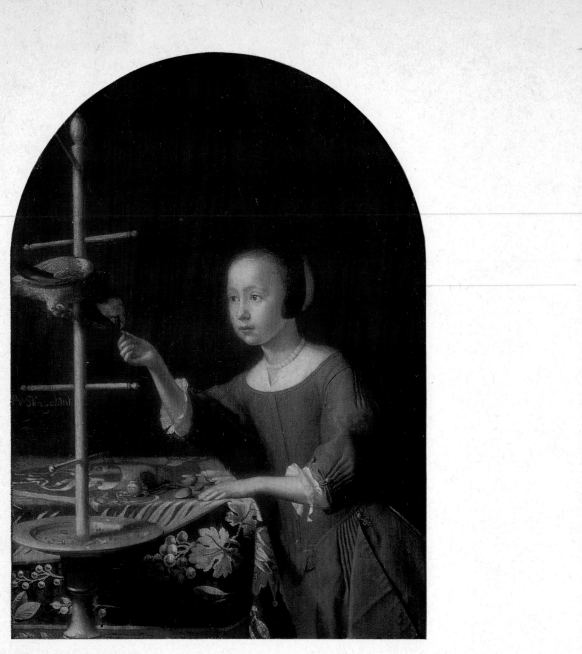

PIETER VAN SLINGELAND
A girl feeding a parrot
On panel, rounded top, signed, 6⅜in by 4½in
London £33,000 ($75,900). 9.VII.75
Formerly in the collection of Sir Bernard Eckstein Bt

ART AT AUCTION

The Year at Sotheby Parke Bernet

1974-75

TWO HUNDRED AND FORTY-FIRST SEASON

A Studio Book · THE VIKING PRESS · New York

Published in 1976 by The Viking Press, Inc
625 Madison Avenue, New York, N.Y. 10022

Published simultaneously in Canada by
The Macmillan Company of Canada Limited

SBN 670-13406-6

Library of Congress catalog card number: 67-30652

Edited by Anne Jackson
assisted by Joan Sarll (UK) and Barbara Evans (USA)

Produced by Sotheby Parke Bernet Publications Ltd

Printed in Great Britain by The Westerham Press Ltd, Westerham, Kent
and bound by W. & J. Mackay Ltd, Chatham, Kent

Contents

9 *The Art Market: Now and Then* by Frank Herrmann

23 Old Master Pictures

40 Old Master Drawings

46 *Turner's 'Dark' Rigi comes to light* by Martin Butlin

48 English Pictures and Drawings

74 European Pictures

82 Topographical Pictures

86 *A Centenary Tribute to Thomas Baines* by Frank R. Bradlow

90 South African Pictures

92 American Pictures

100 Impressionist and Modern Pictures, Drawings and Sculpture

120 Ballet

128 *Henry Moore: the Formative Years, 1925-35* by Robert Melville

144 Contemporary Pictures and Sculpture

153 Prints

167 Manuscripts and Printed Books

172 *Persian Paintings and Manuscripts* by B. W. Robinson

205 Photographs

208 *Monte Carlo* by Charete Watson del Castillo

217 Works of Art

234 Icons

238 Russian Works of Art

242 Objects of Vertu

250 Portrait Miniatures

253 Arms and Armour

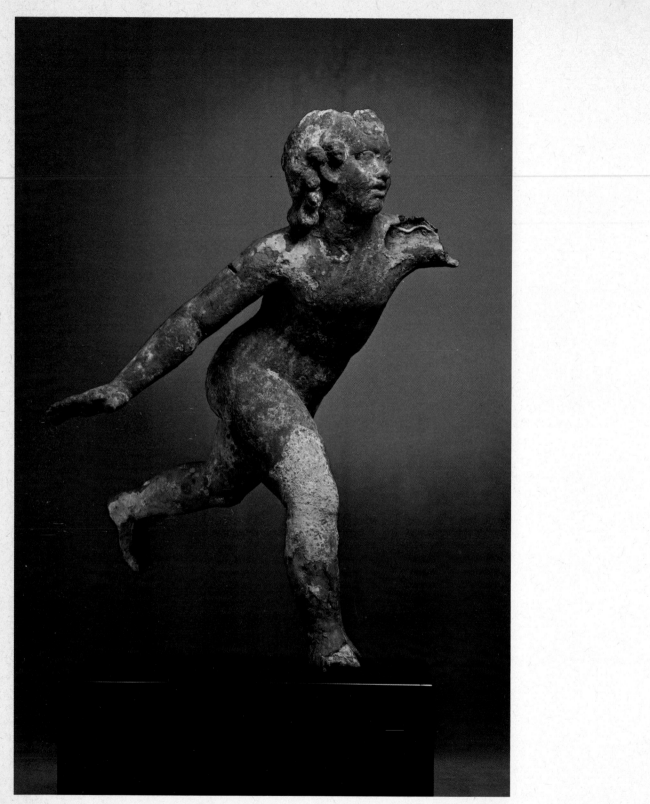

A Roman bronze figure of a boy, possibly the child Eros, late Hellenistic or early Roman, *circa* first century BC/first century AD, height 19⅝in
New York $40,000 (£17,391). 22.XI.74

Contents *continued*

261 Silver

279 Coins and Medals

280 *The Douglas-Morris Collection of English Gold Coins* by Michael Naxton

287 Pewter

289 Furniture, Decorations and Textiles

322 *The Garbisch Collection of American Folk Art* by Nancy Druckman

332 Clocks, Watches and Scientific Instruments

341 Musical Instruments

345 Antiquities, Islamic, Indian, Nepalese and Primitive Art

350 *The Lester Wolfe Collection of Persian Pottery and Metalwork* by Richard Keresey

367 European Ceramics

389 Chinese Ceramics and Works of Art

410 *The Discovery of a Century of Chinese Export Porcelain, 1682-1784* by David Sanctuary Howard

417 Japanese Works of Art

430 *The Henri Vever Collection of Japanese Prints, Illustrated Books and Drawings* by Jack Hillier

439 Glass and Paperweights

445 Art Nouveau and Art Deco

449 Jewellery

457 Wine Sales

459 Games and Gaming

462 Index

Conversion rates between different currencies in the captions of this book have been averaged out over the season. While providing an adequate guide, the sterling or dollar equivalents in brackets after the actual sale prices do not necessarily conform with the exact exchange rate applying on the day of the sale.

The following rates in relation to the pound sterling have been used throughout: US dollars 2.3; Canadian dollars 2.3; French francs 9.3; Swiss francs 5.8; Dutch gilders 5.55; Italian lire 1,450; South African rand 1.55.

The Art Market: Now and Then

Frank Herrmann

The saleroom season roughly follows the academic year. It begins after the summer vacation in September and finishes at the end of July. The 1974–75 season will live in many minds as the most dramatic for generations. It seemed to start reasonably well in the early autumn; then went into a short decline reminiscent of the worst pre-war doldrums on either side of Christmas; it staged a slow recovery in the spring, and bounced back to near record-breaking form in June and July 1975.

SIGNS AND SYMPTOMS

In economic terms we are going through a period of such rapid change that what is a certainty in one month may already be questionable in the next. At such times it is useful to look backwards as well as forwards, and to get some historical perspective of events. In this article we look back at 1974, take a brief selective conspectus of the periods of major economic change during the last century, and marvel at the restored buoyancy of the art market during the summer of 1975.

1974 will certainly remain in our memories as a hair-raising year. The finely balanced economic systems of the Western world suffered violent disruption. Commodity prices soared. The cost of borrowing money was at an all-time peak and borrowing was difficult, if not impossible. Traditional controls proved useless. Inflation raged. Some genius among economists in the Arab world – not yet clearly identified by history – had calculated that oil could be sold easily at a quadrupled price. Local rulers believed, accepted and put into practice a policy based on such a premise. Future historians will have more evidence than they can sift to pinpoint the course of events, but for those of us caught in the immediate turmoil, the future even a month ahead, let alone a year, seemed very hard to foretell. The world was dominated by uncertainty.

And yet earlier in the year, when stock markets all over the world went into steep decline, and second line banks failed in Britain, Germany and Italy, and the property market and land values seemed almost to evaporate, the art market – to everyone's surprise – seemed only to be marginally affected.

If anyone should still doubt that the art market as such exists, and that the great auction houses are at the heart of it, then the late summer of 1974 should have convinced them. For during the long summer recess in July, August and part of September, there were no major sales. And their very absence left a great question mark hanging over that world: what would happen to prices when the salerooms re-opened in the autumn?

Since the early 1950s a seemingly unshakable confidence in works of art as objects of value had established itself, but this was something new or at least it was a trend sustained

longer than anyone could remember. There had indeed been fluctuations, but in retrospect, these reflected mere hiccoughs in the flow of seasons, rather than a serious change of scale.

When the new sale season *did* start in the autumn 1974, the first major portent of things to come appeared at a sale of Impressionist and Modern paintings at Sotheby Parke Bernet in New York. But even that was not as clear-cut as some commentators made out. Curiously enough, some price records were broken. Jean Dubuffet's canvas *Echange de vues* (illustrated p. 143) was sold for $340,000 (£147,826). Salvador Dali's *Battle round a dandelion* realised $100,000 (£43,478). A portrait painted by Matisse in 1943, *Michaela* (illustrated p. 124), changed hands at $240,000 (£104,347). But nevertheless, a lot of pictures did not reach their reserves and were bought in, because neither owners nor auctioneers had yet appreciated how the market had changed, particularly in cases where a picture appeared at auction fairly soon after an earlier sale. The old rule that five to ten years is a minimum interval of safety had come to be ignored more and more frequently.[1] Thus a snow scene by Camille Pissaro, a Monet landscape, a Degas dancer, a fat Renoir lady playing cards, and a rather more demure but familiar type of Renoir lady in a straw hat, were all declared unwanted in the space of a few minutes near the beginning of the sale.

The significance of this event was not so much that almost 50 per cent of the lots were unsold, but that the art market was now clearly seen not to have escaped the acute world depression and that the end of one particular cycle had been reached. However, in all areas of collecting interest, with the possible exception of Chinese works of art, the decline did not parallel anything like the fall of capital values in purely monetary areas and, as we shall see, it recovered much more rapidly.

THE MORE DISTANT PAST

One tends to forget that there had been depressions before and what occurred in them – and in particular that such periods are finite – so it may be of interest to look back a hundred years and to recall that in the UK in 1974 we were merely involved in perhaps the eighth major depression since 1876. There is obviously room for argument about the number, and their relative gravity, but from contemporary accounts, the years 1876-79, 1884-86, 1910-11, 1920-22, 1929-32, 1942-45, and 1969 all saw serious financial set-backs before the present crisis started late in 1973.[2] Sometimes the effect was immediate. Sometimes it took longer to work its way through all sectors of the community. Exact parallels between one crisis and another are rare, but a look at the cause of earlier events often helps to explain later thinking and reaction. One must bear in mind too that we are looking at the bad years here and not overlook the good ones in between.

Almost a century ago in 1876, what we always tend to look back on as the era of great Victorian prosperity was about to suffer a major reverse, both in industrial and agricultural terms, and Britain entered a lean period that lasted almost twelve years. It has, in fact, become branded as the 'Great Depression'.

The major cause of the *agricultural* decline was to be found in the United States. That country had vastly improved its steel manufacture and then its railway system in the 1860s and the early 1870s, and in 1873 farmers benefited beyond anyone's dreams when a self-binder was invented which could be attached to a reaping machine. In simple terms, what this

1 On the other hand a point not often appreciated – yet one that came to the fore time after time in the 1974-75 season – is that if the quality is right, such pictures which the trade shuns because of familiarity, can often be particular bargains from the *long-term* collector's point of view.

2 *The Economist* (17 May 1975) reckoned that the UK had experienced no fewer than fifteen major economic crises since 1945.

meant was that every prairie farmer could double his crop and that this could be moved from producer to consumer much more cheaply. Gradually too, steam was displacing sail in trans-atlantic transport. Thus the cost of sending a ton of grain from Chicago to Liverpool went down from £3 7s 0d in 1873 to a mere £1 4s 0d in 1884. Unlike most other European coun-tries, Britain refused to put tariffs on imported wheat. For the farming community, the con-sequences were disastrous. The price of a bushel of wheat fell from 56s 9d in 1877 to 31s 0d in 1886. Our import of cereals increased from 2 per cent in 1840 to 45 per cent in 1880. In consequence, land values tumbled and rent rolls were decimated. One million people emigra-ted between 1871 and 1881. A tremendous drift away from the land led to rapidly increasing urbanisation. Endless bankruptcies and forced sales followed.

Industry in the mid-1870s had not been faring much better. The earlier generation of individual captains of industry had been replaced by the limited company, and following upon the Companies Act of 1862 there had been such a rush of new share issues that it had put a great strain on the capital available. Also, many sectors of British technology and manu-facturing machinery had become out-dated.

AN ERA OF DISPERSAL

The consequences of this were far-reaching. Private art collections and libraries quietly accumulated over generations in family houses, both in town and country, came on to the market in ever increasing numbers. This, of course, did not happen at once but gradually led to the dispersal of properties that had come to be regarded as almost inviolable. The process was probably accelerated too by legislation culminating in the Settled Land Acts of 1882 and 1884. This permitted the Court of Chancery to authorise the sale by trustees of property passed on as heirlooms. Similarly, collections got together more rapidly by the new techno-crats often had to be dispersed at short notice.

If we turn to that redoubtable chronicler of important art auctions, George Redford[3] (who had been *The Times* saleroom correspondent for fifty years), we find that he describes an increasing tempo of sales from 1877 onwards, particularly of recently formed collections of contemporary English artists, but when one examines the sale catalogues of that period in detail one sees poor cataloguing of pictures and increasingly mediocre prices. Of course, it is difficult to single out examples, but if one were to look at the fall in value of Old Masters, one might do worse than to consider the sale in February 1883 of the picture collection belonging to Mr W. Angerstein of Stratton Street, Piccadilly. He was the son of the celebrated John Julius Angerstein, whose collection of Old Masters had formed the nucleus of the National Gallery when Lord Liverpool had bought it for the nation in 1824. The son's pictures seem to have been respectable rather than outstanding, but even so a Mabuse *Madonna and Child* only fetched £35 14s 0d; a van Dyck *Portrait of a Gentleman, his hand resting on a globe,* whole length, £43; *The Marriage of St Catherine* by Parmigianino from the Uvedale Price and Sir Robert Price Collection, £24 3s 0d; *The Entombment* by Daniele da Volterra, which had been shown at the Manchester Art Treasures Exhibition in 1852 and was probably selected for it by Dr Waagen and imported by Edward Solly direct from Florence, £52 10s 0d. Such prices were a good deal lower than those prevailing in the previous fifteen years.

The year 1884 also saw a complete collapse of prices in the work of contemporary or re-cent English Masters and if it had not been for the all-powerful firm of Agnew's 'supporting the market' as sale followed sale of the recent darlings of the new collectors, such as Landseer, Millais, Copley Fielding, Sir Frederick Leighton, W. S. Burton, W. Collins, Alma Tadema

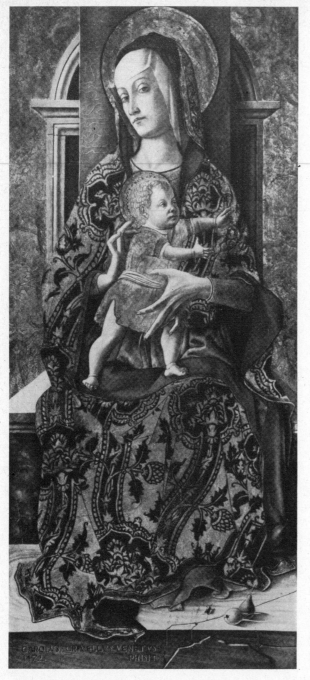

A *Madonna and Child* by Carlo Crivelli, painted in 1472, from the distinguished collection of fourteenth-, fifteenth- and sixteenth-century Italian paintings formed in the third quarter of the nineteenth century by William Graham, a Trustee of the London National Gallery. His 322 pictures came up for sale in 1886, a period of acute depression, and fetched £23,400. This was an average of only just over £70 each and, although there were among them well-authenticated works by Cosimo Tura, Lorenzo di Credi, Ghirlandaio, Filippo Lippi, Piero della Francesca and Taddeo Gaddi (whose *Descent from the Cross* was sold to Agnew's for £21) one should appreciate that such pictures were not then generally popular and attributions were made with difficulty.

This *Madonna and Child* was bought at the sale for £131 5s by the dealer Martin Colnaghi. He sold it to Robert and Evelyn Benson who also formed a fine collection of early Italian Masters which was sold in its entirety to Duveen in the 1920s. Duveen in turn sold the Crivelli to Mr and Mrs A. W. Erickson of New York, and when their collection was sold at Parke-Bernet in November 1961 it fetched $220,000

and the immensely popular Briton Rivière, prices would have been very much more than halved. (Agnew's had customers both at home and overseas who continued to collect actively.)

EXPERTS AND EXPORTS

But, as always, someone benefited. Contemporary writers noted the increase in the number of antiquity and curiosity shops in Britain, and collecting of the decorative arts of times gone by became increasingly popular. This encouraged the more detailed study of their origin, which

in turn led to a clearly discernible increase in the specialist literature, and this in its turn pro-pogated more enthusiasm among collectors and, of course, among dealers. The word 'antiques' as such was not then in common usage.

But there also began the reversal of a process that had gone on uninterruptedly since the era of the Grand Tour. For generations British collectors had imported art from overseas. Now as wealth increased in Europe and America, a massive exodus of great works of art from Britain began. Perspicacious dealers in Paris and in London, such as Seligmann and later Duveen, began to sell them to those very men who had indirectly hastened our own economic decline: the American steel and railroad magnates, French bankers and Ruhr barons. The situation has an extraordinary parallel in the sudden importance of the Middle East and Persia as consumers of works of art, often originating from that area, after the inflow of greatly increased oil revenues began last year.

But in the '80s and the '90s of the last century, it was the *official* as well as the private collectors from overseas who took advantage of the straitened financial circumstances of the British aristocracy, land owners and industrialists. Wilhelm Bode, probably the most distinguished of all directors of Berlin's Kaiser Friedrich Wilhelm Museum, began to come to London several times a year. He not only bought superb pictures at auction at what he considered ridiculous prices, but he also went round the major exhibitions at Burlington House each year quietly marking his catalogue with what he wanted, and subsequently used a German art dealer resident in Paris to approach the owners, offering them prices for their pictures which they felt it was impossible to resist.

There began a constantly increasing chorus of adverse comment on the Government's unchangingly miserly attitude about making more money available for the purchase of pictures for national collections, because the Treasury was always short of cash. No chancellor dared to use taxation then as he would now and every minor increase brought about strong protest. It is also interesting to recall to what extent the country's equilibrium was being upset by increasing signs of major industrial strife. By the summer of 1911 a wave of strikes at the ports was followed by the *first* national stoppage of the railways and a major clash between miners and mine-owners, which one way and another was to go on for many years.

BETWEEN THE WARS

Curiously enough the aftermath of the First World War saw a boom and an uplift of prices and wages on a scale that parallels our own time. There had been a general view that the whole world would be hungry for greatly increased industrial output after five years of privation. But the strained economies of Europe and America could not support this. Prices drifted down incredibly fast and unemployment became rife. By June 1921 it had passed the two million mark and although it then fell again, it never went below one million between the two world wars. *The Economist* called 1921 'one of the worst years of depression since the Industrial Revolution'.

It was also a difficult time for the art market. A study of priced catalogues of the early 1920s—and for that matter during much of the between-war period – seems to show an era of undiluted heaven for any collector with money and taste, and a great indifference to what could be bought, except by a very limited band of dealers and collectors. If we take English furniture as an example, the class of really good seventeenth- and eighteenth-century pieces then available in the saleroom, very often in virgin condition, hardly ever comes on the market today. As far as Sotheby's was concerned, the directors' high standards ensured that only the best of what was offered to them came under the hammer anyway. Nineteenth-century

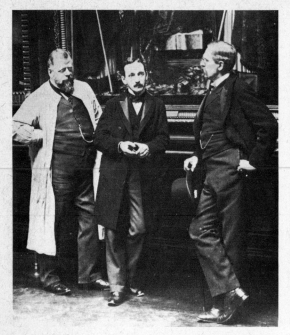

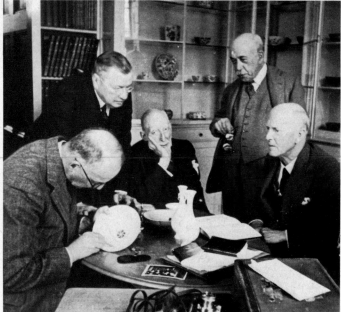

The inestimable and almost forgotten Dr Bode (right) in 1904, with two of his colleagues at the Kaiser Friedrich Wilhelm Museum in Berlin. Bode made many of his finest acquisitions for the museum in London about this time

An early photograph of some of the founder members of the Oriental Ceramic Society in conclave. They are, from left to right: Oscar Raphael, Alfred Clark (part of whose collection was sold at Sotheby's in March 1975), George Eumorfopoulos, Harry Oppenheimer and R. L. Hobson of the British Museum

furniture, and that included the Regency period, only began to be appreciated in the 1930s. As for foreign furniture, good French pieces were accepted by a long-standing tradition dating back to the days of Hertford and Wallace, but they only came into prominence in the Rothschild sale held at 148 Piccadilly in 1937. There was little interest in German, Dutch or Italian pieces.

EARLY CHINESE CERAMICS: THE COLLECTING BACKGROUND

The immediate first post-war depression, however, had little effect on one rather esoteric coterie of collectors: those who were particularly interested in the early ceramic wares of China. Because relatively little was known of the origin of many of these beautiful pieces, twelve enthusiasts, including some museum officials, banded together in 1921 in an Oriental Ceramic Society under the leadership of George Eumorfopoulos, to pool what knowledge they had and to seek for more. The results of their efforts were to be far-reaching in widening collectors' interests. For example, it was only after the Society had come into being in the 1920s that members began to become aware of the fine classical blue and white Ming wares of the fifteenth century and it was not until the 1930s that they began to appreciate the even earlier porcelain of the fourteenth century, having in the main concerned themselves with the later blue and white export wares about which much more was known. Sotheby's began to hold more frequent sales that catered for this interest. Again prices were in a different stratum from that which we know today. Only exceptional pieces ever went into three figures. Collectors rarely bought at sales in person and were fortunate in being backed by a very high and scholarly standard of trade dealing.

By the mid 1930s a number of the new major collections were already being dispersed. Through the generosity of the owners, a great number of them had been given to our national museums and were to form their primary oriental collections. Others were dispersed at sales, and the records of these today make strange reading. Thus at the sale in June 1935 of early blue and white wares belonging to Charles Russell, the editor and owner of the magazine *Old Furniture* and an enthusiastic collector in many spheres, 82 lots out of 113 were bought by Sparks and Bluett. Eleven pieces were bought in. The other twenty were divided between Reitlinger, Winkworth, Moss, Spink and other such well-known names. The total realised was £3,369. It was at this sale that the first dated fourteenth-century piece appeared, although there was much controversy about it at the time. Similarly, the 110 very carefully selected pieces sold at Sotheby's in May 1937 as 'the property of a well-known collector, formerly resident in Peiping' and, in fact, belonging to Wu Lai Hsi, went for a total of less than £2,000. Gerald Reitlinger estimated in 1967 that this collection would have fetched not less than £200,000 in that year.

But if these two sales did not raise headlines, that most famous of all twentieth-century Chinese porcelain sales which occupied four sombre days coinciding with the evacuation of Dunkirk in 1940 did get a mention or two. This was the dispersal of what really amounted to George Eumorfopoulos's *second* collection. Most of the first had been given away or sold for nominal sums to various museums.

Eumorfopoulos had started collecting in 1891. Like so many other early oriental ceramics enthusiasts, he was a banker. Contemporaries admired his immense learning, his personal modesty and his unerring eye. The 515 lots in the 1940 sale fetched just short of £26,000. No collection like it could ever be got together again for mere money. Perhaps two pointers towards this are sufficient evidence. Lot 236 in the Eumorfopoulos sale became lot 91 in the Frederick Mayer sale held at Christie's in June of 1974. In 1940 the Museum Street dealer, H. R. Norton, had bought it for £19. Last year the same small blue and white ewer made £14,000. In 1967 lot 238 of the older collection, a small blue and white Palace bowl bearing the reign mark of Ch'êng Hua reappeared in the Herschel Johnson sale and fetched £16,500. In 1940 it had been bought for £36.

Pre-war collecting of Chinese porcelain reached its high point in the immense 1935-36 International Exhibition of Chinese Art held at Burlington House. This in turn sowed the seed for W. B. Honey's monumental book, *The Ceramic Art of China* which certainly became the bible for all collectors after its first publication in 1944. Honey rightly conceded his gratitude to the man who was at the nub of the whole subject. He wrote: 'I have received much help and information from Mr. A. J. B. Kiddell of Messrs. Sotheby & Co., whose sale catalogues of Chinese and other pottery have set a new standard of accuracy and scholarship.' Indeed, Jim Kiddell had joined the OCS in the '30s. The membership of that Society had increased from that small select band to 1,017 by 1971, reflecting the growth of interest in the subject.

Strangely enough, although prices for Chinese porcelain began a steady ascent from the mid '50s onwards, it was the three-part sale in 1963 of the dealer H. R. Norton's private collection that triggered off the much steeper rise of the 1960s which, after a hesitant period in 1970, continued until early in 1974. The most spectacular point of the upward surge was reached at a sale of nearly 400 lots spread over two days on 1 and 2 April 1974, when an early Ming blue and white 16½in bottle decorated with a single dragon, became the most publicised piece of Chinese porcelain in the world having fetched £420,000. Two other lots fetched £160,000 each and one £170,000, and a hexagonal *famille rose* bowl broke all records for Ch'ing pieces at £95,000.

The principal buyer in the sale was Mrs Helen Glatz, and her absence from the following sale in July, which included many Ch'ing pieces drawn out by the high April prices, together with growing misgivings about the speculative aspect of the market and world-wide lack of liquidity, led to a rapid shakeout in prices. For this reason the sales in the summer and autumn of 1974 undoubtedly presented opportunities to the devoted collector because pieces of all periods could be bought in the saleroom at a level that had prevailed three to four years earlier – painful though this might be for those who chose or were forced to sell at this time. Obviously their number dwindled and in any case, it required courage to use funds for objects of this kind when the economic outlook seemed so bleak.

The testing time for the recovery in the market of Chinese ceramics came at the sale in London of the Mrs Alfred Clark Collection on 25 March 1975. This had been assembled before the war by her late husband, a former chairman of *His Master's Voice*. A number of pieces had originally been bought at Sotheby's in some of the great pre-war Chinese ceramics sales and there had already been an earlier sale from the collection at Bond Street in 1953.

There had been some hint of improvement in the market during a two-day sale at Sotheby Parke Bernet in New York on 12 and 13 March. But the atmosphere before the Clark sale was tense and it was not until the first twenty pieces had been sold that it became clear that confidence had been re-established. The strongest bidding came from buyers from Japan, and to a lesser extent from Hong Kong and the States, but at £442,700 for the 145 pieces (of which only six minor ones remained unsold) it was clear that the major depression was over, after lasting rather less than twelve months.

The good cheer on the early Chinese ceramics front continued throughout the summer. The major London sale of 8 July was particularly successful when the 192 lots fetched a total of £680,990 and only 7 per cent were bought in. It was another piece from the Eumorfopoulos Collection which brought the highest individual price: £100,000 ($230,000) for a rare Ming blue and white bowl (illustrated p. 407). In 1940 Bluett had bought it for £32. Another surprise was the £36,000 ($82,800) which Eskenazi paid for a carved stone figure of a female musician of the T'ang Dynasty (illustrated p. 390). Also impressive was the £78,000 ($179,400) paid by Eskenazi for a kuan-yao bottle vase of octagonal section from the Sung Dynasty (illustrated p. 402). The pre-sale estimate had been £25–£50,000.

ART AND ILLUSTRATION: CAMERA VERSUS BRUSH

Another area which we already know to have undergone major fluctuations in popularity and price, were paintings of the eighteenth- and nineteenth-century English School: violently up in the third quarter of the nineteenth century; down again in the fourth; pushed up sensationally by the Duveen school of collectors in America until the time of the great slump in 1929; out of favour for thirty years or more; up again at first slowly and then on an accelerated scale in the last ten years. At the turn of the year the stream of properties sent for sale into the department at Bond Street dealing with eighteenth- and nineteenth-century British art was reduced to a mere trickle, but by early April a recovery in price began to be noticeable and by the time of the third Dick sale of English Sporting Pictures on 23 April 1975, sellers began to feel a good deal more cheerful.

It is probably fair to say that it is the almost total abandonment of art as illustration by painters in recent times that has led to the increase in appreciation of Victorian pictures. Who would have had the courage to foretell fifteen years ago the great resurgence of interest and marketability in the endless cattle pieces, dusky landscapes and historic allegories for which Belgravia has established a fashion? But here again, it was probably a too strongly speculative

element that had crept in during the previous three years which caused the sharp decline of prices in late nineteenth-century British painting. The recent lower prices indicated a returning sense of realism without seriously mutilating the new public demand for it. Many examples, of course, go overseas. Certain forms of Victorian painting, like genre pictures and landscapes, are particularly popular in Japan and to some extent in the Middle East, but there is also a strong demand for them from Germany, Austria, Spain and Italy.

The Dutch Romantic School also initially took a severe drubbing as far as prices were concerned. In 1973 the nineteenth-century pastiches of seventeenth-century masters by Koekkoek and Springer sold at higher prices than the works they were simulating by such charming townscape painters as Jan van der Heyden. Early in 1974 works of Koekkoek and his contemporaries were down to something like half their former level in the previous year, though by the end of the season a substantial recovery was well under way. Thus a winter scene by Barend Cornelis Koekkoek (illustrated p. 77) fetched a remarkable £30,000 ($69,000) on 11 June 1975.

Yet there was one area in 1974 in which interest and prices moved against the trend, for the year saw a flowering on both sides of the Atlantic of the appreciation of mid nineteenth-century photography. We often forget to what an extent the development of photography disturbed the comfortable execution of representational art in the mid Victorian era. As photography spread artists had to reorientate their objectives. In England they hardly found the answer. French artists did, though perhaps 1974 was one of the first years in which the price of the work of great Impressionists was overtaken by that of artists of much later movements. Max Ernst, Braque and Egon Schiele particularly come to mind. Thus, Ernst's *Papillons* fetched £35,000 ($80,500) on 4 December 1974 against £3,571 in 1966. Among nineteenth-century artists, Boudin and Toulouse-Lautrec took a particular tumble. By the spring of 1975 this trend had again been reversed and the Impressionists were ahead once more.

This became particularly clear in the remarkable evening sale held on 1 July in London of a French private collection that had been formed after 1900 by two generations of one family. Ten pictures remained unsold; the other forty fetched no less than £2,131,700. The buying was extremely international and many of the pictures went to private collectors who successfully outbid dealers. Interest in the collection was particularly strong because it was virtually unknown. It included three outstanding paintings from Maurice de Vlaminck's Fauve period which lasted only three years. The prices were £118,000 ($271,400) for a rather van Gogh-like sky and fieldscape, £130,000 ($299,000) for *Le Pont de Chatou* and £101,000 ($232,300) for *La Seine à Bougival* (illustrated p. 117). A view of Rouen Cathedral by Camille Pissarro (illustrated p. 101) moved from an initial bid of £30,000 to a final £120,000 ($276,000) in just over sixty seconds! One of Monet's thirty or more studies of Rouen Cathedral of 1894 (illustrated p. 100) went for a breathtaking £210,000 ($483,000) to a US buyer. When twenty of these studies were first exhibited by Durand Ruel in 1895, several were sold for the then high price of 15,000 francs each. The last picture in the sale, a late still life by Braque of 1941, *Mandoline à la partition* (illustrated p. 123), was bought by a bidder on the telephone from the US for £170,000 ($391,000).

In New York Sotheby Parke Bernet had already done well in its sale of 21 May where the Impressionists (and more recent painters) once more provided headline material. Paul Gauguin's *Hina Maruru* (illustrated p. 112) was sold for $950,000 (£413,043). Monet's *Le Pont Japonais, Giverny,* so subtle as to be no more than a study of texture, reached $115,000 (£50,000). Matisse's rather symmetrical *Danseuse au Palmier* was sold for $230,000 (£100,000) and Chagall's *Chrysanthèmes* for $117,500 (£51,086). A 1951 Giacometti sculpture of an

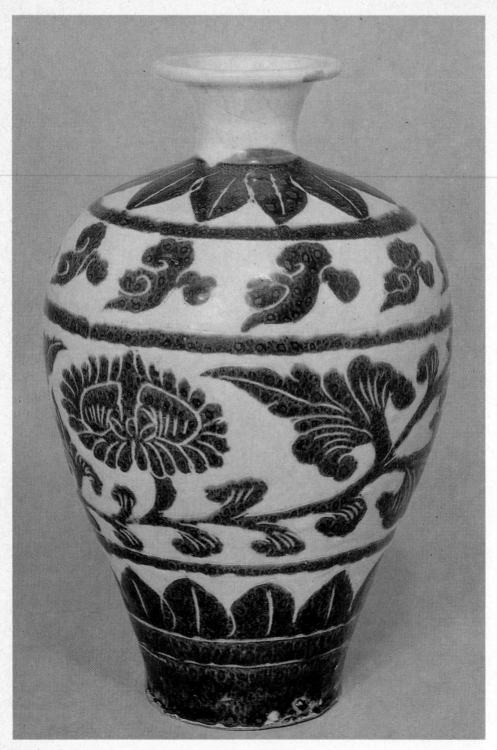

Opposite page
MAURICE DE VLAMINCK
Le Pont de Chatou
Painted in 1906, 25½in by 32in
London £130,000 ($299,000).
I.VII.75
From the French private
collection discussed on p.17

A Tz'ǔ Chou sgraffiato *mei p'ing*, Sung Dynasty, height 10¾in
London £32,000 ($73,600). 25.III.75
From the collection of Mrs Alfred Clark discussed on p.16

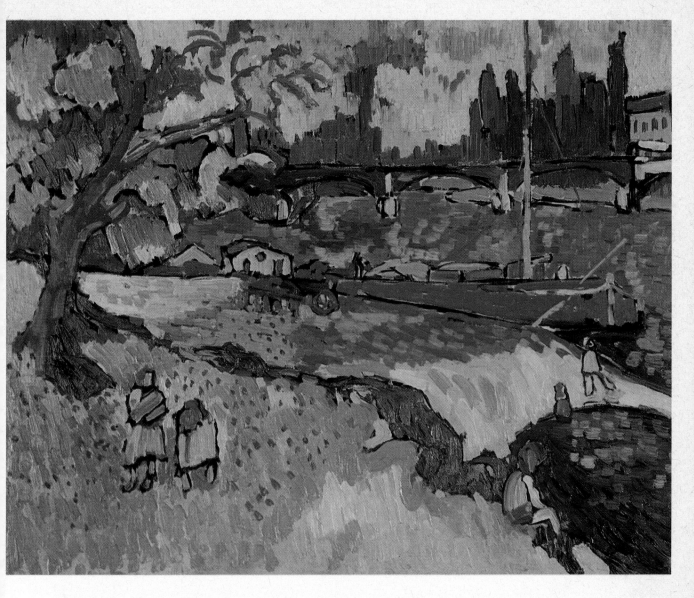

attenuated cat (illustrated p. 138) reached $130,000 (£56,522) and Picasso's very typical female portrait of 1941 (illustrated p. 125) went for $200,000 (£86,956). Earlier in the sale a self-portrait of 1860 (illustrated p. 103) by Henri Fantin-Latour, famous for his flower paintings, was sold for $26,000 (£11,304). Two Vuillard interiors both including female sitters had been sold for $23,000 (£10,000) and $24,000 (£10,435) respectively.

SALEROOM DEVELOPMENTS

As far as Sotheby's was concerned, two changes in saleroom practice occurred in 1974 which should be recorded. First, it became standard practice to include printed estimates with most sale catalogues. As with any innovation, this caused some controversy. It also added a new dimension to the reports by saleroom correspondents in the daily press, which caused a certain amount of wry amusement for those who had the unenviable task of making the estimates. If the price realised was above the estimate, the comment at first was that Sotheby's had failed to

spot a 'sleeper', if below, clearly the piece concerned had been overvalued. If the price came somewhere between the top and bottom estimates, the market was evidently stagnant!

More sadly, the decision was taken to omit the purchasers' names from the printed price lists, except in the case of book sales: a little bit of history lost after two centuries which future generations of saleroom students will lament, and one of the casualties of a time when the tax inspector has more authority than is good for him, though the increasing use of pseudonyms by buyers had often made the name lists of doubtful value. The unsold lots were also omitted for the first time and the historian will thereby be recompensed with information which was previously not available.

Sotheby's also made a major move into the Common Market when, in the summer of 1974 they purchased a 100 per cent holding in Amsterdam's leading firm of art auctioneers, Mak van Waay. This has provided a much closer link with a very important continental market which helps to discount fluctuations in currency and has increased the two-way traffic in works of art of all kinds. Thus the first and very successful Amsterdam sale organised as a joint venture between the Bond Street Old Master Drawing department and Mak van Waay was held on 9 June. The 161 lots which totalled £89,000 came from a distinguished private Swedish collection. It attracted highly competitive bidding from European and American dealers and collectors as well as from local Dutch buyers and National museums, a truly international occasion. Holland, incidentally, is one of the countries where the practice that buyers, as well as vendors, pay a commission has been in existence for many years. This is a break with tradition which both Christie's and Sotheby's have been forced to introduce into the UK from September 1975 in order to counter the effects of inflation, while at the same time reducing the commission paid by most vendors to make the London market more attractive to sellers from overseas.

A further development in the recognition of the increasing importance of Persia in the art market was an exhibition of 500 European paintings of all schools, held at the Hilton Hotel in Tehran during May 1975. It was presented by four London galleries and sponsored by Sotheby's, and interest in the works displayed for only six days was intense. Sotheby's also opened a Tehran office in 1975 bringing its total number of establishments all over the world to twenty-five.

The remarkable results of the Rothschild sale in Monte Carlo late in May 1975 was evidence of the flexibility with which Sotheby's management have reacted to a period of non-stop economic and political crisis. With the Government in Whitehall seemingly bent on the destruction of the middle classes, the muscle in the ball game has moved overseas – the Middle East and the Far East in particular – and the London saleroom is understandably dominated by foreign buyers. This has already begun, and will continue, to create and to dominate fashions.

SUMMER HIGHLIGHTS

The Monte Carlo sale was significant in more ways than one for it heralded a return to buoyancy which it would have been difficult to foresee only a few weeks earlier. After it, buyers began to compete for anything of outstanding quality in every sort of sale in a new spirit. Many records were broken, but probably more important, prices continued to beat even the higher estimates.

Thus in New York on 18 June at a sale of Japanese prints, an Utamaro made a record $70,000 (£30,435) (illustrated p. 426), almost twice the price it had fetched in the sale of the Hans Popper Collection in 1972. At $26,000 (£11,304) for a Hokusai, $15,000 (£6,522) for a

Hiroshige (illustrated p. 438), and $35,000 (£15,217) for a Sharaku *Portrait of the Actor Otani Hiroji II*, all previously in the same collection, the rate of increase was even higher. Both in London and in New York there was greatly increased interest in Japanese *netsuke* and Chinese snuff bottles and prices in the latter part of the season left older collectors gasping. On 18 June an eighteenth-century snuff bottle, admittedly made in the Imperial Workshop, fetched no less than £4,600 ($10,580) (illustrated p. 392). Similarly there were good prices for the late William Bradford's collection of *tsuba* (Japanese sword guards) of 20 May. The highest price was £2,600 for a *shakudo tsuba* which had cost Bradford £16 10s 0d in 1958 and another fetched £1,400 for which he had only paid 15s 0d in 1946. In fact, it has become clear that in many areas of interest (including even Old Masters) it is often the compact, highly portable object which is generally sought after throughout the world today.

An interesting example of this was a portrait miniature of a lady by Nicholas Hilliard of *circa* 1600 which fetched no less than £10,000 ($23,000) (illustrated p. 252). In the Old Master field itself, Sotheby Parke Bernet in New York had a very successful sale on 12 June where paintings of the early Italian School were particularly in demand. Thus a cassone panel painted by an artist in the circle of Apollonio di Giovanni (illustrated p. 23) made $58,000 (£25,217); a *Madonna and Child* by an artist in the circle of Sano di Pietro made $22,000 (£9,566), and another anonymous but attractive fifteenth-century Florentine version of the same subject made $26,000 (£11,304). In London on 9 July paintings by Dutch artists found buyers at very high prices. A winter landscape by Aert van der Neer made £110,000 ($253,000) (illustrated p. 32) and a Jan Steen from the same collection made £88,000 ($202,400) (illustrated p. 33). A miniature panel by Pieter van Slingeland (see frontispiece) made £33,000 ($75,900). Another record of a different kind was the £58,000 ($133,400) paid for a large portrait of the Earl of Hillsborough (illustrated p. 39) by Pompeo Batoni, until recently an unappreciated eighteenth-century Roman painter who specialised in portraits of wealthy visitors to Rome while travelling on the Grand Tour.

The year also revealed a much greater appreciation of early Italian maiolica. Seven pieces out of thirty-six sold on 18 March 1975 at Bond Street fetched over £10,000 each. All but four of these came from two long-established collections – that of the late Sir Stephen Courtauld and Paul Damiron of Lyons. A dated Gubbio Istoriato plate (illustrated p. 377) bought from the Henry Oppenheimer collection in 1936 for £1,029 now fetched the astonishing sum of £55,000 ($126,500). A Faenza tondino which had been sold at Sotheby's in the remarkable maiolica collection of Sir Otto Beit in October 1942 for £51 now went for £4,200. A New York sale on 30 May 1975 also contained a number of highly priced pieces of maiolica.

Very near the end of the season on 24 July, Sotheby's Belgravia had the most ambitious glass sale of its four-year history. The last six items were unique pieces from the Pargeter-Northwood Cameo Glass Collection. An earlier member of the family, Benjamin Richardson had suggested that it should be possible to make a perfect glass copy of the Portland Vase smashed by a lunatic in the British Museum in 1843. John Northwood, working with Philip Pargeter completed a copy in 1876 and this was now sold for £30,000 ($69,000) to an American collector. Northwood and Pargeter's 'Milton Vase' completed two years later in 1878 was sold to Mr Billy Hitt, a New York collector in the same sale. By a curious coincidence, two earlier versions of Wedgwood's copy of the Portland, or as it is sometimes called, the Barberini Vase, had already been sold at Bond Street: the 'Barker' copy on 22 October 1974 for £18,000 ($41,400) and another version known as the 'Poole' copy (illustrated p. 369) for the same sum on 27 May 1975.

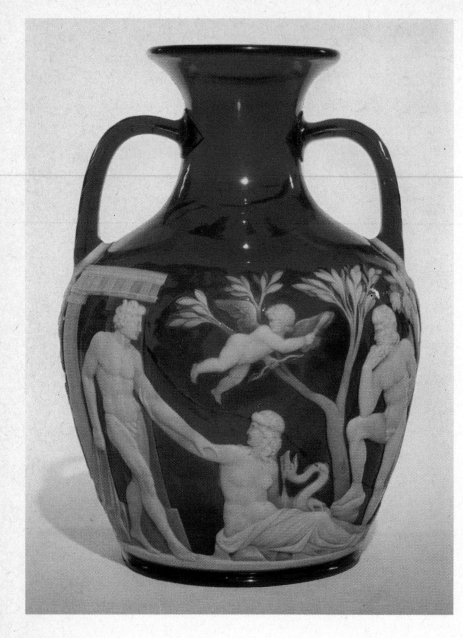

The Portland Vase, cameo
glass, signed and dated *John
Northwood 1876*, height 10in
London £30,000 ($69,000).
24.VII.75
From the Pargeter-
Northwood Cameo Glass
Collection
See description on previous
page

As we have seen, crises come and crises go, but the period of 1974 and 1975 has had the
added dimension of depression *with* inflation. In economic terms, the art market has moved a
long way back up the slope from its nadir in late 1974 and has been strengthened mostly by
the very internationalism which was the result of earlier periods of decline. This rapid
recovery was something that no-one could have foretold with confidence as winter turned
into spring in 1975. Certainly there was little precedent for it from the more distant past and it is
a remarkable proof of the world's ultimate confidence in the permanent value of works of art.

Pictures, Drawings and Sculpture

23 OLD MASTER PICTURES

40 OLD MASTER DRAWINGS

49 ENGLISH PICTURES AND DRAWINGS

74 EUROPEAN PICTURES

82 TOPOGRAPHICAL PICTURES

90 SOUTH AFRICAN PICTURES

92 AMERICAN PICTURES

100 IMPRESSIONIST AND MODERN PICTURES, DRAWINGS AND SCULPTURE

144 CONTEMPORARY PICTURES AND SCULPTURE

CIRCLE OF APOLLONIO DI GIOVANNI
The triumphal procession of a military leader (detail)
On panel, partly gold ground, 15¾in by 57in
New York $58,000 (£25,217). 12.VI.75
From the collection of the late Franklin Mott Gunther
and Louisa Gunther Farcasanu

JUAN REXACH
Two panels from a retable: *Christ on the Cross* and *The Virgin enthroned*
On panel, in the original framing, overall size 68in by 36in
London £21,000 ($48,300). 9.VII.75

NEROCCIO DE' LANDI
The Mystic Marriage of St Catherine
On panel, 15½in by 11½in
London £11,000 ($25,300). 11.XII.74

MASTER OF THE OSSERVANZA TRIPTYCH
The Pietà
On panel, 40½in by 28½in
Florence L45,000,000 (£31,034 : $71,379). 23.X.74
The arms are those of the Volckmar family

FRANCESCO DI STEFANO, called IL PESELLINO
The Virgin and Child enthroned
On panel, 21¼in by 13½in
London £45,000 ($103,500). 19.III.75

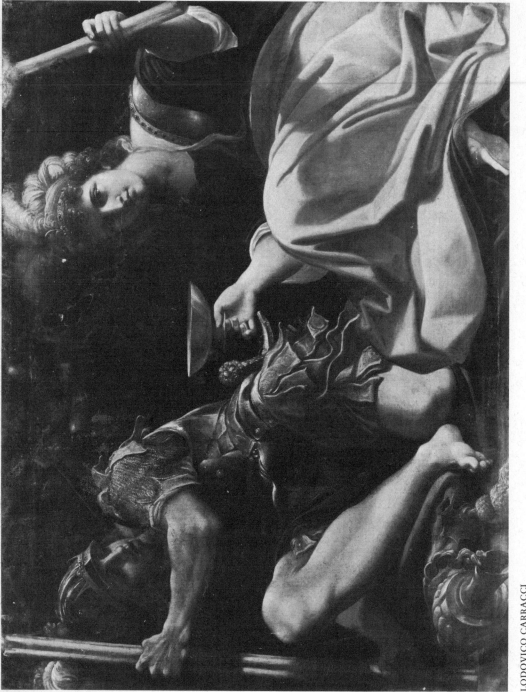

LODOVICO CARRACCI
Alexander and Roxana
51¼in by 66½in
London £20,000 ($46,000). 19.III.75. From the collection of Mrs Peter Somervell

Below
GIUSEPPE MARIA CRESPI
A pastoral scene
71½in by 85in
London £37,000 ($85,100). 11.XII.74. From the collection of Miss Irene Albert

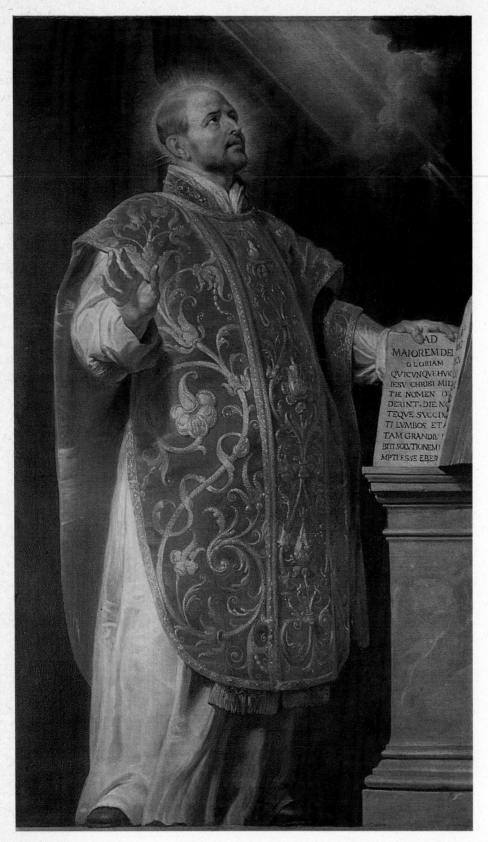

SIR PETER PAUL RUBENS
St Ignatius of Loyola
88in by 51½in
London £140,000 ($322,000). 11.XII.74
Warwick Castle Collection

BARTHOLOMAUS SPRANGER
The dream of St Catherine
On panel, 32½in by 26¼in
New York $82,500 (£35,870). 12.VI.75
From the collection of the Benjamin and Mary Siddons Measey Foundation

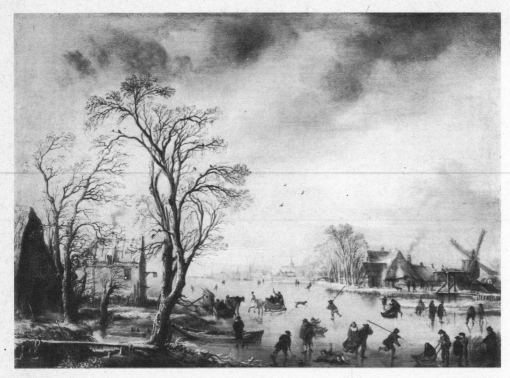

AERT VAN DER NEER
A winter landscape
On panel, signed in monogram, 15¾in by 21¾in
London £110,000 ($253,000). 9.VII.75

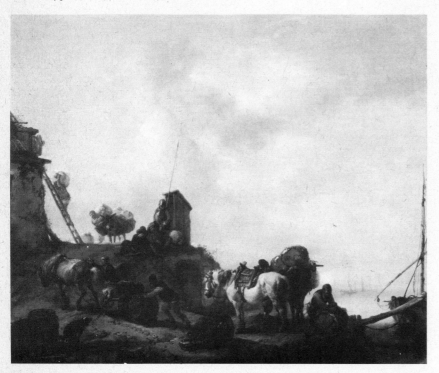

PHILIPS WOUWERMANS
A customs house on the River Maas
Signed with initials, 15½in by 19in
London £31,000 ($71,300). 9.VII.75
Formerly in the collection of R. S. Holford

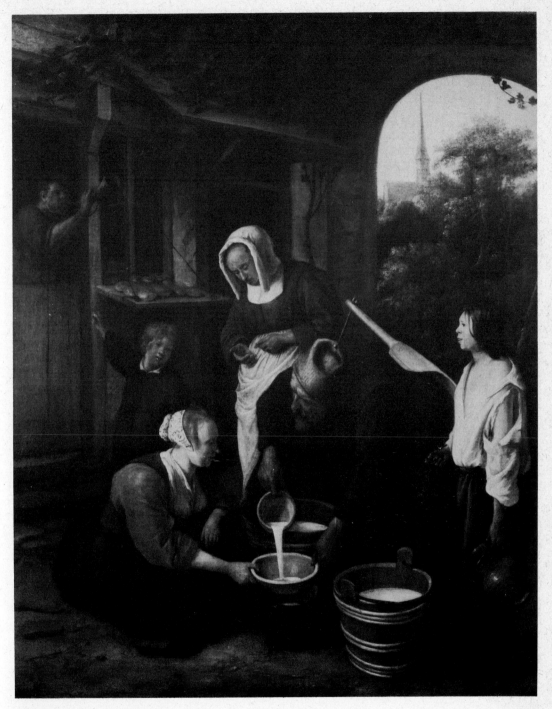

JAN STEEN
A village scene with a milkman
Signed, 23¼in by 19in
London £88,000 ($202,400). 9.VII.75
Formerly in the collection of J. R. Mills in 1857

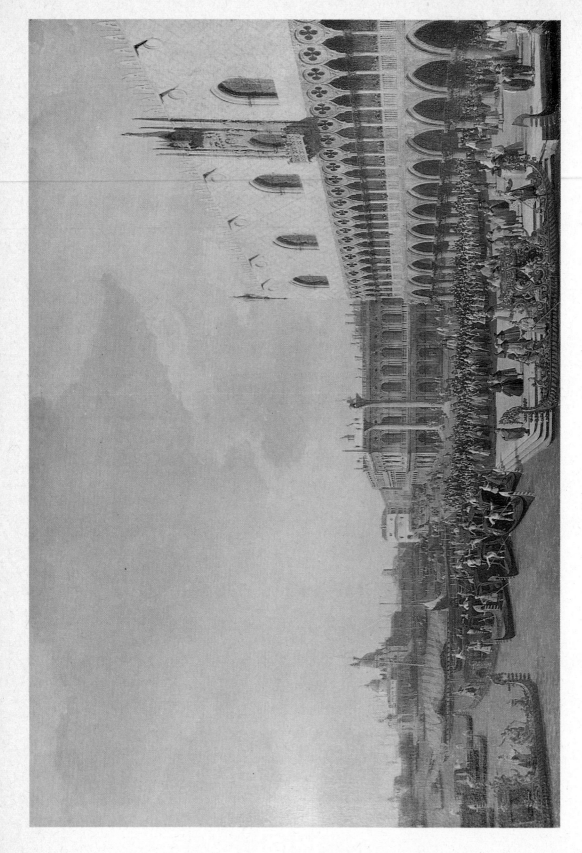

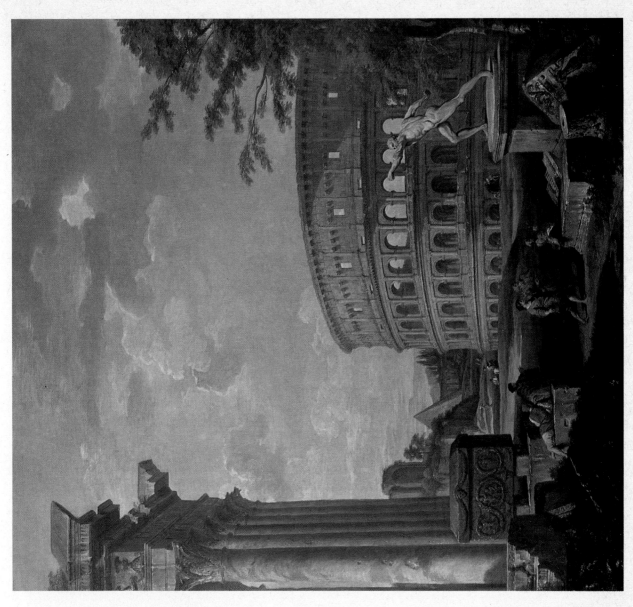

Above
GIOVANNI ANTONIO CANALE, called CANALETTO
*The reception of the French ambassador at the
Doge's Palace*
58½in by 87in
London £125,000 ($287,500). 11.XII.74
The Warwick Castle Collection

The variant of this composition in the
Hermitage Museum in Leningrad was
traditionally identified as the reception of the
French ambassador, Comte de Gergy. He
was appointed in 1723 but did not present
his credentials until 1726, and was recalled in
or after 1731. Canaletto was said to be
working for the French ambassador in 1725
and the present picture probably dates from
this period

GIOVANNI PAOLO PANINI
Landscape with the Colosseum
One of a pair, signed and dated *Roma 1738*,
43¼in by 39in
London £40,000 ($92,000). 11.XII.74

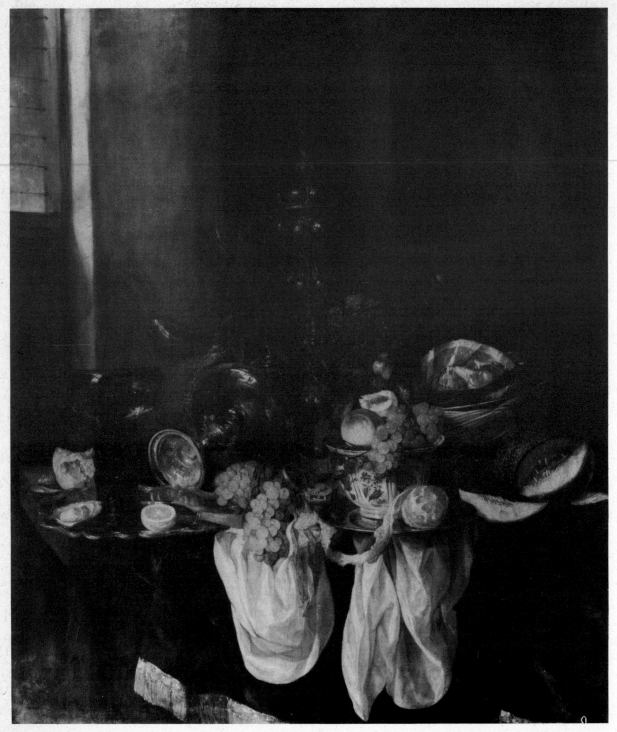

ABRAHAM VAN BEYEREN
A Pronck still life
Signed with monogram, 46in by 40¼in
London £26,000 ($59,800). 11.XII.74
From the collection of the late Dr J. A. van Dongen

JACOB VAN WALSCAPELLE
A still life of summer flowers
Canvas laid down on metal, signed, 20½in by 17½in
New York $27,000 (£11,739). 6.III.75

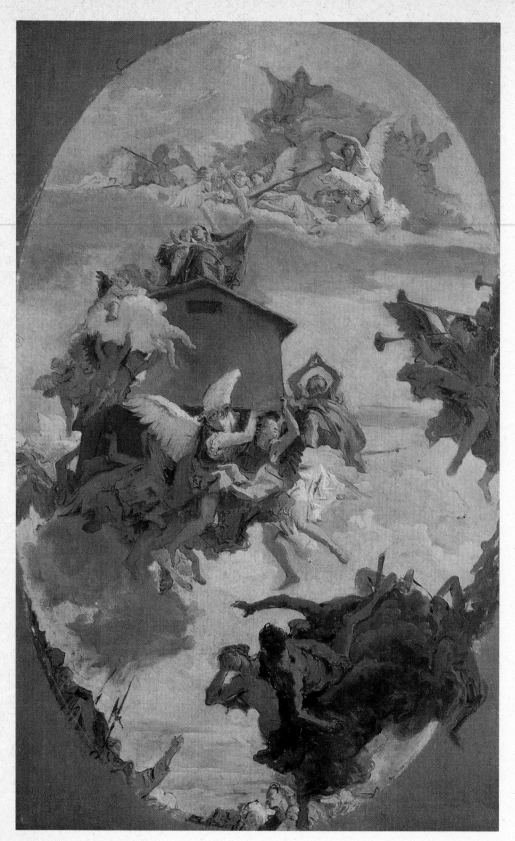

GIOVANNI BATTISTA TIEPOLO
The Miraculous Translation of the Holy House of Loreto
48in by 30in. London £195,000 ($448,500). 11.XII.74
From the collection of Eva, Countess of Rosebery
This is a sketch for the great ceiling fresco of the church of the Scalzi in Venice for which
Tiepolo received the commission in September 1743. It was destroyed by a bomb in 1915.
The sketch differs considerably from the final composition as the architecture of the ceiling
was changed while the work was in progress

POMPEO BATONI
Portrait of the Earl of Hillsborough (later the 1st Marquess of Downshire)
Signed and dated *Rome 1766*, 89½in by 63½in
London £58,000 ($133,400). 9.VII.75
From the collection of the Marchioness of Downshire
Wills Hill (1718-1793) succeeded as 2nd Viscount Hillsborough in 1742 and in 1751 he was created
Earl of Hillsborough. Margaretta Fitzgerald, whose portrait appears in this picture, was the sister of
the 1st Duke of Leinster and the first wife of Lord Hillsborough. She had died in Naples in January
1766, the year this portrait was painted

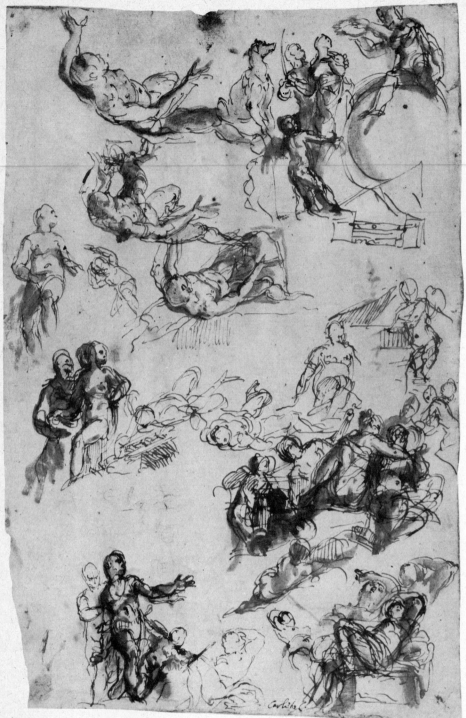

PAOLO CALIARI called VERONESE
Study for the Allegories of Love
Pen and ink and wash, 32.4cm by 22.3cm
Los Angeles $57,500 (£24,783). 21.V.75

This important sheet by Veronese, which has only recently come to light, contains early
ideas for the four pictures in the National Gallery, London

Opposite page
Right
EMILIAN SCHOOL,
circa 1550
St Joseph standing with both
hands resting on his staff
Red and white chalk on
paper washed pale brown,
35.3cm by 23.1cm
London £1,000
($2,300). 4.VII.75

Far right
GIOVANNI BENEDETTO
CASTIGLIONE
Deucalion and Pyrrha
Drawn in red-brown oil
paint and partly coloured
in blue, 33.3cm by 26.2cm
London £4,200
($9,660). 21.XI.74
A study for the painting
in the Bodemuseum,
Berlin, dated 1655

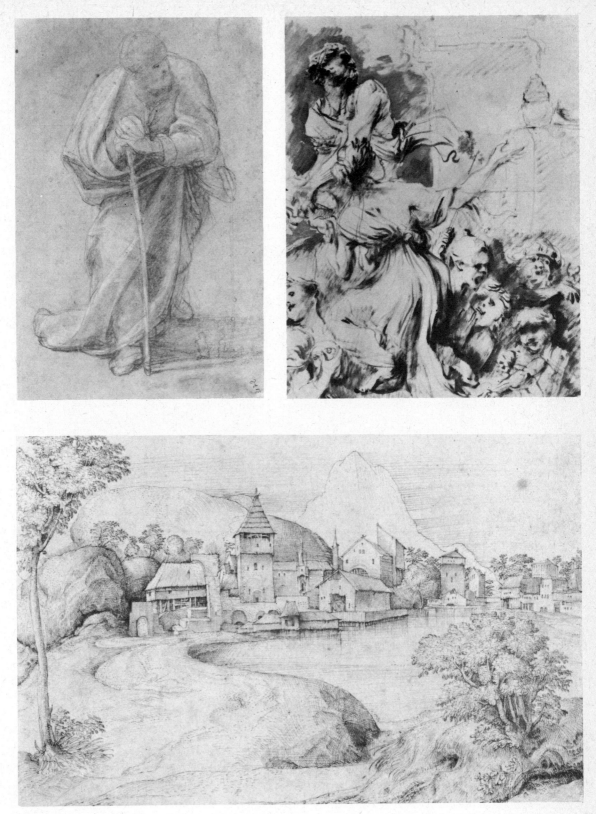

GIULIO CAMPAGNOLA
Village at the edge of a lake
Pen and brown ink, 14.8cm by 23.5cm
London £1,800 ($4,140). 21.XI.74

ESAIAS VAN DE VELDE
Falconers in an autumn landscape
Brown wash over black chalk, signed in black chalk *E. V. Velde 1629*, 18.8cm by 14cm
Amsterdam Fl 24,000. (£4,324: $9,946). 9.VI.75
From a series of drawings of the months of the year, this one represents October

DAVID VINCKEBOONS
The peasant dance
Pen and brown ink and brown and grey wash, signed and dated in ink *DVB 1604*, 21.3cm by 33.9cm
London £2,600 ($5,980). 22.XI.74

SEBASTIAEN VRANCX
Mountainous landscape with figures in the foreground
Pen and brown ink over traces of red chalk, signed and dated in ink on the verso *Sebastian Vrancx/in. et fecit Roma/1597,* 19.6cm by 28.1cm
London £2,200 ($5,060). 22.XI.74
From the collection of Eva, Countess of Rosebery

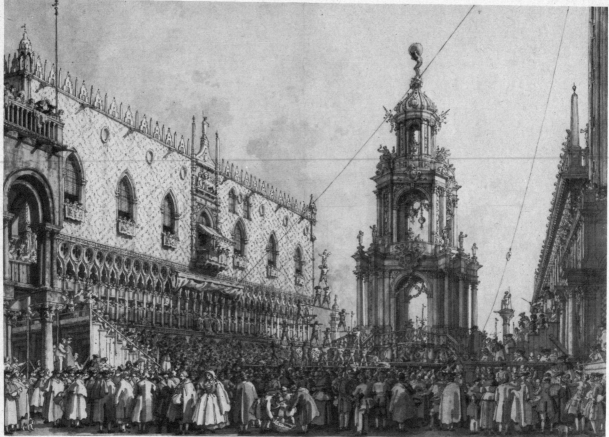

GIOVANNI ANTONIO CANALE called CANALETTO
The Doge attends the Giovedì Grasso festival in the Piazzetta
Pen and brown ink and two shades of grey wash, heightened with white over black chalk, 38.6cm
by 55.5cm
London £35,000 ($80,500). 11.XII.74
From the collection of Eva, Countess of Rosebery
Formerly in the collection of Sir Richard Colt Hoare Bt, Stourhead, Wiltshire

The festival of *Giovedì Grasso* was instituted in celebration of a victory by the Venetians in 1164 over
Ulric, Patriarch of Aquileia. The Doge is seen under the central arch of the opera arcade running
along the façade of the Ducal Palace, left. On a platform next to an elaborate temporary construction
in the middle of the Piazzetta is the human pyramid known as the *Forza d'Ercole*, a gymnastic display
in which the rival factions of the Castellani and the Nicolotti used to compete. The rope running from
the seat of the Doge towards the top of the Campanile, right, was used for the *volo del Turco* or *della
Colombina*. A man or boy in appropriate costume, pulled by another rope (seen on the right) to the top
of the Campanile, descended by the first rope, and presented the Doge with flowers and poetic
compositions. Later, fireworks were set off from the temporary construction which, in the drawing,
carries the coat of arms of Doge Alvise Mocenigo IV

This drawing and the one following are from a series of twelve illustrating the principal official
functions in which the Doge took part at different times of the year. W. G. Constable dates them on
stylistic grounds after Canaletto's return from England *circa* 1756 and thinks they were almost certainly
done for the series of twelve engravings by G. B. Brustoloni. The engravings were published by the
bookseller Lodovico Furlanetto between 1763-1766 and it seems probable that Sir Richard Colt
Hoare purchased ten of the twelve original drawings (including these two) from this source in
either 1787 or 1789. There are no paintings known by Canaletto himself of these subjects, only
isolated examples by his followers and the complete set by Francesco Guardi which is divided between
the Louvre and other museums

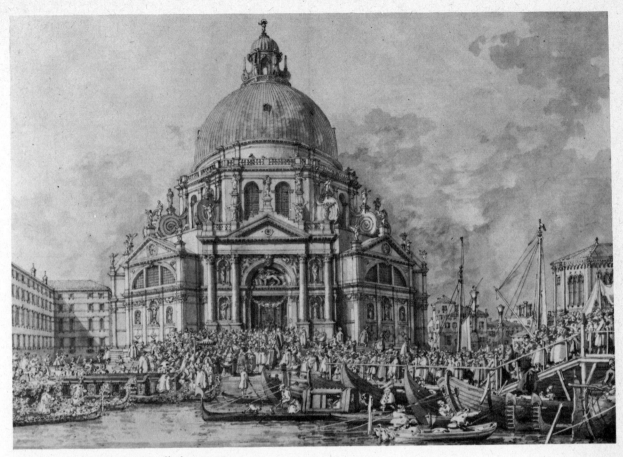

GIOVANNI ANTONIO CANALE called CANALETTO
The annual visit of the Doge to the Basilica of St Maria della Salute
Pen and brown ink and two shades of grey wash, heightened with white over black chalk, 38.8cm
by 55.4cm
London £32,000 ($73,600). 11.XII.74
From the collection of Eva, Countess of Rosebery
Formerly in the collection of Sir Richard Colt Hoare Bt, Stourhead, Wiltshire
This drawing shows the visit to the church of the *Salute* which took place each year on 21 November,
the Feast of the Presentation of the Virgin, to renew thanks to the Virgin for deliverance of the city
from the plague of 1630. On the right is one of the two wooden bridges over boats which were
placed across the Grand Canal for the occasion. The Doge, preceded by ecclesiastics, has evidently
just disembarked from the large *peatone* on the left

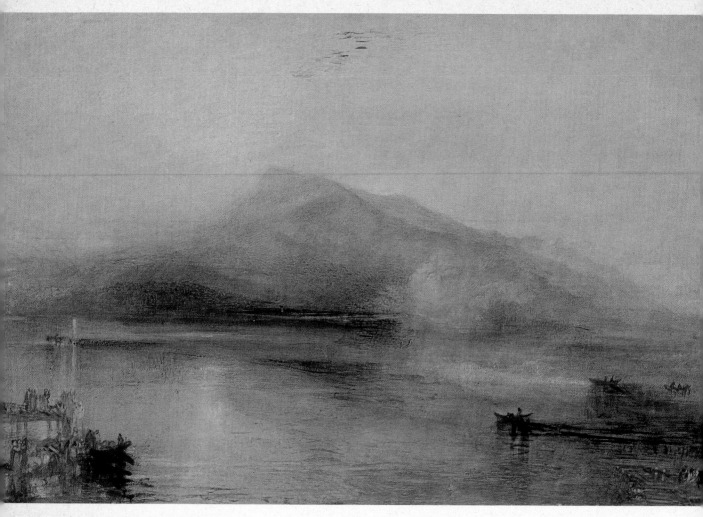

JOSEPH MALLORD WILLIAM TURNER
The Lake of Lucerne, showing the Rigi at sunrise (the 'Dark' Rigi)
Watercolour, 1842, 12in by 18in
London £85,000 ($195,500). 16.VII.75

Turner's 'Dark' Rigi comes to light

Martin Butlin

Possibly the most impressive wall in the large Turner exhibition organised by the Tate Gallery and the Royal Academy at the Academy in the winter of 1974-75 was that devoted to water-colours of the Rigi, the mountain that dominates the far end of Lake Lucerne. Flanked by nine watercolour sketches, which ranged from the most ethereal of thinly floated washes to bold effects of strong colour, were two of the masterpieces of Turner's late years, the 'Blue' Rigi and the 'Red' Rigi. These two views of the mountain from slightly different viewpoints and with the contrasted effect of the light and colour of morning and late afternoon, represent the culmination of Turner's watercolour technique. Highly finished, they demonstrate his mastery of every technical device and in particular a feature that was seen by contemporaries as a new development, the use of stippling or repeated short brush-strokes to produce an effect of detailed finish without losing the transparency of the medium.

These two watercolours were the part result of one of Turner's odder schemes to secure commissions. Early in 1842 he left fifteen sketches of Swiss subjects, together with finished versions of four of the same compositions, with his dealer Thomas Griffith, in the hope of selling ten finished watercolours. Griffith only managed to secure nine orders, receiving the tenth finished watercolour as his commission. Two of the four samples were the 'Blue' and 'Red' Rigis, which were bought by two of Turner's regular patrons in his later years, Elhanan Bicknell and H. A. J. Munro of Novar. Munro bought four further works, including the 'Dark' Rigi, a finished version of one of the compositions as yet only in sketch form.

At the time of the Royal Academy exhibition the 'Dark' Rigi was untraced, having last passed through the salerooms in 1904. What more exciting than the appearance of this lost work, unsolicited, at Sotheby's counter. The reappearance of this watercolour also cleared up one slight art-historical problem. Among the watercolour sketches in the British Museum was one always held to be the sketch submitted to Griffith for the 'Blue' Rigi. Viewpoint, colour and foreground detail were approximately that of the finished version; the only mystery was the name inscribed on the back, 'J. A. Munro Esq' rather than that of Elhanan Bicknell who in fact bought the finished version. The reappearance of the 'Dark' Rigi shows however that the sketch is in fact for this slightly later work, finished as the result of Munro's commission. The actual profile of the mountain, the rising smoke that partly conceals its right flank, and the general placing of the small boats in the right-hand foreground, are closer here than in the 'Blue' Rigi, as is the time of day, dawn just after sunrise.

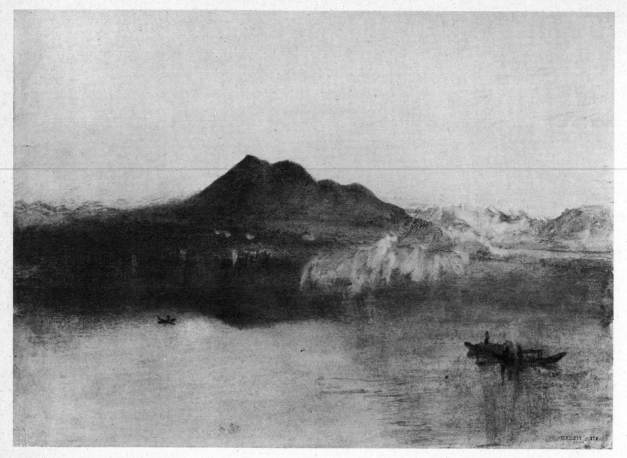

JOSEPH MALLORD WILLIAM TURNER
Sketch for the 'Dark' Rigi
Watercolour, 9in by 12¾in
In the collection of the British Museum (Turner Bequest CCCLXIV-279)

But far more important than this solution of a minor puzzle is the rediscovery of a new masterpiece of Turner's late watercolour style. The technique, minute yet translucent in effect, matches that of the other two Rigis, while the more sombre colouring complements their mood. When Turner first saw the Rigi, on his first visit to Switzerland in 1802, it clearly had little effect on him: only one pencil sketch survives. But in the 1840s, when he revisited the Alps every year from 1840 to 1844, he produced, besides a few pencil drawings, no fewer than nineteen watercolour sketches. Eight are in the Lucerne Sketchbook of 1844 but most if not all of the others must represent the original inspiration behind the three finished masterpieces. Obsession is often a concomitant of genius; rarely is it accompanied by such fantastic technical control.

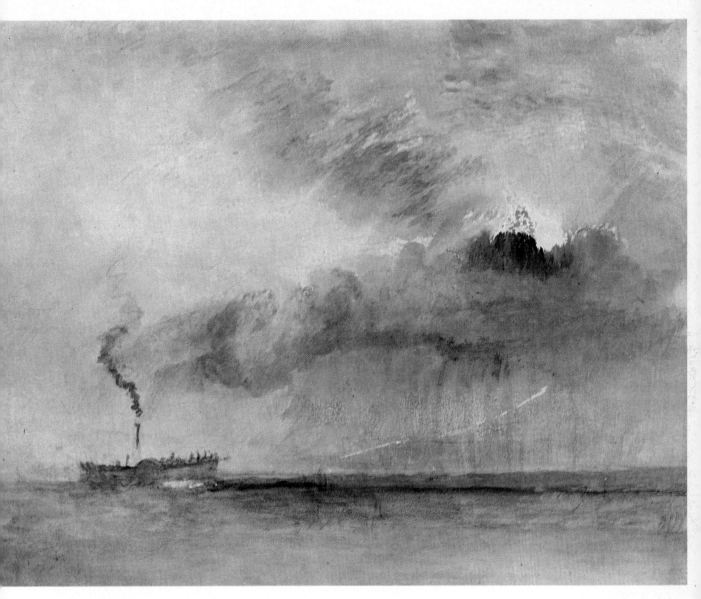

JOSEPH MALLORD WILLIAM TURNER
Steamboat and storm
Watercolour, 9in by 11¼in
London £14,000 ($32,200). 28.XI.74

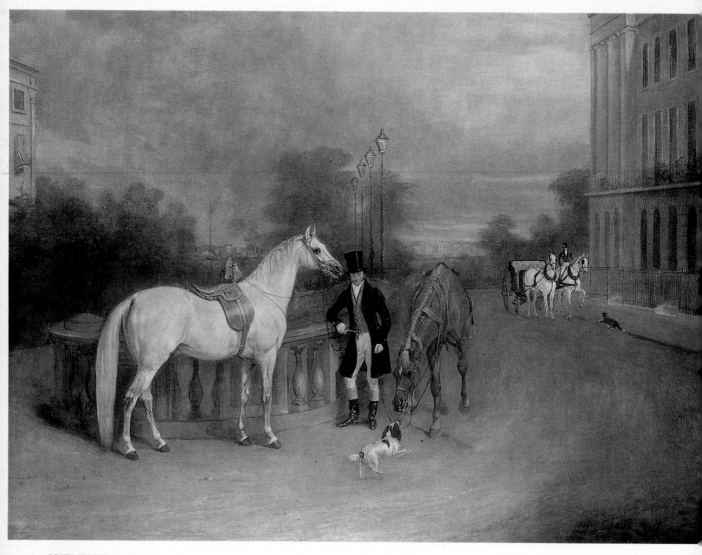

JOHN FERNELEY, Snr
Quirke, groom to the Glengall family, standing in Cumberland Terrace, Regents Park
Signed and dated *Melton Mowbray 1833*, 41in by 58½in
London £30,000 ($69,000). 23.IV.75
From the collection of Mr and Mrs Jack R. Dick

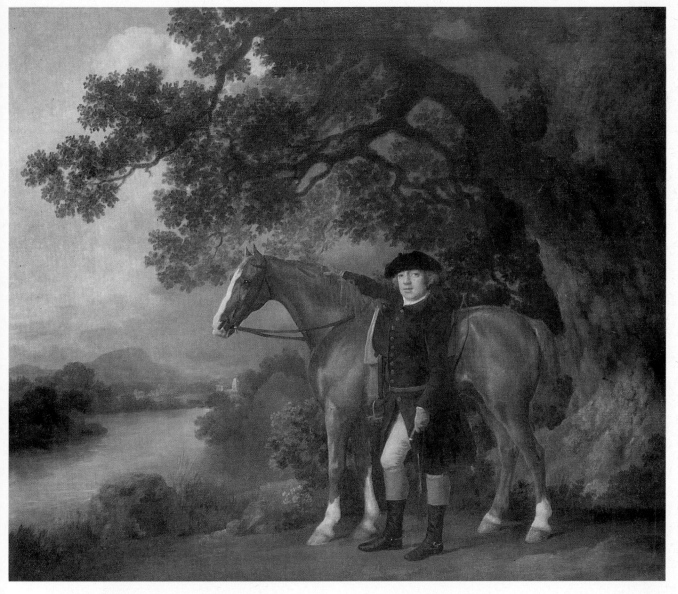

GEORGE STUBBS
Portrait of a huntsman in a green coat
Signed and dated 1768, 24in by 28in
London £60,000 ($138,000). 23.IV.75
From the collection of Mr and Mrs Jack R. Dick

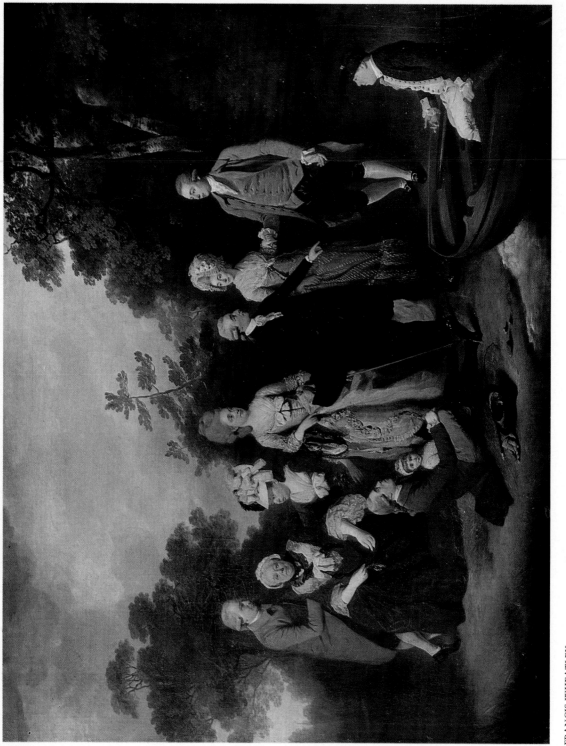

FRANCIS WHEATLEY
The garden party, the Oliver and Ward families
48in by 62¼in
London £55,000 ($126,500). 26.III.75
From the collection of Mr and Mrs A. P. Hoblyn Oliver

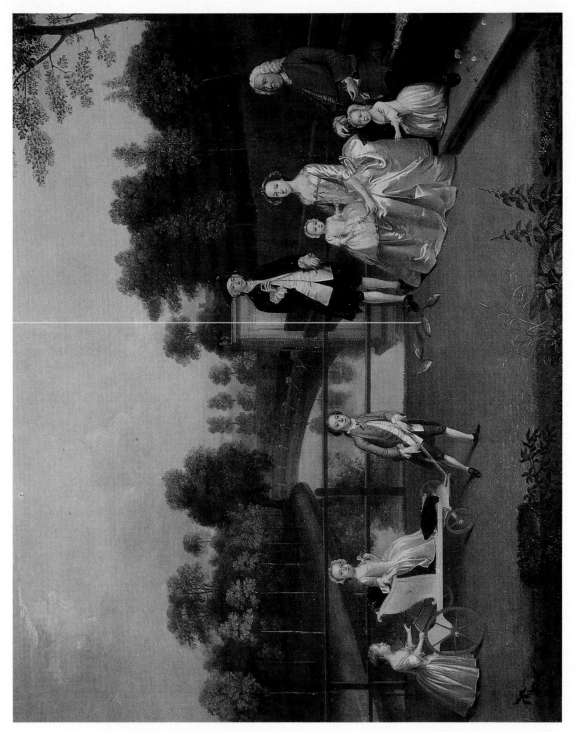

ARTHUR DEVIS
A family group in a garden
Signed and dated 1749, 40in by 49in
London £58,000 ($133,400). 23.IV.75
From the collection of Mr and Mrs Jack R. Dick

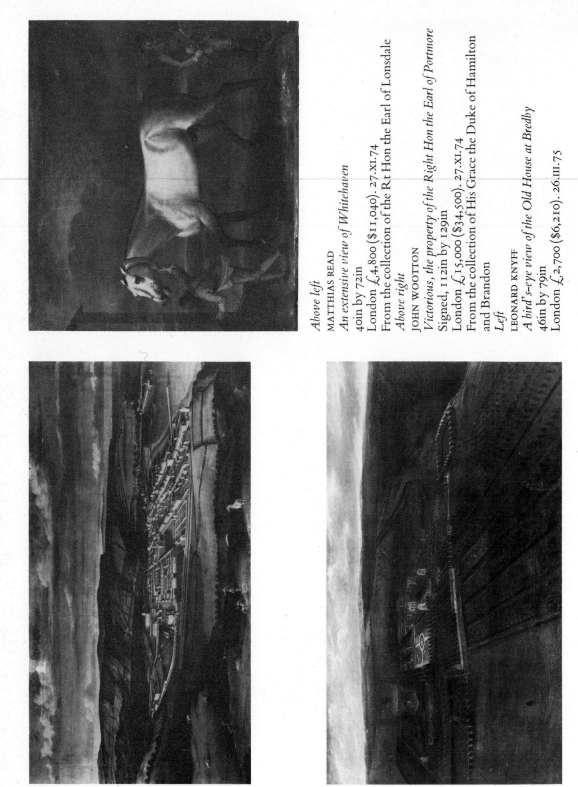

Above left
MATTHIAS READ
An extensive view of Whitehaven
40in by 72in
London £4,800 ($11,040). 27.XI.74
From the collection of the Rt Hon the Earl of Lonsdale

Above right
JOHN WOOTTON
Victorious, the property of the Right Hon the Earl of Portmore
Signed, 112in by 129in
London £15,000 ($34,500). 27.XI.74
From the collection of His Grace the Duke of Hamilton
and Brandon

Left
LEONARD KNYFF
A bird's-eye view of the Old House at Bredby
46in by 79in
London £2,700 ($6,210). 26.III.75

JAMES POLLARD
The Elephant and Castle on the Brighton Road
Signed and dated 1826, 22in by 31in
London £26,000 ($59,800). 23.IV.75
From the collection of Mr and Mrs Jack R. Dick

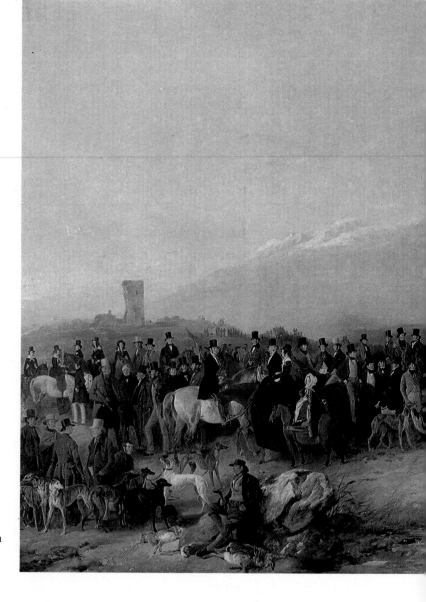

RICHARD ANDSELL
The Caledonian coursing meeting near the Castle of Ardrossan, the Isle of Arran in the distance
Signed and dated 1844, 60in by 119in
London £70,000 ($161,000). 23.IV.75
From the collection of Mr and Mrs Jack R. Dick
This painting was the prize when the Caledonian Coursing Club held a meeting in the Lanark area in March 1845. It was won by Mr J. Gibson's 'Violet' beating the Marquis of Douglas' 'Drift'

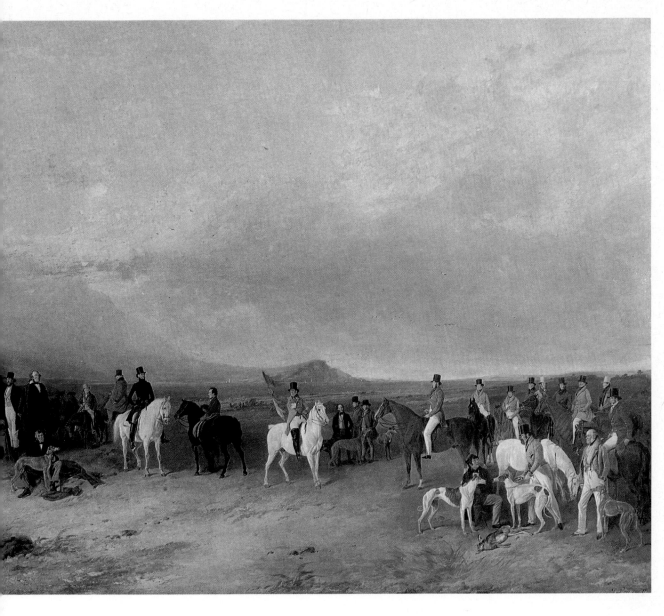

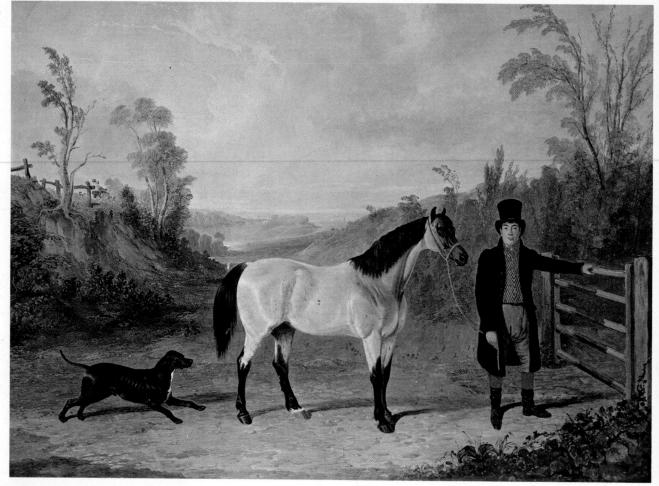

JOHN FREDERICK HERRING, Snr
Benjamin Smith's groom Leslie with Avondale
22in by 30¼in
Los Angeles $26,000 (£11,304). 21.V.75
John Herring was a close friend of Benjamin Smith and often stayed and painted at Stanton Hall.
Avondale, a hunter, was a favourite mount of Herring's when he hunted in Staffordshire

ARCHIBALD THORBURN
When the gloaming comes
Signed and dated 1912, 22½in by 30¼in
Edinburgh £5,000 ($11,500). 25.II.75
From the collection of Mrs R. M. Taylor

SIR EDWARD COLEY BURNE-JONES, Bt
Wise and foolish virgins
Pen and ink, executed in 1859, 18¼in by 24in
London £10,000 ($23,000). 5.XI.74

ALBERT JOSEPH MOORE
The reader
Canvas mounted on masonite, signed with
anthemion, 34in by 12in
New York $8,500 (£3,696). 4.VI.75
From the collection of Dr Rudolf Knickenburg

SIR EDWARD COLEY BURNE-JONES, Bt
Portrait of Cecily Horner
Painted *circa* 1895, 28½in by 17¼in
London £5,000 ($11,500). 1.VII.75

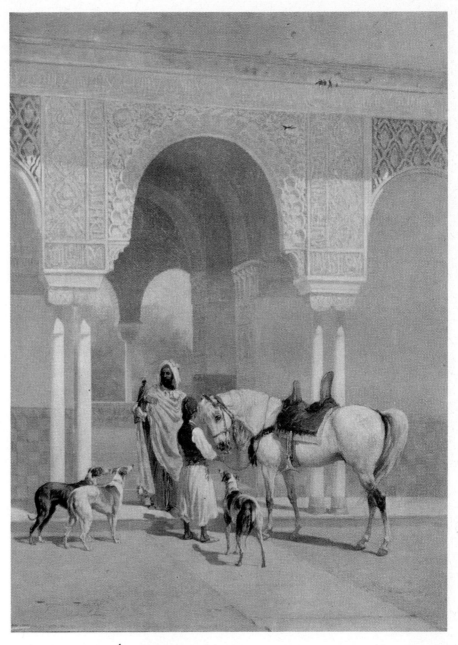

HEYWOOD HARDY and JOHN VARLEY, Jnr
Falconers
On panel, signed by both artists and dated 1887, 25½in by 19in
London £7,800 ($17,940). 1.VII.75
From the collection of P. Rice Stringer

JOSEPH EDWARD SOUTHALL
Man with a sable pencil, portrait of the artist
Tempera, signed with monogram and dated 1896,
16½in by 8in
London £1,700 ($3,910). 5.XI.74
From the collection of Mrs Elizabeth Baker
In 1878, as a result of studying Ruskin, Southall left the
Birmingham firm of architects to which he had been
attached and spent eight weeks in Italy where he studied
fresco and Italian primitive painting. Six years later he was
assisting William Blake Richmond and it was about that
time that he met Burne-Jones who insisted that this self-
portrait be accepted by the New Gallery, 1897. Southall
was a leading member of the Birmingham group and a
founding member of the Tempera Society in 1900

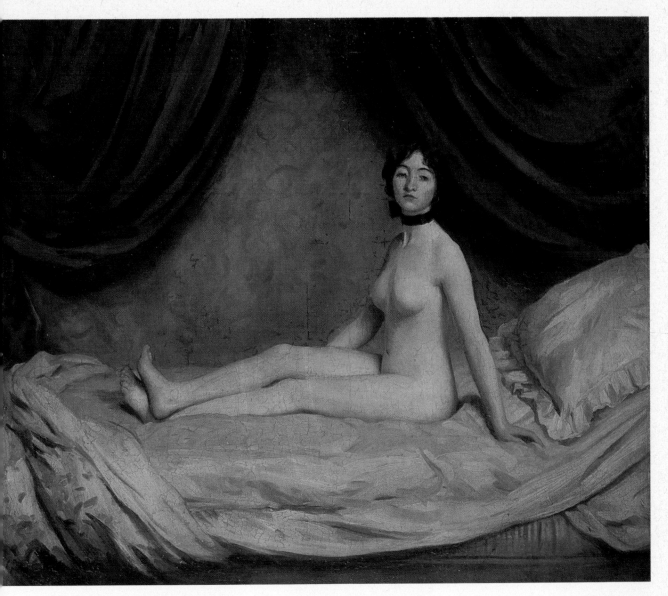

PHILIP WILSON STEER, OM
Nude seated on a bed
Signed and dated 1896, 36in by 42in
London £4,000 ($9,200). 25.VI.75
From the collection of the late Lord Ilford of Bury, MC, TD, QC

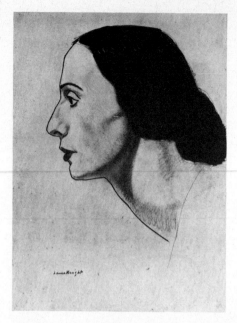

Left
DAME LAURA KNIGHT, DBE
Goliath
One of a pair, black chalk,
both signed, one inscribed,
each 14½in by 10½in
London £90 ($207).
6.XI.74

Right
DAME LAURA KNIGHT, DBE
*Portrait study of Anna
Pavlova*
Pen and indian ink, black
chalk and watercolour,
signed, 14in by 10¼in
London £140 ($322).
6.XI.74

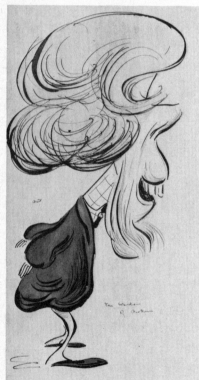

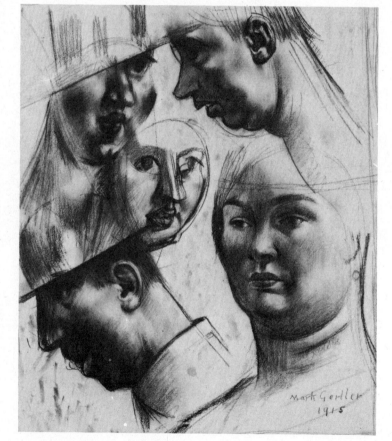

SIR MAX BEERBOHM
*The Warden of Merton, the Hon G. C.
Brodrick*
Pen and indian ink and coloured wash,
heightened with bodycolour, signed and
inscribed, 11½in by 6¼in
London £150 ($345). 12.III.75

MARK GERTLER
Studies for heads in the merry-go-round
Pencil and red chalk, signed and dated 1915, 18in by 15¾in
London £580 ($1,334). 25.VI.75

AUGUSTUS JOHN, OM
Dorelia with skirt over arm
Pencil on buff paper, signed, 14½in by 7⅝in
London £1,600 ($3,680). 25.VI.75
From the collection of the late Captain Edward Molyneux

Above right
GWEN JOHN
Petite fille (à la lampe)
Black chalk, inscribed and dated *Dec. 10. 28.*, on the reverse
of the mount, 9¼in by 8¼in
London £260 ($598). 25.VI.75

GWEN JOHN
Madamoiselle Pouvereau
Black chalk and watercolour heightened
with bodycolour, inscribed and dated
Dec. 31-38 on the reverse of the mount,
6⅞in by 5⅛in
London £450 ($1,035). 25.VI.75

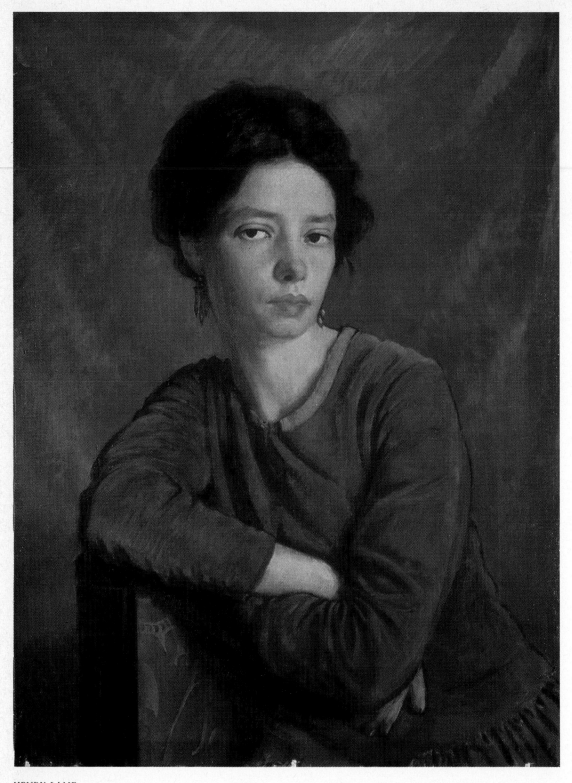

HENRY LAMB
Purple and gold, a portrait of Edie McNeill
signed and inscribed on the reverse, also with the artist's address *19 Fitzroy St., W.C.,* 24in by 19¼in
London £2,900 ($6,670). 25.VI.75
From the collection of the late Lord Ilford of Bury, MC, TD, QC

WALTER RICHARD SICKERT
The haunted house, Dieppe
Signed, *circa* 1898, 21½in by 18in
London £6,000 ($13,800). 20.XI.74
From the collection of the Cottesloe Trustees

SIR STANLEY SPENCER
Swiss souvenir
A triptych, commissioned in 1933; two panels 41¾in by 30in, the centre panel 41¾in by 66in
London £8,200 ($18,860). 20.XI.74
From the collection of Mr and Mrs J. O. Stanley-Clarke

PAUL NASH
Hill 60
Pencil, pen and ink, coloured chalk and watercolour, signed and dated 1917, 16¼in by 19in
London £2,200 ($5,060). 20.XI.74
From the collection of Mrs M. Bernard

Above
DAVID JONES, CH
Helen's Gate, Dockray
Pencil and watercolour
heightened with white,
signed and dated '46,
19¼in by 23½in
London £1,550 ($3,565).
12.III.75
From the collection of the
Very Reverend the Dean
of Chichester

BEN NICHOLSON, OM
Still life, 1928
Canvas mounted on
board, signed and dated
on the reverse,
16in by 22in
London £4,700 ($10,810).
25.VI.75
From the collection of
S. Nicholson Graves

LUCIAN FREUD
Scillonian beachscape,
Painted 1945–1946, 19½in by 29½in
London £9,000 ($20,700). 20.XI.74

BEN NICHOLSON, OM
Galileo, February, 1961
Oil and pencil on carved board, signed, inscribed and dated on the reverse, 27in by 33½in
London £14,000 ($32,200). 20.XI.74
From the collection of D. Gebhard

ISAAK OUWATER
The Mint Tower, Amsterdam
Signed and dated 1778, 15½in by 20in
London £19,000 ($43,700). 11.VI.75
From the collection of the late Lord Ilford of Bury, MC, TD, QC

JACOB HENRICUS MARIS
A Dutch riverside town
Signed, 42in by 39½in
London £5,500 ($12,650). 26.II.75
From the collection of Miss Alexa Scott-Plummer

MICHAEL CHRISTOPH GREGOROVIUS
The langemarkt in Danzig
Signed, dated 1818 on the reverse, 24½in by 19in
London £3,500 ($8,050). 16.X.74

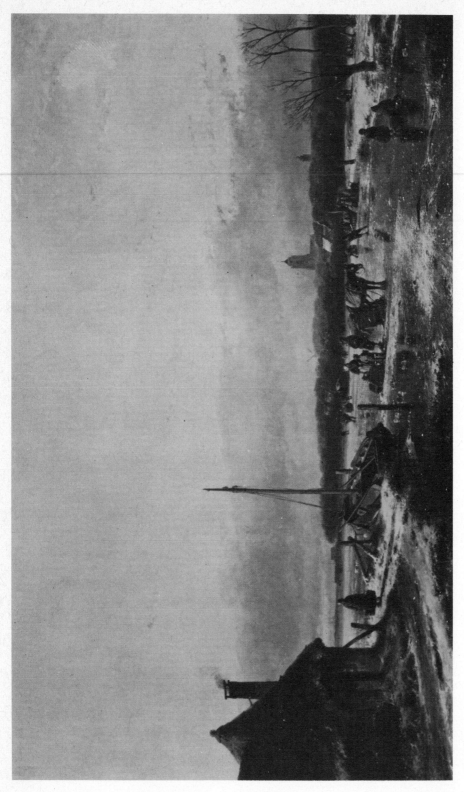

ANDREAS SCHELFHOUT
A frozen landscape
Signed and dated 1880, $21\frac{3}{4}$in by $36\frac{1}{4}$in
Amsterdam Fl88,000 (£16,000 : $36,800). 4.III.75

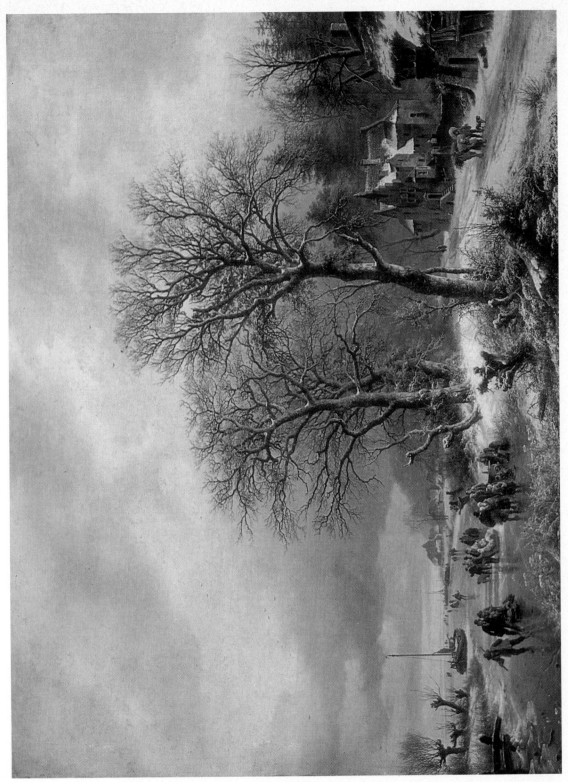

BAREND CORNELIS KOEKKOEK
The end of winter
Signed and dated 1848, on panel, 31in by 41in
London £30,000 ($69,000). 11.VI.75

CARL SPITZWEG
The night visitor
on panel, 10¼in by 6¼in
London £12,000 ($27,600). 26.II.75

Below
ALBERT ANKER
The sleeping child
Signed and dated 1879, 26¼in by 30¾in
New York $28,000 (£12,174). 4.VI.75

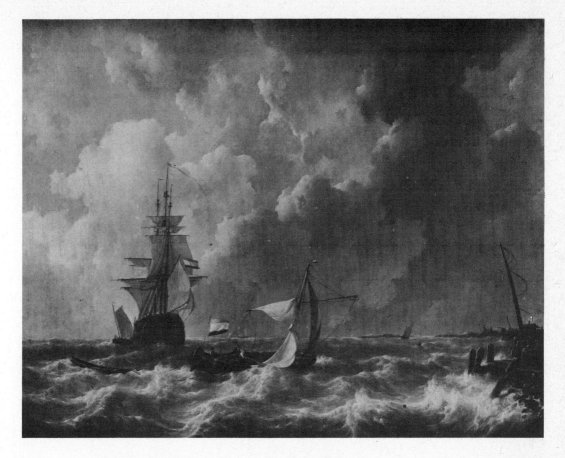

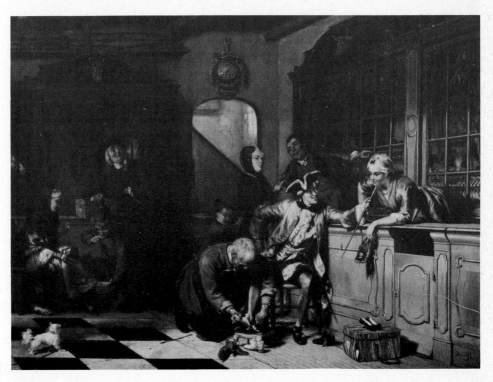

Above
JOHANNES CHRISTIAN
SCHOTEL
A seascape
Signed, 25½in by 32½in
Amsterdam Fl 22,500
(£4,054: $9,324). 3.XII.74

DAVID JOSEPH BLES
A shoemaker's shop
Signed and dated 1859,
16¾in by 23in
Amsterdam Fl 31,000
(£5,585: $12,845). 3.III.75

FRANCESCO PAOLO
MICHETTI
A misty morning
Signed and dated '73,
30¾in by 38¼in
New York $13,000
(£5,652). 16.1.75

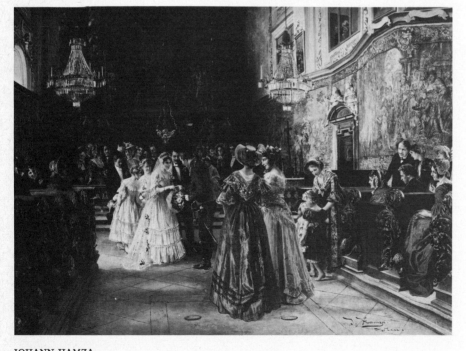

JOHANN HAMZA
The wedding (illustrated) and *The christening*
A pair, on panel, signed and inscribed *Wien*, each 16¼in by 23¾in
New York $26,000 (£11,304). 9.x.74

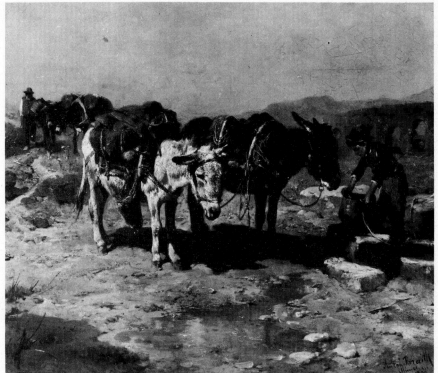

ANTON BRAITH
A boy watering two mules
Signed and dated *Munchen*
1896, 23¾in by 29½in
New York $11,500
(£5,000). 16.1.75
From the collection of
Dr David Marcus

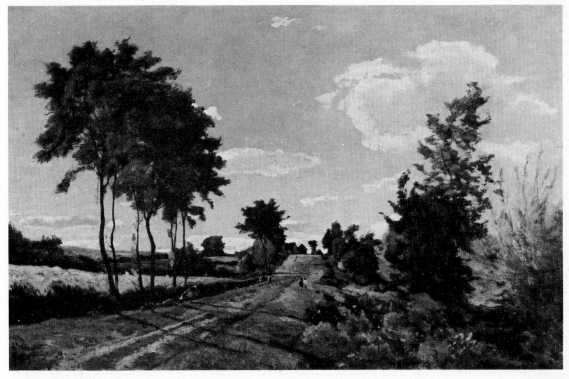

HENRI JOSEPH HARPIGNIES
Old road at Fargian near St Prive
Signed and dated *'86*, 19¾in by 32¼in
New York $17,000 (£7,391). 16.1.75
From the collection of Mr and Mrs Donald E. Battey Jr

CORNELIUS KRIEGHOFF
Coming down the rapids
Signed, titled on the
backing, 14in by 21in
Toronto $29,000
(£12,609). 21.X.74

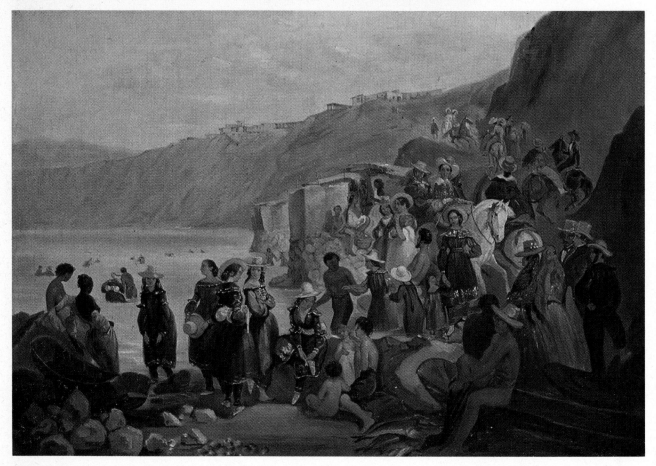

JOHANN MAURITZ RUGENDAS
A bathing-place on the coast of Peru
19¼in by 28in
London £3,100 ($7,130). 28.IV.75

M. EMILY CARR
Near Langford, British Columbia
Signed, titled on the reverse, 27in by 40in
Toronto $30,000 (£13,043). 21.X.74

LAWREN STEWART HARRIS
Lake Superior, painting IX, 1923
Signed, titled on the stretcher, 40in by 50in
Toronto $45,000 (£19,565). 21.X.74

WILLIAM CHARLES PIGUENIT
Break o'day plains, Tasmania
Signed, titled on the stretcher, 30in by 50in
London £4,800 ($11,040). 12.XI.74

CHARLES MARION RUSSELL
The hunting party
Watercolour, signed, 20¾in by 33½in
London £8,800 ($20,240). 12.XI.74

CORNELIUS KRIEGHOFF
Royal mail sleigh
Signed, 10¼in by 14in
London £7,000 ($16,100). 28.IV.75

ALFRED JOSEPH CASSON
The white village
On masonite, signed, 34in by 45in
New York PB84 $20,500 (£8,913). 28.I.75

Left
THOMAS BAINES, FRGS
*Portrait of Roualeyn Gordon
Cummings of Altyre*
Signed, 14½in by 12in
Johannesburg R7,000 (£4,516).
15.IX.73

Below
THOMAS BAINES, FRGS
Eildon Cleugh
Inscribed with the title and
signature *T. Baines, Grahamstown,
Febr. 10, 1849.*, 19¾in by 29¾in
Johannesburg R8,000 (£5,161).
21.X.74
From the collection of Mrs E. R.
Russell, née Pringle

A Centenary tribute
to Thomas Baines

Frank R. Bradlow

When Thomas Baines died unromantically one hundred years ago, few newspapers in his adopted country South Africa, took notice of his death. The exceptions were the *Eastern Province Herald* in Port Elizabeth, and the *Natal Mercury* in Durban, where he died penniless. The *Mercury* paid tribute to him only as a traveller and explorer, and 'as a brave and able and distinguished and single-hearted man', not as an artist.

Within the last thirty years, and especially in the last five, Baines has acquired belated recognition as an artist of considerable merit whose pictures have, in addition, an abiding historic and topographic value. In the past he was regarded solely as a pictorial journalist and topographical recorder, but recently his works have become sought after not only as collectable Africana, but as desirable works of art.

In the early nineteenth century the artists who recorded the local South African landscape were predominantly British. Some were itinerant painters like Samuel Daniell (1775-1811) and George French Angas (1822-86); others like Thomas William Bowler (1812-69) and Thomas Baines, made South Africa their home. After Bowler, Baines is the best known of these artists.

To a large extent Baines was a narrative painter, his paintings and drawings relating to incidents he witnessed, and to scenes and people that interested him. In his journal he wrote 'the better years of my life having been passed in Africa, it is on the scenes there witnessed my memory loves to dwell.' Like Constable, he annotated his works with amazing detail giving such information as time, date and place, and even in his more studied oils, the length of time that elapsed between his making the preliminary sketch and the finished painting. In view of this narrative element in Baines's works, it is instructive to know about the background and life-experience of this colourful personality.

Baines was a prodigious figure with an overwhelming zest for life. He was several men embodied in one: a prolific artist, an inspiring writer, an adventurous explorer, a naturalist, and above all, a likeable and engaging human being. His world, as depicted in his pictures and writings, was a boundless one – a world, often of radiant beauty, and always of inexhaustible interest. It is the recognition of these qualities, so easily discernible in his work, that has given Baines the important position he now occupies in South African art.

In November 1842, on his twenty-second birthday, Thomas Baines arrived in Cape Town where he was to spend the next six years. We do not know why he went to the Cape, only that he had spent the previous five years in King's Lynn, his birthplace, serving apprenticeship as an 'ornamental painter' – probably a signwriter. In Cape Town he started work as a coach

painter and, using the paints available in his daily work, he commenced making early canvasses of Cape life and scenery. Later, he was persuaded by his friend Frederick Logier, organist at St George's Cathedral, to become a professional artist.

In February 1848, inspired by a fellow painter, George French Angas, he commenced his travels and moved to Grahamstown. During the next few years, using Grahamstown as his base, he made three long and arduous trips. He spent three months travelling to the Orange River, near Colesberg, with the Liddle brothers, and subsequently made a solo trip by horseback and foot from Grahamstown to the mouth of the Kei River. Later, he went as far as Mooi Riviersdorp (now Potchefstroom), on the Vaal River, with Joseph McCabe, in an unsuccessful attempt to reach Lake Ngami. On his return to Grahamstown, during the eighth frontier war, Baines joined Major-General Henry Somerset's forces in the field, serving for six months as South Africa's first war artist.

This small man, only 5ft 4in and slightly built, proved to be an intrepid and hardy traveller. After the frontier war, when he was back in England, he joined A. C. Gregory's expedition to Northern Australia. For over two years, from May 1855 to September 1857, he was with Gregory exploring Northern Australia and undergoing feats of endurance which included a 700-mile journey in an open boat. Gregory named both a mountain and a river in Northern Australia after Baines. His next trip was with Livingstone to the Zambesi. It ended disastrously when Livingstone, who found it difficult to get on with white people, dismissed him on an unjust charge of theft. On his return to Cape Town he joined James Chapman on a journey from Walvis Bay, via Lake Ngami, to the Victoria Falls, becoming the third white man ever to see the Falls. In 1868, whilst on a further visit to England, he was asked by the South African Goldfields' Exploration Company to lead an expedition to Matabeleland to obtain concessions and to exploit the newly-found gold in, what is now, Rhodesia. Between 1869 and 1872 he made two trips to obtain Lobengula's goodwill. He died while planning a third.

Throughout this adventurous and active life, Baines had not neglected to paint, sketch and write. Nearly 4,000 oil paintings and drawings have been found by the writer to be still in existence, and he must, therefore, be regarded as the most prolific South African artist of his time. His paintings show him to have been both imaginative and creative, and on his death the *Eastern Province Herald*, rightly wrote, that 'as an artist and traveller, truth was his great characteristic. . . .' Although he described himself as a 'marine and portrait painter' few of the portraits he executed have come to light, apart from an excellent self-portrait and a lively portrait of Roualeyn Gordon Cummings, the famous game-hunter.

Baines's method of working was to make sketches on the spot, translate them immediately into watercolour, and ultimately, when he had the time, the materials and the will, to work them up into his rather studied oils. Sometimes, he had reluctantly to make copies of his own works for purchasers requiring a picture already sold by him. In his journal he complained 'no sooner had I struck out something new than half a dozen persons, not a little to my annoyance, demanded "an exact copy", which if I undertook it, was seen to be a failure.' Although Baines considered these copies to be failures, today it is difficult to tell which is the original and which is the duplicate!

Two early oils, *A South-Easter off the Cape*, painted in March 1849, and *Surf Boats off the Jetty Algoa Bay*, painted 1848 (sold Johannesburg, 1973, for R12,000), show his mastery of the seascape, and his knowledge of the sea which no doubt he acquired from his King's Lynn childhood. An early picture, *74 Going Free*, painted in 1846, and sold at the November 1971 Johannesburg sale for R2,100, also shows in his painting of the rigging an understanding of ships and a grasp of sailing technicalities.

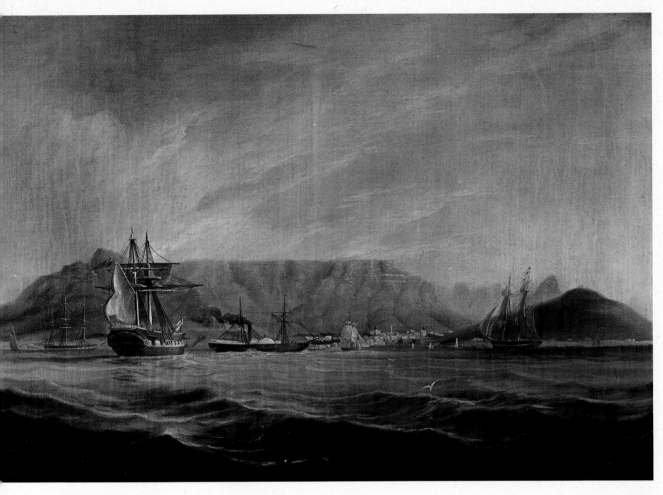

THOMAS BAINES, FRGS
Table Mountain and Bay
Signed and dated *Cape Town Dec 29, 18 . . .*, inscribed on reverse *Table Mountain and Bay T. Baines, Cape Town Dec. 29, 1846.*, 24¼in by 31½in
Johannesburg R18,500 (£11,935). 21.X.74

 In some of his later pictures, such as the *Eastern Cataracts of the Victoria Falls, Zambesi River from Garden Island*, which he sketched in 1862 and reworked in oils in 1869, he shows an imaginative and almost impressionistic use of colour very different from his earlier work. This picture was sold in October 1972 for R2,400. Three excellent examples of his lively landscape technique are the magnificent watercolour *Climbing the Heights of the Drakensberg*, sold in 1973 for R5,500, *Table Mountain and Bay*, a combined land and seascape and *Eildon Cleugh* (the residence of Mr R. Pringle) a picture which evokes the grandeur of the Eastern Cape Province.

 Thomas Baines left a rich artistic legacy: the centenary of his death having been commemorated by exhibitions in King's Lynn, Sydney, Johannesburg, Durban, Cape Town, Windhoek and Salisbury – all of which firmly establish his high artistic reputation. To judge by the present-day popularity of his work, Baines's expressed hope that 'some few at least may share a portion of the pleasure I have experienced during my wandering', has not been in vain.

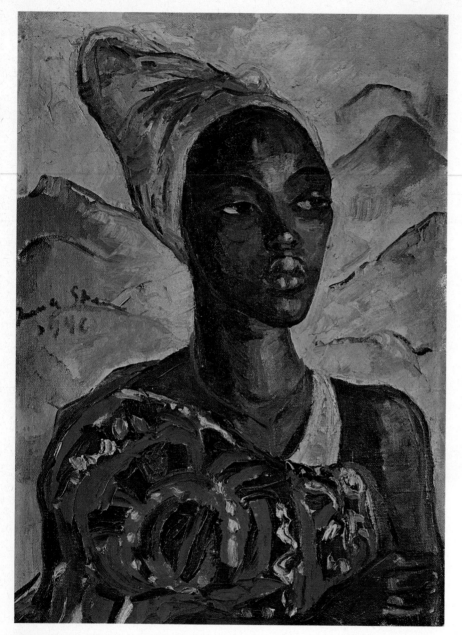

IRMA STERN
A Watussi woman
Signed and dated 1946, 27in by 19¼in
Johannesburg R10,000 (£6,452:$14,839). 22.X.74
From the collection of R. L. Worrall

JACOB HENDRIK PIERNEEF
Laeveld, Zoutpansberg
Signed and dated 1930, titled on the reverse, 31in by 43in
Johannesburg R9,000 (£5,806:$13,355). 22.X.74

WILLIAM T. RANNEY
On the wing
Signed *W. Ranney* and dated *1850*, 29¾in by 44¾in
New York $50,000 (£21,739). 17.IV.75
From the collection of the Kimbell Art Foundation

Although Ranney executed several versions of the subject, this painting is the only signed
example known.

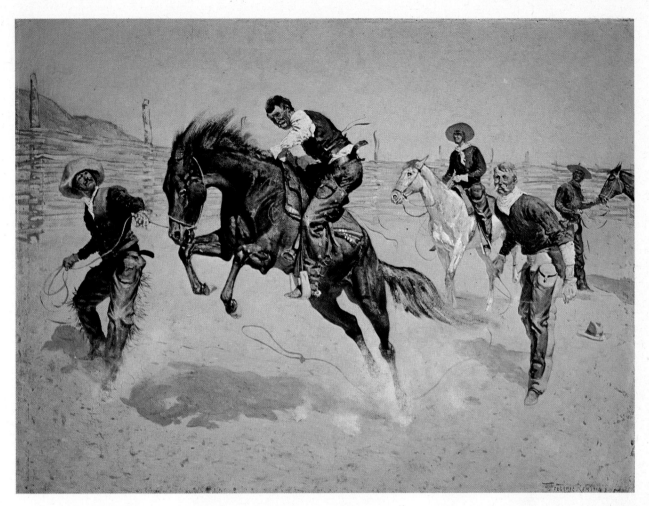

FREDERIC REMINGTON
Turn him loose, Bill
Signed *Frederic Remington*, 25in by 33in
New York $175,000 (£76,087). 16.X.74
From the collection of Mr and Mrs Kay Kimbell

Opposite above
JAMES G. TYLER
*The 'America' and the
'Coquette' at Storm King on
the Hudson*
Signed *J. G. Tyler* and
dated *1880*, 42in by 72¼in
New York $17,000
(£7,391). 17.IV.75

The *America* was built in
Brooklyn in 1852 for
towing barges between
New York and Albany

THOMAS MORAN
Grand Canyon
Signed *T. Moran* and inscribed *Copyright 1904 by T. Moran*, 40¼in by 30in
New York $55,000 (£23,913). 16.X.74

Opposite below
WILLIAM M. HARNETT
Eleme figs and newspaper
Signed *W. M. Harnett* and dated *1876*, also inscribed *Sold to Mr. Gilbert/Grand Rapids/
Michigan*, 20in by 28in
New York $22,000 (£9,565). 16.X.74

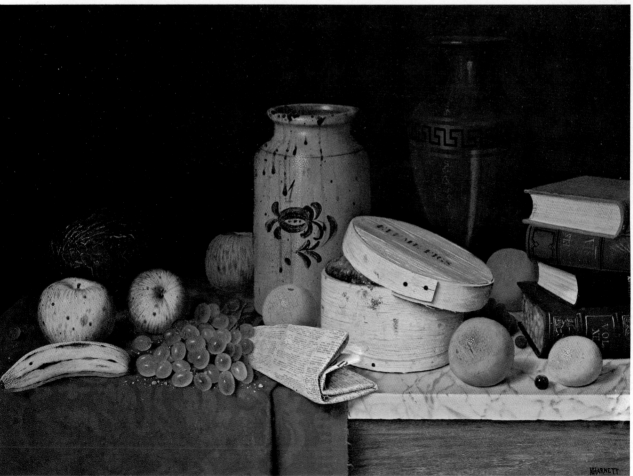

ARTHUR G. DOVE
Anchorage
Signed *Dove*, also titled and dated 1937 on the reverse, 10in by 14in
New York $18,500 (£8,043). 17.IV.75

GEORGIA O'KEEFFE
Tree with cut limb
Inscribed *OK* in star on the backing; also inscribed by Alfred Stieglitz, *Tree with Cut Limb by
Georgia O'Keeffe 509 Madison Ave (Room 1710) A.S.*, painted in 1920, 20in by 17in
New York $18,000 (£7,826). 17.IV.75

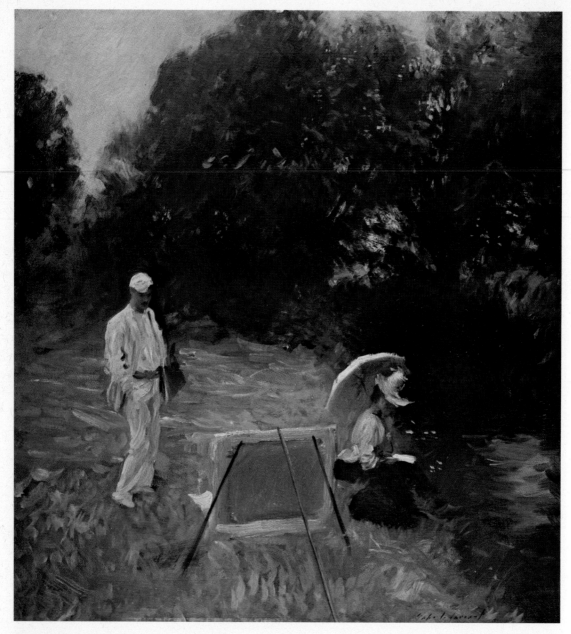

JOHN SINGER SARGENT
The artist – Dennis Bunker painted at Calcott
Signed *John S. Sargent*, 27in by 25in
New York $60,000 (£26,087). 16.x.74
From the collection of the late Eugenie S. Breed

This painting was executed during the summer of 1888 when Dennis Miller Bunker was
visiting the Sargent family at Calcott Hill, Reading, England. The young woman in the
picture is Sargent's younger sister, Violet

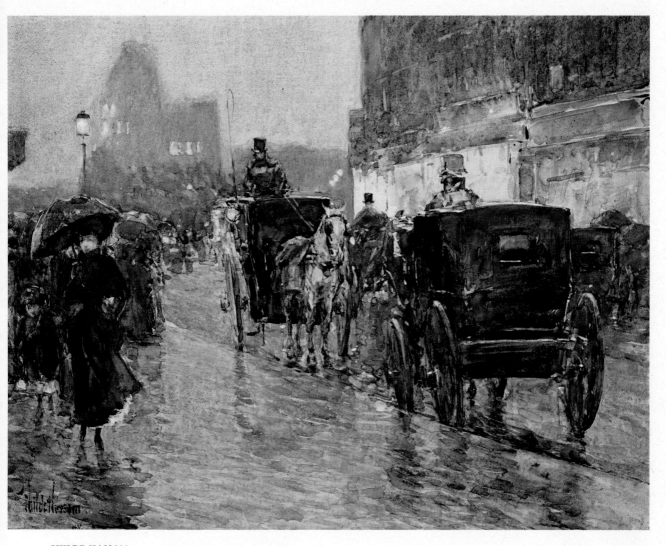

CHILDE HASSAM
Horse drawn cabs at evening
Signed *Childe Hassam* and inscribed *N.Y.*, watercolour, 13½in by 17¾in
New York $28,000 (£12,174). 16.X.74

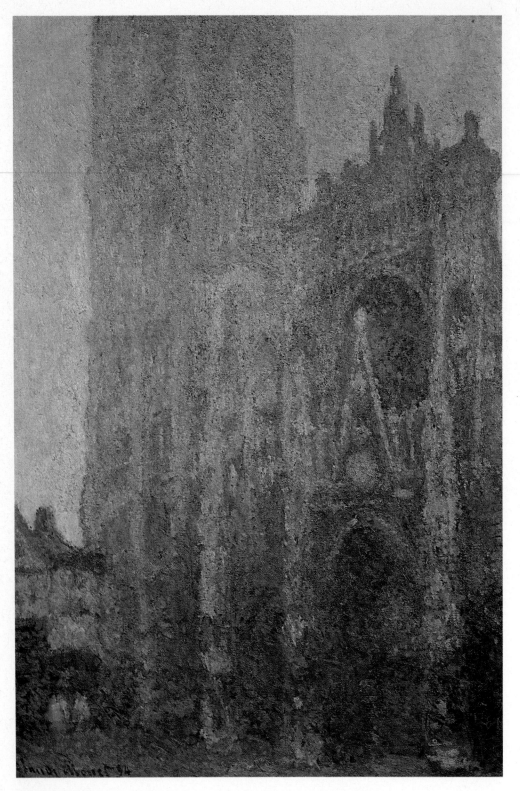

CLAUDE MONET
La Cathédrale de Rouen, la Tour d'Albane, le matin
Signed and dated '94, 41¾in by 29in
London £210,000 ($483,000). 1.VII.75

The Impressionist and Modern paintings sold on 1 July 1975 were collected by a Parisian family
between 1900 and 1968

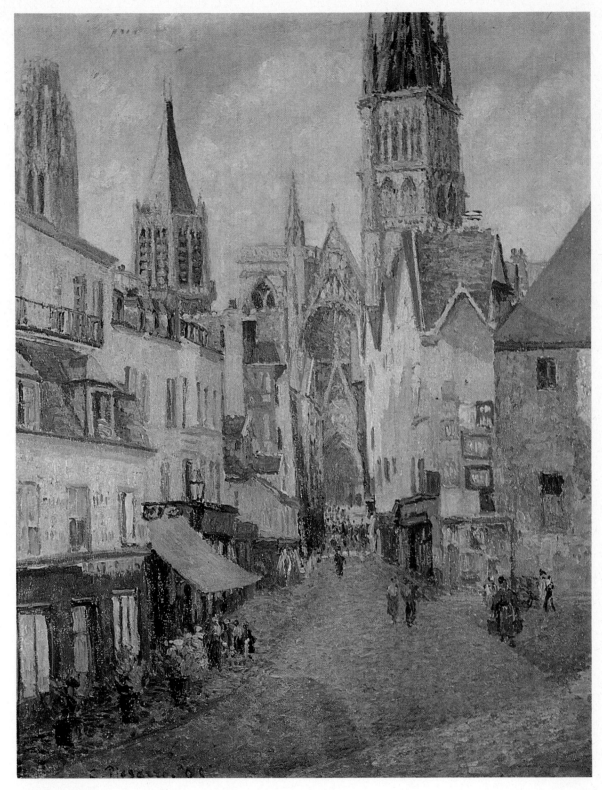

CAMILLE PISSARRO
Soleil, après–midi, la rue de l'Epicerie à Rouen
Signed and dated '98, 32in by 25½in
London £120,000 ($276,000). I.VII.75

HENRI FANTIN-LATOUR
Portrait de l'artiste
Signed and dated 1860, 14in by 11¼in
New York $26,000 (£11,304). 21.V.75

Opposite above
JOHAN BARTHOLD JONGKIND
Le Château de Nyon
Signed and dated 1875, 13½in by 18½in
London £26,000 ($59,800). 1.VII.75

Opposite below
EUGENE BOUDIN
Laveuses au bord de la Touques à Trouville
On panel, signed and dated *Trouville '84,* 10½in by 13½in
London £23,500 ($54,050). 1.VII.75

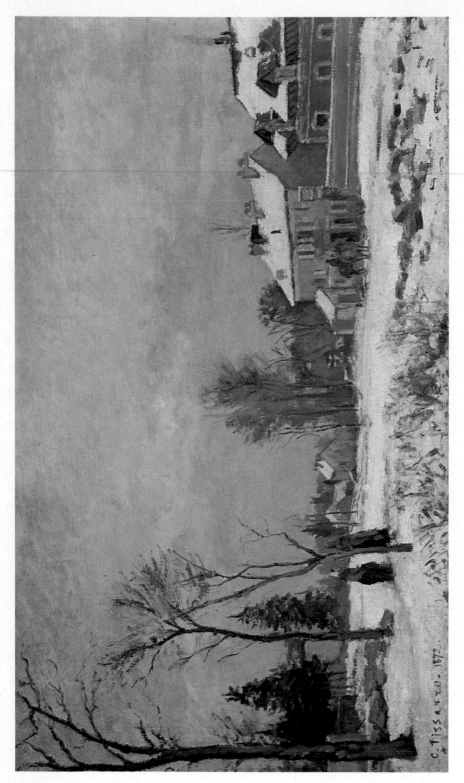

CAMILLE PISSARRO
La route de Versailles à Saint-Germain. Louveciennes, effet de neige
Signed and dated 1872, 21½in by 35¾in
London £90,000 ($207,000). 16.IV.75

CLAUDE MONET
Pommiers en fleur
Signed and dated '81, 31¼in by 39½in
London £65,000 ($149,500). 1.VII.75

CONSTANTIN GUYS
Cabriolet attelé à un cheval blanc
Pen and ink and watercolour, 12in by 17½in
London £3,200 ($7,360). 16.IV.75

JOHAN BARTHOLD JONGKIND
Le Port de Dordrecht
Watercolour and pencil, signed and dated *Dort. 5 Oct '67*, 11in by 17¾in
London £4,000 ($9,200). 4.XII.74

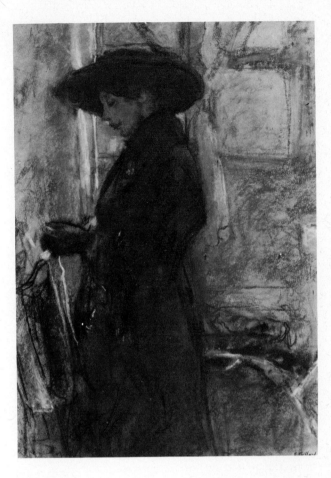

EDOUARD VUILLARD
Jeune femme à l'intérieur
Charcoal and pastel, stamped with the signature,
executed *circa* 1918, 25in by 18in
London £11,000 ($25,300). 4.XII.74
From the collection of the late Hon Lady Baillie

PIERRE–AUGUSTE RENOIR
Portrait de Mademoiselle Dieterle
Charcoal and pastel, signed with the initial, executed
circa 1902, 20¼in by 15¼in
London £19,000 ($43,700). 4.XII.74
From the collection of the late Hon Lady Baillie

EDGAR DEGAS
Deux danseuses
Stamped with the signature, painted *circa* 1891, 21½in by 15¾in
London £100,000 ($230,000). 1.VII.75

PIERRE BONNARD
Nature morte à la fenêtre ouverte, Trouville
Signed, painted *circa* 1934, 38¼in by 23½in
London £73,000 ($167,900). I.VII.75

PAUL CEZANNE
Sept baigneurs
14¾in by 18in, painted *circa* 1900
London £160,000 ($368,000). 2.VII.75

HENRI MATISSE
Vase de fleurs à Belle-Ile
Signed, painted in 1897, 18in by 15in
London £42,000 ($96,600). I.VII.75

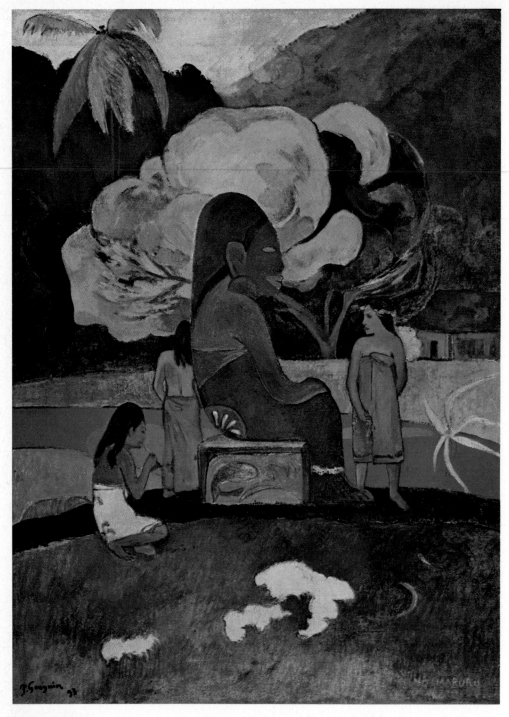

PAUL GAUGUIN
Hina Maruru
Signed, titled and dated '*93*, 36½in by 27½in
New York $950,000 (£413,043). 21.v.75
Formerly in the collection of Mrs Marius de Zayas, Greenwich, Connecticut. Sold at
Parke-Bernet on 14 October 1965 for $275,000 (£98,214)

Paul Gauguin: *Hina Maruru*

This work was painted during Gauguin's first trip to Tahiti from 1891 to 1893. It was in 1892 that Gauguin began to paint a series of works based upon themes from Tahitian legend and mythology. His sources were *Voyage aux Iles du Grand Océan* by Moerenhout (1837), and *Etat de la Société Tahitienne à l'Arivée des Européens* by Bovis (1855), from which he copied the most interesting passages into a notebook which he called *Ancien Culte Mahorie*.

The moon goddess Hina, who appears in a number of Gauguin's pictures painted in 1892 and 1893, was the only female divinity in Polynesia. She was believed to be the mother of all the gods and the mother of the human race. In his mind Gauguin formed a strong link between the goddess and Buddha. Although his portrayal of Hina is based purely on his imagination, as there is no other representation of her in the South Seas, Gauguin's idol appears to be derived from representations of Buddha, Easter Island figures and Egyptian sculpture.

In his partly autobiographical work, *Noa-Noa*, which he wrote in collaboration with Charles Morice during 1894 and 1895, Gauguin describes his vision:

'Leaving the track that runs beside the sea, I follow a narrow path through a thicket, which reaches quite far along the mountain, and find myself in a small valley, whose inhabitants still follow ancient Maori customs. They are content, untroubled people, dreaming, loving, sleeping, singing, praying; in my mind's eye, though not in reality, I can clearly see the statues of their female divinities; statues of Hina and feasts in honour of the moon goddess. The idol, carved from a solid block of stone, measures ten feet from shoulder to shoulder, and is forty feet high. On her head she bears an enormous reddish coloured stone, shaped like a cap and the worshippers dance around her according to the ancient rites of "matamua". The varying notes of the "vivo" sound clear and gay, then sad and dark, as the hours pass.'

ANDRE DERAIN
Arbre, paysage au bord d'une rivière
Signed and dated 1905, 23½in by 31¼in
London £77,000 ($177,100). I.VII.75

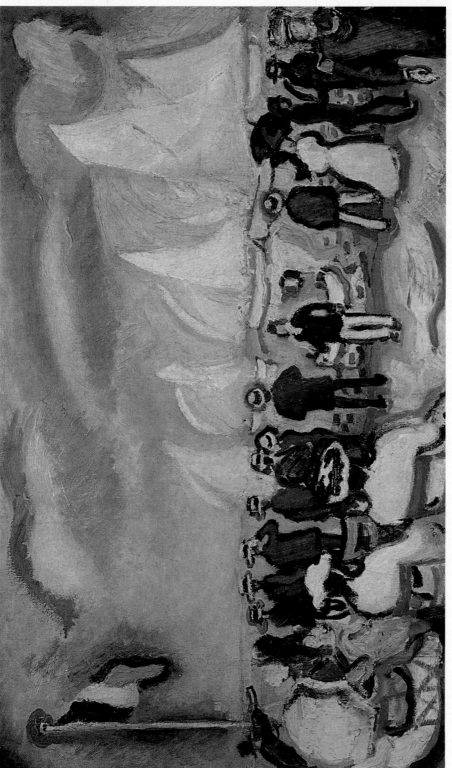

RAOUL DUFY
Les Régattes à Trouville
Signed, painted in 1907, 19¾in by 31½in
London £56,000 ($128,800). 1.VII.75

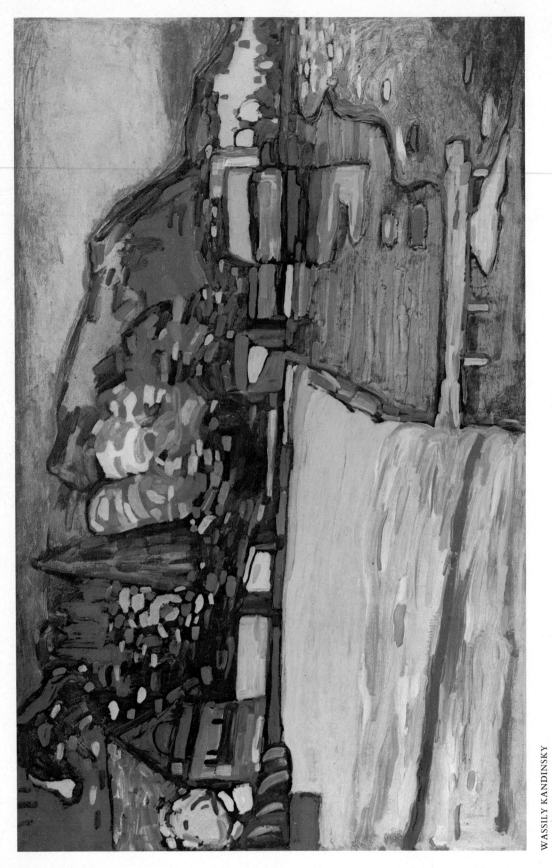

WASSILY KANDINSKY
Starnberger See II
On board laid down on panel, painted in 1908, 24¼in by 38¼in
London £89,000 ($204,700). 1.VII.75

MAURICE DE VLAMINCK
La Seine à Bougival
Signed, painted in 1906, 23¼in by 31¾in
London £101,000 ($232,300). 1.VII.75

EGON SCHIELE
Liebespaar
Gouache and pencil, signed, titled and dated 1913, 18in by 12½in
London £24,000 ($55,200). 4.XII.74

PIET MONDRIAN
Red Amaryllis
Watercolour, signed with the monogram, 15½in by 18½in
New York $26,000 (£11,304). 23.X.75

LEON BAKST — *Schéhèrazade*
Design for the décor
Watercolour, pencil and gold paint, signed, 29in by 40¼in
London £13,000 ($29,900). 5.VI.75
From the collection of the late Baroness von Wrangell

JEAN COCTEAU
Igor Stravinsky
Pen and brush and indian ink heightened with white gouache, signed, inscribed
and dated 1913, 18in by 11in
London £2,200 ($5,060). 5.VI.75

PAVEL TCHELITCHEW
*Design for the cover of the programme for the 21st Paris Season of
Diaghilew's Russian Ballet*
Pencil and gouache, signed and dated '28, 12½in by 9¾in
London £2,200 ($5,060). 5.VI.75

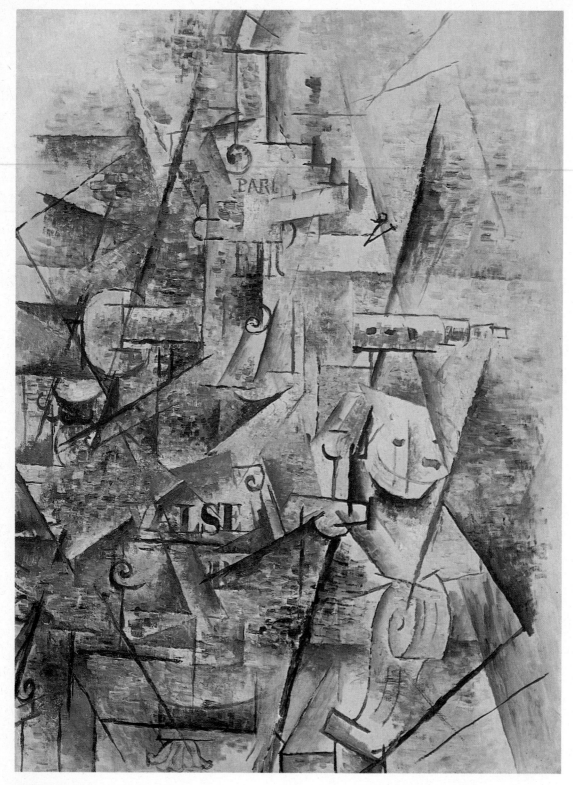

GEORGES BRAQUE
Clarinette et bouteille de rhum sur une cheminée
Signed and inscribed *Ceret* on the reverse, painted in 1911, 31½in by 23¼in
London £240,000 ($552,000). 4.XII.74
Formerly in the collection of Le Corbusier
Sold at the Palais Galliera, Paris, 10 June 1970, for Fr 1,260,000 (£94,500: $226,800)

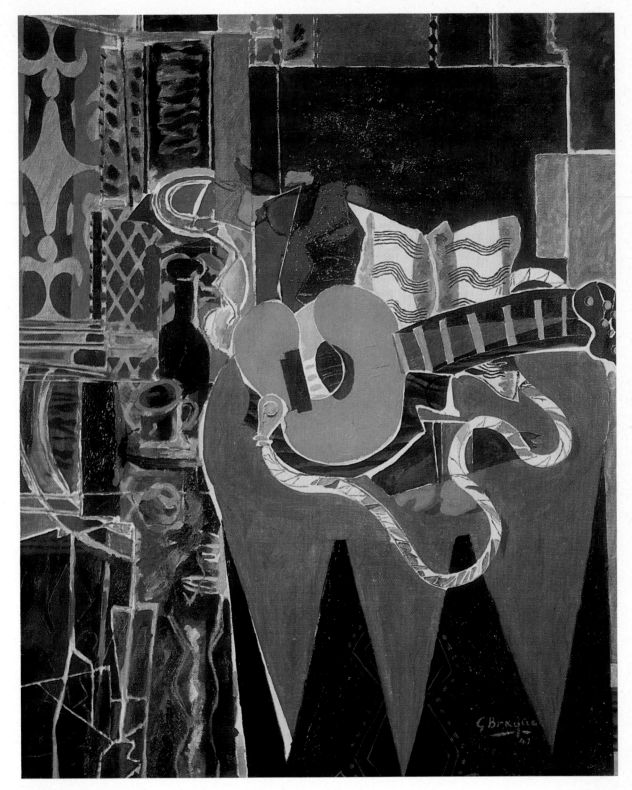

GEORGES BRAQUE
Mandoline à la partition
Signed and dated '41, 42½in by 35in
London £170,000 ($391,000). 1.VII.75

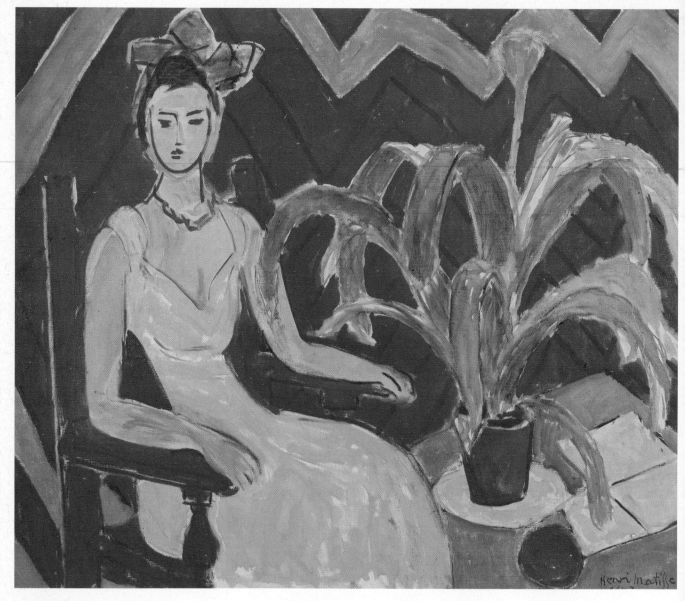

HENRI MATISSE
Michaela
Signed and dated *1/43*, 24½in by 29in
New York $240,000 (£104,347). 23.X.74
From the collection of Mrs Maurice Newton

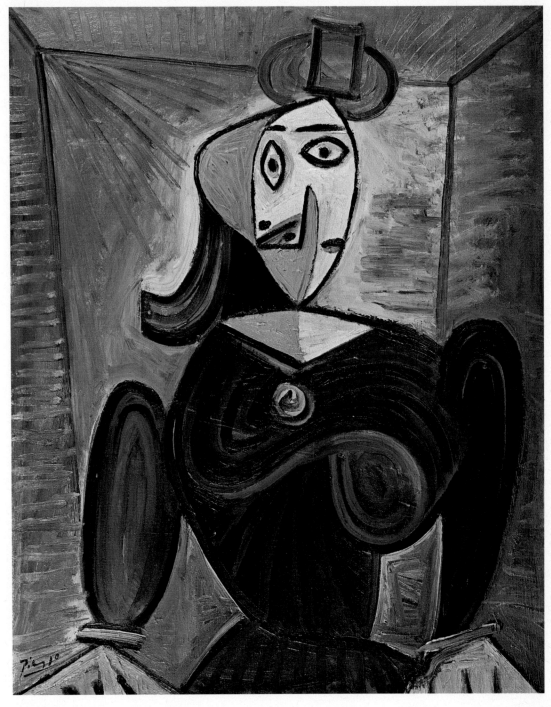

PABLO PICASSO
Portrait
Signed, painted on 4 November 1941, 31¾in by 25½in
New York $200,000 (£86,956). 21.V.75

MAX ERNST
La forêt
Oil and frottage on canvas, signed and dated '25, 45½in by 28½in
New York $120,000 (£52,174). 21.V.75
From the Phillips Collection, Washington, DC

ALBERTO GIACOMETTI
La trace des heures
Painted plaster and metal rods, executed in 1930, height 24¾in
London £23,500 ($54,050). 2.VII.75
Purchased by the Tate Gallery, London

Fig 8 *Seated female nude*, drawing from the life in black oil and chalk on paper, 1929, signed,
21¼in by 14½in
London £8,200 ($18,860). 12.III.75

Henry Moore:
the Formative Years, 1925-35

Robert Melville

In 1925, at the age of twenty-seven, Henry Moore spent six months abroad on a Royal College of Art travelling scholarship. The award specified Italy as the country to be visited, and after one week in Paris, he went first to Genoa, then to Pisa, Siena, Rome, Assisi, Florence, Ravenna, Padua and Venice. During his short stay in Paris there would seem to have been no important contemporary artists exhibiting, but in a letter he wrote from Italy to Sir William Rothenstein he mentioned that he was impressed by the Indian sculpture at the Guimet Museum. Boldly, he went on to tell Sir William of his unresponsiveness to the sculpture of the Italian Renaissance.

'Of great sculpture I've seen very little – Giotto's painting is the finest sculpture I met in Italy – What I know of Indian, Egyptian and Mexican sculpture completely overshadows Renaissance sculpture – except for the early Italian portrait busts, the very late work of Michelangelo and the work of Donatello – though in the influence of Donatello I think I see the beginning of the end – Donatello was a modeller, and it seems to me that it is modelling that has sapped the manhood out of Western sculpture. . . .'

It is a forthright statement, filled with the necessary extremism of a young sculptor determined to make a powerful contribution to the art of his time. However, it does not exaggerate his view, for in the light of the work he produced during what is usually called his formative period (the ten years from 1925 to 1935 in which he created some of his finest carvings), the letter can be seen as a declaration of intent. Although it has since been dismissed as the travel-weary reactions of a young man anxious to get back to England, I nevertheless reject the implication that Moore's carvings were influenced as much by his Italian journey as by his countless visits to the British Museum, from 1921 onwards, to marvel at the pre-historic, archaic and 'primitive' works in its collection.

In the catalogue of the Tate Gallery Retrospective in 1968, it was pointed out that the reclining figure is a European theme, rarely used in the alien cultures whose carving was already influential in the sometimes deliberately brutalistic work Moore produced before he made the Italian trip. It is true that he did not start to carve reclining figures until he returned from Italy, but it is surprising that in the catalogue a stone sculpture of a reclining figure carved by Moore in 1927 was described as 'academically classical'. The block has been scooped into hills and valleys signifying woman, but the figure has not fully emerged as representation, and the emphasis is on what Moore himself has called the 'stoniness' of stone.

Fig 1 The *Chac Mool:* a pre-Columbian reclining male figure

It was executed *before* he saw the photograph of the pre-Columbian reclining male figure from Chichén Itzá, a rain spirit (*Chac Mool*) of the Toltec-Maya culture in Yucatan, which was to affect his approach to recumbency and to turn repose into a dynamic activity (Fig 1). If it looks less belligerently anti-classical than the boulder-like mother-and-child sculptures he had carved before he went to Italy, it is because his regard for the sculpture of ancient cultures no longer carried atavistic overtones. (His 1922 *Mother and child*, a small work conceived in terms of vast bulk, looks as if it celebrates the birth of a child to the prehistoric fertility image known as the Willendorf 'Venus'.)

Lord Clark, in his recent book on Henry Moore's drawings, has noted that 'Cycladic and Negro art were as remote from his sense of form as was the sculpture of Brancusi', but I believe that earlier writings on Moore have not exaggerated the influence of ancient and tribal sculpture on his work. It is not without interest, for instance, that the British Museum has paid Moore the rare compliment of exhibiting some of his carvings beside its small, priceless collection of Cycladic figurines (*circa* 2000 BC). And one has only to think of his superb *Mother and child* in alabaster (1930) (Fig 2), or his boxwood *Girl* (1932), in relation to the famous Cycladic *Lyre player* in the National Museum of Greece, to realise that Moore's feeling for shape included a distinct admiration for the snakily sleek tubularities of the Cycladic piece. However, no one would think of suggesting that these two masterly works by Moore are in any way derivative.

There are two very early works by Moore which definitely show some dependence on the forms of African sculpture, and these are his initial exercises in the art of collaborating with wood (*Head of a girl* (1922), and *Standing woman* (1923)). Always sensitive to the material with which he was working, and convinced that it should never lose its identity in imitation, perhaps the most important lesson of tribal sculpture for Moore was that the stylised form disengaged the figures from human appearance to give them authority as messengers from the spirit world. Moore has persistently invented shapes which, over and above their formal assurance and aesthetic appeal, have an animistic significance. He was never particularly interested in the magical or religious cults which great sculpture of the past has served, but neither has he thought of his own creations as art for art's sake.

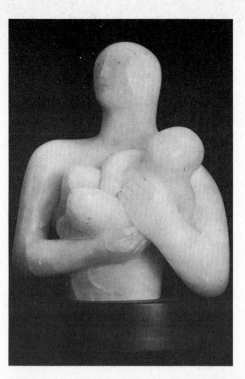

Fig 2 *Mother and child,* 1930, alabaster, height
11½in including base
London £23,500 ($54,050). 20.XI.74

Fig 3 *Reclining figure,* 1929, brown Hornton
stone, length 33in (in Leeds City Art Gallery).
This is one of a series of reclining figures carved
by Moore after he had seen a photograph of the
Chac Mool

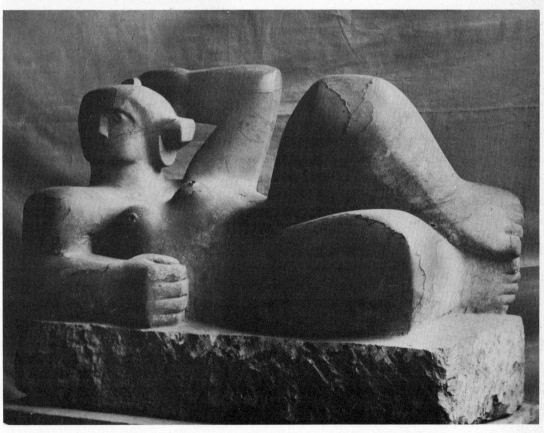

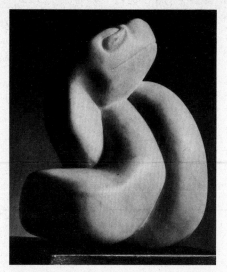

Fig 4 Marble snake carving, 1924, height 6in

Before Brancusi turned to the egg for inspiration, he made a number of fine wood-carvings which, nevertheless, look more like the work of an African tribesman than anything Moore has done. In the text of a broadcast published in *The Listener* in 1937, Moore stated his sense of the importance of Brancusi very plainly, and also made it clear why he condemned the academic sculptors who turned Donatello's knowledge of anatomy into a tyranny and caused European sculpture to be judged, not as an art, but as an exact science of bodily structure.

'Since the Gothic,' he said, 'European sculpture had become overgrown with all sorts of surface excrescences which completely concealed shape. It has been Brancusi's special mission to get rid of this overgrowth, and to make us once more shape-conscious. To do this he has had to concentrate on very simple direct shapes, to keep his sculpture, as it were, one-cylindered, to refine and polish a single shape to a degree almost too precious. . . .'

(Moore's own little marble snake carving (Fig 4), with its dangerous flat head rising from the smooth, tight knot of its body, could itself have been hatched out of one of Brancusi's eggs, under the warmth of a Mexican sun.) Moore went on to say in his broadcast: 'We can now begin to open out. To relate and combine together several forms of varied sizes, sections and directions into one organic whole,' and this is precisely what he had already done in the first great series of reclining figures, for which the original inspiration had been the photograph of the *Chac Mool*. It was not the example of the Gothic that broke the tyranny of academic sculpture. As in the art of Brancusi, Moore's heightened consciousness of shape was nourished by the sculpture of alien cultures.

In 1931 his combination of forms underwent a radical transformation, achieved by fitting together two distinctly unrelated shapes in a way which involved them in a subtle interchange of sustenance and support, as inextricably interdependent as a tortoise and its shell (Fig 5). By 1933, Moore was putting two or more biomorphic forms on to a wood or stone base without joining them, and sometimes keeping them a considerable distance apart. When two forms only are involved, one larger than the other, they seem to relate to the mother and child theme. In an alabaster, *Head and ball* of 1934, and in *Two forms*, a wood carving of the same

year, the larger form assumes a kind of maternal watchfulness. While in *Two forms*, the larger biomorph looms over the other with a sombre protectiveness, the 'head', in the alabaster, allows the aspherical 'ball' to stray quite a distance away. Thus separated, it seems to act as a reminder of Moore's admiration for Indian sculpture. (At this point in his career, it is possible that one breast broken from a stone Apsaras in the Sun temple at Konarak, would have been closer to his conception of a sculptural entity than an entire figure by Donatello!)

An ebony three-piece carving of 1935 sustains the sense of a 'blood relationship' between the separate objects and introduces a 'father': the child remains an organic-looking ball. Paradoxically, the four separate objects grouped on a platform in *Composition* (1934), have become the dislocated parts of a single figure. There is no doubt that these signify the reclining posture as a somewhat similar arrangement in alabaster, also executed in 1934, is entitled *Four-piece composition: Reclining figure*: the main difference between the two being that the ball in the latter occupies a position that evidently relates to the female breast. In a further *Composition* (executed in reinforced concrete in 1934 and cast in bronze in 1961, Fig 6), it is not difficult to recognise the elements of the elmwood carving of a much more anthropomorphic figure executed two years later: the forms for the raised head and hole under

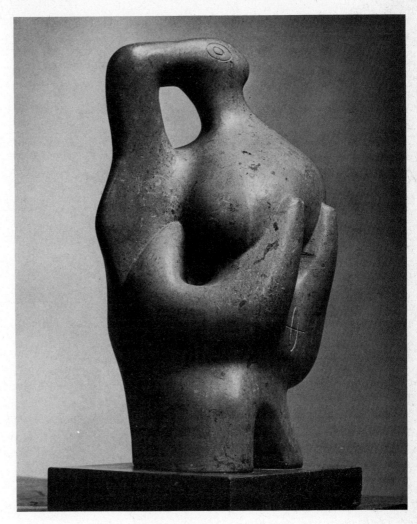

Fig 5 *Composition*, 1931, blue
Hornton stone, height 19in

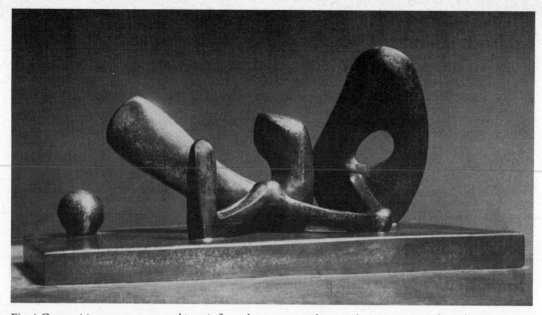

Fig 6 *Composition*, 1934, executed in reinforced concrete and cast in bronze in 1961, length 17½in

the breast, for the elbow and slightly inward curving back, and for the drawn-up knee of one leg are all there, and the bronze ball at the end of the platform becomes the tightly compressed embryo of the ankleless leg and toeless foot which terminate the elm figure (Fig 7).

During an interview with J. J. Sweeney, published in *Partisan Review* in 1946, Moore says that when he was at The Royal College of Art his aims as a 'student' were at odds with his taste in sculpture:

'For a considerable while after my discovery of the archaic sculpture in the British Museum there was a bitter struggle within me, on the one hand between the need to follow my course at college in order to get a teacher's diploma and, on the other, the desire to work freely at what appealed most to me in sculpture. . . . Finally, I hit on a sort of compromise arrangement: academic work during the term, and during the holidays a free rein to the interests I had developed in the British Museum.'

Drawing from the life was an important part of the curriculum, and the drawings of his student days indicate that he was an outstandingly skilful draughtsman: it was also an aspect of his academic studies that helped him to win his travelling scholarship to Italy. But after his return, his life drawings began to manifest that innate feeling for mass and weight that had drawn him to Mexican sculpture (and perhaps to Picasso's neo-classical giantesses), though these studies do not seem to relate to specific carvings of the early period.

When the British Museum arranged a Retrospective of Moore's drawings in connection with his illustrations for a book of Auden's poems, it included a remarkable example executed in 1927, which had not previously been exhibited. It is a study of a seated nude in which, to all intents and purposes, the model's supporting arm has become the subject. Her head and body are indicated only by a delicate linear tracery, outlining quite a slim figure,

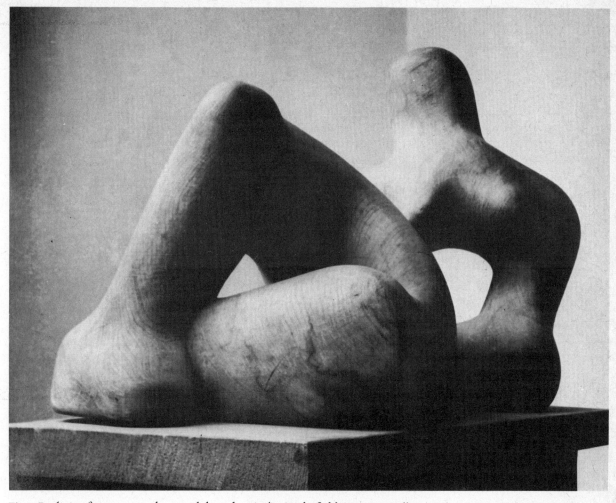

Fig 7 *Reclining figure,* 1936, elmwood, length 42in (in Wakefield City Art Gallery)

but the arm and the hand pressing down on an invisible support, create an illusion of such tremendous solidity that the image is that of a huge, free-standing biomorph. The effect is unique, and it is one of Moore's many studies of the nude executed between 1925 and 1929, which have no rivals in English art. The noble roundedness of *Seated female nude* (1929) (Fig 8) in black chalk and oil, shows why he thought of the figures in Giotto's paintings as the best 'sculpture' he had met in Italy.

The first of his famous sheets of 'ideas for sculpture' were in the 1928 'Underground Relief' sketchbook. Only some of the pages contain ideas for the big figure, personifying the North Wind, which floats in a somewhat unlikely defiance of gravity on the Underground Headquarters at St James's Park Station. Other pages are variations on the *Chac Mool* theme and closely connected with the two masterly sculptures of a reclining female figure carved in 1929. One such sheet is rather poignantly entitled 'Subjects for Garden Reliefs'. Moore had already executed a commission in 1926-27 for reliefs on two four-sided *jardinières* – designed by the architect Gordon Holt for the garden of the Reckitt house in Chelsea – which had

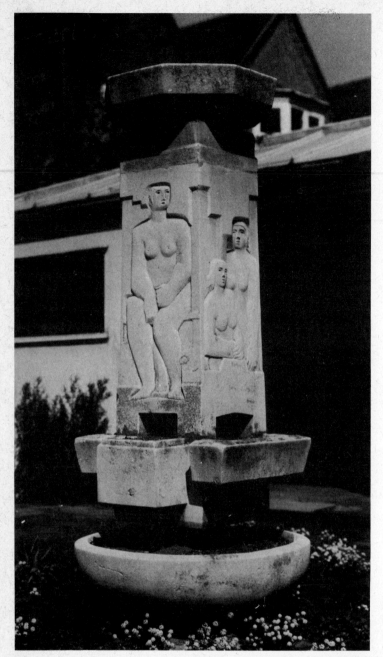

Fig 9 Garden relief-sculpture on a four-sided *jardinière*, executed 1926-27 in Portland stone, overall height 6ft 8in

gone unrecorded before their auction at Sotheby's in 1964 (Fig 9). He has said himself that he never felt any desire to make relief sculpture and, if he was still toying with the idea of doing garden-reliefs, it was because at that time it seemed to be the only way in which he would be likely to get his work into the open air. He has always declared sculpture to be an art of the open air, and has said that he would have liked to carry out the two reclining figures of 1929 on a big enough scale to dominate a landscape. It was not possible then, but at least they were colossal conceptions prophetic of the monumental works to come.

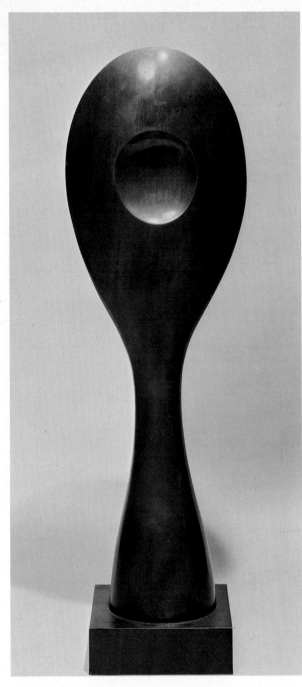

JEAN ARP
Feuille miroir
Bronze, executed in 1962 (number three of an
edition of five), height 39in
New York $28,000 (£12,174). 23.X.74

DAME BARBARA HEPWORTH, DBE
Single form (Aloe)
Bronze, signed, dated 1969, numbered 7/7
and inscribed *Morris Singer Founders London*,
height 43in
New York $20,000 (£8,695). 21.V.75

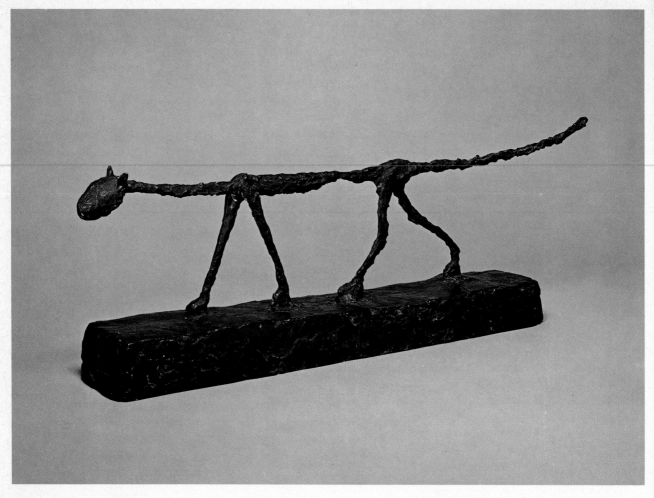

ALBERTO GIACOMETTI
Le chat
Bronze, signed, numbered *5/8* and stamped with the foundry mark *Susse Fondeur Paris,* executed in 1951, length 32in
New York $130,000 (£56,522). 21.v.75

MAX ERNST
Peinture pour les jeunes
Signed and dated '43, 24in by 29¾in
London £82,000 ($188,600). 4.XII.74

VICTOR BRAUNER
Mythotomie
Signed and dated *Mai 1942*, 24in by 19½in
New York $82,500 (£35,870). 21.v.75
From the collection of Mr and Mrs Fredrick Weisman

GEORGES BRAQUE
Les pommes
Red conté crayon, signed, drawn in 1934, 19½in by 26¼in
Johannesburg R19,500 (£12,187: $28,031). 4.III.75

RENE MAGRITTE
La voix du sang II
Gouache, signed, executed
circa 1952, 14in by 18in
New York $46,000
(£20,000). 21.V.75

NICOLAS DE STAËL
Rochers sur la plage
Signed, painted in 1954, 23¼in by 31¼in
London £48,000 ($110,400). 4.XII.74

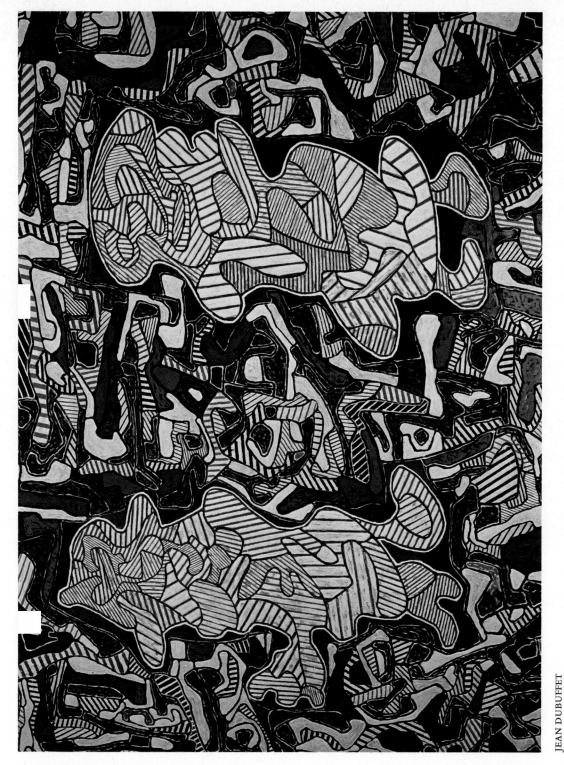

JEAN DUBUFFET
Echange de vues
Signed, titled and dated *décembre '63* on the reverse, 86¼in by 118in
New York $340,000 (£147,826). 23·x·74

FRANZ KLINE
Diamond
Signed and dated '*60* on the reverse, 64½in by 79¼in
New York $95,000 (£41,304). 24.x.74

ROBERT RAUSCHENBERG
Stopgap
Oil on canvas with silkscreen, painted in 1964, 58in by 40in
New York $75,000 (£38,609). 21.v.75

ANTONIO TAPIES
Brun et ochre
Mixed media, signed and dated 1959 on the reverse, 77in by 67in
New York $45,000 (£19,566). 24.x.74

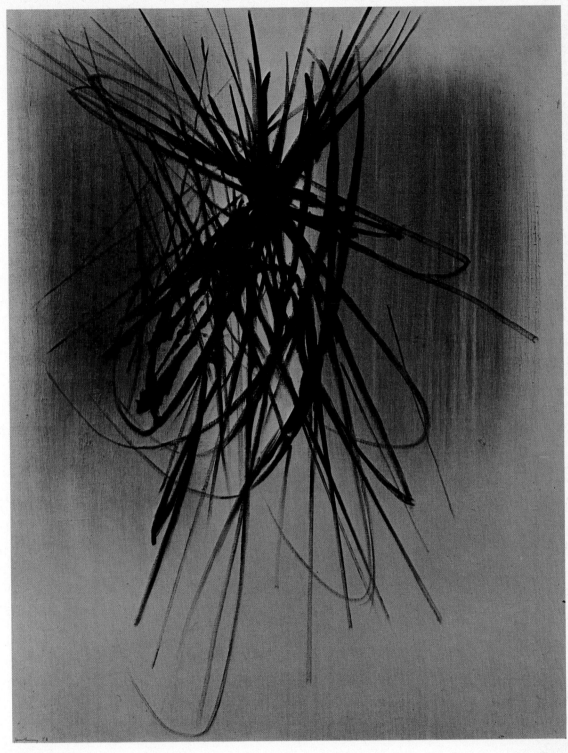

HANS HARTUNG
Composition
Signed and dated '58, 36½in by 28¾in
London £14,000 ($38,800). 4.XII.74

LUCIO FONTANA
Concetto spaziale
Signed and titled on the reverse, painted in 1961, 34¾in by 45¾in
London £11,000 ($25,300). 2.VII.75

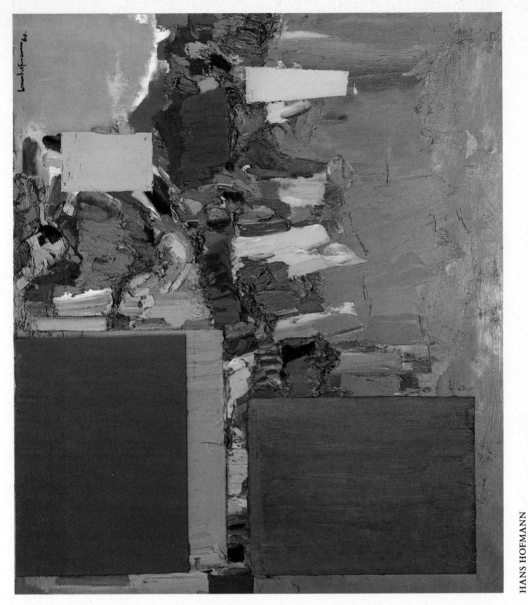

HANS HOFMANN
Land of bliss and wonder, California
Signed and dated '60; also signed, titled and dated on the reverse, 52in by 60in
Los Angeles $70,000 (£30,435). 3.11.75

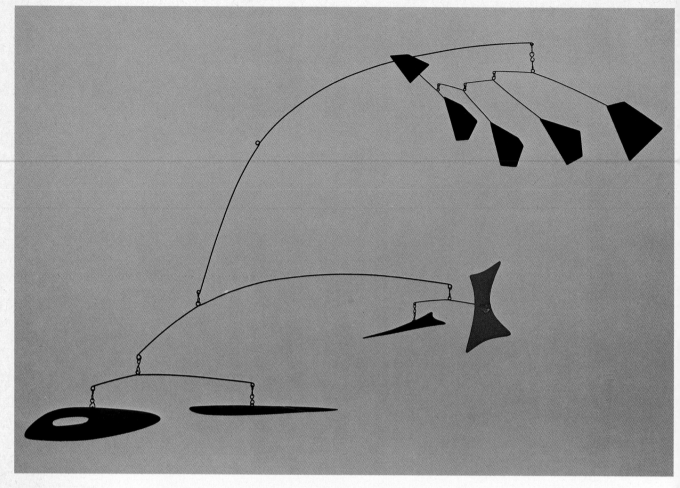

ALEXANDER CALDER
Red hourglass
Mobile, painted metal, signed with initials, executed in 1959, 55⅞in by 37in
New York $30,000 (£13,044). 21.v.75

DUANE HANSON
Tourists
Fiberglass cast from human figures with surface polyester and talcum mix,
polychromed in oil with clothing and mixed media, executed in 1970, height of
male 62in, height of female 64in
New York $33,000 (£14,348). 21.v.75
From the collection of Mr and Mrs Saul P. Steinberg

RICHARD ESTES
Bus reflections
Painted in 1972, 38½in by 50½in
New York $55,000 (£23,913). 21.v.75
From the collection of Mr and Mrs Saul P. Steinberg

Prints

JOST AMMAN
One of the illustrations to Wenzel Jamnitzer's *Perspectiva*, 1568
Engravings, title-plate and set of forty-three plates, each 176mm by 255mm
London £800 ($1,840). 3.VII.75
From the collection of William Gordon

GIULIO CAMPAGNOLA
The young shepherd
Engraving, second state with stipple, 136mm by 179mm
London £4,200 ($9,660). 3.VII.75
From the collection of Sir William Pennington-Ramsden Bt
A rare print of which only ten other impressions are recorded

VENETIAN SCHOOL, *circa* 1470–1480
A ship under full sail
Engraving, 199mm by 139mm
Florence L3,500,000 (£2,300: $5,290). 23.X.74

REMBRANDT HARMENSZ. VAN RIJN
Saskia with pearls in her hair
Etching, only state, 87mm by 68mm
London £2,200 ($5,060). 19.XI.74
Left
REMBRANDT HARMENSZ. VAN RIJN
David and Goliath
Etching and drypoint, third state of four,
119mm by 74mm
London £600 ($1,380). 21.III.75

REMBRANDT HARMENSZ. VAN RIJN
Christ returning with his parents from the temple
Etching and drypoint, only state, 94mm by 144mm
London £4,550 ($10,465). 21.III.75

REMBRANDT HARMENSZ. VAN RIJN
Saskia ill, wearing a white headdress
Etching with drypoint,
62mm by 51mm
New York $9,500 (£4,130). 8.V.75

UGO DA CARPI
Putti at play, after Raphael or Peruzzi
Woodcut, printed from four blocks in dark green and three shades of sage green,
270mm by 403mm
Florence L1,400,000 (£930: $2,139). 23.x.74
This composition is taken from an oval in the painted vault of the garden Loggia of the
Villa Madama, Rome

ENEA VICO
The studio of Baccio Bandinelli
Engraving, first state, 302mm by 476mm
Florence L1,500,000 (£1,034: $2,379). 23.x.74

ANDREA ANDREANI
Allegory of Virtue, after Ligozzi
Woodcut, printed from four blocks in black and three shades of
brown, first state of two, 475mm by 322mm
Florence L1,200,000 (£800: $1,840). 23.x.74

HENDRIK GOLTZIUS
Hercules slaying Cacus
Woodcut, printed from three blocks in black, moss green and yellow,
fourth state, 410mm by 333mm
Florence L3,000,000 (£2,069: $4,759). 23.x.74

FRANCESCO GOYA
Los Caprichos
A bound set of eighty trial proof aquatints before the first edition
and before corrections of titles on five of the plates, sheet size
each 305mm by 203mm
New York $90,000 (£39,130). 7.XI.74
Only ten other sets of trial proofs before corrections have
previously been recorded

GIOVANNI BATTISTA PIRANESI
Invenzioni capric di carceri
Etchings, a set of fourteen plates in the first edition before numbers,
each 535mm by 405mm
London £19,000 ($43,700). 21.III.75

W. DICKINSON
*The gardens of Carlton
House, after Henry Bunbury*
Stipple and etching,
printed in black, proof
state before letters,
495mm by 650mm
London £110 ($253).
13.V.75

After JOHN FREDERICK HERRING, Snr
Fox Hunting Scenes 1874
Four colour aquatints inscribed *To Mr and Mrs J. Bailey with F. C. McQueen Mannily's best wishes
June 2nd 1886,* in pencil in the margin of each, proofs before plate numbers, each 440mm by 775mm
London £650 ($1,495). 13.V.75
From the collection of Mrs Gooden

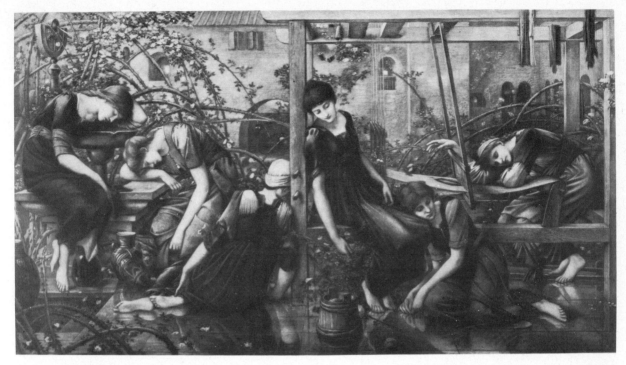

SIR EDWARD COLEY BURNE-JONES
The Garden Court
Photogravure, artist's proof, signed in pencil lower right, with the stamp of the Printseller's
Association H.J.T., third in the series *The Legend of the Briar Rose*, 423mm by 770mm
London £75 ($173). 17.IX.74

JOHN MARTIN
One of twenty-four illustrations to *Paradise Lost* by Milton
Mezzotints, first edition of the twenty-four plates bound in two volumes, published
by Septimus Prowett, 1827
London £620 ($1,426). 24.VI.75

MARY CASSATT
Feeding the ducks
(or *Les canards*)
Drypoint, 1895, first state
before the colour aquatint,
295mm by 398mm
Los Angeles $6,750
(£2,935). 17.II.75

CAMILLE PISSARRO
*Paysage sous bois, à
L'Hermitage, Pontoise*
Aquatint, 1879, fifth state of
five, 221mm by 270mm
Los Angeles $7,750
(£3,370). 24.IX.74

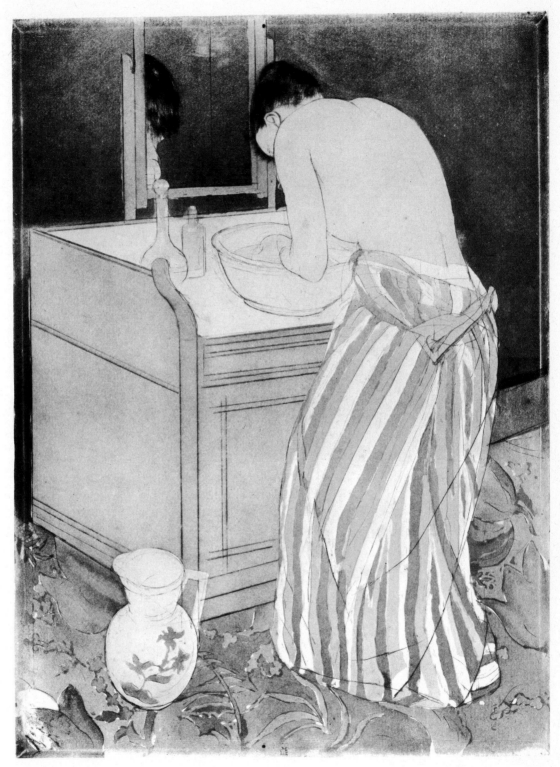

MARY CASSATT
Woman bathing – the toilette
Drypoint and aquatint printed in colours, 1891, fifth state, with the Cassatt monogram stamp,
362mm by 268mm
New York $19,000 (£8,261). 6.11.75

PABLO PICASSO
Torse de femme
Aquatint, 1953, signed in pencil and numbered
41/50, 834mm by 471mm
New York $13,500 (£5,870). 7.V.75

JIM DINE
Night portrait
Lithograph in white on black paper, 1969, signed in pencil and numbered
20/21, 1,350mm by 960mm
New York $2,000 (£870). 8.V.75

Opposite below
ROY LICHTENSTEIN
Peace through chemistry I
Lithograph and silkscreen printed in five
colours, 1970, signed in pencil, dated and
numbered 13/32, 760mm by 1,450mm
New York $3,000 (£1,304). 7.II.75

JASPER JOHNS
Color numerals: figure 7
Lithograph printed in four colours, 1969, signed in
purple crayon, dated and numbered 10/40,
708mm by 543mm
New York $4,100 (£1,783). 7.II.75
From the collection of Carter Burden

DAVID HOCKNEY
Flowers and vase
Etching and aquatint, signed in pencil, dated '69
and numbered 72/75, 695mm by 545mm
London £500 ($1,150). 6.XII.74

HENRY FUSELI
'*Evening thou bringest all.*' *A woman sitting by a window*
Polyautograph, first state of three, André 1803 edition, 235mm by 320mm
London £500 ($1,150). 15.IV.75

GEORGE BELLOWS
Stag at Sharkey's
Lithograph, 1917, signed in pencil, titled and numbered no 14 (from an
edition of ninety-eight), 478mm by 607mm
New York $8,500 (£3,696). 6.II.75
The scene depicted is Tom Sharkey's boxing club in New York City

Manuscripts and Printed Books

168 ORIENTAL MANUSCRIPTS AND MINIATURES
180 WESTERN MANUSCRIPTS
186 AUTOGRAPH MANUSCRIPTS AND LETTERS
190 PRINTED BOOKS

APOLOGVS.

Sfendo maritata vna donna ad uno latro tuſto el ſuo uicinato ballãdo
& triũphando monſtraua ſigno de grande leticia aſſe nocze & in tal triũ
pho cõparendo uno ſauio & homo prudente & coſtumato aſſai coſſi in
nelle nocze incomẽzo ad parlare, O turba triũphante intendete che ſucceſe una

AESOPUS
Vita et Fabulae
88 large woodcuts within borders, Naples, 1485
London £24,000 ($55,200). 23.VI.75
This is the most famous Italian edition of Aesop, and one of the greatest
woodcut books produced in Italy

Hamza and the Queen of the Fairies carried through the sky in Palanquins borne by Demons
A page from the Hamza–nama, [Mughal, *circa* 1570]
London £12,000 ($27,600). 7.IV.75
From the collection of the Hagop Kevorkian Fund

Vishnu and Shiva standing by a Torrent from which appears a Monster Demon
A Mughal miniature, [Akbar period, *circa* 1600]
London £4,400 ($10,120). 27.XI.74
From the collection of the late Sir Thomas Phillipps Bt (1792-1872)

Qur'an written for Sultan Mehmed Fatih
Arabic manuscript on paper, 433 leaves, [Turkish, third quarter of fifteenth century]
London £6,500 ($14,950). 8.IV.75

The Four Gospels
Armenian manuscript on vellum, copied by the monk Vardan, decorated with ten full-page
and other smaller decorations, Awag Vanq, near Erzincan, AD 1200
London £13,000 ($29,900). 7.IV.75
From the collection of the Hagop Kevorkian Fund

Fig 1 *Sam kills Faghfur of Chin riding on a blue elephant*
A Persian miniature from *Firdausi's Shahnama*,
Qazwin, dated 991AH [1583]
London £42,000 ($96,000). 7.IV.75
From the collection of the Hagop Kevorkian Fund

Persian Paintings and Manuscripts

B. W. Robinson

As a means of acquiring a comprehensive knowledge of any branch of art the saleroom is in some respects preferable to the museum. Granted, in the latter we can contemplate, albeit in limited numbers and behind glass, the finest productions of any given nation, culture, school, or period, accompanied by explanatory labels; but in the former, over the years, a vastly greater number of objects passes before our eyes, not only 'museum pieces', but also bad and indifferent ones. They can be handled, examined, and compared, and in the acid test of the sale itself the prices will give us a workable scale of merit (so long as we discount the more extravagant vagaries of current fashion). We thus gain a wider conception of the art in question in all its manifestations and at every level.

The art of Persian painting is an excellent example of this proposition. The unrivalled collections of the British Museum are for the most part contained in manuscript books, only a tiny proportion of which are on show at any given time, and even so only one miniature in each volume can be exposed to view. On the other hand, anybody who has followed Sotheby Parke Bernet's sales of oriental manuscripts and miniatures over the past year has been able to examine examples of virtually every period and quality, from calligraphic phoenixes in a Bestiary of *circa* 1300 to a vast canvas depicting a selection of Fath 'Ali Shah's enormous family, paraded in serried ranks. Three sales have been held in London during the past season: the 10 December 1974 sale, including the property of D. Mehta Esq, the Kevorkian on 7 April 1975, and a sale from various sources on the following day. On 2 May a remarkable *Shahnama* manuscript also appeared in a sale of antiquities in New York.

In referring to particular lots in the London sales I shall use the numbers I, II, and III respectively. For the student of Persian painting the most important was, of course, the Kevorkian (II). It was the fourth of a series of sales in which the vast collections in this field of the late Mr Hagop Kevorkian (a name which some American friends have accurately but irreverently translated as Jacob MacGeorge) have been dispersed by the Foundation whose property they became on his death. Over twenty years ago I was given the task of cataloguing his Islamic manuscripts and miniatures in New York, and these sales have re-introduced me to some old friends; but I have also made a number of new ones, for Mr Kevorkian was incessantly acquiring fresh material, as well as disposing of items already in his possession. Though well on in his seventies at the time of my visit, Mr Kevorkian was the best dressed man I met in New York, and his was the only house in the United States where I have been offered sherry (and very good sherry it was too). His handsome and dapper figure, in a beautifully cut grey suit, no doubt London made, crowned by an immaculate pearl-grey Homburg hat,

and supported by an elegant silver-knobbed cane, was striking and unmistakable. I have always felt immensely grateful to him for affording me the opportunity of studying this huge and very varied mass of material.

Perhaps the most important single item in this sale was the *Zafar Nama* manuscript of 1436, still containing eight miniatures and the colophon (II.187). Together with the Bodleian *Shahnama* (Ouseley Add.176) of a few years earlier,[1] this provides the foundation for our knowledge of the style of painting practised at Shiraz under the patronage of Ibrahim Sultan b. Shah Rukh. It is an attractive style, large, vigorous, and unsophisticated in comparison with the more meticulous and academic work of the contemporary school of Herat under Ibrahim's brother Baysunghur. Detached miniatures from this *Zafar Nama* are widely scattered in collections on both sides of the Atlantic; one of the best is the celebrated giraffe in the Worcester (Mass.) Art Museum.[2] Several of them appeared in Paris at the Sevadjian sales of 1960-61,[3] where they fetched what were then considered to be high prices of between Fr2,100 and 4,100.

Three other notable illustrated Persian manuscripts appeared in this sale: a good Nizami of *circa* 1570, with miniatures in the Qazwin style (II. 189), and two *Shahnamas*. Of these latter the first (Fig 1: II. 190), also from Qazwin, and a magnificent volume, fetched the deservedly high price of £42,000, the highest in the sale. The other (II.191), though at no time more than a second-rate manuscript, and with now sadly damaged and discoloured miniatures, is yet of considerable interest as adding one more to the small group of known manuscripts illustrating the provincial style of painting practised at Astarabad (now Gurgan, at the south-eastern corner of the Caspian Sea) under the Safawids. Since 1967, when three Astarabad *Shahnamas* were exhibited at the Victoria and Albert Museum Loan Exhibition,[4] four others have come to light: H.1493 in the Topkapi Library, Istanbul, dated 973/1566; one in a Persian private collection, dated 971/1564, and lavishly published by its owner in honour of the Cyrus celebrations;[5] Ethé 874 in the India Office Library, of the early seventeenth century; and the present volume, dated in the catalogue, no doubt correctly, to the first quarter of the seventeenth century. This vigorous local style is characterised by strong and somewhat primitive drawing, retaining a certain flavour of the Timurid period, and a vivid and sometimes surprising colour-scheme. It is perhaps noteworthy that all these Astarabad volumes are copies of the *Shahnama,* and that they fall neatly into two groups, the first of 1564-66, and the other of *circa* 1600-1630. It remains to be seen what conclusions, if any, can be drawn from these circumstances, pending the appearance of further examples or literary evidence.

Not many of the detached miniatures call for special mention, though their general quality was high. The phoenixes from the Bestiary of *circa* 1300 (II.17) comprise one of the the most attractive pages of the manuscript, from which a number of miniatures passed through Mr Kevorkian's hands. Among the later paintings in the sale were the usual examples of the Turkman 'commercial' (II.21-23) and Shiraz Safawid (II.26-28, 35-37) styles. Later sixteenth-century work was well represented by the *Elderly musician* (II.30), obviously a 'prestige' painting (though personally I preferred the charming, though less ambitious, drawing on the verso), and the little miniature (II.31) of a prince and princess. The latter is

1 See B. W. Robinson, *Persian Miniature Painting from Collections in the British Isles* (London, Victoria and Albert Museum, 1967), No 118, where further references will be found. This publication will be referred to as *VAM 1967.*

2 International Exhibition of Persian Art, Burlington House, 1931, *Illustrated Souvenir*, p. 35.

3 Hotel Drouot, 23 November 1960, lots 132 – 36, 138; 20 March 1961, lots 135 – 36.

4 *VAM 1967*, Nos 182 – 84.

5 *Parda-hai az Shahnama*, Tehran 1346. Short Persian text and 39 coloured reproductions.

Fig 2 *Portrait of a royal physician of Shah 'Abbas I,* probably Mirza Muhammad Shirazi
A Persian miniature by Mu'in, signed and dated *15 Muharrum 1085*AH [21 April 1674]
London £10,000 ($23,000). 7.IV.75
From the collection of the Hagop Kevorkian Fund

Fig 3 *Gushtasp killing the dragon*
A Persian miniature from *Firdausi's Shahnama*, Herat, 27th day of Ramadan 1008AH [August 1599]
New York $250,000 (£108,696). 2.v.75
From the collection of Mrs Eleanor Searle Whitney McCollum.
This manuscript was unknown before it appeared at auction. Its high quality disproves the view that artistic activity in Herat had declined by the end of the sixteenth century

surely by the same practised hand as the splendid miniatures in the British Museum *Shahnama* (Add.27257),[6] a majestic volume formerly in the collections of the East India Company servant Edward Galley (1786) and of Sir John Malcolm, whose *History of Persia* (1815) was the first comprehensive and scholarly treatment of the subject in a European language.

6 *VAM 1967*, No 59.

The sale offered the normal range of Isfahan drawings, amongst which the *Maiden sleeping on the ground* (II.41), surely from the hand of Riza, the *Mustachio'd European* (II.43), probably by Muhammad Yusuf, and the *Page* (II.49) signed by Muhammad 'Ali, were outstanding. Mu'in was well represented by a fine portrait of the royal physician (Fig 2: II.53), a standing girl, very lightly attired (II.60), and a calligraphic drawing of a lion and a kylin (II.61); and there was a fine painting of an Indian girl, of 1646, by Muhammad Taqi b. Shaykh 'Abbasi (II.46) in which Indian and European influences are nicely blended, as in the work of his father and of his brother 'Ali Naqi, who supplied some of the best miniatures in the late seventeenth-century *Shahnama* in the Metropolitan Museum of Art.[7] A few not very notable Qajar miniatures (II.63-80) – portraits, animals, and flowers for the most part – rounded off the Persian section of the sale.

But we cannot leave this sale without noticing a manuscript of the *Shahnama* (II.186) from which a number of detached miniatures have long been known.[8] This was not in Mr Kevorkian's collection when I saw the latter in 1952, and its appearance here was a very pleasant surprise; but, alas, there is no colophon, so the problem of its origin still remains. It clearly belongs to the middle years – probably the second quarter – of the fifteenth century, though the text is written in six columns, an extremely rare feature in the Timurid period. Its miniatures, by several different hands, have something in common with contemporary Shiraz work, and they used to be labelled and catalogued as 'provincial Persian', but alien elements are apparent in drawing, colour, composition, and details of furniture and costume, and it is now almost certain that the manuscript comes from western India. How pleasant it would have been to find a colophon with a date and place of completion, or a dedication to one of the Sultans of Golconda!

The *Shahnama* manuscript sold in New York for $250,000 (Fig 3), however, has a long and circumstantial colophon, naming the patron as the well-known bibliophile Husayn (Hasan?) Khan Shamlu, the place of completion Herat, the scribe Muhammad Mumin b. Muhammad Qasim and the date Ramazan 1008/August 1599. The manuscript is remarkable in that it contains forty-four miniatures in excellent condition, which are thus well-documented work of the Khurasan school at the turn of the century.

The miniatures of the classical period in the Mehta sale (I) were representative and fairly good in quality, but very few stood out as major works. The *Young lady reclining* (I.381) bore a Riza-i 'Abbasi signature that may well be genuine, but her face had been transformed by a late Indian painter, and her whole character thereby lost. Nevertheless she forms an interesting comparison with the Kevorkian drawing (II.41), perhaps by the same hand but thirty years earlier, and with a similarly, or even more abandoned young lady by Afzal al-Husayni in the British Museum.[9] This latter artist was responsible for the *Maiden performing acupuncture on her lover* (I.395), perhaps the best Persian miniature in the sale. Afzal takes Riza's style a little further along the path of decadence, but he has undeniable brilliance and charm. A slightly earlier contemporary, Shah Qasim, was almost certainly the painter of the outdoor court scene (I.394), which has much of the charm, but little of the impact, of the

7 See B. W. Robinson, 'The Shahnameh Manuscript Cochran 4 in the Metropolitan Museum of Art' in *Islamic Art in the Metropolitan Museum of Art* (New York, 1972), pp 73 – 86.
8 *VAM 1967*, No 113, where further references will be found. For the general quesiton of Indian painting in the Timurid period, see R. Ettinghausen and I. Fraad, 'Sultanate Painting in Persian Style' in *Chhavi* (Benares, 1969).
9 See Basil Gray, *Persian Painting* (London, 1931), pl 14.

later artist's work. The sale also included an attractive group of examples of the later sixteenth-century style of Khurasan (I.442-46).

But the top prices at sales I and III, and by a very long chalk, went to oil paintings of the Qajar period. The extraordinary escalation in the prices paid for these nineteenth-century works is one of the major phenomena of the world of oriental art during the last decade. Twenty years ago they could hardly be given away. Examples in museums were relegated to basement stores; they were derided, neglected, allowed to gather dust and dirt, or even cut up into more convenient sizes for mounting on screens or decorating staircases. The late Leopold Amery was the only collector who had ever been in the field. But then the same was true, *mutatis mutandis,* of English Victorian art a generation ago, whereas now it has become the subject of innumerable coffee-table books; it has featured in numerous exhibitions, and regular auction-sales are devoted to it, at which high prices are consistently paid. There must be a connection here, and there can be no question but that Victoriana and Qajariana (if the word may be forgiven) have a number of qualities in common, and not only because in some cases the latter was consciously imitating the former. Naive, comfortable, eclectic, painstaking naturalistic, self-satisfied, and undiscriminating are all adjectives applicable to both, and perhaps one reason for their present popularity is that current values (which many of us deplore) are so radically different. Modern man tends to be uncomfortable, worried, self-questioning, and sophisticated, and much of his art is abstract in design and slap-dash in execution. No doubt nostalgia plays its part. But further speculation belongs to the realm of the sociologist.

The two girls' heads in the Mehta sale (I.403, 404) were on a smaller scale than such works usually are. They were of very good quality, and their attribution in the catalogue to Muhammad 'the Shirin (sweet) painter' is probably correct, though the execution is more precise than in his larger works. The £4,000 and £3,500 they fetched might be thought high prices, but the huge canvas in the last sale (III.183), depicting fifteen of Fath 'Ali Shah's sons and grandsons, reached the staggering figure of £200,000. Although it measures about 8ft by 9ft, it is only part of what must have been a truly gigantic painting, which once, no doubt, covered the entire wall of a great audience-chamber in one of the airy palaces erected for the 'Asylum of the Universe' in Tehran, Isfahan, and elsewhere. It may perhaps have been painted by the long-lived court artist 'Abdallah Khan. The well-known Paris dealer, M. Jean Soustiel, recently published a corresponding portion of the same composition, in which a further eighteen princes are similarly represented, but all facing in the opposite direction.[10] There can be no doubt that these two canvases originally flanked a central one, of similar proportions, on which Fath 'Ali Shah himself was portrayed, probably seated on the Peacock Throne and attended by a galaxy of his elder sons, as in the famous Nigaristan fresco, also by 'Abdallah Khan.[11] It would be interesting to locate this hypothetical centre-piece.

In conclusion it may be observed that on a previous appearance of this astonishing painting in Sotheby's rooms some thirteen years ago, the auctioneer's estimate was £60-£80. It went for £380, and I was the under-bidder!

10 J. Soustiel, *Objets d' Art de l'Islam* (Paris, 1973), No 28.
11 See E. G. Browne, *A Year amongst the Persians* (London, 1926), p 105. Notices and descriptions of this painting, which no longer exists, will also be found in almost all the nineteenth-century European travellers' narratives. A reduced copy of the central group is reproduced in B. W. Robinson, 'The Court Painters of Fath 'Ali Shah', *Eretz Israel*, L. A. Mayer volume Jerusalem, 1964, pl XXXIII. A full-sized copy, made about seventy years ago, is said to be in the Foreign Office, Tehran, from which a number of details are reproduced by Ahmad Suhayli Khwansari, 'Qasr wa Bagh i Nigaristan', in *Honar va Mardom* No 144, pp 31-37.

Portrait of Fath 'Ali Shah, attributed to Mihr 'Ali,[Qajar, *circa* 1810–1815]
£100,000 ($230,000).
This portrait was also sold in London on 7 July 1975

Gospels in Latin, with Canon Tables and Capitulary
Manuscript on vellum, [Metz, second quarter of the ninth century]
London £80,000 ($184,000). 25.III.75
One of the Hornby Manuscripts from the collection of the late Major J. R. Abbey

L. IVNII. MODERATI. COLVMEL
LE. REI. RVSTICE. LIBER PRIMVS
INCIPIT

Praecepta que sequantur qui rusticari uelint I
Qualiter dispositus fundus maxime probetur II
Quae precipue respiciendo agro anteq emat notãda sunt III
De salubritate regionum IIII
De aqua V
De positione uille VI
De officiis patrisfamiliae VII
De pecore et pecorum magistris VIII
Qualis corporature mancipia cuiqᷓ operi tribuenda sunt VIIII

AEPE NVMERO CIVITATIS
NOSTRAE PRINCIPES AVDIO
CVLPANTES MODO AGRORᵛ
INFOECVNDITATEM. MODO
caeli per multa iam tempora noxiã
frugibus intemperiem. quosdam
etiam praedictas querimonias ue
lut ratione certa mitigantes: qd
existiment ubertate nimia prioiſ
qui defatigatũm et effetum solum, nequire pristina benigni
tate prebere mortalibus alimenta. Quas ego caufas silui
ne procul a ueritate abesse certum habeo. Qᷓ neq fas est exi
stimare humⁱ naturam: quam primus ille mundi genitor
perpetua foecunditate donauit: quasi quodã morbo sterili

L. J. M. COLUMELLA
De Re Rustica, with the treatises on Agriculture by Varro and Cato
Manuscript on vellum, [Rome (?), before 1472]
London £18,000 ($41,400). 25.III.75
One of the Hornby manuscripts from the collection of the late Major J. R. Abbey

Missal of the Augustinian Abbey of St Etienne, Dijon
Manuscript on vellum, with two full-page miniatures and other decoration,[Dijon, *circa* 1240]
London £42,000 ($96,600). 25.III.75
One of the Hornby manuscripts from the collection of the late Major J. R. Abbey

Missale pro Defunctis
Manuscript on vellum, with one full-page miniature and other decoration, [Liège, *circa* 1320–1330]
London £18,000 ($41,400). 25.III.75
One of the Hornby manuscripts from the collection of the late Major J. R. Abbey

Hours of the Virgin, use of Rome
Manuscript on vellum, with 36 full-page and 77 smaller miniatures, [Paris (?), *circa* 1500]
London £16,000 ($36,800). 9.XII.74

T. LUCRETIUS CARUS
De Rerum Natura
Manuscript on vellum, with decorated frontispiece, title-page and five fine initials, [Florence, *circa* 1485–1500]
London £15,000 ($34,500). 25.iii.75. One of the Hornby Manuscripts from the collection of the late Major J. R. Abbey

ROBERT BURNS
Scotch Song
Autograph manuscript of the poem, [1795–1796]
London £2,400 ($5,520). 24.VI.75
From the collection of the Reverend David Sillar

JANE AUSTEN
Autograph letter to her publisher John Murray, 1816
London £2,400 ($5,520). 24.VI.75

NATHANIEL HAWTHORNE
The Lily's Quest, an Apologue
Autograph manuscript, [1839]
New York $5,250 (£2,282). 19.XI.74
From the collection of the late William E. Stockhausen

BENJAMIN DISRAELI
The Wondrous Tale of Alroy
The autograph manuscript for the novel, published 1833
London £4,000 ($9,200) 15.VII.75
From the collection of the Rt Hon the Earl of Rosebery

D. H. LAWRENCE
The Boy in the Bush
Autograph manuscript for the novel, first printed 1924
Los Angeles $13,000 (£5,652). 11.V.75

SAMUEL LANGHORNE CLEMENS 'MARK TWAIN'
The Sandwich Islands
Autograph manuscript, [circa 1866–1867]
New York $9,000 (£3,913). 19.XI.74
From the collection of the late William E. Stockhausen

ROBERT SCHUMANN
Sketches for his *Overture to Shakespeare's 'Julius Caesar'*
Autograph manuscript, [1851]
London £3,200 ($7,360). 28.X.74

JULES MASSENET
Thaïs: Poème Lyrique – 3 Actes & 6 Tableaux
Autograph manuscript, signed and dated 1892
New York $20,000 (£8,695). 15.X.74

RANALPH HIGDEN
Polychronicon
First edition, 324 leaves (of 450), Westminster, William Caxton, 1482
London Chancery Lane £4,000 ($9,200). 31.x.74
From the collection of the late John Worth

ANICIUS MANLIUS TORQUATUS SEVERINUS BOETHIUS
De Consolatione Philosophiae
First English edition, 55 leaves (of 94). [Westminster, William Caxton, circa 1478]
London Chancery Lane £12,000 ($27,600). 31.x.74
From the collection of the late John Worth

HOMER
Opera
First edition, bound in 2 volumes, [Florence, Bernardus and Nerius
Nerlius, and Demetrius Damilas, not before 13 January 1488/89]
London £8,600 ($19,780). 23.VI.75
From the collection of the Rt Hon the Earl of Rosebery

CARDINAL BESSARION, Archbishop of Nicaea
Adversus Platonis Calumniatorem. An Natura et Ars Consilio Agant
First edition, presentation copy, inscribed by the author to Candiano
Bollani, Rome, Conradus Sweynheym and Arnoldus Pannartz,
[before 13 September 1469]
London £5,000 ($11,500). 23.VI.75
From the collection of the Rt Hon the Earl of Rosebery

JACOBUS PHILIPPUS FORESTI BERGOMENSIS
De Plurimis Claris Sceletisque Mulieribus
First edition, with 172 woodcuts, Ferrara, Laurentius de Rubeis
de Valentia, 1497
London £4,500 ($10,350). 23.VI.75
From the collection of the Rt Hon the Earl of Rosebery
One of the finest early Italian illustrated books, and the first
printed book to contain real portraits

JOHANNES DE KETHAM
Fasciculus Medicinae
Third edition, with 10 full-page woodcuts, Venice, Ioannes &
Gregorius de Gregoriis, de Forlivio, 1500
London £5,000 ($11,500). 20.I.75

A BRIEFE
Defcription of the Portes,
Creekes, Bayes, and Hauens,
of the Weaſt India:

Tranflated out of the Caſtlin
tongue by I. F.

The Originall whereof was dı
reſted to the mightie Prince
Don Charles, King of
Caſtile, &c.

Imprinted at London, by
Henry Bynneman.
Anno. 1578.

Rounds or Catches of 3. Voices.　　10

Olde thy peace, and I pree thee hold thy peace thou knaue,

ſecond.
third.
thou knaue : hold thy peace thou knaue.

11

Ladam I, glad am I, my mother is gone to Henſy,　ſhut

the doore and ſpare not, doe thy worſt I care not.　If I dye vpon the ſame,

bury, bury, bury me a gods name.

MARTIN FERNANDEZ DE ENCISO
A Briefe Description of the Portes, Creekes, Bays, and Havens of the Weast India, translated by John Frampton
First edition in English, 1578
London £10,000 ($23,000). 11.XI.74
From the celebrated collection of books on early scientific subjects formed by Harrison D. Horblit

THOMAS RAVENSCROFT
Deuteromelia, or the Second Part of Musicks Melodie
First edition, Thomas Adams, 1609
London £2,700 ($6,210). 25.XI.74
From the collection of the late Sir Thomas Phillipps Bt (1792–1872)
'Three Blind Mice' appears as one of the songs, probably for the first time in print

DIEGO GARCIA DE PALACIO
Instrucion Nauthica
First edition, Mexico, Pedro Ocharte, 1587
London £3,500 ($8,050). 11.XI.74
From the celebrated collection of books on early scientific subjects
formed by Harrison D. Horblit
The first book on navigation and shipbuilding compiled and printed in
the New World

SIR ROBERT DUDLEY
Arcano del Mare
2 volumes, with 391 maps and illustrations, Florence, G. Cocchini,
1661
London £9,500 ($21,850). 11.XI.74
From the celebrated collection of books on early scientific subjects
formed by Harrison D. Horblit

THOMAS L. MCKENNEY and JAMES HALL
History of the Indian Tribes of North America
3 volumes, with 120 hand-coloured portraits, Philadelphia,
1848–1850
New York $3,750 (£1,630). 21.1.75

GONZALO FERNANDEZ DE OVIEDO Y VALDEZ
La Historia General de las Indias
First edition, 2 volumes, Seville, Juan Cromberger, 1535, and Valladolid,
Francisco Fernandez de Cordoba, 1557
New York $8,500 (£3,695). 5.III.75

CAPTAIN THOMAS JAMES
The Strange and Dangerous Voyage of Captaine Thomas James, in his intended Discovery of the Northwest Passage into the South Sea
First edition, with the rare folding map present, 1633
London £2,100 ($4,830).
26.XI.75
From the collection of the late Sir Thomas Phillipps Bt (1792–1872)

JOHN J. AUDUBON and
JOHN BACHMAN
The Viviparous Quadrupeds of North America
3 volumes, with 150 hand-coloured plates, New York, 1845–1848
New York $25,000
(£10,869). 21.I.75

L. FUCHS
De Historia Stirpium
512 woodcuts coloured by a contemporary hand, Basel, 1542
London £6,800 ($15,640) 17.VI.75
From the collection formed by the late Arpad Plesch

PRVNELLA Braunellen.

Herbe aux charpetiers

Palma Christi flo: purpureo. Hyacinthus stellatus peruanus. Orchis minor flo: incarnato.

BASILIUS BESLER
Hortus Eystettensis
Second edition with 367 engraved plates, [Nuremberg and Eichstadt], 1640
New York $28,000 (£12,173). 5.III.75
A copy of the first edition in the collection formed by the late Arpad Plesch realised £16,000 ($36,800). 16.VI.75

JOHN EDWARDS
A Collection of Flowers drawn after Nature
79 engraved plates, and 2 additional plates at end, all coloured by hand, [1783–1798]
New York $30,000 (£13,043). 5.III.75

M. CATESBY
The Natural History of Carolina, Florida, and the Bahama Islands
2 volumes, with map and 220 hand-coloured plates, 1754
London £8,500 ($19,550). 16.VI.75
From the collection formed by the late Arpad Plesch

P. J. REDOUTÉ and C. A. THOREY
Les Roses
3 volumes, large paper copy with 170 plates, Paris, 1817–1824
London £9,000 ($20,700). 18.XI.74

P. P. ALYON
*Cours de Botanique pour servir à l'Education des Enfans de S. A.
Sérénissime Monseigneur Le Duc d'Orleans*
7 engraved titles and 104 plates coloured by hand, Paris, 1787–1788
London £9,200 ($21,160). 16.VI.75
From the collection formed by the late Arpad Plesch
The only complete copy recorded

TAMERLANE

AND

OTHER POEMS.

BY A BOSTONIAN.

Young heads are giddy, and young hearts are warm,
And make mistakes for manhood to reform.—Cowper.

BOSTON:
CALVIN F. S. THOMAS....PRINTER.

1827.

EDGAR ALLAN POE
Tamerlane and Other Poems
First edition, Boston, 1827
New York $123,000 (£53,478). 20.XI.74
From the collection of the late William E. Stockhausen
The finest copy known of Poe's first book

COMMON SENSE;

ADDRESSED TO THE

INHABITANTS

OF

AMERICA,

On the following interesting

SUBJECTS.

I. Of the Origin and Design of Government in general,
 with concise Remarks on the English Constitution.

II. Of Monarchy and Hereditary Succession.

III. Thoughts on the present State of American Affairs.

IV. Of the present Ability of America, with some misc-
 cellaneous Reflections.

Man knows no Master save creating Heaven,
Or those whom choice and common good ordain.
 Thomson.

PHILADELPHIA;
Printed, and Sold, by R. BELL, in Third-Street.
MDCCLXXVI.

THOMAS PAINE
Common Sense, addressed to the Inhabitants of America
First edition, first issue, Philadelphia, 1776
New York $11,000 (£4,782). 15.X.74

WILLIAM WORDSWORTH
An Evening Walk, an Epistle in Verse
First edition, 1793
New York $3,750 (£1,630). 20.XI.75
From the collection of the late William E. Stockhausen

JOHN KEATS
Lamia, Isabella, The Eve of St. Agnes, and other Poems
First edition, in original boards, 1820
New York $5,200 (£2,260). 20.XI.75
From the collection of the late William E. Stockhausen

T. STURGE MOORE
A Brief Account of the Origin of the Eragny Press
One of 6 copies printed on vellum, with 15 illustrations and device by
Lucien Pissarro, 1903
London £720 ($1,656). 12.III.75

JULES RENARD
Histoires Naturelles
22 lithographed illustrations and cover design by Toulouse-Lautrec, Paris, 1899
New York $7,500 (£3,260). 21.I.75

BEATRIX POTTER
A large watercolour drawing of a cat asleep in a garden, signed and dated *Fawe Park, Aug.* 1903
London £900 ($2,070). 10.VI.75

A FAREWELL TO ARMS

with Catherine until she died. She was unconscious all the time, and it did not take her very long to die.

Outside the room, in the hall, I spoke to the doctor, "is there anything I can do to-night?"

"No. There is nothing to do. Can I take you to your hotel?"

"No, thank you. I am going to stay here a while."

"I know there is nothing to say. I cannot tell you——"

"No," I said. "There's nothing to say."

"Good-night," he said. "I cannot take you to your hotel?"

"No, thank you."

"It was the only thing to do," he said. "The operation proved——"

"I do not want to talk about it," I said.

"I would like to take you to your hotel."

"No, thank you."

He went down the hall. I went to the door of the room.

"You can't come in now," one of the nurses said.

"Yes I can," I said.

"You can't come in yet."

"You get out," I said. "The other one too."

But after I had got them out and shut the door and turned off the light it wasn't any good. It was like saying good-by to a statue. After a while I went out and left the hospital and walked back to the hotel in the rain.

THE END

· 355 ·

ERNEST HEMINGWAY
A Farewell to Arms
First edition, inscribed by the author with extensive revisions to text, New York, 1929
New York $5,250 (£2,282). 21.I.75

H. L. DUHAMEL DU
MONCEAU
*Traité des Arbres et
Arbustes*
7 volumes, with 497
plates after Redouté
and Bissa, printed in
colour and finished by
hand, bound in
contemporary red
morocco for Francis I,
Emperor of Austria,
Paris, [1800]–1819
London £21,000
($48,300). 17.VI.75
From the collection
formed by the late
Arpad Plesch

Photographs

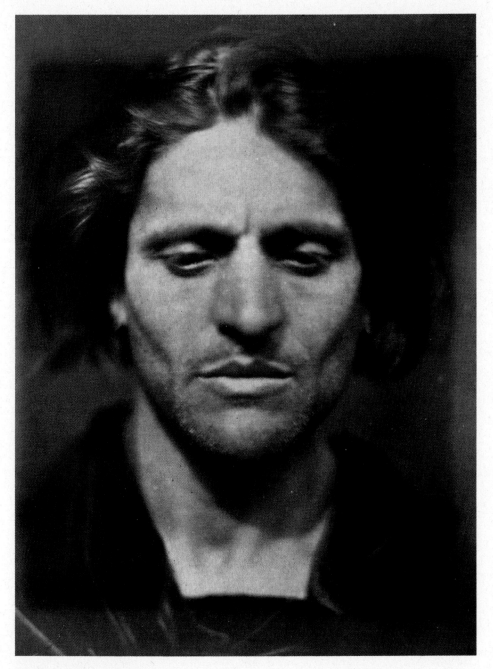

JULIA MARGARET CAMERON
Iago study from an Italian
A photograph from an album of ninety-four presented by Mrs Cameron to Sir John
Herschel in November 1864, 334mm by 248mm
London £52,000 ($119,600). 18.X.74

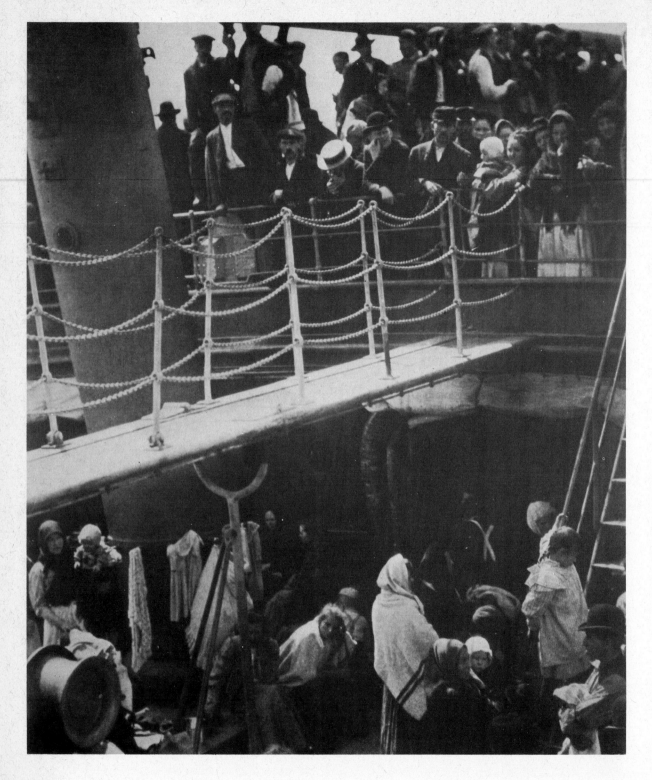

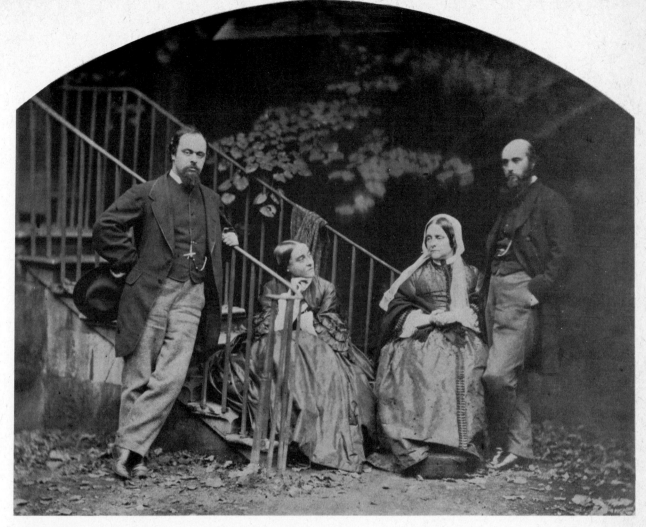

LEWIS CARROLL
Group portrait of Dante Gabriel, Christina, William Michael and Mrs Rossetti
Arched top, mounted on card, 7 October 1863, 162mm by 201mm
London £920 ($2,116). 18.x.74

Opposite page
ALFRED STIEGLITZ
The steerage
Specimen proof of the large format photogravure as published with Volume 7/8 of *291* in 1915,
312mm by 254mm
New York $4,500 (£1,957). 25.II.75
Stieglitz himself described this photograph as follows: *A round straw hat, the funnel leaning left, the stairway leaning right . . . round shapes of iron machinery, a mast cutting into the sky . . . I saw a picture of shapes and underlying that the feeling I had about life,* and for the rest of his life considered it to be his finest work

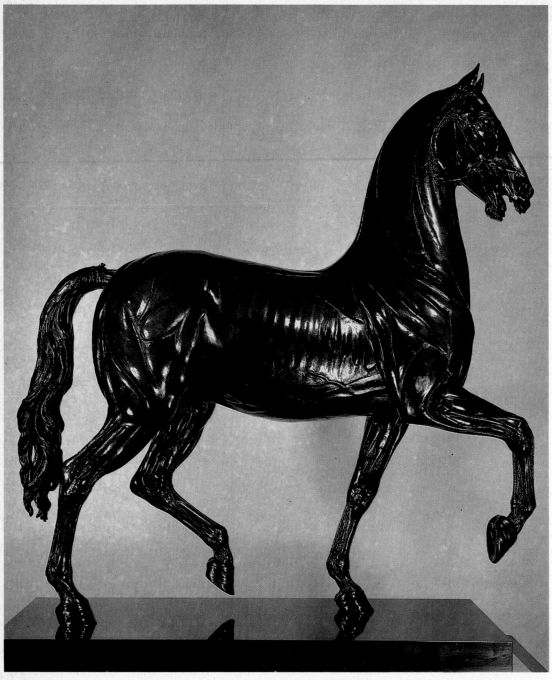

A Florentine bronze figure of a horse from the Bologna-Susini workshops, late sixteenth/early seventeenth century, height 3ft
Fr1,500,000 (£161,290: $370,967).
In 1587 a bronze equestrian statue of Cosimo I de' Medici was commissioned from Giovanni da Bologna, who while collaborating with Ludovico Cigoli and Goro Pagani in the design, was assisted by Antonio Susini in the casting of the monument. The group was finally completed and placed in the Piazza della Signoria in 1594. It has been suggested by Dr Dahnens, and in reference by Sir John Pope-Hennessy, that the large model of an anatomical horse, formerly in the Loeser Collection and now in the Palazzo Vecchio, was one of the studies for the equestrian group and dates from about 1588.
The fine patina, technical excellence and finish of the present bronze would indicate that it is a cast of slightly later date from the Bologna-Susini workshops

Monte Carlo

Charete Watson del Castillo

Anybody entering the lofty Art Deco rooms of the Winter Casino in Monte Carlo at the end of May this year, and seeing the contents of the Redé-Rothschild sale, unusually well displayed, might have been excused for wondering: why Monte Carlo?

The principality has many claims to fame but, until now, it has certainly not been the centre of even a small international art market and no comparable sale has ever taken place there. It is, nevertheless, the only place in France, given its particular status, where a foreign auctioneer could hope to organise a sale. Both the two collectors and Sotheby's can congratulate themselves that due to their sophisticated analysis of the art market and their willingness to take a calculated risk the Redé-Rothschild sale at Monte Carlo was such a success.

Staged by Sotheby's the auction had the giddy atmosphere of a Gala at the Paris Opera. The reasons for the success, despite a mood of resigned pessimism in various sectors of the art market, were certainly less superficial. For once all the necessary elements were present: prestige, taste, known provenances and unusual works of art. From the very beginning everything augured well. Important dealers fought for good hotel rooms and, amidst the non-stop flow of local visitors, one could spot those international clients who obviously were not exclusively preoccupied by the gaming tables or their suntan. The only question left unanswered was how far could Sotheby's and the sellers' openly positive attitude inspire a genuine renewal of confidence.

The works of art themselves were not only of outstanding quality but also had rarely, if ever, been seen in salerooms. The collection came from two sources only, both of which had their own aura. In the last twenty years Alexis de Redé had formed in his field one of the finest collections in Europe. He was himself in constant contact with dealers and fellow collectors and, in addition, his very name had that magic appeal of well-known social personalities. The Rothschild label with its unique connotations speaks for itself.

Carefully divided into three sections, the first part of the sale included small and delicate works of art: hardstone and gold snuff-boxes and an extraordinary collection of gold, hardstone or jewel-handled canes, objects specifically designed to be carried in the hand whether as a luxurious souvenir or as a portable investment. Services of silver plates and some elaborate pieces of metalwork completed this group.

An early indication of what was going to happen became apparent when a Louis XV gold snuff-box, decorated with natural and tinted mother-of-pearl (illustrated p.242), made Fr260,000 (£27,957: $64,301) just after a glittering snuff-box, by Daniel Baudesson, encrusted with simulated white and pink diamonds, the lid decorated with a miniature of Madame Adélaide after Nattier, had doubled the estimated price in making Fr165,000 (£17,742: $40,806).

A German wrought and chiselled iron casket with an intricate locking mechanism of twenty-six bolts.
Two cartouches are engraved with inscriptions which record that the chest was the masterpiece of
Johann Gottlieb Dittman and that the mechanism was invented by Sigmund Gatchen, who worked
with him, dated 1733, height 1ft 8½in
Fr370,000 (£39,785 : $91,506)

Left One of a pair of Sèvres royal portrait plaques set with silver-mounted biscuit medallions of Louis XVI (illustrated) and Marie-Antoinette, 1774, 6½in Fr105,000 (£11,290: $25,968)

Far left A *Palais Royal* souvenir specimen of the rock of Mont Blanc, nineteenth century, 6¾in Fr5,500 (£591: $1,360)

Auctions flourish around spectacular items and the excitement created when they come under the hammer helps to carry along the rest of the sale. When the most important lot came up, a silver-gilt late Gothic cup and cover (illustrated p.268), competition between a Scandinavian Museum and an English buyer pushed the bids up to Fr640,000 (£68,817: $158,279), twice the original estimate. This was a very high price indeed although understandable given the rarity of cups of this period from a Strasbourg workshop, coupled with the fact that the existence of this particular piece was previously unknown even to specialists in the field.

By now it was clear that, in addition to the glamorous presence of the international jet-set, European and American dealers and collectors were at the sale in force, prepared to compete with Iranian and Middle-Eastern buyers, whose economic stimulus is so often relevant nowadays.

On the second day, what could have been the contents of a Renaissance collector's cabinet occupied the afternoon sale: carved ivories and tankards, Baroque jewels, rock-crystal and agate-mounted cups and Italian and Flemish bronzes. The tension was again very high when the first of the two most important bronzes was announced, a Flemish seated Venus by the 'Master of the Genre Figures' which had the special distinction of being marked with the inventory number of French royal collections (illustrated p.227). The price of Fr380,000 (£40,860: $93,978) which it reached was altogether exceptional but the next lot, a Florentine *écorché* horse, *circa* 1600, from the Bologna-Susini workshops, overshadowed it at Fr1,500,000 (£161,290:$370,967). It was the last known example in private hands and, in terms of quality, equal to the two others of a similar date in museum collections. The horse provoked fierce competition between English and Italian buyers who were both obliged to give way to an Iranian collector.

An example *par excellence* of the Rothschild taste for curious and flamboyant objects, an imposing German iron casket decorated with applied figures of Roman warriors in classical niches, with an elaborate locking mechanism, signed with a sigh of relief by its maker, fetched Fr370,000 (£39,785: $91,506). In the final evening sale, and equally typical of the Rothschild taste with its tendency for the biggest and the best, were the four giant Ch'ien Lung armorial vases that had stood formerly in the four corners of the *salon blanc* at the Château de Ferrières. Estimated at Fr120,000 each pair, they were captured by a buyer acting, it is believed, for a Middle Eastern client, for Fr540,000 (£58,065: $133,550).

One of four Ch'ien Lung armorial vases and covers enamelled in
famille rose pallette, the covers moulded with arms which are
probably of the Westphalian family of von Jabath. In the early
nineteenth century they were mounted on ormolu bases and fitted
with ormolu and crystal candelabra, overall height 6ft 4in
Fr540,000 (£58,065 : $133,550)

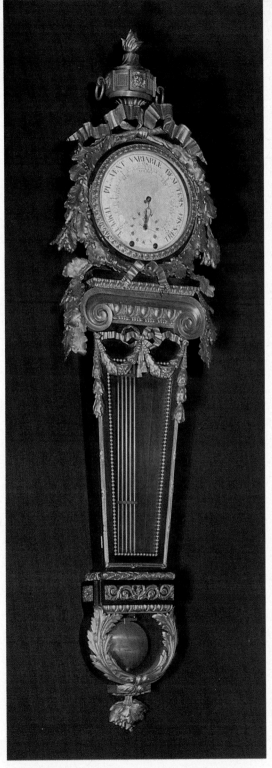

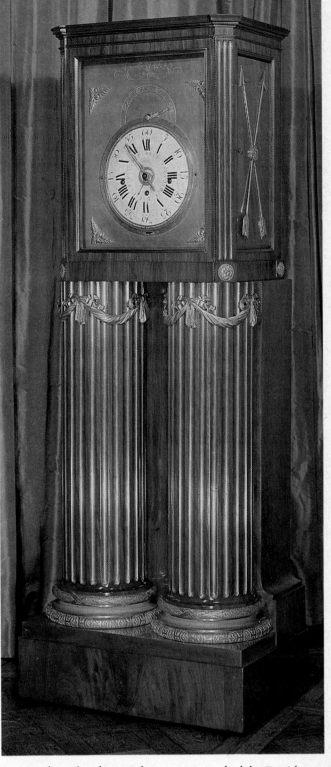

A Louis XVI ormolu-mounted mahogany cartel clock/barometer, the case attributed to Martin Carlin, height 4ft 10in
Fr140,000 (£15,054: $34,624)

An ormolu and mahogany longcase organ clock by David Roentgen, signed *Rontgen et Kintzing, Neuwied*, height 6ft 4in
Fr230,000 (£24,731: $56,882).

Far left
A Louis XV kingwood
prie-dieu (illustrated) and
reading desk *ensuite*, in the
manner of Pierre Migeon,
marked with an *F* beneath
a crown for the Château
de Fontainebleau and the
inventory mark no
435 2, height 2ft 8in
Fr140,000 (£15,054:
$34,624)
Now in the Musée du Louvre

Left
One of a pair of late Louis
XVI *chauffeuses*, one
stamped *G. Jacob*, and with
an ink-written label
M. Thenadey
Fr80,000 (£8,602:
$19,785)

Tapestries, French furniture and ormolu-mounted works of art completed the sale. Here prices were on average high but not always spectacular owing, no doubt, to the fact that three of the most important lots had been refused export licenses by the French authorities. Also by this stage in the proceedings, there was a feeling of slight exhaustion in the auction rooms after all the previous excitement. Nevertheless a pair of incredibly fragile ormolu-mounted ivory urns, probably made by Gouthière for Marie Antoinette, eventually reached Fr320,000 (£34,409: $79,141), despite the somewhat conservative pre-sale estimate of between Fr80,000 and Fr120,000 (illustrated p.289).

Among the group of furniture by or attributed to David Roentgen, an organ clock made Fr230,000 (£24,731: $56,882) and an architectural medal cabinet was sold for Fr240,000 (£25,806: $59,355). Other interesting prices were Fr80,000 for an enchanting pair of *chauffeuses* by Jacob and Fr240,000 (£25,806: $59,355) paid by a Belgian dealer for a romantic Louis XVI console in green marble from the destroyed Château de St Cloud.

Will this sale prove to be somewhat of a flash in the pan? It definitely provided a welcome stimulus and recreated a climate of optimism. Just as the world's economy does not always follow the predictions of its high priests, the art market has its own capricious character. By now one can say that a new trend is becoming apparent: buyers have changed their habits. They come to certain sales knowing exactly what they want, and for this they are prepared to bid heavily. However the day has passed when something is bought speculatively on the assumption that it is going for less than its 'real' market value. Both this eclectic tendency and buyers' confidence were confirmed by the July Impressionist sale in London. So in retrospect Monte Carlo may well prove to have been a watershed in the fortunes of the art market.

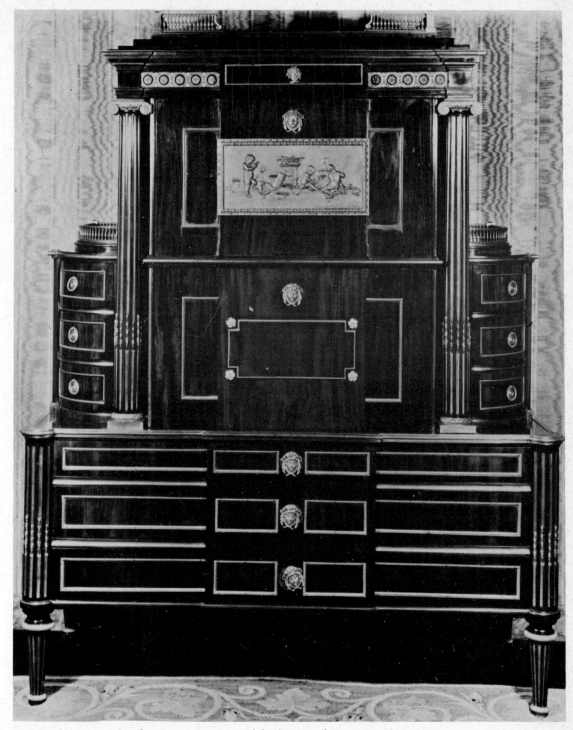

An ormolu-mounted mahogany secretaire medal cabinet in the manner of David Roentgen, the upper front faced with a gilt-metal panel which is probably by Gouthière, height 5ft 10in
Fr240,000 (£25,806:$59,355)

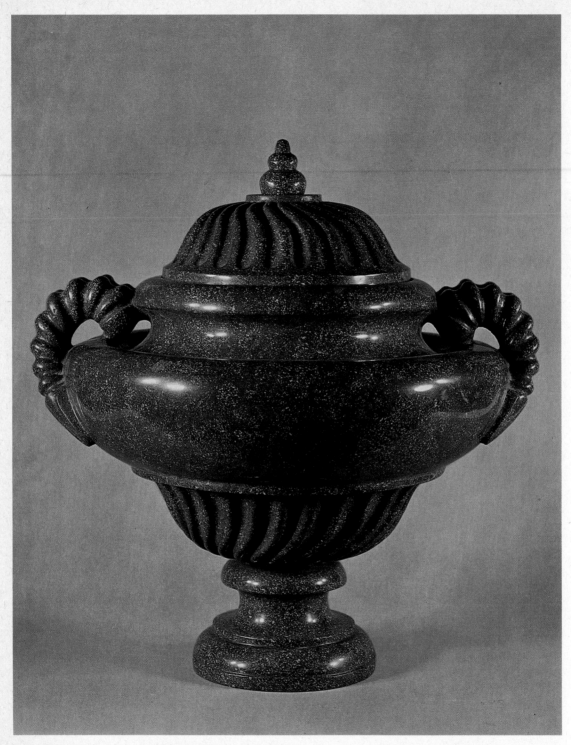

One of a pair of Régence porphyry urns, height 1ft 8in
Fr100,000 £10,753 : $24,731)

Works of Art

217 GOTHIC, RENAISSANCE AND BAROQUE WORKS OF ART
230 NINETEENTH-CENTURY WORKS OF ART
234 ICONS AND RUSSIAN WORKS OF ART
242 OBJECTS OF VERTU
250 MINIATURES

A Rhine-Meuse bronze aquamanile in the form of a lion, early thirteenth century, length 9in
London £8,200 ($18,860). 10.IV.75

A *champlevé* enamel and gilt-copper crucifix, Limoges, thirteenth century, height 2ft
New York $23,000 (£10,000). 21.11.75
From the collection of the late Harriet H. Jonas

A pair of North German oak figures of the Virgin and St John, *circa* 1220, height 5ft 4in
London £36,000 ($82,800). 10.VII.75
From the collection of the late Baron Descamps

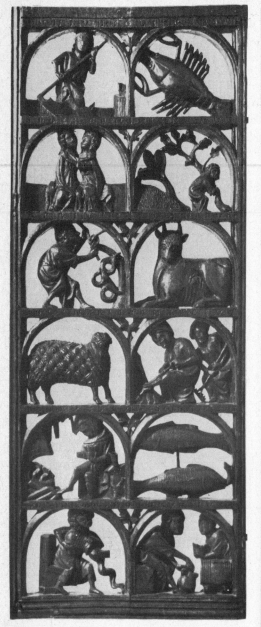

January–June

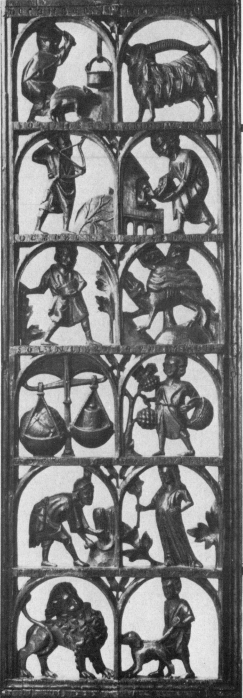

July–December

A pair of Westphalian pierced oak reliefs, mid fourteenth century, width of each 18in, heights 3ft 7½in and 4ft
London £36,000 ($82,800). 10.IV.75
From the collection of Hermann and Maria Schwartz

The reliefs are carved with the months of the year and the accompanying signs of the Zodiac identified by inscriptions

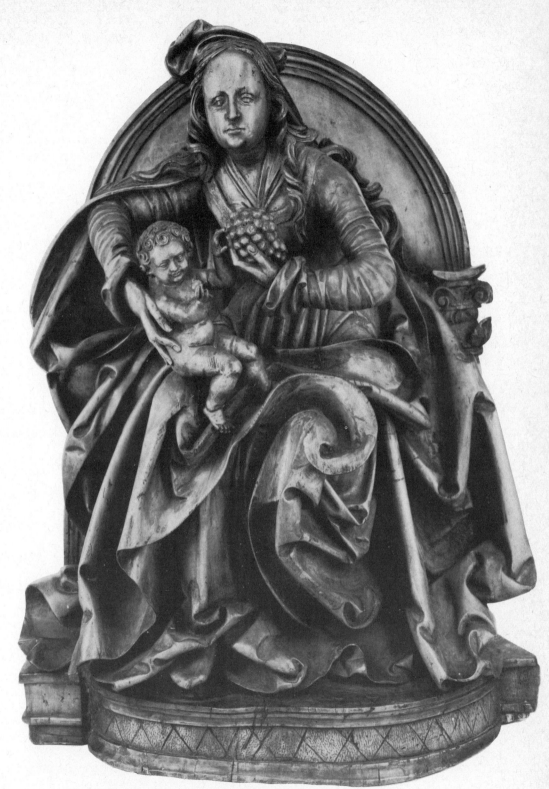

An Austrian limewood group of the Virgin and Child, from the circle of the Meister
von Mauer, *circa* 1515-1520, height 2ft 3½in
London £12,500 ($28,750). 10.IV.75
From the collection of Hermann and Maria Schwartz

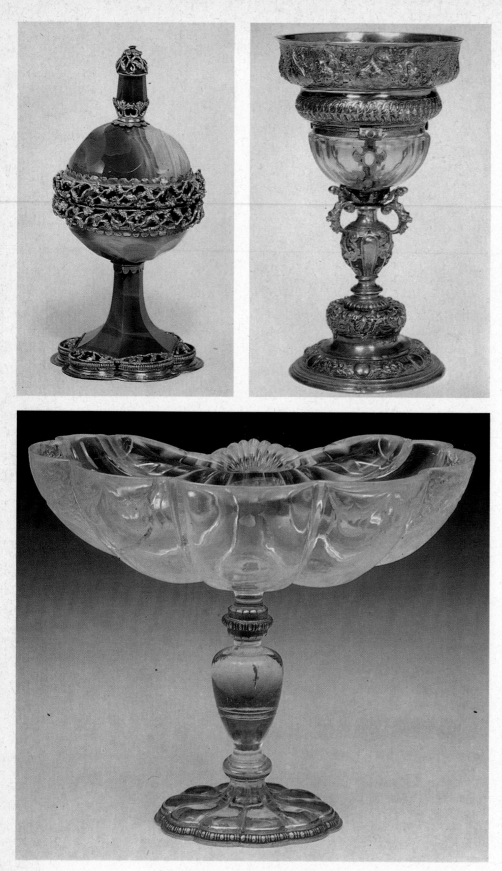

Far left A South German silver-gilt mounted late Gothic agate cup and cover, early sixteenth century, height 6⅛in Fr95,000 (£10,215: $23,495)

Left A silver-mounted rock-crystal cup struck with the town mark of Nuremberg and maker's mark of Elias Lencker, late sixteenth century, height 6½in Fr50,000 (£3,576: $12,366)

A North Italian rock-crystal cup, late sixteenth century, height 6⅛in Fr85,000 (£9,140: $21,022)

These three cups were sold in Monte Carlo on 26 May 1975

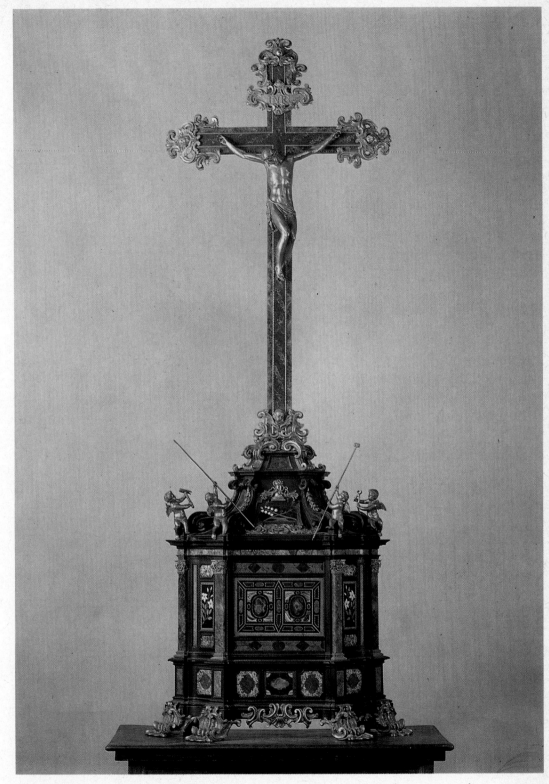

A North Italian crucifix of *pietra dura* and ebony mounted in gilt-bronze, late seventeenth century, height 6ft 2in
Florence L15,000,000 (£9,646: $22,490). 24.X.74

A pair of South German polychromed wood figures of the
Virgin and St John, early sixteenth century, height of
each 1ft 9¾in
New York $6,600 (£2,870). 1.XI.74
From the collection of J. J. Klejman

A Swabian limewood group of St Anne teaching the
Virgin to read, *circa* 1520, height 2ft
London £8,000 ($18,400). 10.IV.75

A South German walnut figure of the
Good Thief, possibly Augsburg,
circa 1520, height 8½in
London £2,200 ($5,060). 10.IV.75
From the collection of Hermann and
Maria Schwartz
The figure is from a miniature
Crucifixion group, formerly attribu-
ted to the Lower Rhenish school of
Kalkar, but the handling of the
subject seems closer to South German
work, in particular, of the Augsburg
master Hans Schwarz

A Florentine polychrome enamelled
terracotta group of the Virgin and
Child, from the workshop of Della
Robbia, early sixteenth century,
height 4ft 4½in
New York $14,000 (£6,087).
30.V.75
From the collection of Mrs
Bernice McIlhenny Wintersteen

A Florentine bronze group of the Rape of the Sabines,
attributed to the Bologna-Susini workshops, early
seventeenth century, height 1ft 9½in
Monte Carlo Fr110,000 (£11,828 : $27,204). 26.V.75

A Venetian gilt-bronze figure of Fortezza, late
sixteenth/early seventeenth century, height 8¼in
New York $4,000 (£1,739). 1.XI.74
From the collection of J. J. Klejman

A Flemish bronze figure of the seated Venus, by the Master of the Genre Figures, incised with the
French royal inventory no 321 and on the tree stump with the initials
B.M., early seventeenth century, height 7¾in
Monte Carlo Fr380,000 (£40,860: $93,978). 26.v.75

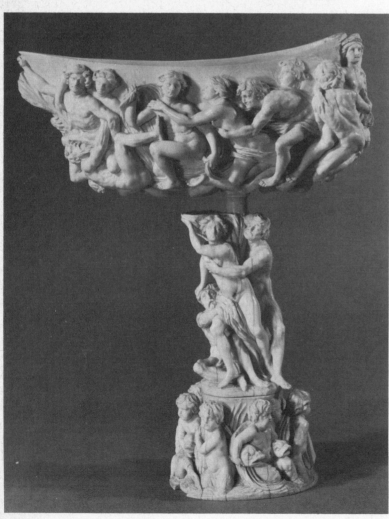

Above left
A late Gothic French ivory comb,
late fifteenth century, 6¾in by 6in
London £7,800 ($17,940).
10.VII.75

Above right
A Nuremberg silver-gilt
mounted tankard with the mark
of Thomas Stoer the Elder, *circa*
1550, height 5⅞in
Monte Carlo Fr38,000 (£4,086:
$9,398). 26.V.75

A Flemish ivory cup or nef, late
seventeenth century, height 15⅜in
Monte Carlo Fr145,000 (£15,591:
$35,859). 26.V.75

A German spoon mounted in silver-gilt, the bowl being of carved wood, mid sixteenth century, length 7in
Monte Carlo Fr22,000 (£2,366: $5,441). 25.V.75

Left A rock-crystal plaque, engraved by Giovanni dei Bernardi, mid sixteenth century, 4¼in by 3½in
London £16,000 ($36,800). 10.VII.75
This hitherto unrecorded plaque depicts Christ driving the money-changers out of the Temple, probably after Pierino del Vaga

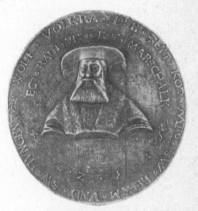

A Flemish carved boxwood diptych rosary bead, *circa* 1500, diameter 2in
London £5,600 ($12,880). 10.VII.75

A bronze portrait medal of Raffaello Maffei da Volterra (1451-1552), by Lysippus the Younger
Florence L4,200,000 (£2,897: $6,662). 14.V.75
This medal is no 110 in the *Guardarobba dell' Ariccia*. The inventory of the Chigi medals was made in 1670 by Carlo Bini for Prince Agostino Chigi

A German pearwood model for a medal, in the manner of Hans Kels the Younger, dated 1527
London £4,800 ($11,040). 10.IV.75
The bust portrait is of Wolfgang Volkra, an Austrian nobleman. There is no record of the medal ever having being struck

A French bronze figure of the Cheval Turc, signed *Barye*, *circa* 1845, height 7½in
London £2,800 ($6,440). 27.XI.74
The Cheval Turc was listed as one of a pair in Antoine Louis Barye's first catalogue of 1847, but the model was executed in the late 1830's. This small cast is rarer than the larger (11¼in) cast

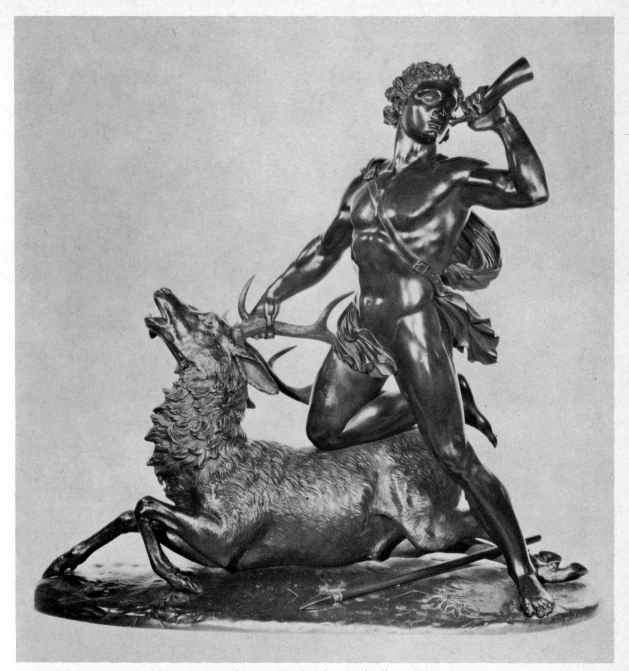

An English bronze group of Huntsman and Stag, signed *Holme Cardwell Fec. Roma, circa* 1855,
height 2ft 8in
London £1,400 ($3,220). 27.XI.74
Holme Cardwell was born in Manchester in 1815, and after studying at the Royal Academy Schools
went to Paris in 1841 to study under P. J. David. Eventually he made his home in Rome where much
of his best work was executed.
The original marble group of 'Huntsman and a Stag' was exhibited at the 1857 Manchester Exhibition
of Art Treasures of the United Kingdom

From left to right above
An English bronze figure
of Comedy and Tragedy,
by Sir Alfred Gilbert,
circa 1890, height 1ft 1½in
London £800 ($1,840).
27.XI.74
An English bronze figure
of Perseus arming, by Sir
Alfred Gilbert, *circa* 1885,
height 1ft 2¼in
London £620 ($1,426).
27.XI.74
An Australian bronze
figure of Circe, signed
B Mackennal, circa 1895,
height 2ft 1in
London £1,800 ($4,140)
19.III.75

Left A pair of French
bronze and *brèche violette*
marble busts of Flora and
Ceres, attributed to
Charles Cordier, *circa* 1870,
height 3ft 11½
London £6,500 ($14,950).
11.VI.75

Above
A Russian bronze steeplechase group, by Eugène Lanceray, late nineteenth century, length 1ft 4½in
New York $5,750 (£2,500). 9.V.75

Right
A French bronze allegorical group of an episode from the war of 1870, inscribed *Gve. Doré*, late nineteenth century, height 4ft 10in
New York $3,700 (£1,609). 5.IV.75

Below
A Russian silver equestrian group, by Ivan Chlebnikov, signed *A. Safonof*, circa 1890, length 9⅝in
Los Angeles $6,750 (£2,935). 5.V.75

A Russian icon of the raising of Lazarus, Novgorod school, *circa* 1500,
29¼in by 28½in
London £6,200 ($14,250). 9.VI.75

Opposite page
A Russian icon of St Paraskeva, surrounded by panels of scenes from her
life, Novgorod school, sixteenth century, 32¾in by 25½in
London £9,800 ($22,540). 9.VI.75

A Russian icon of St John the Evangelist,
Novgorod school, early sixteenth century,
22½in by 14½in
London £3,200 ($7,360). 9.VI.75

Above left
An icon of the Old Testament Trinity, Moscow
school, sixteenth century, 13in by 11in
London £3,000 ($6,900). 9.VI.75

Left
A Balkan icon of St Demetrios, probably
Romanian, sixteenth century, 17½in by 12½in
London £2,100 ($4,830). 9.VI.75

An iconostas panel of the Mother of God
of the Deisis, Central Russian, sixteenth
century, 52½in by 22½in
London £5,400 ($12,420). 9.VI.75

Above right
A Russian icon of Christ Pantocrator
with a gilded-silver okhlad by Pavel
Ovchinnikov, Moscow, both *circa* 1900,
10⅞in by 9in
New York $11,000 (£4,783). 11.XII.74

Right
A Russian icon of the Virgin and a group
of saints, seventeenth century, with a
gilded-silver and cloisonné enamel
okhlad by Yakov Mishukov, late
nineteenth century, 13in by 10¾in
New York $10,000 (£4,348). 11.XII.74

From left to right
A gilded-silver and enamel presentation bowl, height 7⅛in
$26,000 (£11,364)
A gilded-silver and shaded enamel punch bowl and ladle, height 16½in
$36,500 (£15,870)
A gilded-silver and enamel bowl, height 7⅞in
$22,000 (£9,565)
From the collection of Augustana College, South Dakota
These bowls were made by Pavel Ovchinnikov, Moscow, *circa* 1900, and were sold in New York on 10 December 1974

Opposite above
Imperial presentation silver, gold, enamel and niello tray, inscribed *True Bokhara* and dated 1911, length 18in
$4,000 (£1,739)

Opposite below
A set of twelve silver-gilt and enamel demi-tasse cups, saucers and spoons by the Eleventh Artel, Moscow,
the porcelain liners to the cups by Kornilov, St Petersburg, *circa* 1900, height of cups 2¼in
$27,000 (£11,739)
From the collection of the Evergreen House Foundation
The objects illustrated opposite were sold in New York on 9 May 1975

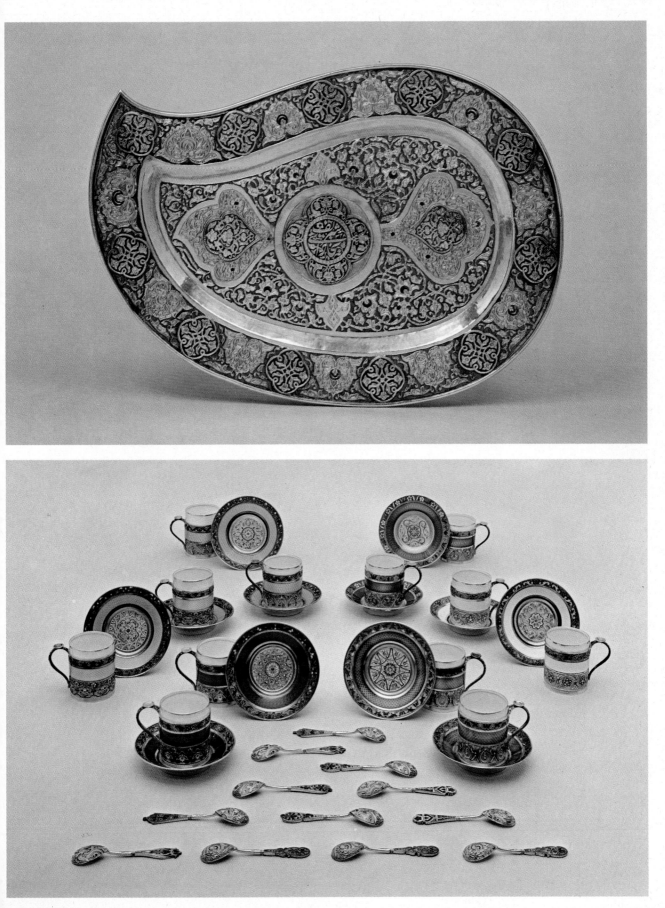

1. Silver and shaded enamel punch service by Orest Kurliukov, Moscow, late nineteenth century, height of punch bowl 10in $13,000 (£5,652) 9.v.75 **2.** Silver-gilt and enamel liqueur service by A. I. Kuzmitchev, Moscow, 1891, height of decanter 10¼in $27,000 (£11,739) 9.v.75 **3.** Shaded enamel and silver-gilt presentation vase and cover by Ivan Chlebnikov, Moscow, *circa* 1913, 10¾in $18,000 (£7,826) 20.XI.74 **4 & 5.** Silver tea-glass holder and spoon by Nichols & Plinke, St Petersburg, mid nineteenth century, 3¼in $1,660 (£722) 9.v.75 **6.** One of a pair of Imperial porcelain plates from the Orloff service, 1762-1796, 9in $3,400 (£1,478) 10.XII.74 **7.** Fabergé gold and enamel photograph frame, workmaster Michael Perchin, St Petersburg, *circa* 1900, 3in $6,000 (£2,609) 9.v.75 **8.** Fabergé gold, enamel and agate snuff-box, workmaster Henrik Wigström, St Petersburg, *circa* 1900, height 1⅜in $11,000 (£4,783) 9.v.75 **9.** A silver fruit bowl stamped *Fabergé, Moscow*, 13¾in $2,800 (£1,217) 5.v.75 **10.** Fabergé rock-crystal jewelled dish symbolising sun and moon, St Petersburg, *circa* 1900, 4⅜in $7,750 (£3,370) 10.XII.74

From left to right
Above A jewelled and gold-mounted nephrite cigarette case, workmaster Henrik Wigström, 3¾in by 2¾in
$3,000 (£1,304)
A translucent enamel and two-colour gold table clock by Ivan Britzin, 5¾in by 3⅜in $2,250 (£978)
A gold cigarette case set with rubies and diamonds, workmaster Henrik Wigström, 3¾in by 2⅜in $6,000
(£2,609)
Below A nephrite and two-colour gold-mounted dish, height 1in $4,100 (£1,783)
A green jasper figure of a frog, height 1½in $1,200 (£522)
A gold, diamond and translucent enamel cigarette box by Henrik Wigström, 3½in by 2in $3,500 (£1,522)
The Fabergé objects illustrated on this page were made in St Petersburg, *circa* 1900, and were sold in New
York on 10 December 1974

A gold and mother-of-pearl snuff-box, probably French, mid eighteenth century, 3¼in
Fr 260,000 (£27,957: $64,301)

Opposite page
Above
A Louis XV mother-of-pearl snuff-box, Fermier Général Louis Robin, Paris 1743, 3⅛in
Fr 80,000 (£8,602: $19,785)
Centre
A gold-mounted hardstone snuff-box by Johann-Christian Neuber, Dresden *circa* 1770, 3⅜in
Fr 95,000 (£10,215: $23,495)
Below
A Louis XV Japanese lacquer snuff-box, maker's mark *GIG* or *CIC,* Fermier Général Julien Berthe,
Paris 1750, 3½in Fr 70,000 (£7,527: $17,312)

The objects illustrated on these pages were sold in Monte Carlo on 25 May 1975

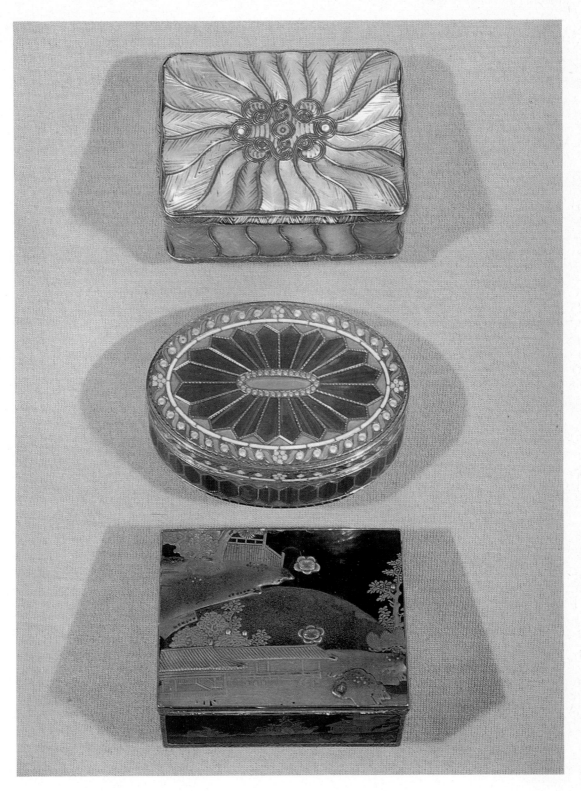

From left to right
A German gold-handled cane, *circa* 1750, length 35¾in
A French ivory-handled malacca cane, late eighteenth century, length 36½in
An ivory and lapis lazuli cane, Paris 1838–1847, length 35½in
A Fabergé rock-crystal cane handle, workmaster Michael Perchin, late nineteenth century, length of cane 33½in
A silver salamander-handled walking stick stamped *LALIQ*★★ and overstamped with Moscow *kokoshnik* for 1908–1917, length 35in
These are a selection from the thirty-two canes sold in Monte Carlo for a total of Fr 385,000 (£41,398: $95,215) on 25 May 1975

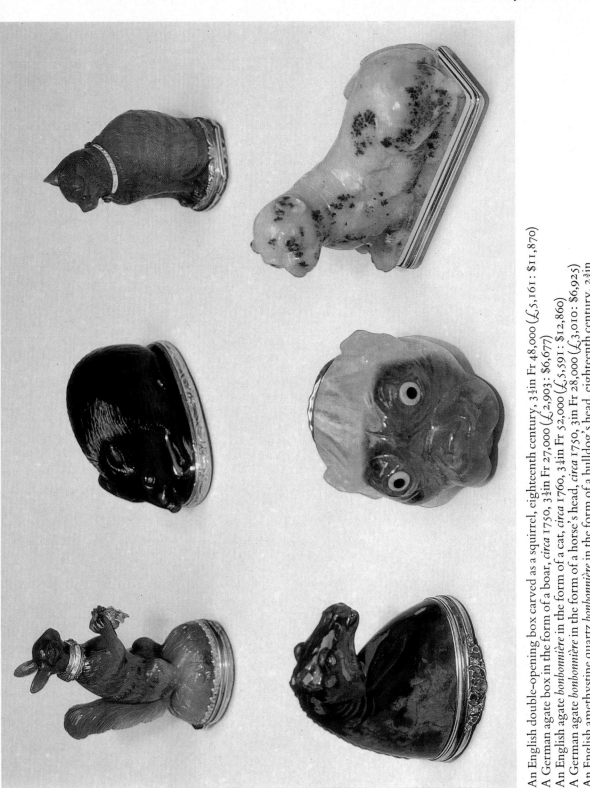

An English double-opening box carved as a squirrel, eighteenth century, 3¼in Fr 48,000 (£5,161 : $11,870)
A German agate box in the form of a boar, *circa* 1750, 3½in Fr 27,000 (£2,903 : $6,677)
An English agate *bonbonnière* in the form of a cat, *circa* 1760, 3¾in Fr 52,000 (£5,591 : $12,860)
A German agate *bonbonnière* in the form of a horse's head, *circa* 1750, 3in Fr 28,000 (£3,010 : $6,925)
An English amethystine quartz *bonbonnière* in the form of a bulldog's head, eighteenth century, 2¾in Fr 15,000 (£1,613 : $3,710)
A German onyx box in the form of a pug, *circa* 1750, 3¼in Fr 42,000 (£4,516 : $10,387)
The boxes on this page were sold in Monte Carlo on 25 May 1975

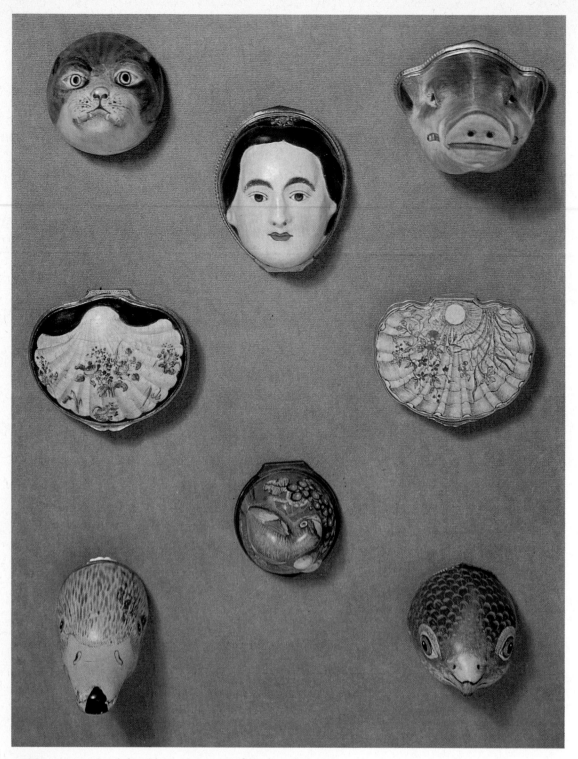

A Bilston enamel cat's head *bonbonnière*, 2in £400 ($920)
A Bilston enamel *bonbonnière* of Flora MacDonald, 3in £380 ($874)
A Bilston enamel boar's head *bonbonnière*, 3in £440 ($1,012)
A Birmingham enamel shell *bonbonnière*, 3in £360 ($828)
A Cantonese enamel shell snuff-box, *circa* 1750, 3in £680 ($1,564)
A Bilston enamel duck's head *bonbonnière*, 3in £400 ($920)
A Bilston moulded *bonbonnière* decorated with a parrot perched on a grape vine, 2in £360 ($828)
A Bilston enamel hawk's head *bonbonnière*, 2¼in £420 ($966)
The boxes illustrated on this page were sold in London on 21 October 1974

A Birmingham enamel transfer-printed fable plaque, *circa* 1760, 4in
London £2,000 ($4,600). 9.VI.75
Formerly in the collection of the late Hon Mrs Nellie Ionides

Above left
A gold-mounted glass snuff-box engraved on the rim *Vachette Bijer. à Paris* and marked 1795–1797
and 1819–1838, 3⅜in
London £5,700 ($13,110). 2.VI.75
Above right
A three-coloured gold Swiss presentation musical snuff-box inset with an enamel miniature of
Alexander I of Russia by Laval, Geneva 1815–1825, 3½in
London £5,900 ($13,570). 2.VI.75

A Louis XV gold snuff-box by Jean-Baptiste Devos, signed *Govers à Paris,* Fermier Général Jacques Cottin, 1730, 3in
London £10,000 ($23,000). 20.1.75

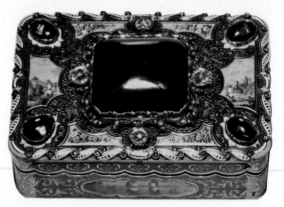

A Swiss gold and enamel snuff-box set with jewels, *circa* 1820, 3⅜in
New York $7,500 (£3,261). 10.VI.75

A Swiss gold and enamel musical snuff-box which has a watch concealed by a panel at one end, *circa* 1820, 3½in
New York $15,000 (£6,522). 19.II.75

A bloodstone, gold and diamond snuff-box probably German, early nineteenth century, 3⅝in
New York $14,500 (£6,304). 25.IV.75

A London gold-mounted *nécessaire,* circa 1760, 3½in
London £3,700 ($8,510). 9.VI.75

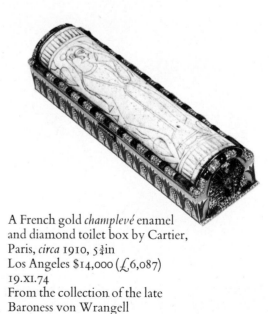

A French gold *champlevé* enamel and diamond toilet box by Cartier, Paris, *circa* 1910, 5¾in
Los Angeles $14,000 (£6,087) 19.XI.74
From the collection of the late Baroness von Wrangell

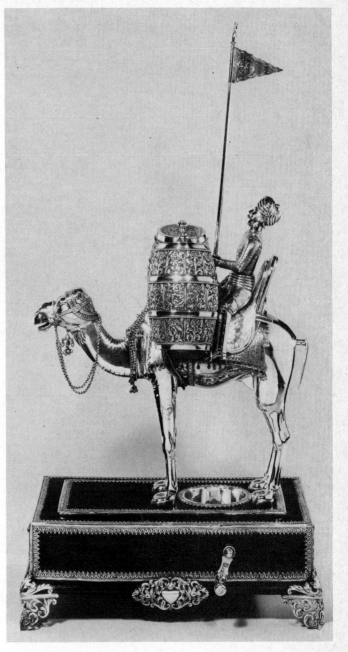

A Hermann Böhm Viennese enamel, lapis lazuli and silver-gilt ostrich casket and stand, late nineteenth century, height 27in
London £4,500 ($10,350). 7.XI.74

An Indian silver tea urn engraved *M.T.*, mid nineteenth century, height 28¼in
Monte Carlo Fr 62,000 (£6,667: $15,333). 25.V.75

Above A miniature of a young gentleman by George Engleheart, signed with initial, 3⅛in London £750 ($1,725). 2.VI.75

Right A continental miniature of a nobleman, *circa* 1700, 3¼in London £600 ($1,380). 10.III.75

A miniature of Miss Boswell Preston by Richard Cosway, 2¾in London £1,400 ($3,220). 10.III.75 Formerly from the Pierpoint Morgan Collection

A miniature of a lady by John Smart, signed and dated 1799, 3¼in London £2,200 ($5,060). 10.III.75

A miniature of John Samuel Hudson Esq by George Engleheart, signed and dated 1810, 3⅜in London £560 ($1,288). 25.XI.74 From the collection of Miss Brown-Wilkinson

A miniature of a young lady by
Richard Cosway, 2¾in
London £420 ($966). 25.XI.74

Above A miniature of Captain
George Lewis Hamilton by
Andrew Plimer, 3in
London £820 ($1,886). 10.III.75

Left A miniature of Elizabeth Penn
by George Engleheart, *circa* 1783,
1⅞in
London £620 ($1,426). 25.XI.74
From the collection of
Jack D. Goetze

A miniature of a lady, possibly Mrs George
Hamilton, by Andrew Plimer, 3in
London £400 ($920). 10.III.75

A miniature of a youth by Andrew Plimer, 3in
London £520 ($1,196). 2.VI.75

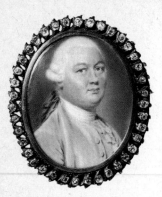

Left
A miniature of James Bruce Esq by John Smart, signed
and dated 1776, 1½in
London £2,000 ($4,600). 25.XI.74
From the collection of Jack D. Goetze
Right
A miniature of a lady by Nicholas Hilliard, *circa* 1600,
1½in
London £10,000 ($23,000). 2.VI.75
From the collection of Mrs Clement Williams

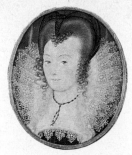

A pair of miniatures of a lady and gentleman by John
Smart, both signed and dated 1777, each 1½in
London £2,750 ($6,325). 2.VI.75

A miniature of the Hon Frederick Sylvester
Douglas (1791-1819) as a young boy by Henry
Burch, 3in
London £880 ($2,024). 25.XI.74
From the collection of Jack D. Goetze

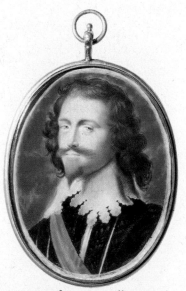

A miniature of George Villiers, Duke of
Buckingham, by John Hoskins, 2⅛in
London £2,600 ($5,980). 25.XI.74

Arms and Armour

A French Empire enamelled gold hilted court sword, traditionally made for the Duc de Cambacérès, the locket signed *Manufre à Versailles, Entreprise Boutet, Paris,* maker's mark *JM,* early nineteenth century, length 37¾in
Monte Carlo Fr 95,000
(£10,215 : $23,494).
25.V.75
Jean-Jacques Cambacérès (1757-1824), a leading politician during the French Revolution and Empire, was second only to Napoleon in the government of France from 1799 to 1815. He was appointed second Consul to Napoleon in 1799 and held the office of *Archi-Chancelier* with the title of the Prince of Parma

Far left
An English close helmet,
mid sixteenth century
London £1,300 ($2,990).
15.X.74
From the collection of
Her Majesty's Tower of
London

Left
A Milanese chanfron,
circa 1570–1580
London £650 ($1,495).
11.II.75

Right
A complete composite suit
of German fluted armour,
struck with the
Nuremberg mark,
circa 1520–1540
London £2,800 ($6,440).
15.X.74
From the collection of
Her Majesty's Tower of
London

Left
A German three-quarter
black and white armour,
late sixteenth century
London £1,700 ($3,910).
15.X.74
From the collection of
Her Majesty's Tower of
London

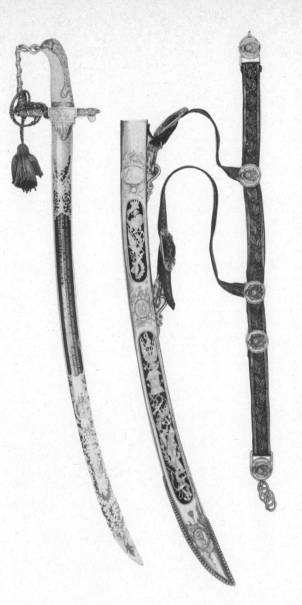

Left
A Hundred Pound Lloyd's Patriotic Fund naval sword presented to Conway Shipley, Commander of *HMS Hippomenes,* signed *R. Teed Sword Cutler Lancaster Court Strand,* 1804, length 34½in
London £5,200 ($11,980).
17.XII.74

Right
An Italian knightly sword, *circa* 1500, length 37½in
London £4,600 ($10,580).
19.XI.74
From the collection of the Counts von Giech

A German crossbow, late seventeenth century, length 28in
London £1,050 ($2,415). 13.V.75

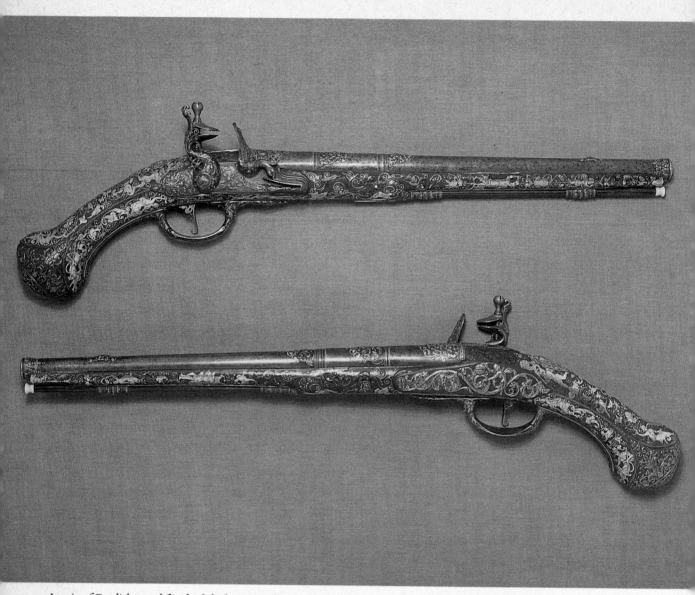

A pair of English royal flintlock holster pistols signed *Monlong Londini*, the barrels in three stages, chiselled with masks and winged figures, the muzzle rings chiselled with acanthus leaves and inlaid with gold, the locks with demi-figures, masks and scrolls terminating in heads, the cock screws chiselled with a portrait bust, the full-length walnut stocks carved in low relief with scrolls terminating in serpents' heads and inlaid with figures in cut and engraved silver sheet. There are minor differences in ornament on the two pistols. *Circa* 1690-1700. Length 20⅝in
London £78,000 ($179,400). 17.XII.74
From the collection of Anne, Duchess of Westminster
Pierre Monlong was appointed *Arquebusier de la Maison du Roi* in 1664 at the court of Louis XIV. He came to England as a Huguenot in 1684 and was made Gunmaker in Ordinary to William III about 1689 and died in 1701. These pistols were probably made for William III and the portrait on the cock screws may represent him

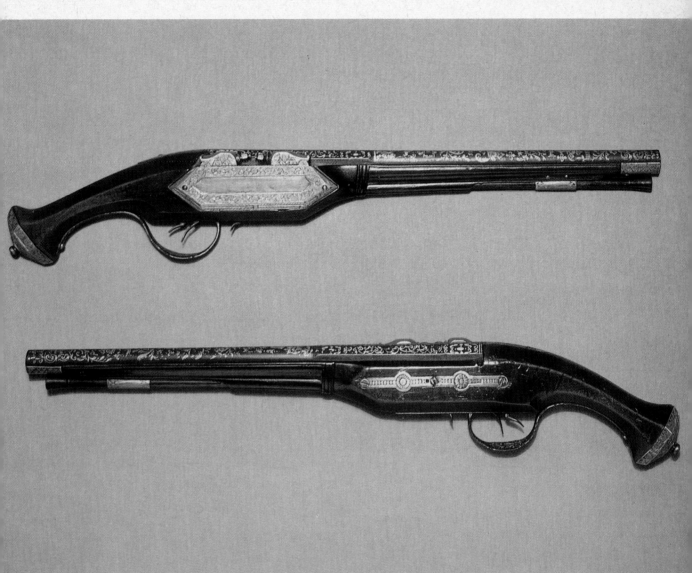

A pair of French superimposed load waterproof wheel-lock holster pistols, firing two superimposed charges, by Pierre Bergier of Grenoble, made for Louis, Dauphin of France, later Louis XIV. The barrels in two stages, octagonal and round, damascened in gold with scrollwork and fleur-de-lys with Minerva on one barrel, Mars on the other. The barrels also have motto inscriptions, and the barrel tangs the monogram *HO* or *OH*. The bronze lock-plates have two separate enclosed wheel-locks invented by Bergier. The winding squares are accessible through hinged caps on the left side of the stocks which are of ebonised pearwood. The furniture is of gilt-copper but for the steel trigger guards, damascened in gold. *Circa* 1638-1643. Length 20½in
London £26,000 ($59,800). 17.VI.75
From the collection of the late William Goodwin Renwick
The combination of crowned dolphins and fleur-de-lys only refers to a Dauphin of France. Louis XIV was born in 1638 and became king in 1643. The pistols must have been ordered for his son by Louis XIII, who was a patron of Bergier

A French royal flintlock fowling piece, signed *Piraube aux Galleries à Paris 1682*,
length 60¼in
London £8,200 ($18,860). 11.11.75
Bertand Piraube was personal gunmaker to Louis XIV

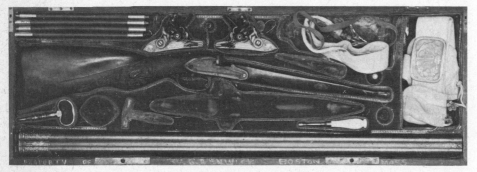

A Spanish double-barrelled combined flintlock and percussion cap fowling piece, signed
Franco. Lopez, Madrid 1832, with fittings and a waist-belt plate with the crowned
monogram of Milosh Obrenovich who was elected Prince of Serbia in 1817 and died in
1860, length 49¾in
London £3,400 ($7,820). 18.III.75
From the collection of the late William Goodwin Renwick

A pair of Brescian flintlock holster pistols signed *Lazarino Cominazzo*, the lock-plates
signed *Pietro Manini Brescia*, second half of the seventeenth century, length 22½in
London £13,000 ($29,900). 18.III.75
From the collection of the late William Goodwin Renwick

A pair of Swiss wheel-lock pistols by Felix Werder of Zürich, mid seventeenth century, length 19⅜in
London £21,000 ($48,300). 18.III.75
From the collection of the late William Goodwin Renwick

A pair of flintlock holster pistols signed *Grice*, London hallmark for 1781, length 16¼in
London £6,200 ($14,260). 17.VI.75
From the collection of Clay P. Bedford

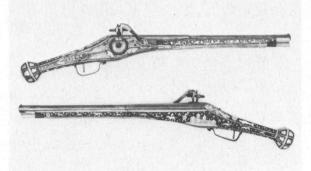

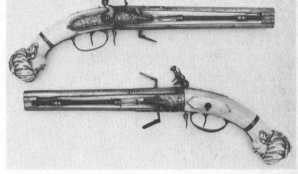

A pair of German wheel-lock holster pistols, late sixteenth century, length 27in
London £42,000 ($96,600). 18.III.75
From the collection of the late William Goodwin Renwick

A pair of Dutch double-barrelled ivory stocked turn-over flintlock pistols, probably Maastricht, late seventeenth century, length 17in
London £6,500 ($14,950). 17.XII.74
From the collection of the late William Goodwin Renwick

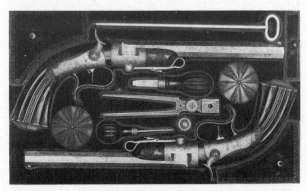

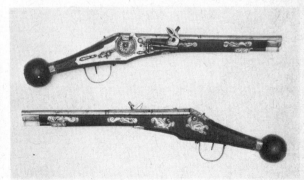

A pair of French rifled breech-loading centre-fire saloon pistols signed *Béringer Bté à Paris*, late nineteenth century, length 15½in
London £1,700 ($3,910). 17.XII.74
From the collection of the late William Goodwin Renwick

A pair of Saxon wheel-lock holster pistols, initialled *I.P.* and engraved with the arms of Saxony, *circa* 1600, length 24½in
London £12,500 ($28,750). 17.XII.74
From the collection of the late William Goodwin Renwick

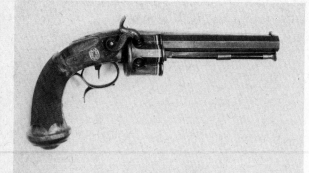

An Italian .62 five-shot percussion Collier style revolver inscribed in gold *Mazza Armiere di S.H.R.Princ. di Salerno,* length 14in
Los Angeles $5,200 (£2,260). 15.IV.75
From the collection of Dr. William R. Funderburg

A Colt model 1851 percussion cap navy revolver stamped *Address. Col. Colt. London,* in original London case with most accessories, length 13¼in
London £1,750 ($4,025). 15.X.74
From the collection of Mrs Ian Galloway

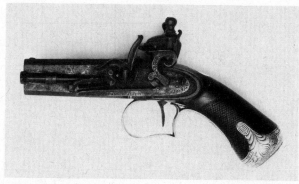

A silver-mounted flintlock repeating pistol with the Lorenzoni action, signed *Grice,* late eighteenth century, length 12¾in
London £5,200 ($11,960). 13.V.75

A double-barrel over and under flintlock pocket pistol signed *J. Egg, London* and engraved with the arms of St Lawrence, Earls of Howth, *circa* 1820, length 6in
London £920 ($2,116). 15.X.74

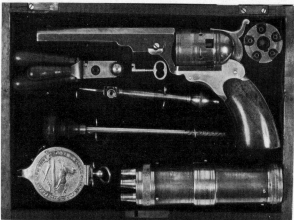

Above French four-barrel revolving flintlock pistol signed *Jean Paul Clett,* late seventeenth century, length 22½in
Los Angeles $6,000 (£2,609). 14.IV.75
From the collection of Dr William R. Funderburg

Right A Colt Patterson .34 belt revolver marked *Patent Arms Mg. Co., Patterson, N.J., Colt's Pt.,* barrel 4⅞in
Los Angeles $14,000 (£6,086). 14.V.75
From the collection of Dr William R. Funderburg

Silver

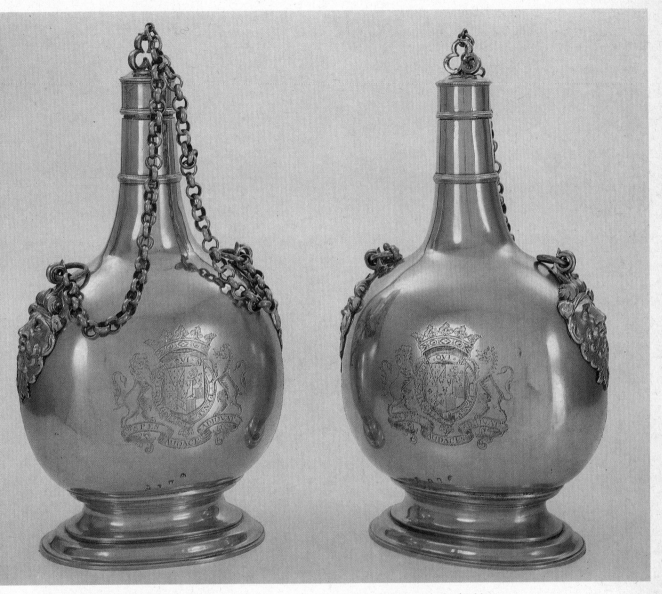

A pair of William III silver-gilt pilgrim bottles, each engraved with armorials flanked by supporters
between ducal coronets and mottoes, maker's mark of Jonathan Bodington, London, 1699,
height 16¾in
London £62,000 ($142,600). 26.VI.75
From the collection of H.R.H. the Duke of Kent, GCMG, GCVO, ADC
The Arms are those of Holles impaling Eastley, Scopham and De Vere with Cavendish in pretence,
all within the Collar of the Garter and below a ducal coronet.
The earliest English pilgrim bottles, or wine bottles as they are later called, known to have survived,
are a pair of circular baluster form, of 1579. The earliest English model of the accepted design,
flattened pear-shape, retained since the Middle Ages, is dated 1663. A strong French influence in the
English examples of the late seventeenth/early eighteenth century is evident from those which have
survived. At this date the large proportions suggest that they were intended for display

An English mazer bowl with silver-gilt rim, unmarked,
fifteenth century, height 2¾in
London £2,000 ($4,600). 24.IV.75

Above right
Two of a set of twelve William III trefid spoons, maker's
mark of Joyce Issod, London, 1698
London £5,200 ($11,960). 12.XII.74
From the collection of the late Galfry William Gatacre

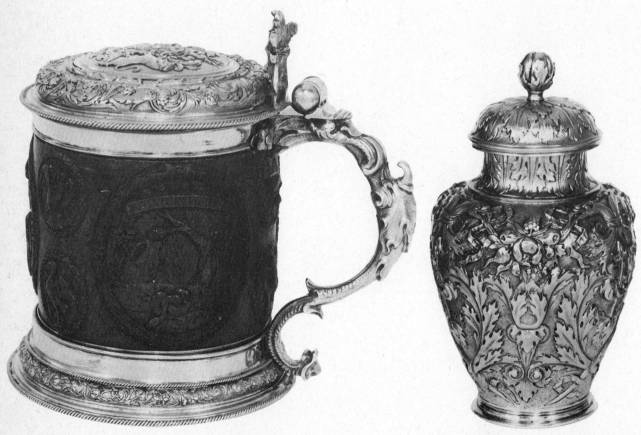

A Charles II silver-gilt and walnut root tankard, maker's mark of
Jacob Bodendick, London, 1664, height 8¼in
London £3,000 ($6,900). 12.XII.74

One of a set of three Charles II silver-gilt
ginger jars, all apparently unmarked,
circa 1675, height 7½in
London £1,900 ($4,370). 12.XII.74

An American fish slice, maker's mark of Joseph Anthony Jnr,
Philadelphia, *circa* 1800, length 12¾in
New York $800 (£348). 29.I.75

An American covered ladle, maker's mark of Basset or William S. Nichols,
Providence or Newport, Rhode Island, *circa* 1810, length 11in
New York $825 (£358). 29.I.75

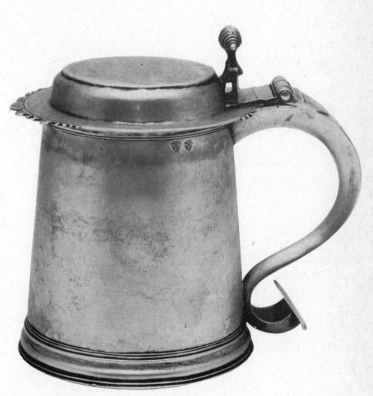

An American castor, maker's mark
of Johannis Nys, Philadelphia,
circa 1710, height 6⅜in
New York $7,500 (£3,260). 5.XI.74

An American tankard, maker's mark of Benjamin Wynkoop, New York,
circa 1720, height 7in
New York $5,400 (£2,347). 26.IV.75

A pair of Charles II candlesticks, maker's mark of Jacob Bodendick, London, 1669, height 12¼in
London £38,000 ($87,400). 12.XII.74
From the collection of the late Galfry William Gatacre

A pair of late seventeenth-century covered jugs, the earlier maker's mark T. I. between escallops, London 1685; the other maker's mark of Philip Rollos the elder, overstruck by that of Thomas Jenkins, London, 1698, height 14in
London £18,000 ($41,400), 20.11.75
From the collection of the late Hon Lady Baillie

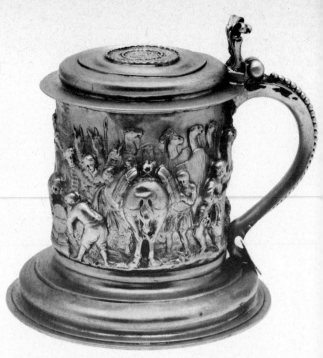

One of a pair of silver-gilt toilet boxes, maker's mark of
Gottlieb Satzger, Augsburg, 1753-1755, height 5½in
Monte Carlo Fr 125,000 (£13,397: $30,813). 25.V.75

A German parcel-gilt tankard, maker's mark M.M.
conjoined, Konigsberg, 1691 or 1695, height 7⅞in
New York $5,400 (£2,348). 26.IV.75

Right
A Dutch sabbath lamp consisting of five parts with foliage and flower relief, maker's mark I. D. I., Amsterdam, 1769
Amsterdam Fl 37,000 (£6,379: $14,672). 19.1.75

Opposite page, below
An eighteenth-century Italian dish, Genoa, 1733, width 13½in
London £2,000 ($4,600). 12.XII.74
An eighteenth-century Italian ewer, Genoa, *circa* 1720, height 9¾in
London £3,800 ($8,740). 12.XII.74

A parcel-gilt cup and cover, probably from the Krug workshop, Strasbourg, sixteenth century, height 18½in
Monte Carlo Fr 640,000 (£68,817: $158,279). 25.v.75

This cup corresponds most closely to the work of the Nuremberg Goldsmith family of Krug, and in particular to the various pieces attributed to Ludwig Krug. There were, however, several members of the family and their individual styles (if they had any) have not yet been distinguished. The presence of the Strasbourg mark suggests that the cup may have been made by Erasmus Krug, who was probably born in the last quarter of the fifteenth century, and moved to Strasbourg where he is first recorded in 1506 and subsequently again in 1519. As the mark dates from the second half of the sixteenth century, the cup may have been made either in Nuremberg or Strasbourg.
The design of the foot and stem is derived from a drawing by Dürer

Opposite above
A south German gold *nécessaire de voyage*, apparently unmarked, probably Augsburg, late eighteenth century
Monte Carlo Fr 60,000 (£6,430: $14,789). 25.v.75

Opposite below
A German gold *nécessaire de voyage*, apparently unmarked, probably Augsburg, eighteenth century
Monte Carlo Fr 67,000 (£7,181 :$16,516). 25.v.75

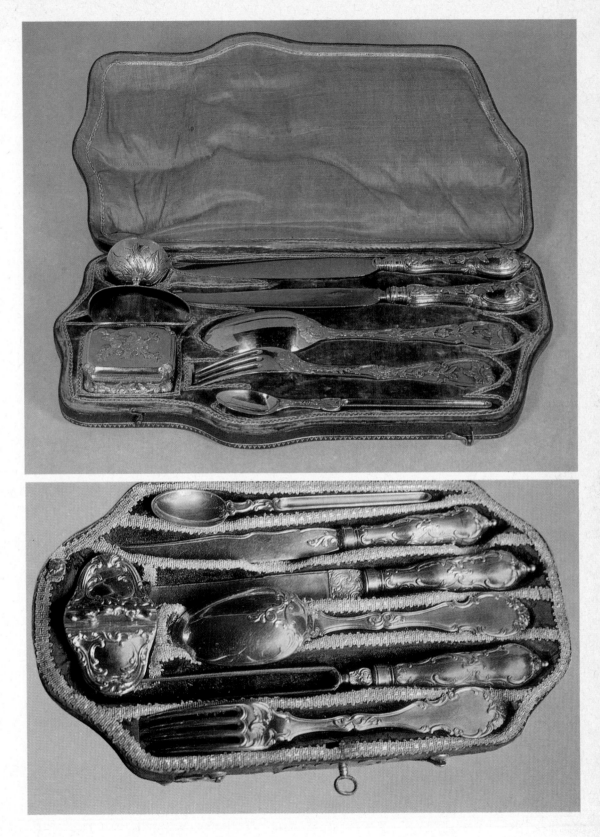

One of a pair of George III soup tureens, covers and stands, maker's mark of Robert Garrard, London, 1810, length of tureen 12⅝in
New York $18,000 (£7,826). 11.VI.75

Left
A set of three George II tea caddies, maker's mark of Edward Wakelin, London, 1751, height 4¼in
Johannesburg R 4,500 (£2,884 : $6,633). 3.III.75

A George IV gold toddy ladle, maker's mark of Crispin Fuller, London, 1823, the bowl centred by a Spanish gold coin dated 1801, the handle of whalebone, length 16¼in
New York $1,600 (£695). 21.III.75

One of a pair of George IV silver-gilt vases, maker's mark
of John Bridge of Rundell, Bridge & Rundell, London,
1827, height 6½in
New York $9,250 (£4,021). 11.VI.75
From designs by John Flaxman with the arms of Thomas
Hope of Deepdene, Surrey

A George III global inkstand, maker's
mark of John Robins, London, 1792,
height 10½in
London £920 ($2,116). 24.IV.75

A George IV silver-gilt oval snuff-
box, maker's mark J. L., London,
1823, width 3in
London £1,000 ($2,300). 20.II.75
From the collection of R. Anstec

A George III silver-gilt thistle cup, maker's
mark of Benjamin Smith I and Benjamin Smith
II, London, 1817, height 6⅜in
Los Angeles $1,100 (£478). 9.XII.74

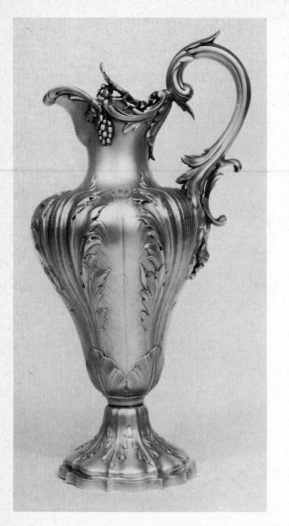

A George III silver-gilt pot-pourri, maker's mark of
Edward Cornelius Farrell, London 1814, diameter 4in
London £470 ($1,081). 20.III.75

Left
A Victorian wine ewer, maker's mark of E., E., J. & W.
Barnard of Edward Barnard & Sons, London, 1838, height
12¼in
London £410 ($943). 10.X.74

Below
One of a set of four Victorian shaped square entrée dishes
and covers, maker's mark of John S. Hunt of Hunt &
Roskell, London, 1844, width 12¾in
London £1,850 ($4,255). 9.I.75

A silver-gilt and gem-set font-shaped cup, monarch's head and lion passant marks only, probably London, *circa* 1820–1830, height 3¼in
London £190 ($437). 7.XI.74

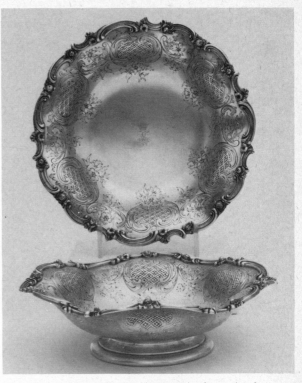

Below
A Victorian tea and coffee set, engraved with the royal armorials of William IV, maker's mark of John Tapley, London, 1836
London £1,450 ($3,335). 3.IV.75

A pair of Victorian fruit baskets, maker's mark of J. S. Hunt of Hunt & Roskell, London, 1843, each 12¼in
London £750 ($1,725). 3.IV.75
From the collection of H.R.H. the late Prince Hermann of Saxe-Weimar

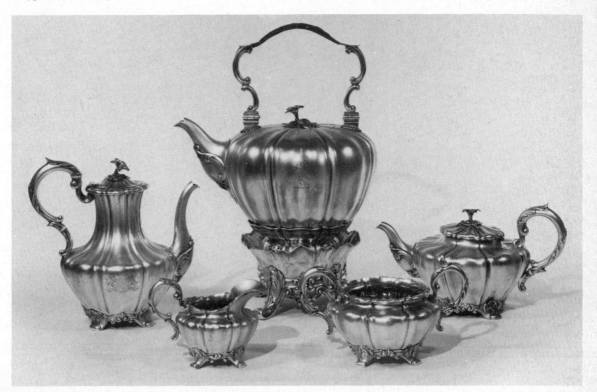

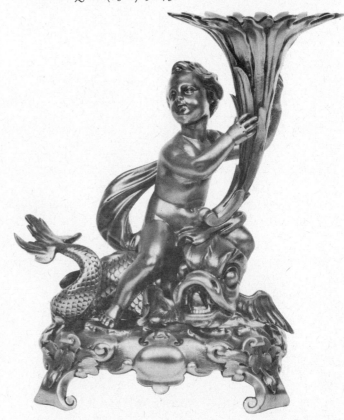

Left
One of a pair of Victorian silver salt cellars, maker's mark
of J. S. Hunt and J. Mortimer of Mortimer & Hunt, late
Storr & Mortimer, London, 1840, height 4in
New York $2,100 (£4,830). 29.1.75

Right
A Victorian mustard pot, maker's mark of James Barclay
Hennell, London, 1878, height 3¼in
London £160 ($368). 9.1.75

A German quartz and silver-gilt centrepiece,
maker's mark of J. H. Werner, Berlin, *circa*
1890, height 10in
London £310 ($713). 9.1.75

A Victorian salt cellar stand, maker's mark of Charles T. &
George Fox, London, 1856, height 6¾in
London £380 ($874). 27.11.75

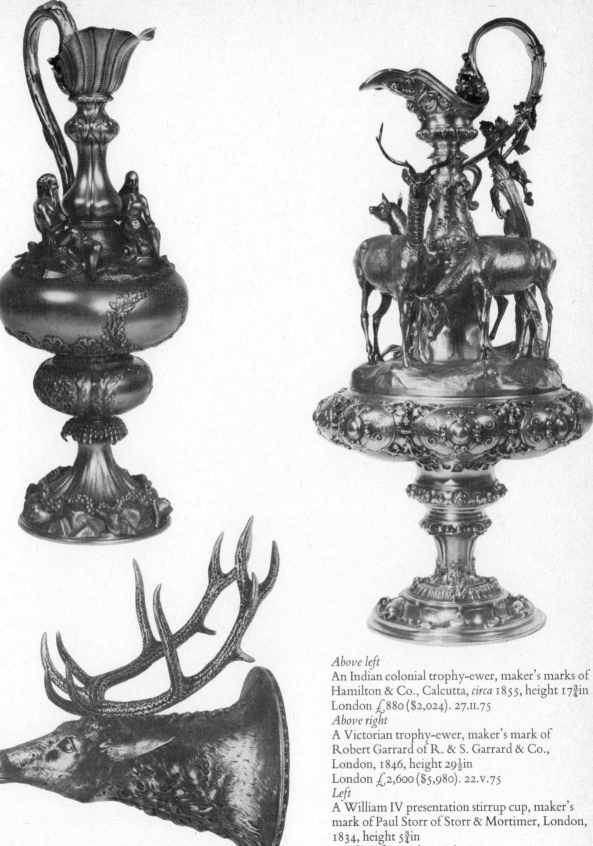

Above left
An Indian colonial trophy-ewer, maker's marks of
Hamilton & Co., Calcutta, *circa* 1855, height 17¾in
London £880 ($2,024). 27.II.75
Above right
A Victorian trophy-ewer, maker's mark of
Robert Garrard of R. & S. Garrard & Co.,
London, 1846, height 29½in
London £2,600 ($5,980). 22.V.75
Left
A William IV presentation stirrup cup, maker's
mark of Paul Storr of Storr & Mortimer, London,
1834, height 5¾in
London £1,950 ($4,485). 12.IX.74

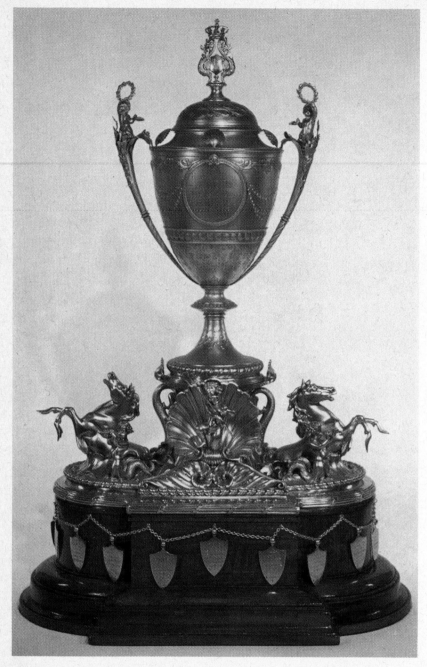

The Royal Victoria Yacht Club International Gold Challenge Cup, maker's
mark of Elkington & Co. Ltd., Birmingham, 1890, height 20in
London £7,000 ($16,100). 3.IV.75

The idea for an International Gold Cup for the Royal Victoria Yacht Club was
first mooted in 1890. By August 1893 the four originators had been presented
with silver medals 'for the trouble they took in making it a successful reality'. In
1911 it was won by the Kaiser who took it back to Germany and an unconfirmed
report states that it was copied in silver-gilt. Some consternation was caused
when only the copy was returned to the Club. The gold cup, however, was
again in evidence for the 1913 season and races for the cup were last held in 1933.
On 27 January 1940 the *Daily Mirror* reported the cup to have 'been sold as old
gold to a firm of London bullion merchants for £500'. The price, however, was
actually £475

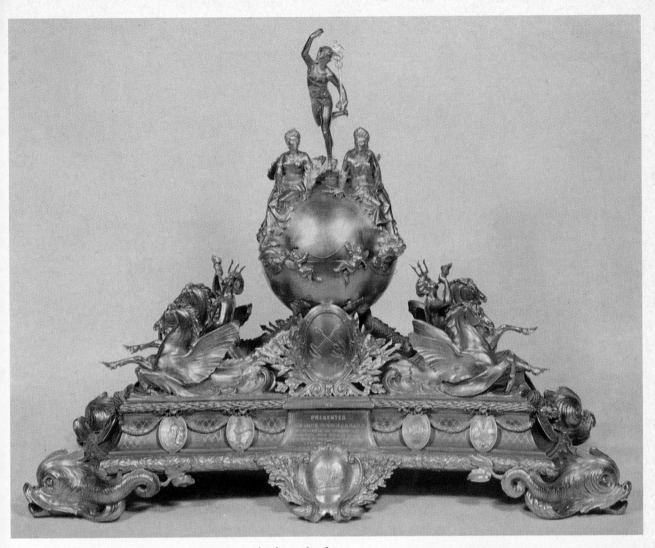

A Victorian presentation centrepiece, maker's mark of
Elkington & Co. Ltd., Birmingham, 1894, height 51½in
London £7,500 ($17,250). 1.v.75
Designed by Auguste Adolphe Willms

Detail

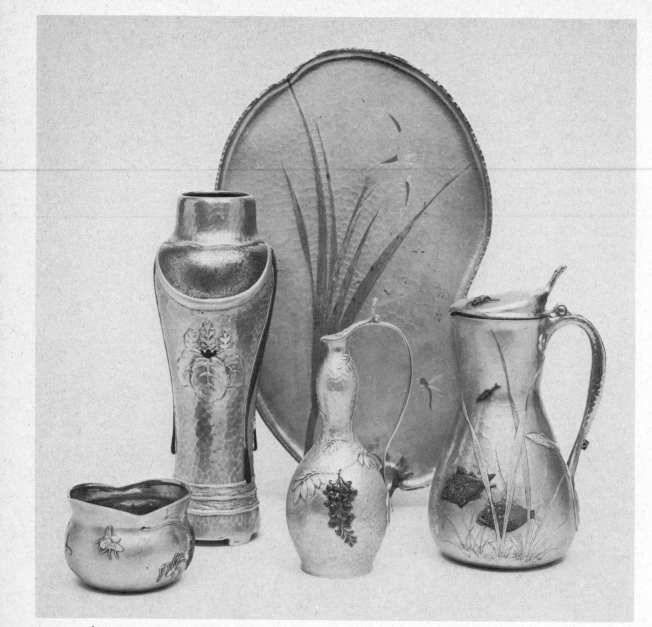

A group of American silver, applied with brass, copper and silver, maker's mark of Tiffany & Co., New York, *circa* 1900:

From left to right
Bowl, diameter 4in $400 (£173); vase, height 11½in $650 (£282); tray, length 16½in $1,200 (£521); small covered pitcher, height 8⅜in $900 (£391); covered pitcher, height 9½in $1,300 (£565)

From the collection of the late Louis de B. Moore sold in New York on 11 June 1975

Coins and Medals

A Greek tetradrachm of Cyzicus, *circa* 360BC Zürich SF16,000 (£2,759 : $6,346). 7.V.75
From the collection of the late Frederick J. Woodbridge

The set of three George III pattern five-guinea pieces. Although of similar design, the issues of 1770 and 1773 are by John Tanner, and that of 1777 is by Richard Yeo, both Chief Engravers to the Royal Mint. Together with the corresponding two-guinea pieces, these six gold coins comprised the first complete series of George III patterns to appear at public auction since 1927.

London £20,000 ($46,000), £18,000 ($41,400), and £20,000 ($46,000) respectively. 26.XI.74

The Douglas-Morris Collection of English Gold Coins

Michael Naxton

When a truly great collection is dispersed in the saleroom, the market, both academic and commercial, is plunged into a *cortège* of feelings ranging from curiosity – through speculation and controversy – to triumph, and even to outrage. Such was the tremendous impact upon the numismatic world when, on 26 November 1974, the Distinguished Collection of English Gold Coins (1700-1900), formed by Captain K. J. Douglas-Morris, RN, was sold in London. Even its critics acknowledged it to be one of the most important sales of the century and it was, beyond doubt, the finest collection of its kind in existence, in public or private hands. It was, in fact, so superlative in every respect that numismatists are unlikely ever to see it equalled now that the coins have been scattered amongst the cabinets of the world.

It is generally agreed that the greatest collection of English pattern and proof coins was that formed by Hyman Montagu during the second half of the nineteenth century, his British coins rivalled only by those being assembled by John G. Murdoch at about the same time. Although Sotheby's (as Sotheby, Wilkinson & Hodge) handled the sales of Montagu's extensive collection after his death in 1895, he had already disposed of his patterns and proofs by private treaty in 1890, thereby presenting J. G. Murdoch with a unique opportunity to acquire many of the finest specimens. When, in their turn, Murdoch's patterns and proofs were sold at Sotheby's in 1904, many of the very same pieces then passed into the third well-known collection of this series which was being formed by Count P. Ferrari, an eccentric Italian. Although Ferrari's German coins were sold later on the Continent, it was decided by his executors that London should be the venue for one sale from his estate and thus 'The Famous & Remarkable Collection of British and Colonial Coins, Patterns and Proofs, Formed by a Nobleman, Recently Deceased' appeared at Sotheby's in March 1922. Of the many auctions held in the intervening half-century, the collections of Reginald Huth (1927), G. Hamilton-Smith (1927), S. A. H. Whetmore (1943), and, more recently, Lady Duveen (1964) have all contained a section of patterns and proofs, but without question Captain Douglas-Morris's collection was the most comprehensive to appear at public auction since that anonymous 'Nobleman' sale over fifty years ago.

In beginning his cabinet of English gold coins, covering the period from the accession of Queen Anne in 1702 to the death of Queen Victoria in 1901, Captain Douglas-Morris's objective had been to assemble as complete a range of coin types as possible, concentrating especially on the patterns and proofs of the series for which no standard work of reference yet exists. Fortunately for numismatics, the Captain was both a connoisseur and a man of purpose, and he accomplished his ambition – a task which had taken his earlier competitors

a lifetime – in only twelve years, beginning in 1962. Therein, quite incidentally, lay the reason for the sale itself – the question most frequently asked in the months leading up to it. It was, quite simply, that the collection had reached a point where the few remaining gaps might never have been filled, even after years of searching. Since, therefore, the owner was also such a perfectionist, the greatest strength of the collection lay in the superb condition of the coins and whilst the patterns and proofs were brilliant, almost without exception, the few currency issues which showed any signs of wear were those of such great rarity that better specimens are virtually unknown.

This is perhaps the place to qualify the terms 'pattern' and 'proof' for whilst there is a general understanding of the motivation behind the collecting of coins, these two rather abstract terms belie their fascination. A 'proof' is an example of a coin adopted for use as currency but struck on a superior flan from specially prepared dies to produce a perfect specimen with a mirror-like or matt surface to further enhance the design. A 'pattern' coin, however, whilst possessing all these attributes has the additional attraction of individuality and often surprising non-conformity. This was the result of the fierce competition for royal and official favour whenever a new coin or whole coinage was projected, and the 'pattern' was the only means to recognition for many young engravers. Similarly, each 'pattern' was, of necessity, strictly limited in number and this obvious and considerable rarity merely adds to their desirability and demonstrates the importance of the Douglas-Morris cabinet. Thus, by concentrating on these two aspects of coinage, the sale was able to show to the widest possible audience the most exclusive grouping of British coin design assembled within living memory, particularly from the Royal Mint's most colourful period (1800-1840). It is a fruitless exercise to attempt to give prominence to the finest and rarest, or even the most celebrated coins in the cabinet, but a special mention should be accorded to John Croker's striking guinea of George I (lot 28, £6,200); Lewis Pingo's famous 'spade' guinea of 1787 (lot 111, £3,200) and his beautiful 'Royal Standard' guineas of 1813 (lots 119 and 120, £3,000 and £2,600); William Wyon's splendid royal portraits of George IV and William IV; Pistrucci's memorable and timeless St George and Dragon; and finally, Wyon's magnificent allegory of Queen Victoria, as Una, leading the British lion to greatness.

The rarity factor raises the question of provenance and its importance in the context of this particular sale cannot be overestimated. What was probably the first of regular public auctions of coins in this country was held by Messrs Baker, Leigh & Sotheby in 1755, when Mr Langford took the sale of Dr Mead's collection, and even a cursory glance through the catalogues of the past two hundred years reveals many examples of the rarer coins in the Douglas-Morris collection. What is often overlooked by the casual reader, however, is that many of these coins are actually the same specimens, continually reappearing after each succeeding generation of collectors, thereby accentuating their extreme rarity. For example, Richard Yeo's pattern two-guineas of 1777 in the sale (lot 129, £9,000) was previously recorded in six well-known collections, beginning with that of J. Halliburton Young in 1881, and extending right into modern times with Captain Vivian Hewitt. This last name is relevant since, although not a collection sold at auction, it illustrates the aim of preserving a complete pedigree wherever possible and the obvious tragedy when this evidence is lost. Some of the lots in the sale, like the 'heavyweight' two-pound and five-pound pieces of George IV, 1826 (lot 167, £3,500 and lot 170, £9,000), are believed to be unique and are those described as such in the Montagu, Murdoch and 'Nobleman' catalogues – the cataloguer can only wonder how many other pieces originated from them but cannot now be proved.

It was decided to present the collection in the accepted chronological manner but instead of heading each new reign with a coin of the largest denomination, this traditional format was reversed and it was a half-guinea of 1702 which started the auction as lot 1. The principal reason for this was the inadvisability of having what was certainly the most sought-after currency coin as the first lot of the sale. In the event, the Queen Anne five-guineas of 'Vigo' type, 1703 – prudently replaced as lot 12 – created a new world record price for a British coin at £26,000, with many existing records in other categories being shattered in the same way. As an auction, it was an overwhelming success and the total of £569,390 for only 237 lots was equally remarkable as the highest figure realised by a single sale of coins in this country. Captain Douglas-Morris's bold attempt at completeness provided an unforgettable opportunity to view the world's choicest assembly of the English gold coinage from 1700 to 1900, and his decision to dispense with any reserves ensured the truest possible indication of desirability. The art of numismatics owes a debt to this determination, and the fact that the final total was an investment triumph worthy of the most experienced financier was entirely coincidental to the original purpose.

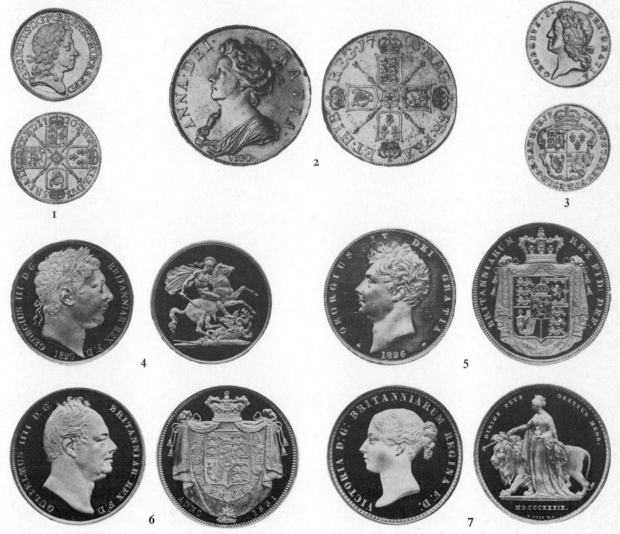

1. George I, guinea, 1720 £1,900 ($4,370) 2. Anne, five-guineas, 1703, Vigo type £26,000 ($59,800) 3. George II, guinea, 1728 £2,800 ($6,440) 4. George III, pattern five-pounds, 1820, St George type £21,000 ($48,300) 5. George IV, pattern five-pounds, 1826 £4,200 ($9,660) 6. William IV, pattern five-pounds, 1831 £16,000 ($36,800) 7. Victoria, pattern five-pounds, 1839, Una and the Lion type £8,500 ($19,550)

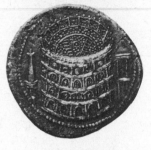

Agrippina, SF9,400
(£1,621:$3,726)

Vitellius, SF7,000
(£1,207:$2,776)

Vespasian, SF2,200
(£379:$872)

Titus, SF20,000
(£3,448:$7,930)

Hadrian, SF3,600
(£621:$1,428)

Antoninus Pius, SF2,600
(£448:$1,030)

Marcus Aurelius, SF5,000
(£862:$1,983)

Lucius Verus, SF4,000
(£690:$1,587)

The Roman bronze sestertii illustrated on this page were from a private collection sold in Zürich
on 7 May 1975

Aegina, stater,
circa 480BC
London £2,900 ($6,670)
10.X.74

Egypt, Ptolemy I, stater,
circa 300BC
London £4,800 ($11,040)
10.X.74

Ancient British, stater,
circa 80BC
London £600 ($1,380)
12.III.75

Australia, Adelaide,
pound, 1852
London £850 ($1,955)
18.IV.75

USA, proof twenty dollars, 1891
London £3,500 ($8,050). 13.XII.74

Charles II, gold coronation medal, 1661
London £1,100 ($2,530). 29.I.75

Poland, Stanislaus Poniatowski,
pattern thaler, 1766
London £1,300 ($2,990). 10.X.74

Henry VIII, London sovereign,
London £3,000 ($7,360). 12.III.75

Zeeland, gold ducaton, 1686
London £2,700 ($6,210). 13.XII.74

The Most Noble Order of the
Garter, (K.G.), Lesser George,
circa 1820
£6,200 ($14,260)

The Most Illustrious Order of
St Patrick, (K.P.), sash badge,
circa 1830
£4,800 ($11,040)

The Most Honourable
Order of the Bath, The
Gentleman Usher's badge,
circa 1820
£2,000 ($4,600)

These three badges were sold in London on 5 February 1975

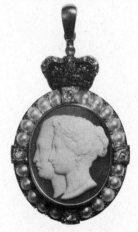

The Most Ancient and Most Noble Order of the Thistle, (K.T.), a pair
of Royal presentation badges awarded to William Hay, 18th Earl of
Erroll, 1834
London £9,500 ($21,850). 9.VII.75

The Royal Order of Victoria
and Albert, Third Class
badge (post 1880)
London £6,500 ($14,950).
5.II.75

Pewter

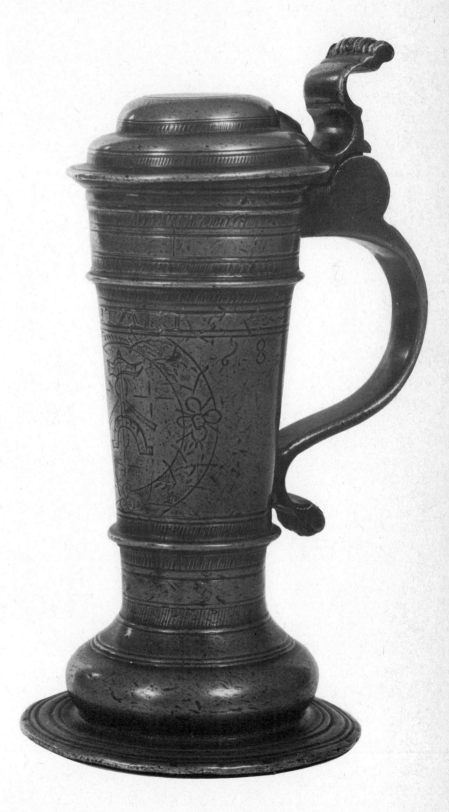

A German guild flagon, with two
makers' marks and town
mark on handle *PS* probably
of Memmingen,
circa 1670, height 8in
London £1,050 ($2,415).
1.v.75

A Stuart tavern mug, maker's
mark in base, with William III
capacity mark struck near lip,
circa 1680–1700, height 5½in
London £800 ($1,840). 17.VII.75

A broad-rimmed dish,
attributed to William Gilly,
circa 1670–1690, diameter 14¾in
London £380 ($874). 17.VII.75
From the collection of the
late J. L. Grant

A German tankard by Hans
Jacob Seifertold of Hall,
Wurtenberg, seventeenth
century, height 7¼in
London £800 ($1,840). 1.V.75

An English baluster measure,
cast mark in mirror writing on
the underside of the lid by
W. Bancks (Cott.no. 240),
circa 1690–1710, height 13in
London £580 ($1,334). 27.II.75
From the collection of
A. R. Drummond

An English broad-rimmed charger, probably
by Thomas Smith (Cott.no. 4386a), *circa* 1670,
diameter 23in
London £680 ($1,564). 1.V.75
From the collection of P. A. Latham

A Swiss flagon or
bauchkanne, maker's mark of
André Utin, of Vevey, mid
eighteenth century, height
14in
London £1,150 ($2,645).
1.V.75

Furniture, Decorations and Textiles

One of a pair of Louis XVI ormolu-mounted
ivory urns, the mounts attributed to Gouthière,
height 12in
Monte Carlo Fr 320,000 (£34,409: $79,141).
26.V.75

An Italian walnut centre table, sixteenth century, 2ft 6½in by 4ft 9in
London £6,100 ($14,030). 6.XII.74

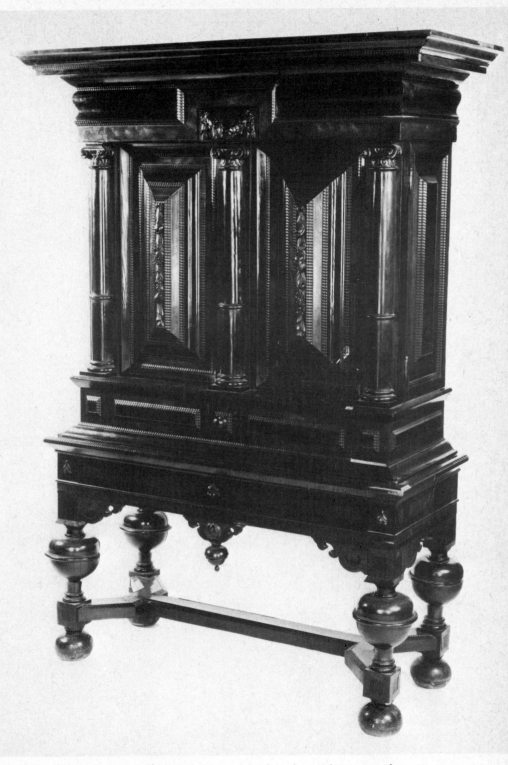

A Flemish cabinet on stand, veneered in ebony and palisander, mid seventeenth century,
7ft by 4ft 11in
London £3,400 ($7,820). 13.VI.75
From the collection of Alan More-Nisbett

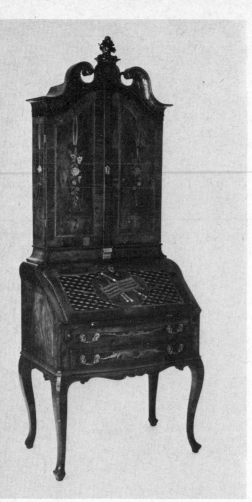

A marquetry bureau cabinet in walnut inscribed
Friedericus Borussorum Rex MDCCLX, mid eighteenth
century, 7ft 2in by 2ft 10in
London £5,800 ($13,340). 13.VI.75

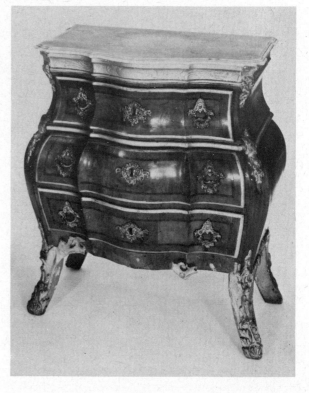

One of a pair of Danish parcel-gilt walnut commodes
each with the trade label of *M. Ortmann* and one with the
pencil inscription *No 3X,* eighteenth century, 2ft 7in by
2ft 5in
London £12,000 ($27,600). 28.II.75

Mathias Ortmann was a famous Danish cabinet-maker of
the mid eighteenth century who usually numbered his
furniture in ink on printed labels inside each item

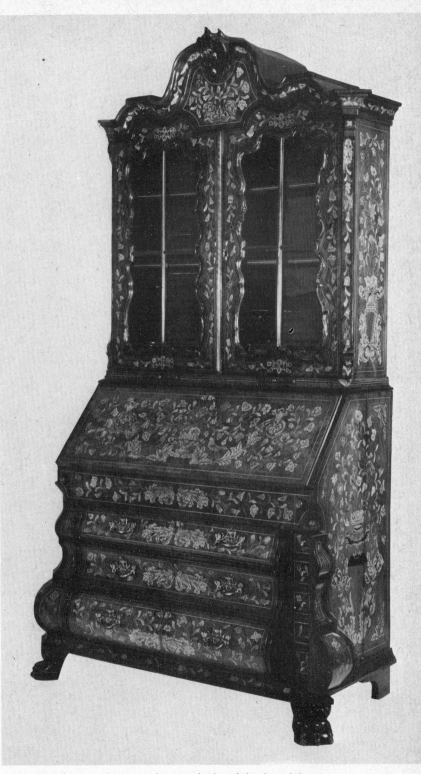

A Dutch marquetry bureau cabinet, inlaid with birds and flowers on a
burr-walnut ground, mid eighteenth century, 8ft 5in by 4ft 7in
London £7,100 ($16,330). 15.XI.74

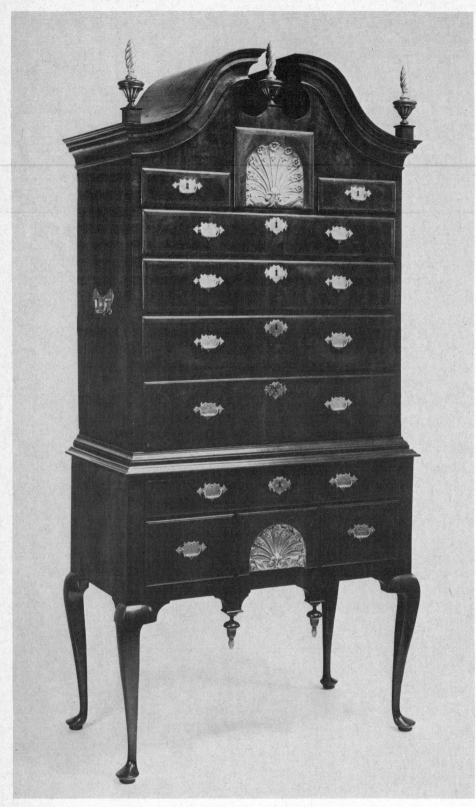

A Queen Anne inlaid walnut gilded-shell bonnet-top highboy, Boston,
Massachusetts, *circa* 1720-1740, height 7ft 3½in
New York $22,000 (£9,565). 16.XI.74

Right
A collection of occupational shaving mugs and
barber bottles comprising forty-three pieces, and
original turned pine rack, Rhode Island and New
York, 1875-1925, height 4ft 6¼in
New York $5,000 (£2,174). 16.XI.74
From the collection of Mrs L. Wister Randolph

Centre
A painted and stencilled pier table, school of
Duncan Phyfe or Charles-Honoré Lannuier,
New York, 1810-1815, 33½in by 40in
New York $10,000 (£4,347). 31.I.75

Below
A Windsor bench of turned maple and pine,
Pennsylvania, *circa* 1780, length 6ft 5in
New York $3,750 (£1,630). 17.V.75
From the collection of Leonard Sillman

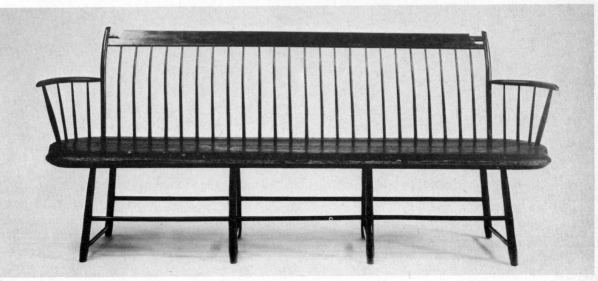

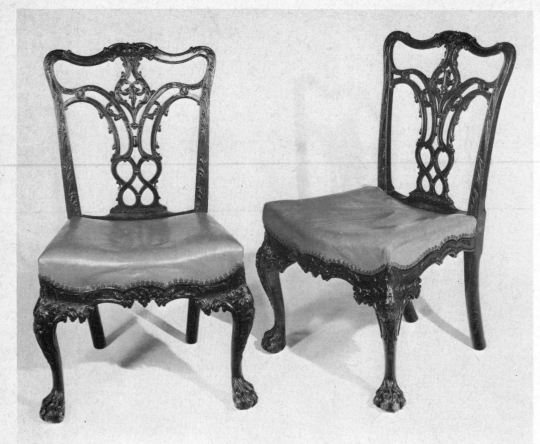

Two from a set of five Chippendale carved mahogany hairy-paw foot side chairs, attributed to
Benjamin Randolph, Philadelphia, *circa* 1770
New York $207,500 (£90,217). 16.XI.74
Benjamin Randolph was a Philadelphia cabinet-maker of the Chippendale period who worked
from about 1760 to 1792. He is considered to be one of the greatest cabinet makers and carvers
in the history of the American decorative arts and is noted for his richly carved pieces of ample
proportions.
There is a similar chair to this set, by Benjamin Randolph, in the collection of the H. F. du Pont
Winterthur Museum, Wilmington, Delaware

Opposite above
One of a pair of George III marquetry commodes in the manner of Pierre Langlois, late
eighteenth century, 2ft 11in by 4ft 7in
New York $41,000 (£17,826). 22.II.75
From the collection of the late Harriet H. Jonas
Pierre Langlois worked in London between 1763 and 1770

Opposite below
George III marquetry and parquetry commode signed and dated *Angelica Kauffman, R. A.
pinxent C. Fuhrloghg fecit MDCCLXXII [sic]*, 3ft 2in by 4ft 8in
London £11,500 ($26,450). 11.IV.75
From the collection of M. P. Knapp
Christopher Fuhrlogh was the Swedish-born *ébéniste* to the Prince of Wales. Angelica
Kauffman (1741-1807) was a founder member of the Royal Academy in 1769 when Sir
Joshua Reynolds, who painted two portraits of her, was president

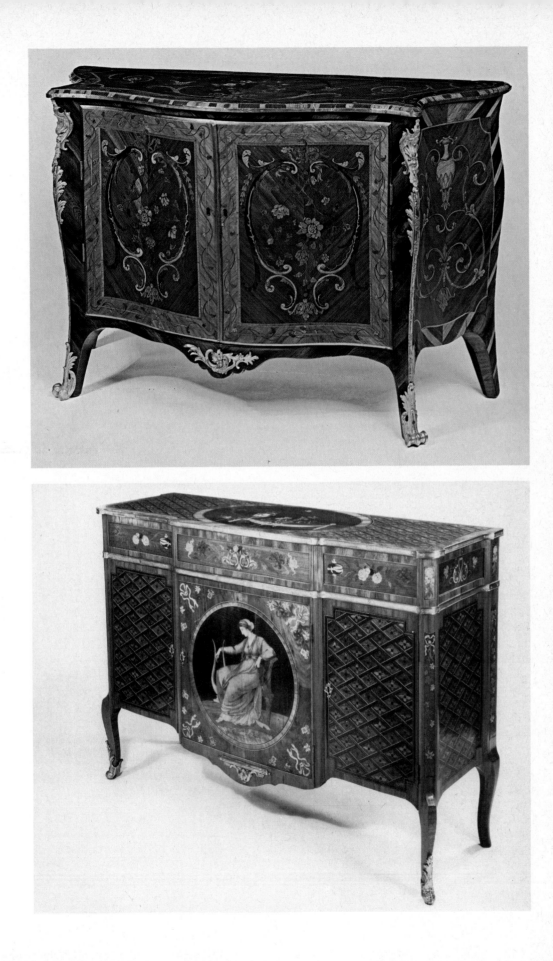

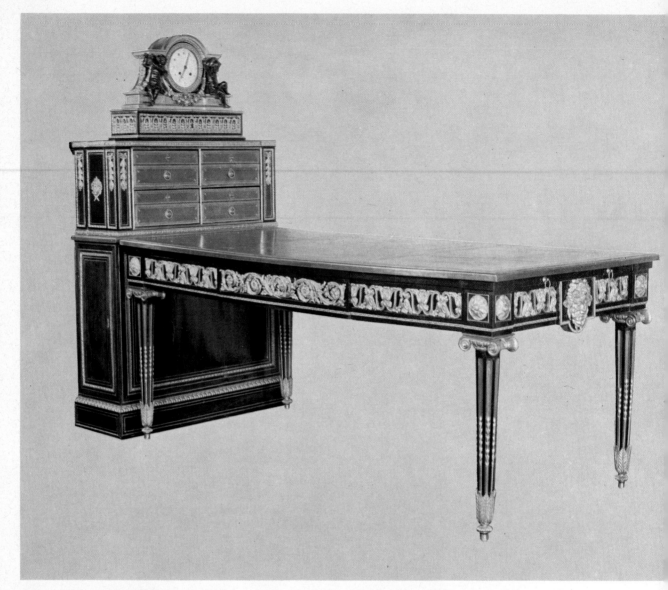

A Louis XVI ormolu-mounted ebony *bureau plat* and *cartonnier*, the *bureau plat* 2ft 8in by 6ft 2in; the *cartonnier* surmounted by a clock, the dial signed *Robin Paris*, the movement signed *Chles Dutertre, Paris*, 5ft 4½in by 3ft 1½in
London £240,000 ($552,000). 13.XII.74
From the collection of the late Hon Lady Baillie. Previously from the collections of the Duc de Choiseul and the Earls of Malmesbury

One of the stationery boxes has a label with the ink inscription: *This table & inkstand belonged to the Duc de Choiseul Prime Minister of Louis XV. They were bought at the sale of his house and effects in 1796 by the first Lord Malmesbury during his diplomatic mission to the Directory at Paris for 100 Louis. A duplicate is at Versailles wh [sic] belonged to the King. Malmesbury.*

Etienne François Duc de Choiseul (1719-1785) gained the favour of Madame de Pompadour, at whose instigation Louis XV employed him as ambassador to Rome in 1753 and as Minister for Foreign Affairs in 1758. From 1770 to 1774, having fallen from favour after the death of Madame de Pompadour, he was compelled to live in retirement. Spending liberally, he amassed a great collection of paintings and works of art

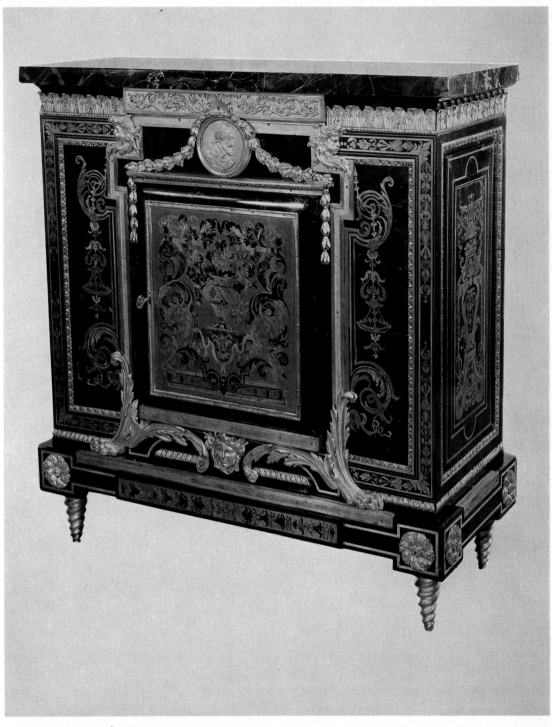

One of a pair of Louis XIV Boulle *meubles d'appui* with Portor marble tops, 3ft 3½in by 3ft 1in
London £55,000 ($12,650). 13.XII.74
From the collection of the late Hon Lady Baillie

These cabinets are evidently based on a drawing in the Musée des Arts Décoratifs attributed to
André-Charles Boulle which shows a matching stand. A closely related cabinet is in the
Musée du Louvre

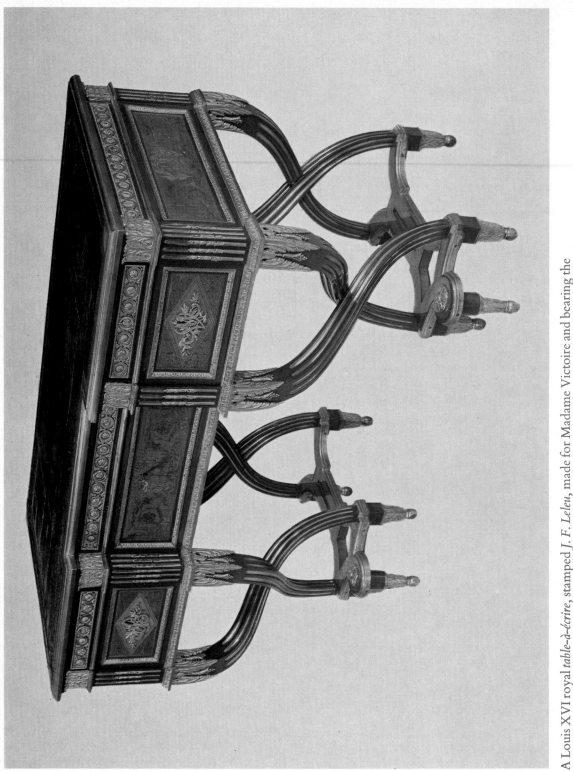

A Louis XVI royal *table-à-écrire*, stamped *J. F. Leleu*, made for Madame Victoire and bearing the
Bellevue château mark, 2ft 4in by 3ft 3in
London £92,000 ($211,600). 13.XII.74
From the collection of the late Hon Lady Baillie
Jean-François Leleu was received Master in 1764

A pair of Louis XVI ebony-veneered *meubles à hauteur d'appui* attributed to Adam Weisweiler, 3ft 2in
by 2ft 1in
London £48,000 ($110,400). 20.VI.75
From the collection of the late Lady D.M. Kroyer-Kielberg

A Louis XV mantel clock in Chinese porcelain, red lacquer and ormolu, both dial and movement
signed *Balthazard à Paris*, 2ft by 1ft 8½in
London £38,000 ($87,400). 13.XII.74
From the collection of the late Hon Lady Baillie

A Louis XIV ormolu chandelier in the manner of A. C. Boulle, 2ft 10in by 3ft 7in
Monte Carlo Fr 350,000 (£37,634: $86,558). 26.v.75

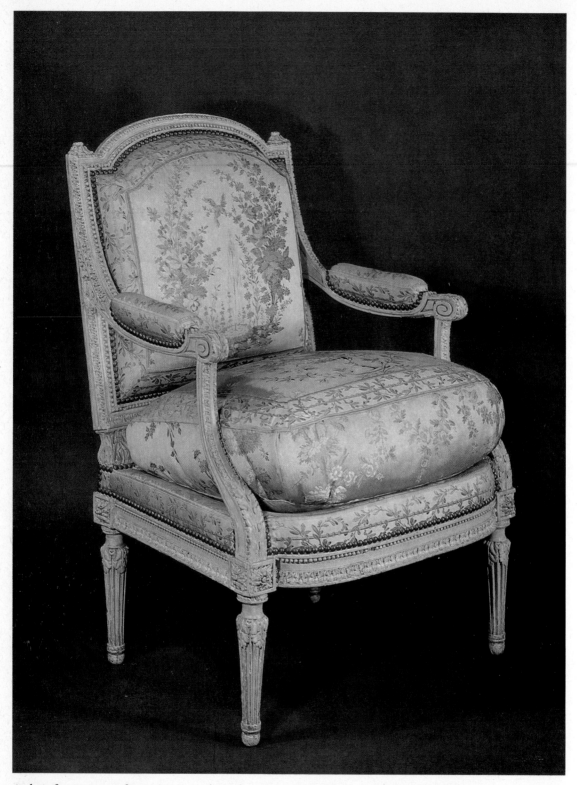

A chair from a suite of Louis XVI royal seat furniture supplied by I. B. Boulard to Madame
Elisabeth, sister of Louis XVI, comprising a canapé, two *bergères*, six *fauteuils*, and a firescreen
Monte Carlo Fr 620,000 (£66,667: $153,334). 26.v.75

1. Louis XIII *fauteuil* £2,800 ($6,440). 13.XII.74
2. George I walnut open armchair $3,750 (£1,630).
5.XI.74 **3.** Louis XV beechwood *fauteuil* stamped
I. B. Boulard £1,050 ($2,415). 13.XII.74 **4.** Régence
walnut *fauteuil* £1,800 ($4,140). 13.XII.74 **5.** Ivory,
gold and silver Caucasian armchair, *circa* 1800,
£4,000 ($9,200). 6.XII.74 **6.** Empire ormolu-
mounted mahogany revolving *fauteuil de cabinet*

Fr 80,000 (£8,602 : $19,785). 26.V.75 **7.** One of a set
of twelve George III mahogany dining chairs
£3,400 ($7,820). 30.V.75 **8.** One of a pair of
Chinese Huang Huali high-backed armchairs
(Kuan Mao Shih) early eighteenth century, $6,250
(£2,717). 25.I.75 **9.** George III painted and gilt-
wood armchair $2,800 (£1,217). 5.XI.74

A French ormolu-mounted kingwood *bureau plat*, mid nineteenth century, 7ft 6in
London £5,200 ($11,960). 27.XI.74

Left
A French ormolu-mounted kingwood parquetry display cabinet, late nineteenth century, 8ft by 4ft 9in
London £5,200 ($11,960). 19.III.75

Right A Sèvres porcelain and gilt
bronze-mounted centre table
nineteenth century, 2ft 7in diameter
London £2,600 ($5,980). 19.III.75

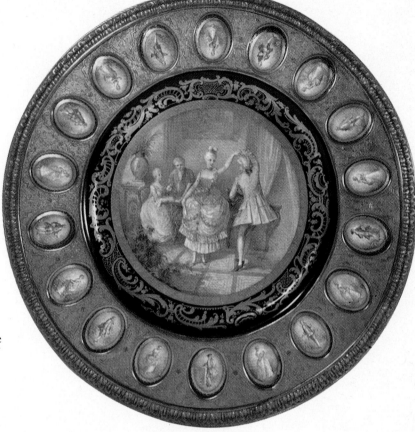

Below One of a pair of *scagliola* table
tops each having a central profile of
Victoria and of Albert, on later
giltwood neo-classical bases, mid
nineteenth century, 5ft 1in by
2ft 7in
London £7,000 ($16,100). 11.VI.75
Formerly in the collection of
Mrs N. Ionides

Indian silver, silver-gilt and enamel throne, Hirji Kanji and Sons,
nineteenth century, height 4ft 9in
New York $8,500 (£3,696). 4.IV.75

Indian silver, silver-gilt and enamel peacock throne, nineteenth century,
height 3ft 10¼in
New York $10,000 (£4,348). 4.IV.75

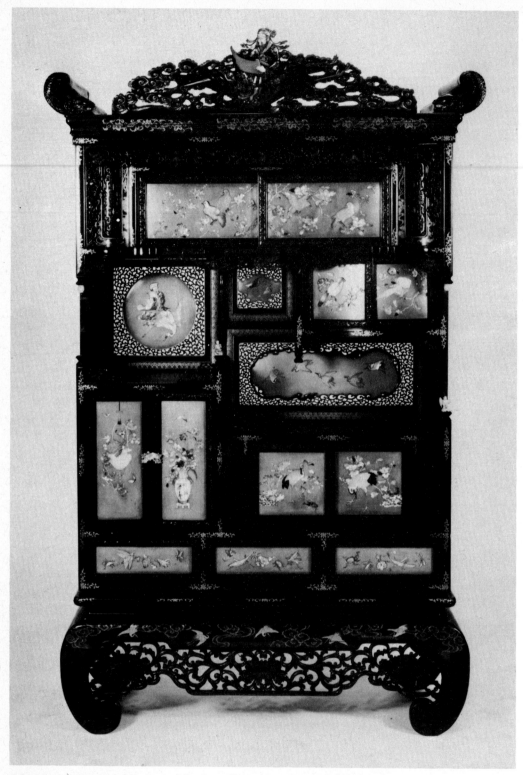

A Japanese lacquer and rosewood display cabinet, *circa* 1870, 6ft 6in by 4ft 3in
London £1,000 ($2,300). 8.v.75

A Holland and Sons satinwood display
cabinet, 1868, 5ft 10½in by 2ft 11½in
London £900 ($2,070). 28.v.75

A Holland and Sons parcel-gilt satinwood
breakfast table, *circa* 1865-1868, diameter 4ft
London £1,400 ($3,220). 28.v.75

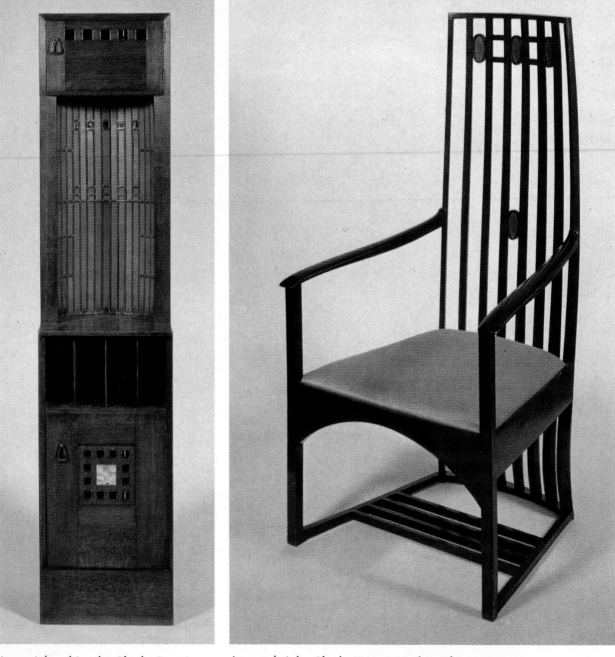

An upright cabinet by Charles Rennie
Mackintosh, *circa* 1905, height 66in
London £2,700 ($6,210). 13.III.75
Constructed in dark stained oak, the
central bowed recess of leaded mauve
glass set with pink and mirrored glass
squares

An armchair by Charles Rennie Mackintosh, *circa* 1905,
height 47in
London £9,200 ($21,160). 13.III.75
Designed for the music room at Hous'hill, Glasgow, the
home of Mackintosh's great patron Miss Catherine
Cranston; the chair is constructed in dark stained wood
with mauve oval glass insets between the tapering slats
which comprise the back. It was designed *ensuite* with a set
of smaller side-chairs and is believed to be unique.

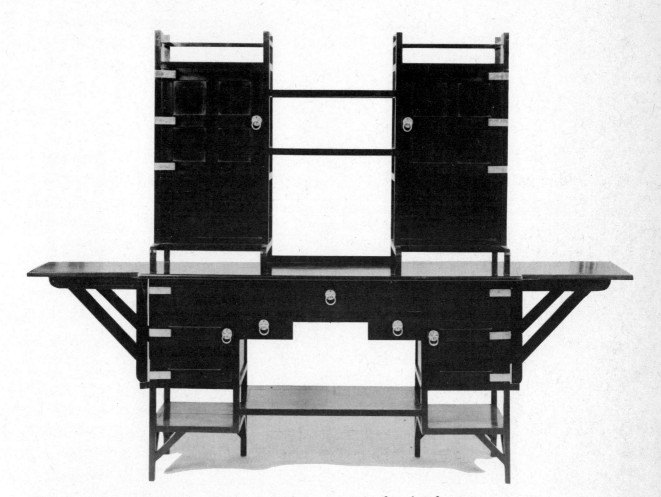

An ebonised display cabinet designed by E. W. Godwin, *circa* 1875, 6ft 3in by 8ft 4½in
London £6,200 ($14,260). 28.v.75

Two other versions of this cabinet are known. One cabinet is in the Bristol Art Gallery and the
version in the Victoria and Albert Museum is identical save that this example lacks the pressed paper
panels. The original design was executed in 1867 although it seems likely that the example in the
Victoria and Albert Museum dates from 1877, when it appeared in William Watt's Catalogue.
Liberty & Co began to import the pressed paper from Japan in 1876 and its seems possible therefore
that this cabinet predates that in the Victoria and Albert

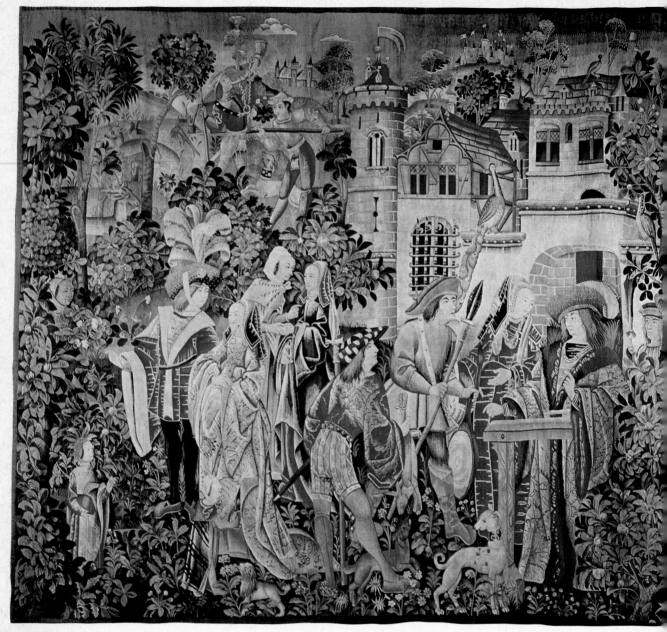

A late Gothic Tournai tapestry depicting the *Lord of the Manor*, early sixteenth century,
11ft 4in by 13ft
Los Angeles $113,000 (£49,130). 17.III.75
From the collection of the late Fletcher Jones

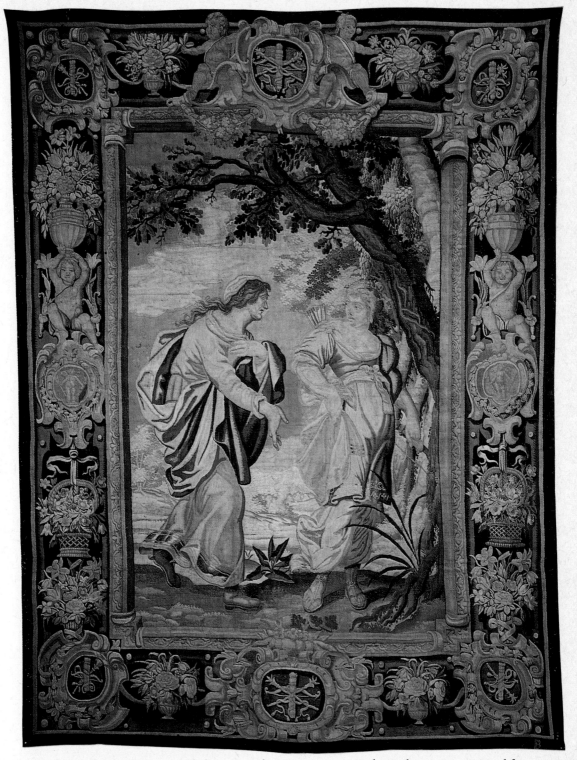

One of a set of eight Paris pre-Gobelins pastoral tapestries woven in the Faubourg Saint-Marcel for
Cardinal Francesco Barberini, papal legate to the court of King Louis XIII, depicting the story of
Aminta and Sylvia, seventeenth century
Monte Carlo Fr 340,000 (£36,559: $84,086). 26.v.75

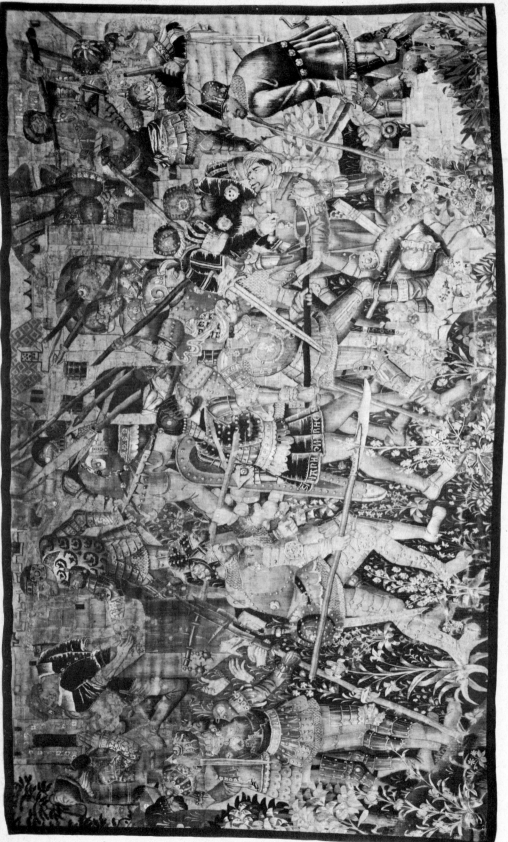

A Gothic Tournai tapestry depicting the *Siege of Jerusalem*, possibly from the story of Titus and Vespasian who, having quarrelled with the Jews, starved them into submission, *circa* 1460, 13ft 3in by 15ft 4in, probably reduced in height
London £30,000 ($69,000). 13.XII.74
From the collection of the late Hon Lady Baillie

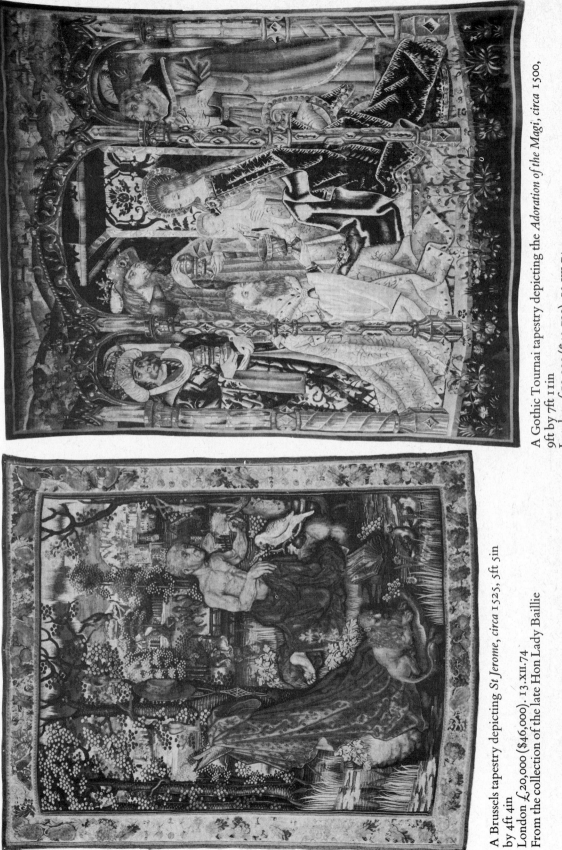

A Gothic Tournai tapestry depicting the *Adoration of the Magi, circa* 1500,
9ft by 7ft 11in
London £19,000 ($43,700). 13.XII.74
From the collection of the late Hon Lady Baillie

A Brussels tapestry depicting *St Jerome, circa* 1525, 5ft 5in
by 4ft 4in
London £20,000 ($46,000). 13.XII.74
From the collection of the late Hon Lady Baillie

A Louis XVI Gobelins tapestry signed *Neilson Exit, circa* 1780, 11ft 9in by 7ft 6in
Monte Carlo Fr 220,000 (£23,656: $54,409). 26.v.75

A Dutch tapestry table carpet depicting the *Four Elements*, *circa* 1700, 5ft 2in by 6ft 9in
London £15,000 ($34,500). 13.XII.74

A Herez silk carpet, nineteenth century, 10ft by 8ft 4in
London £12,000 ($27,600). 16.v.75

An antique Oushak (*Holbein* or
Lotto) carpet, sixteenth/seventeenth
century, 17ft 6in by 8ft 5in
New York $32,000 (£13,913).
10.V.75

Fig 8 An embroidered mourning picture: *Sacred to the memory of George Washington*, anonymous, Boston, Massachusetts, *circa* 1825, diameter 23in
New York $2,250 (£978). 24.1.74

Fig 11 A watercolour picture: *The Prodigal Son* by Ruby Devol Finch, Westport, Massachusetts, *circa* 1830, 12¼in by 13¾in
New York $7,250 (£3,152). 23.1.74

American Folk Art from the Garbisch Collection

Nancy Druckman

The past two seasons have presented spectacular opportunities for the collector of American folk art. Not only were over three hundred objects from the collection of Edith Gregor Halpert offered for sale in November 1973 but January 1974 also saw the first of three sales of Pennsylvania-German frakturs, needleworks, theorem paintings and other related material belonging to Colonel Edgar William and Mrs Bernice Chrysler Garbisch. One of the most comprehensive collections of its kind ever assembled, over six hundred objects, excluding naive oil paintings and three-dimensional sculpture, totalled $600,000 – the highest price ever reached for a sale of folk art. The sales represented a penultimate chapter in a fairytale story of collecting, where the collectors' foresight as to the historic and artistic importance of the material was confirmed by the incredible appreciation in its value. Almost without exception, each piece fetched several hundred times its original purchase price. The success of the sales again demonstrated the dramatic rise in the popularity of all aspects of Americana which has developed in the United States over the past thirty years.

Generally, folk art is defined as the art of the common man, created by craftsmen as a means of supplementing their frequently meagre incomes. Coach and sign painters executed family portraits; wood-workers built ships and also carved figureheads and other sculptures; schoolmasters penned ornamental pieces; and women and young girls wove material and sewed clothing for everyday use, but also turned out embroideries and decorative fancy pieces. While folk artists have often been ignorant of academic forms and techniques, in the best work there is an intuitive and instinctive emphasis on colour, line, rhythm, pattern and texture, which is often unique and quite compelling. These abstract elements provide the core of the similarities shared by folk and modern art.

The history of collecting American folk art is even more brief than the hundred years of its development. As recently as fifty years ago, most of it enjoyed the dubious status of family junk. Hidden in dusty attics, folded away in trunks and shoe-boxes, it was considered, at best, old-fashioned and quaint. Those people who did seek it, a few social historians and a few stalwart enthusiasts of modern art with a penchant for championing unpopular artistic causes, were considered hopelessly eccentric. This lack of interest reflected a generally deprecatory outlook on the part of Americans towards their native art as a whole. The notion that American art was inferior to European had existed in this country for two centuries and was reflected in major American museums and private collections which contained, almost exclusively, examples of European works.

Gradually, however, the attitude began to change. Among the several reasons for this, the most significant was the surge of national pride and patriotism following the Second World War, which re-kindled an interest in the American past and brought about a pervasive reassessment of all aspects of culture. The establishment of public collections at such places as the H. F. du Pont Winterthur Museum, the Shelburne Museum, the Bayou Bend collection and the Henry Ford Museum, reflected a developing concern with the preservation and study of all aspects of American decorative arts, including folk art. This new enthusiasm was reflected in the auction market as well. In March 1944, the George H. Lorimer collection of fine American furniture and decorations was sold at Parke-Bernet. The collection included many examples of Pennsylvania-German fraktur and pottery and, for the first time in auction history, folk art brought notably high prices.

It was in this new patriotic and positive atmosphere that Colonel and Mrs Garbisch began to collect. In 1944, they acquired a home on the eastern shore of Maryland and furnished it with eighteenth-century American antiques. They tried to find examples of American naive painting which would be in keeping with its furnishings and architectural design. Once they had embarked on their project, the Garbisches were struck by the intrinsic artistic quality of much of the work.

'We saw in those native American paintings, those unique qualities of simplicity and forthright directness and creative vitality in color and design which set them apart as being so indigenous to America and so genuinely American. By the time we had gathered a representative number of these pictures, we arrived at the decision that good American naive paintings merited an important place in the history of American art and the history of world art as well.'[1]

Hoping to generate enthusiasm among a larger audience, they decided to compile a comprehensive collection which would afford scholars and critics an opportunity to study American folk art as a whole. The purpose of the collection then shifted from one that was being assembled for personal enjoyment to one that was intended for the nation. In March 1953, Colonel and Mrs Garbisch donated a representative group of five hundred items to the National Gallery in Washington, D.C. With the exception of a few pieces, all the folk items, (those smaller examples with a more distinct ethnic or craft association which had been collected along with the naive paintings) remained in their private collection, which by now numbered over 2,500 pieces. Finally, in the fall of 1973, the Garbisches, wishing to con-centrate their energies and time on naive paintings, decided to sell the folk portion of their collection at auction.

Their decision met with an incredible response from collectors. Not since the landmark sales of 1958 – the Arthur J. Sussel sale here at Sotheby Parke Bernet and the Walter Himmelreich sale at Pennypacker's in Reading, Pennsylvania – had the announcement of a sale generated so much excitement and anticipation among folk art collectors. The allure of the Garbisch's by now legendary name; the knowledge that the collection contained an unusually high proportion of rare and in some cases, unique pieces; its superb condition (it was well known that the Garbisches cared a great deal about the condition of the material in their collection and had often spent as much on restoring the works as they had paid for them), combined with an element of mystery surrounding the collection which had had less public exposure than the Halpert material, all pointed to a highly successful sale. Added to this was the fact that the audience for folk art had grown enormously in number and sophistication since the time the collection had been amassed.

1 *Art In America*, May 1954, vol 42, no 2, p 95

Each of the three parts of the sale, held in January, May and November 1974, consisted largely of the same combination of items – Pennsylvania-German frakturs, cutwork pictures, and calligraphic specimens; needleworks, including embroidered pictures, mourning pictures and samplers, and theorem paintings and other decorative fancy pieces.

Of all the categories of folk art offered for sale, the most highly valued were the 'frakturs', those examples of ornamental calligraphy used by Pennsylvania-Germans to embellish certificates of birth and baptism, death and marriage, as well as many other documents and pictorial forms. *Frakturschriften*, or fraktur-writing, was derived from the medieval art of manuscript illumination in which the first letter of a word had a broken or 'fractured' appearance. Practised in Germany by pastors and schoolmasters, the Pennsylvania-Germans, with their conspicuous love of decoration and sense of tradition, continued the art here in America. Frakturs were produced during a period of roughly fifty years – from the late eighteenth century until the mid-nineteenth century, when mass-produced, printed frakturs replaced the hand-written and decorated ones.

Each of the German religious groups who came to America in search of religious freedom, the Mennonites, the Schwenkfelders, Dunkers and Anabaptists, had a preference for a particular form of fraktur and a distinctive, individual style. The Garbisch collection was representative of nearly all groups, including many signed examples – unusual for an art form which is largely anonymous – and amounted to an historical documentation of this specialised art.

Probably the rarest and most outstanding piece, artistically and historically, was the *geburts* (birth letter) of Lydia Kriebel (Fig 1), a member of a Schwenkfelder family born in Montgomery County, Pennsylvania, in 1796. This piece of 1806, which achieved $7,000, the highest price ever paid for a fraktur, satisfied all the requisites for success. The Schwenkfelders, followers of Casper Schwenkfelder, came from Silesia, the easternmost point of departure of all the German groups who came to America. Silesia was situated along the trade routes from the East and Eastern art influences, in the form of luxuriant floral motifs, and precise, symmetrical and delicate designs, illuminated in jewel-like colour, are reflected in Schwenkfelder fraktur work.[2] The Kriebel *geburts* exemplifies all these elements. The Schwenkfelders were amongst the best educated of all the Pennsylvania-German groups and as a result have retained examples of their heritage, making it rare for a piece of fraktur to come on the market. They also held a variety of unusual religious and social beliefs, amongst them a belief in the equal distribution of labour between men and women. The maker of the Kriebel fraktur has been identified as Barbara Schultz, and is one of the few known examples to have been made by a woman.

Of a different type, but equally formidable in quality, rarity and, hence, price, was the 1806 *geburts und taufschein* (birth and baptismal certificate) of Elias Haman (Fig 2), one of the 35,000 Virginia-Germans who settled along the Shenandoah River Valley in the last decade of the eighteenth century.[3] Communities of Virginia-Germans were far more widespread and diffuse than the highly concentrated Pennsylvania-German communities to the north. Being less insulated and homogeneous, the Virginia-Germans more readily assimilated non-German customs and motifs. As a result, only a small number of frakturs were produced. Those which have survived, superbly illustrated in the Haman *geburts und taufschein*, reflect a freer, more naturalistic treatment of flowers and figural forms, and a pastel colouring, more in

2 Donald A. Shelley, *The Fraktur-Writing or Illuminated Manuscripts of the Pennsylvania-Germans*, *Pennsylvania-German Folklore Society*, Vol 23, p 112.
3 Klaus West, *Arts in America*, vol 15, no 1, p 2.

Fig 1 A fraktur: *geburts* of Lydia Kriebel by Barbara Schultz, Montgomery County, Pennsylvania, dated 1806, 12½in by 15¼in New York $7,000 (£3,043). 9.v.74

keeping with contemporary southern art of that period than northern. The inscribed 'vital statistic' portion of the text, which forms an integral part of the overall design, is a universal feature of the best of early frakturs, but is particularly prominent in Virginia work.

A superb example of Mennonite work, is the *vorschrift*, or writing specimen (Fig 3) done for Daniel Bart of Hempfield County, Pennsylvania in 1797, by the schoolmaster, Christian Strenge. The Mennonites valued formal education highly and their work is frequently signed 'Schoolmaster'.[4] This writing specimen typifies the best of Mennonite work and indeed of all frakturwork. The large, ornamentally-rendered first letter and good penmanship, make work from this sect the most frequently cited example of Pennsylvania-German fraktur.

A piece known as *The mystical doves* (Fig 4) is illustrative of another type of fraktur; the religious broadside. Sombrely handsome in colour, its text is a passionate outpouring of religious fervour. While it bears the name of Barbara Landes and the date 1788, this piece is largely a mystery in terms of its origins and place of manufacture. However, it does illuminate the dramatic rise in the fraktur market over the last thirty years. Sold originally in the George Lorimer sale of 1944, it achieved $90, a very respectable sum when pieces of similar type were fetching about $30. The piece was purchased by Arthur J. Sussel and was eventually sold as part of his estate at Parke-Bernet in 1958, when Colonel and Mrs Garbisch paid $800 for it. The fraktur reappeared in the first part of the Garbisch sale where it fetched $5,500 – a total increase of fifty-five times its original sale value.

An outstanding example of a non-religious ornamental piece by a fraktur artist, is the *Parrot from Guinea* (Fig 5). Brightly coloured in green, and depicting an exotic subject, this might be compared to the whimsical piece of glass blown at the end of the day by the glass maker.[5] The probable early date of the *Parrot*, its rare form and direct, colourful charm, account for the remarkably high price of $6,500 it fetched at auction.

4 Shelley, *op cit*, p 108.
5 *Ibid*, p 96.

Fig 2 A fraktur: *geburts und taufschein* of Elias Haman,
Shenandoah County, Virginia, dated 1806, 15in by 12½in
New York $7,000 (£3,043). 9.V.74

Fig 4 A fraktur: *The mystical doves,* signed
I.A.E., S.D., dated 1788, 9¾in by 8in
New York $5,500 (£2,391). 23.1.74

Fig 3 A fraktur: *vorschrift* or writing specimen, by Christian
Strenge, Hempfield County, Pennsylvania, dated 1797,
7¾in by 13¾in
New York $4,250 (£1,848). 24.1.74

Fig 5 A fraktur: *Parrot from Guinea,*
anonymous, Pennsylvania, early nineteenth
century, 10in by 7½in
New York $6,500 (£2,826). 24.1.74

Fig 6 A needlework sampler by Mary Antrim, Burlington County, New Jersey, dated 1807, 22in by 16⅞in
New York $3,750 (£1,630). 12.11.74

The next most successful category was the needlework, including samplers, embroidered mourning pictures and general pictorial subjects. These have, over the past twenty years, followed behind the frakturs in terms of popularity. Interestingly enough, in contrast to the late 1920s and 1930s when sophisticated silk and chenille-embroidered pictures were preferred, it is now the more naive and child-like samplers which command high prices.

During the late eighteenth and early nineteenth centuries, it was considered both a necessity and a virtue for a young girl to have skill with needle and thread. Surprisingly, the emphasis was often on the virtue – ornamental sewing was considered an important mark of social grace. There were numerous academies which offered, in addition to other items in the curriculum, instruction in sewing. The best of these were found in New England, around Boston and especially in Rhode Island, where the famous Miss Mary (Polly) Balch Academy was located. In these schools, all kinds of needlework was produced. Samplers, in which girls rehearsed and recorded newly learned stitches as an 'exemplar' of her skill, were the basic starting-out pieces, done by all students. The elaborate embroidered picture was reserved for the more accomplished needlewoman and probably represented the culmination of several seamstresses' work.[6] While samplers were made until the middle of the nineteenth century, the painstaking embroidered picture was superseded by the more easily achieved painted picture around 1835. The Garbisch collection contained superb examples of needlework, both plain and fancy, from the late eighteenth to the mid-nineteenth century.

The record auction price for a piece of American needlework, was the $3,750 paid for the 1807 sampler done by Mary Antrim of Burlington County, New Jersey[7] (Fig 6). It is not the conventional sampler with bands of numeral and alphabets, but a pictorial composition which makes use of the variety of stitches Mary had learned to master. Its charm derives from the

6 Betty Ring, 'Memorial Embroideries by American Schoolgirls', *The Magazine Antiques*, October 1971.
7 Identification of the origins of this sampler as well as research concerning the maker was done by Betty Ring.

Fig 7 A needlework sampler by Anna Pope, Spencer, Massachusetts, dated 1796, 16in by 21¾in New York $2,800 (£1,217). 24.1.74

contrasting use of green and white, its imaginative combination of animals and figures in a complicated landscaped setting, and the fact that its unique two-part frame had survived intact. This piece represents the best in folk art because it is not only a record of Mary's progress, but an immediate record of the energy and forthright charm of the child herself. Anna Pope's sampler (Fig 7) done in 1796 in Spencer, Massachusetts combines the more traditional alphabet with pictorial composition, namely the Congregational parsonage in which her family lived. While the delicacy of this work reflects greater expertise than the Antrim piece, it, too, is a practice work – notice the corner of the field which is reserved for Anna's practising the fashionable 'Irish Stitch'.

An excellent example of a more sophisticated piece is the *Memorial to George Washington* (Fig 8), executed in Boston between 1820 and 1830.[8] This embroidery picture represents the level of proficiency and skill to which both the student and instructress aspired. The epitome of elegiac romanticism tempered by neo-classical restraint, the piece has the qualities of refinement in colour and design which are found in the furnishings and decorative arts of the Federal period. Until recently, the personal mourning pictures were considered to be too morbid to be actively collected. However, with greater understanding that they were more fashionable than sad (often done for distant relatives, long-gone and unknown by the stitchers, or as a means of providing family statistics in a period when there was no official bureau of census), they have recently gained in popularity.

The next category which can be discussed as such, is the theorem paintings and fancy pieces. These are decorative pictures, derived from the embroidered pictures, which were turned out in large number by women and young girls who, having been freed from their daily chores by the increased mechanisation of American life during the middle of the

8 The composition of this embroidery was based upon a print by Enoch C. Gridley which in turn was based on a painting by John Coles Jr, a student of Gilbert Stuart.

nineteenth century, turned their attention to the appearance of their homes. These pieces, usually depicting some aspect of nature's bounty in the form of tables and bowls loaded with fruit or flowers, could be made by anyone with the inclination to do so, since they were done with the aid of pre-cut stencils and then painted with watercolour on heavy paper or velvet to achieve a rich effect. Despite the inherent repetitiousness of the technique and subject matter, a few imaginative and enterprising artists achieved some unsusual and lively effects. One piece which transcends the sameness of this type is the *Melons on a scalloped platter* (Fig 9). Painted in watercolour on paper, the use of stencils is easily identifiable in the painting of the grapes where no outline overlaps another. The artist has managed, by the simplicity of the design and the vitality of the strong rhythmic patterns, to compensate for the severity of the method.

Related to decorative pieces in conception though not in technique, was a single piece which fetched a very respectable price and again demonstrates the range of the Garbisch material. This was the paper collage by F. Hanson, dated 1833 (Fig 10). The footed vase filled with flowers is standard, but the colourful assemblage of variously textured papers makes for a unique and appealing treatment.

Finally, there is one piece which does not fit into any of the categories mentioned but is of superior artistic quality and achieved a correspondingly high price. It is the outstanding watercolour of the *Prodigal Son*, by an artist identified as Ruby Finch of Westport, Massachusetts, about 1830[9] (Fig 11). This piece comes closest to the naive paintings than any other in the three sections of the sales. It is one of many examples of the folk artist treating a Biblical theme as a contemporary event, underlining again what central importance the Bible had as the source of inspiration and artistic subject matter for Americans in the nineteenth century. The parable of the Prodigal Son is seen not as a distant celebration of an old story, but in a wholly contemporary context, with figures dressed accordingly. Nevertheless, it retains its original meaning as a warning to any potentially 'prodigal' children who might be tempted to stray. It is unusual for a woman to be handling thematic material such as this yet here is an example of an obviously accomplished painter, in full control of her medium. As a postscript to the Garbisch sales, it is worth mentioning that the two most expensive pieces, the *Lydia Kriebel* and the *Prodigal Son*, were both made by women. In fact, when we consider that well over half the material in these sales was the work of women, it is obvious how active a role they played in determining the artistic quality of everyday life in the nineteenth century.

Taken as a whole, the exhibition and sale of the Garbisch collection provided a unique opportunity for collectors of American folk art to enjoy an immediate glimpse into life in nineteenth-century America. The freshness, vitality, and simplicity of the artwork, reflecting a tranquil and optimistic period of history, has special meaning and appeal on the eve of the Bicentennial, when life in America is considerably more complex and frenetic.

As for the market, no folk picture is as rosy as its prospects for continued success. The audience grows, the ranks continually swelled by people who appreciate the historical importance, artistic validity and decorative quality, while the supply is obviously static or diminishing. The strength of the market, proven during the sales themselves where over six hundred objects were readily absorbed without any appreciable softening in price, has been solid in subsequent sales. The Garbisch collection offered unique opportunities for folk collectors to acquire example of this extraordinary art form – those buyers, as well as those of us involved in the field, look forward to the prospect of another Garbisch year.

9 Identification of Ruby Devol Finch and research on her life was done by Donald Walters, Associate Curator, the Abby Aldrich Rockefeller folk art collection, Williamsburg, Virginia.

Fig 9 A theorem painting on paper: *Melons on a scalloped platter,* anonymous, mid nineteenth century, 13¾in by 21½in
New York $1,200 (£522). 12.11.74

Right
Fig 10 A paper collage by F. Hanson, probably Pennsylvania, dated 1833, 25½in by 19¼in
New York $2,300 (£1,000). 12.11.74

Fig 12 A watercolour and silhouette picture: *Harbor scene,* anonymous, probably New York, *circa* 1845, 21in by 29in
New York $3,500 (£1,522). 12.11.74

THOMAS TOMPION NO. 88 A walnut quarter repeating bracket timepiece, the 6-inch dial signed
Tho. Tompion Londini Fecit, circa 1680, height 12½in
London £15,000 ($34,500). 2.XII.74
From the collection of Mrs Alfred Clark

Clocks, Watches and Scientific Instruments

A gilt-metal musical table clock, the 7½-inch dial signed *Wm Webster Exchange Alley London* in the arch below a dial selecting six tunes, height 19in, London £19,000 ($43,700). 21.VII.75

William Webster was apprenticed to Thomas Tompion and became one of his journeymen. Free of the Clockmakers' Company in 1720, he was Warden in 1734 and died in the same year. Gilt-metal case clocks are extremely rare among English clocks of the classic period

1. A porcelain-mounted alarum carriage clock signed *Henry Capt à Genève* and numbered 11702, 6in £1,050 ($2,415) 21.VII.75. 2. An English carriage clock signed *E. White 20 Cockspur St. London*, mid 19th century, 7¾in £2,000 ($4,600) 12.V.75. 3. A miniature ebony-veneered travelling alarum timepiece signed *Rich. Vick London*, 5in £1,450 ($3,335) 12.V.75. 4. An ebony-veneered mantel timepiece signed *Grimalde & Johnson Strand London*, dated *AD 1815*, 9¼in £780 ($1,794) 21.VII.75. 5. A George III mahogany bracket clock signed *Alexr. Cumming London*, 15½in £1,000 ($2,300) 12.V.75. 6. A lantern clock signed *Abel Cottey Crediton*, 15in £800 ($1,840) 27.I.75. 7. A gilt-brass skeleton timepiece signed *Dwerrihouse, Ogston & Bell*, c. 1845, 13¼in £1,250 ($2,875) 27.XI.74. 8. A French ormolu mantel clock signed *Fd. Berthout à Paris*, early 19th century, 9½in £420 ($966) 27.XI.74. 9. An ebony bracket clock signed *Pieter Visbach Hagae*, Fl38,000 (£6,847: $15,748) 11.III.75. 10. A George II burr-walnut wall clock signed *John Ellicott London*, 31in £3,000 ($6,900) 21.III.75. 11. An Italian ebony calendar clock signed *Gio Pietro Calin Genova*, late 17th century, 32½in £2,200 ($5,060) 21.X.74.

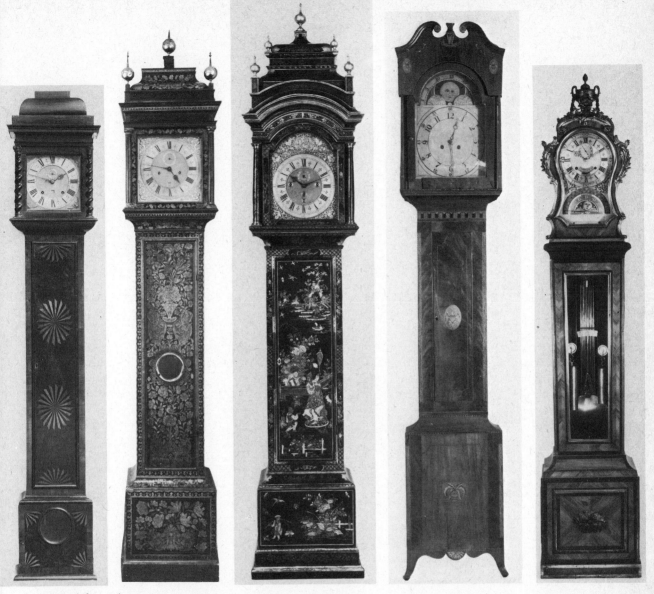

From left to right
An olivewood parquetry month longcase clock, the 10-inch dial signed *Robert Siegnior London*, height 7ft 2in
London £3,100 ($7,130). 2.XII.74
A marquetry month longcase clock, the 12-inch dial signed *Dan Quare London*, height 8ft 4in
London £3,400 ($7,820). 27.I.75
A Queen Anne dark green lacquer longcase clock, the movement by Peter Garon with a 22-bell musical train, early eighteenth century, height 9ft 9in
Los Angeles $12,000 (£5,217). 5.XI.74 From the collection of the late William Haines
A Federal eagle-inlaid walnut longcase clock, Virginia, *circa* 1790-1810, height 9ft
New York $7,750 (£3,370). 15.XI.74 From the collection of Dr Edmond Horgan
A French kingwood regulator, the 11-inch dial signed *Thiout L'Ainé Réparé Par Janvier*, late eighteenth century, height 7ft 7in
London £6,800 ($15,640). 13.XII.74

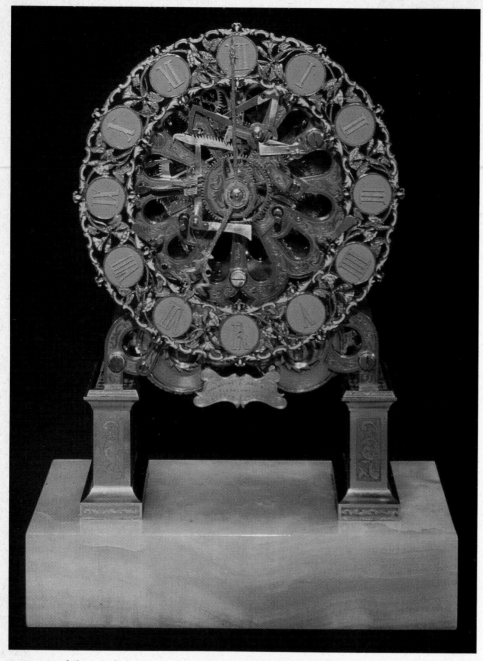

A Great Exhibition skeleton clock by John Moore and Sons, the fretted frame in the form
of a rose window raised on a plinth support inlaid overall with blue *champlevé* enamel and
engraved brass foliate scrollwork, the chapter ring pierced with scrolling convolvulus
in green, the movement with chronometer escapement, twin barrels and fusees, and
chiming the quarters on two coiled steel rod gongs, with brass etiquette enamelled in
blue *John Moore and Sons, Clerkenwell, London, No. 12852, circa* 1851, but now mounted
on a white onyx base of more recent origin, height 11¾in
London £1,400 ($3,220). 27.XI.74

Right
A German square brass
sundial, maker's mark
H.H. conjoined, Danzig,
1601, restored by Jacob
Dick, 1802, width 192mm
New York $3,500
(£1,522). 25.IV.75

Far right
A brass octant by Sarrazin
of Marseille, signed,
eighteenth century, length
overall 232mm
London £750 ($1,725).
21.III.75

A pair of gilt-metal dividers by Christopher
Schissler dated 1580 with original gold-
stamped case
Amsterdam Fl27,000 (£4,865: $11,189).
16.VI.75

A Persian brass astrolabe, probably
Safawid, seventeenth century, diameter
208mm
New York $5,000 (£2,174). 2.V.75
Left
An early single-draw compound
microscope, late seventeenth century,
height 280mm
London £2,000 ($4,600). 21.X.74

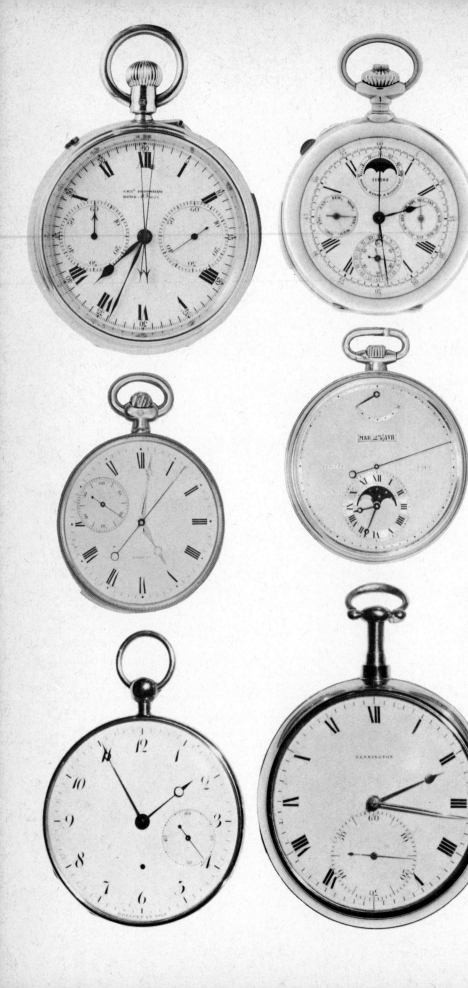

From left to right
Above

CHARLES FRODSHAM NO. 010304
A gold minute repeating
tourbillon with split second
chronograph, 1929, diameter
64mm
New York $24,000 (£10,435).
19.II.75
From the collection of Harry
P. Davison Jnr

PATEK PHILIPPE NO. 111689
A gold minute repeating
perpetual calendar split second
chronograph, Geneva, *circa*
1900, diameter 54mm
New York $13,500 (£5,870).
25.IV.75

Centre

BREGUET NO. 5008
A gold keyless half-quarter
repeating *secondes d'une coup*
lever watch, diameter 46mm
London £2,300 ($5,290).
27.I.75

BREGUET NO. 2343
A gold keyless lever watch,
diameter 50mm
London £3,300 ($7,590).
27.I.75

Below

BREGUET NO. 1583
A gold half quarter repeating
double wheel duplex watch,
diameter 56mm
London £5,200 ($11,960).
14.X.74

PENNINGTON NO. $\frac{117}{511}$
A gold pair cased half ten
minute repeating pocket
chronometer, 1808, diameter
65mm
London £4,400 ($10,120).
14.X.75.
Both from the collection of the
Lord Brownlow

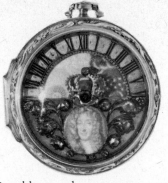

A gold sun and moon verge watch
by Richard Baker of London,
movement *circa* 1690, case *circa*
1740, diameter 48mm
London £2,600 ($5,980). 16.VI.75

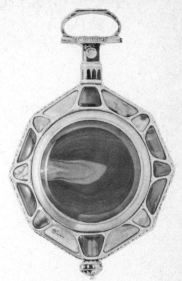

THOMAS TOMPION NO. 355
A gold pair cased repeating verge
watch signed *T. Tompion, London,
No. 355* and hallmarked 1709,
diameter 56mm
London £4,300 ($9,890). 12.V.75

WILLIAM ILBERY NO. 6116
A gold, enamel and hardstone
open faced watch made for the
oriental market, London *circa*
1790, length 105mm
New York $13,000 (£5,652).
30.X.74

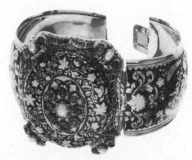

A gold and *champlevé* enamel alarum
bracelet watch, *circa* 1840
London £1,800 ($4,140). 16.VI.75
The unusual alarum mechanism extends
through the back of the case upon release and
reminds the wearer of the hour by tapping
the wrist

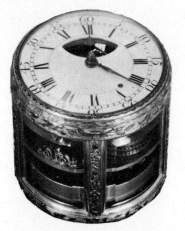

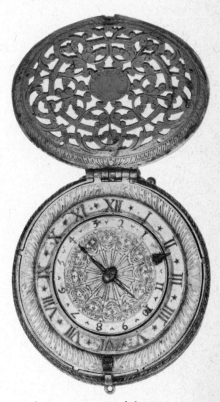

A gilt-metal and rock-
crystal cased verge watch
by Giovanni Batta
Mascarone, early
seventeenth century,
length 67mm
London £4,600
($10,580). 14.X.74
From the collection of
the Lord Brownlow

A gilt-metal striking table clock by
Alexander Cumming of London,
mid eighteenth century, height
73mm
London £3,450 ($7,935). 16.VI.75

An alarum verge watch by Pierre
Maingot of Paris, *circa* 1600, diameter
72mm
London £3,800 ($8,720). 14.X.74
From the collection of
the Lord Brownlow

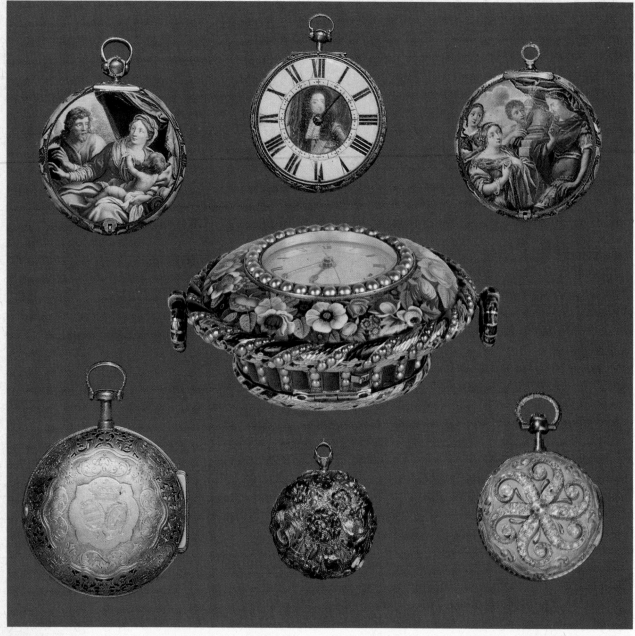

From left to right
Above A gold and enamel verge watch by C. Bonneux of Paris, *circa* 1700, diameter 51mm £15,000 ($34,500)
A gold and enamel verge watch by Robert Dingley of London, *circa* 1680, diameter 50mm £10,000 ($23,000)
A gold and enamel verge watch by Josephus Norris of Amsterdam, *circa* 1700, diameter 53mm £6,000 ($13,800)
From the collection of the Lord Brownlow sold in London on 14 October 1974
Centre A Swiss gold and enamel 'basket of flowers' musical clock watch, *circa* 1820, diameter 67mm
New York $28,000 (£12,194) 30.x.74. From the collection of the late Tony Chun Afong
Below A gold pair cased quarter repeating verge watch, no 486 by George Graham, hallmarked 1720, diameter
51mm £1,600 ($3,680)
A gold and enamel verge watch by Thomas Baldwin of London, the movement and dial early eighteenth century,
the case seventeenth century, diameter 32mm £1,500 ($3,450)
From the collection of the Lord Brownlow sold in London on 14 October 1974
A pair cased repeating watch of gold set with rose-diamonds, no 4051 by George Prior of London, early
nineteenth century, diameter 67mm London £6,200 ($14,260). 27.i.75

Musical Instruments

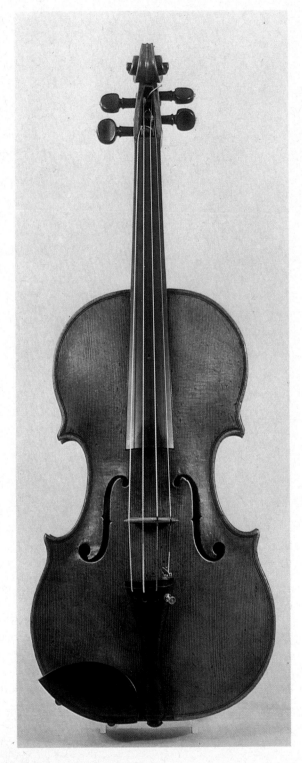

A violin by Nicholo Amati, with its original label *Nicholaus Amatus, Cremonen Hieronymi Fil: ac Antonij Nepos fecit 1682,* and with a certificate from W. E. Hill & Sons dated 9 December 1908 with their receipt, length of back 13 $\frac{15}{16}$ in

London £26,000 ($59,800). 8.v.75

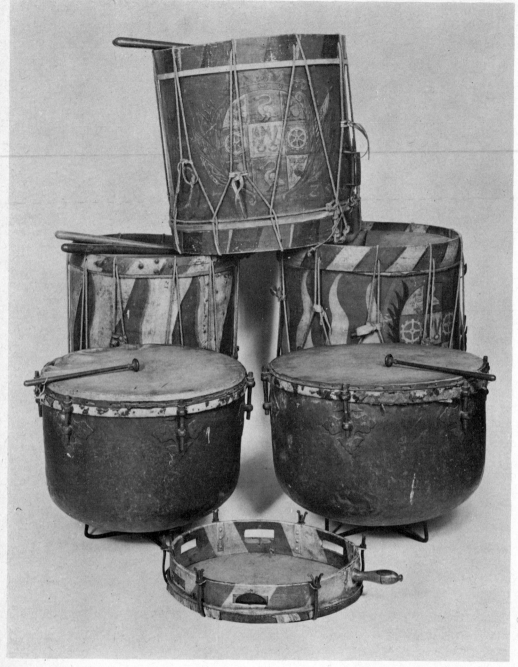

From top to bottom

Three side drums, two bearing the arms of the von Giech family, one dated 1725, the others being late seventeenth/early eighteenth century, £400 ($920), £280 ($644), and £340 ($782).

A pair of kettle drums, German, *circa* 1700, height 15¼in £3,900 ($8,970); and a pair of fruitwood kettle drumsticks, sold with a third similar stick, £120 ($276).

A tambourine, German, late seventeenth century, diameter of vellum 15½in, £250 ($575).

These percussion instruments were part of the collection of the Counts von Giech sold in London on 21 November 1974. They were probably used by the militia of Christian Carl von Giech (1641-1695), the first Count

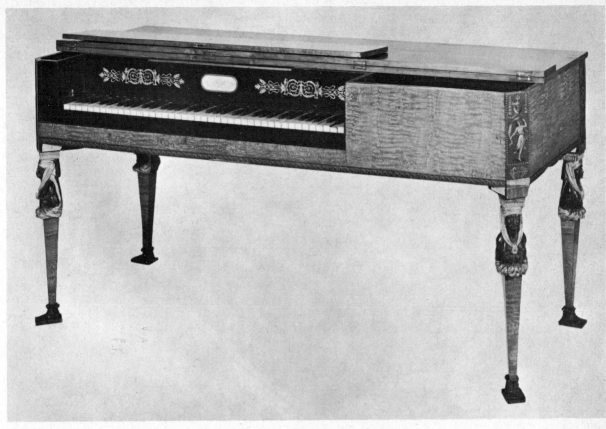

A square piano by Johann Fritz, inscribed *Johann Fritz Wien*, length 5ft 5½in
London £1,100 ($2,530). 21.XI.74

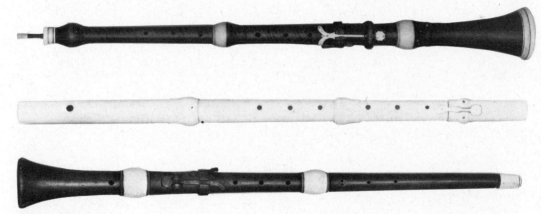

From top to bottom
A stained boxwood two-keyed oboe stamped *Astor, London* on each joint, late eighteenth century,
length 22½in
London £720 ($1,656). 21.XI.74

A French one-keyed ivory flute, mid eighteenth century, sounding length 22⅜in
London £1,550 ($3,565). 8.V.75
From the collection of the Dowager Countess of Lytton

A stained boxwood two-keyed oboe by Thomas Stanesby Jnr of London, stamped *Stanesby Iunior*
on each joint, mid eighteenth century, length 24in
London £1,250 ($2,875). 8.V.75

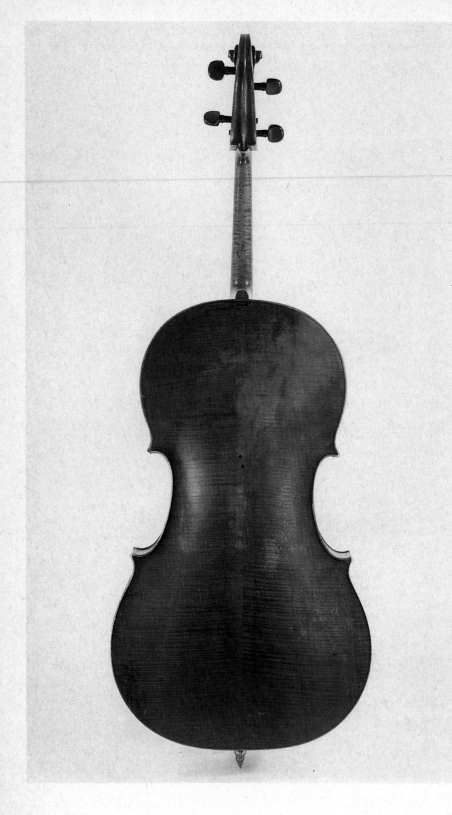

A violoncello by Carlo
Tononi labelled *Carolus
Tononis Bononienfis fecit
Venetijs Anno 1722*, length
of back 30⅜in
London £15,000
($34,500). 8.v.75
From the collection of the
Grote Lewin Family

Antiquities, Islamic, Indian, Nepalese and Primitive Art

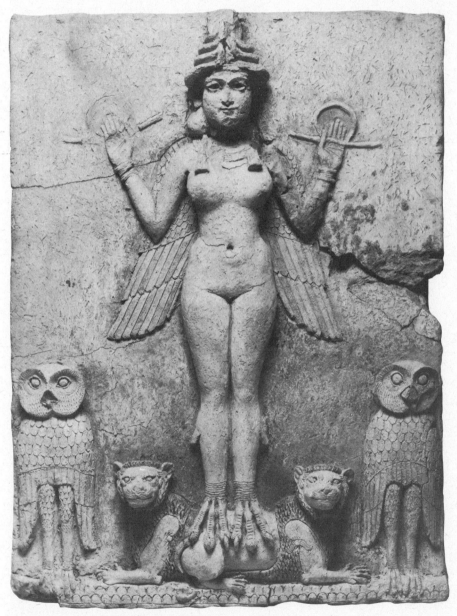

A Sumerian baked clay relief, *circa* 2000 BC, 20in by 14½in
London £31,000 ($71,300). 21.IV.75
From the collection of the late Colonel N. R. Colville, MC, FSA

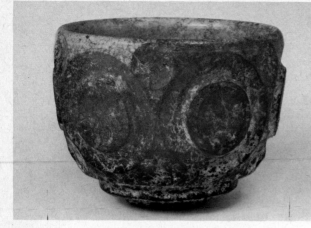

A Sassanian or Early Islamic pale green glass bowl, *circa*
fifth/eighth century AD, diameter 4in
London £8,500 ($19,550). 14.VII.75

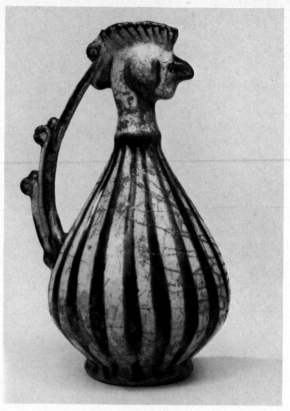

A Gurgan pottery ewer, *circa* thirteenth century AD,
height 9½in
London £11,000 ($25,300). 14.VII.75

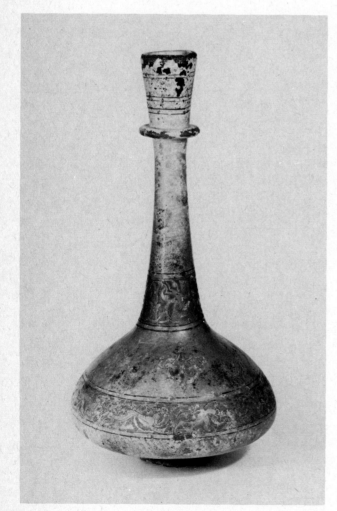

An Islamic glass bottle, fourteenth century AD, height 13in
London £4,500 ($10,350). 21.IV.75
From the collection of the late Colonel N. R. Colville, MC, FSA

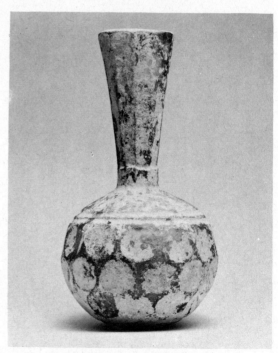

An Islamic blue-green glass ewer, probably
Persian, *circa* eighth/tenth century AD,
height 7⅝in
New York $19,000 (£8,261). 2.V.75
From the collection of Ray Winfield Smith

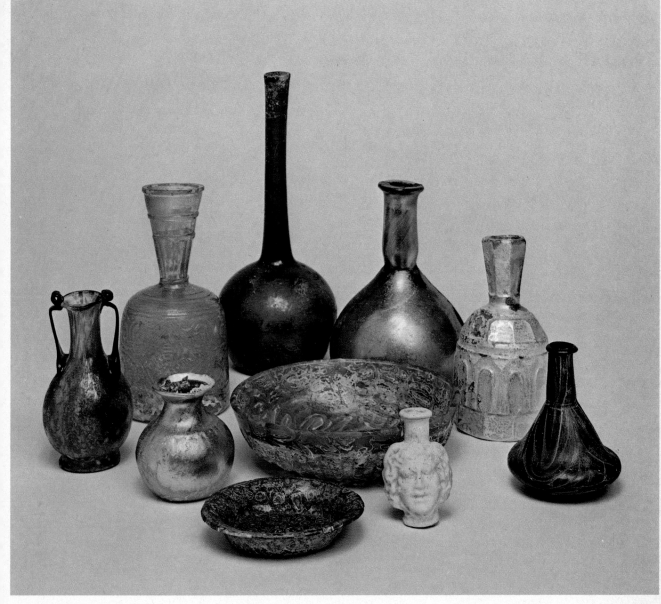

From left to right
Back row
A clear glass vase, first century AD, height 4½in $1,600 (£696)
A Persian brownish–clear glass bottle, *circa* ninth/tenth century AD, height 6¼in $12,500 (£5,217)
An Islamic deep blue glass bottle, possibly Persian, *circa* ninth/twelfth century AD, height 8¾in $1,700 (£739)
A greenish glass bottle, *circa* first/second century AD, height 6in $2,800 (£1,217)
A Persian clear glass bottle, tenth century, height 5in $11,000 (£4,783)
A purplish-red glass bottle, *circa* first century AD, height 3½in $2,000 (£870)
Centre
A clear glass bottle, *circa* third century AD, height 2½in $1,000 (£435)
A *millefiori phiale* mesomphalos, *circa* first century AD, diameter 3⅝in $4,200 (£1,826)
A blue mosaic ribbed bowl, *circa* early first century BC, diameter 5¾in $18,000 (7,826)
A white glass head flask, *circa* first century AD, height 2½in $2,200 (£957)

From the collection of Ray Winfield Smith sold in New York on 2 May 1975

An Etruscan bronze lion, from Orvieto, *circa* late sixth century BC, length 5¼in
New York $8,000 (£3,478). 22.XI.74
From the collection of J. J. Klejman

Right
A Neolithic limestone female figure, Anatolia, *circa* 6000–5000 BC, height 3¾in
London £3,400 ($7,820). 9.XII.74
From the collection of J. J. Klejman

Below
An Apulian red-figure rhyton, *circa* 360–330 BC, length 7¾in
New York $2,700 (£1,174). 2.V.75
From the collection of Mrs Ernest J. Lewis

An Etruscan bronze figure of a horse, late sixth century BC, length 4⅜in
London £8,500 ($19,550). 9.XII.74
From the collection of H. J. P. Bomford

A Greek terracotta *plastic vase*, late sixth century BC, 4½in
London £850 ($1,955). 14.VII.75

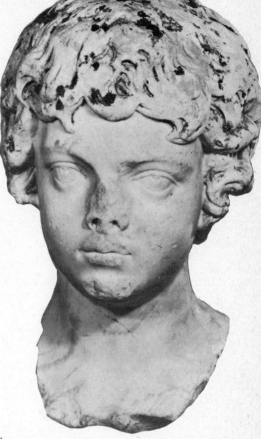

From left to right
Above
A Cypriot limestone head of a
man, *circa* 575-525 BC
New York $7,500 (£3,261). 22.XI.74
From the collection of Lester Wolfe

An Irish Bronze Age gold pin,
circa 800 BC, height 7¼in
London £4,200 ($9,660).
21.IV.75
From the collection of the late
Colonel N. R. Colville, MC, FSA

A Roman marble head of
Caracalla, from Kula in Lydia,
circa 196-202 AD, height 17in
New York $15,000 (£6,522).
22.XI.74

Right
A Cypriot *plank* figure, Bronze
Age, *circa* 2000-1800 BC,
length 23¾in
London £4,600 ($10,580).
14.VII.75

Below
A Cycladic marble hanging lamp, *circa* 2500 BC,
height 10¼in
London £3,800 ($8,740). 14.VII.75

Fig 5 A Seljuk cock's head ewer, probably Kashan, early thirteenth century, height 10⅞in
New York $18,000 (£7,826). 14.III.75

The Lester Wolfe Collection of Persian Pottery and Metalwork

Richard Keresey

The Lester Wolfe collection of Persian pottery and metalwork was the most important of its kind to appear on the market since 1964. During the last decade, interest in Persian and related works of art has increased steadily, and in some areas dramatically. This is chiefly because the Iranians themselves have been competing successfully with Western collectors to buy works of art from their own country, most of which seems to have arrived on the European and American art market in the late nineteenth and early twentieth centuries. Thus a significant rise in prices for Persian and other Near Eastern pottery and metalwork has been evident for several years. On 4 May 1974 this was emphasised by the $54,000 realised at Sotheby Parke Bernet, New York, for a Persian *minai* bowl from the Olsen collection. The same piece had been sold at Parke-Bernet in 1954 for $450. It was in the promising atmosphere created by this sale and other significant indications of heightened interest that Lester Wolfe's collection appeared in March 1975. It spanned the entire range of Persian ceramic art, from the fourth millennium BC through to the eighteenth century. The sale's results were often surprising, with numerous objects selling far above or below their pre-sale estimates. Bidding was active, with more purchasers than in any similar sale recently.

Most of the important pieces from the pre-Islamic period went to private collectors from New York City. A pottery vessel in the form of a bull (Fig 1), from the south-west Caspian area, belongs to a type known as Amlash, named after a site where many are said to have been found. As with Cycladic marble figures, the simplicity and good sculptural sense of these pieces has exerted great influence on modern taste. It is not surprising, therefore, that by the 1960s numerous Amlash figures by modern craftsmen were on the market, causing prices to fall sharply, even for objects authenticated by thermoluminescent testing. Apparently, now a more sophisticated market is beginning to re-accept genuine objects in this area, for, without the benefit of tests, the bull fetched $5,000, quintuple its pre-sale estimate and an auction record for a piece of Amlash pottery.

Although slightly lower than records made by pieces from the Klejman collection in November 1974, prices paid for Luristan and other ancient bronzes in the Wolfe sale bore out the recent intensified interest in this field. A simple but finely-modelled horse-bit fetched

$1,800, slightly less than expected. Other bronze artifacts like vessels and weapons, continued to fetch low prices.

The Wolfe collection was particularly rich in Persian ceramics from the Islamic period, which constitute the largest group of Islamic pieces available on the market. These were the highlight of the sale, and while parallels had appeared recently at auction they were not enough to give a clear prediction of price trends.

Several pieces represented the earliest well-known Persian pottery of the Islamic period, from the early medieval site of Nishapur. This pottery is essentially a peasant ware and has always been popular among collectors, although this has never been reflected in the prices paid as high values have been reserved for more sophisticated types. In the Wolfe sale a particularly fine example of the best-known polychrome type (Fig 2), skilfully combining in one motif the foliate, bird, and calligraphic forms which are the favourite themes of so much Islamic art, was bought by a New York dealer for $600.

Another type of Nishapur ware, equally familiar but rarely seen on the market, is painted with brownish-black inscriptions over a white slip. Its simple shapes are an excellent complement to the calligraphic ornament. A fine example (Fig 3), fetched $1,900 and was probably an auction record.

Perhaps the most sought-after Islamic pottery, and certainly the best known, belongs to the Seljuk period. The Seljuk Turks occupied the whole of Iran by the middle of the eleventh century, and became generous patrons of the arts. The greatest ceramic wares of the period came from Iran, where numerous technical advances led to a rich variety of methods of ornament. The simplest of these, painting directly on the pottery beneath a monochrome glaze, reached its height in the pottery of Kashan. The Wolfe collection included two particularly fine examples, both painted in black beneath a translucent turquoise glaze. One piece, restored from numerous fragments (Fig 4), belongs to what is probably the finest kind of Seljuk ware, its thin walls and delicate shape seldom duplicated in later periods. It possesses an especially fine arabesque design of unusual intricacy. The cock's head ewer (Fig 5), relies for its effect less on its underglaze decoration than on its magnificent glaze and irridescence. The ewer numbers among those extreme rarities in early Islamic pottery, for it is intact. This may account for the price a Tehran dealer paid for it. At $18,000 it made over fifty times what it had fetched at a Parke-Bernet auction in the early 1950s.

Of all the decorative techniques used in the Seljuk period the most difficult, and today the most prized, was *minai*. *Minai* ware was painted both over and under the glaze, and many colours could be employed by firing the vessel two or more times at different temperatures. The overglaze painting allowed the artist great freedom, and *minai* vessels tend to be much more pictorial than their contemporaries. Some compare with the miniature style found in the few Seljuk manuscripts which survive, and it is probable that they were decorated by the same artists. As such they constitute an important contribution to the history of Persian painting.

Not surprisingly, *minai* wares have traditionally fetched the highest prices for Persian ceramics. Huge sums (still unequalled) were paid for them by pioneer collectors early in this century. In recent memory, however, they have generally fetched between $1,000 and $5,000. The sale of the Olsen *minai* bowl and those in the Wolfe collection showed a dramatic upturn in the market. The Wolfe sale contained an exceptionally large group of *minai* pieces, in a broad range of styles. The best examples were bowls, such as that illustrated in Fig 6, which is painted in a refined style with a frequently encountered theme, the court scene. The bowl's

Fig 1 An Iranian pottery vessel in the form of a humped bull, south-west Caspian area, *circa* 1000 BC, length 9¾in New York $5,000 (£2,174). 14.III.75

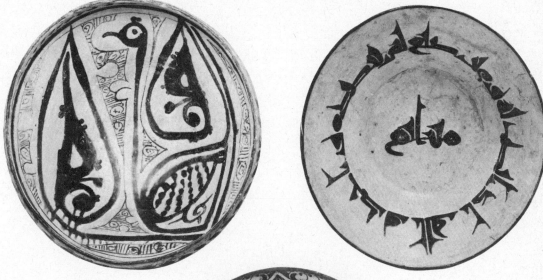

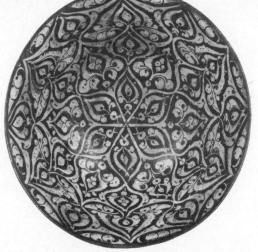

Fig 2 *Above left* A Samanid white-slip bowl, Nishapur, late tenth century, 9in New York $600 (£261). 14.III.75

Fig 3 *Above right* A Samanid white-slip bowl, Nishapur, tenth century, 9¼in New York $1,900 (£826). 14.III.75

Fig 4 *Left* A Seljuk turquoise-glazed bowl, Kashan, early thirteenth century, 8¼in New York $3,750 (£1,630). 14.III.75

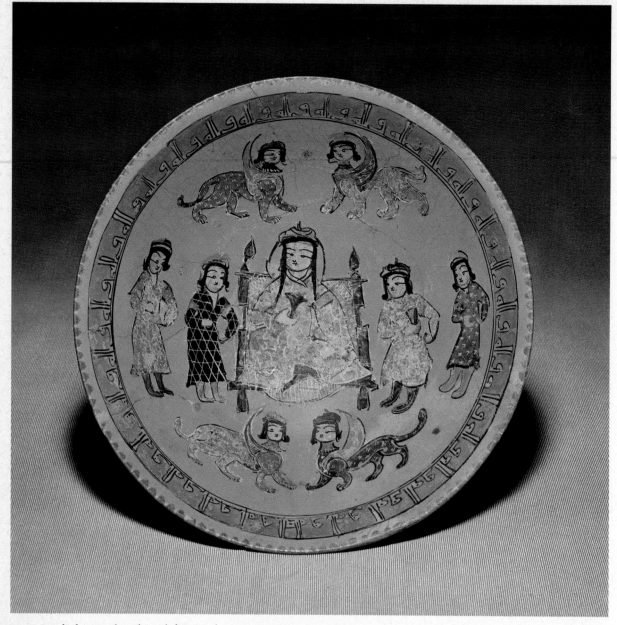

Fig 6 A Seljuk *minai* bowl, mid thirteenth century, 8⅛in
New York $18,000 (£7,826). 14.III.75

form is exceptionally elegant. More remarkable, however, is the opaque glaze on which
the scene is painted. The usual ivory-white ground has been stained a delicate shade of
turquoise blue.

Initially the Mongol conquest of Persia during the first half of the thirteenth century did
not significantly affect the course of Persian art. In fact the predominately overglaze technique
used for the bowl just described probably indicates a date after the end of Seljuk rule. The
minai technique seems to have developed gradually during the course of the thirteenth century

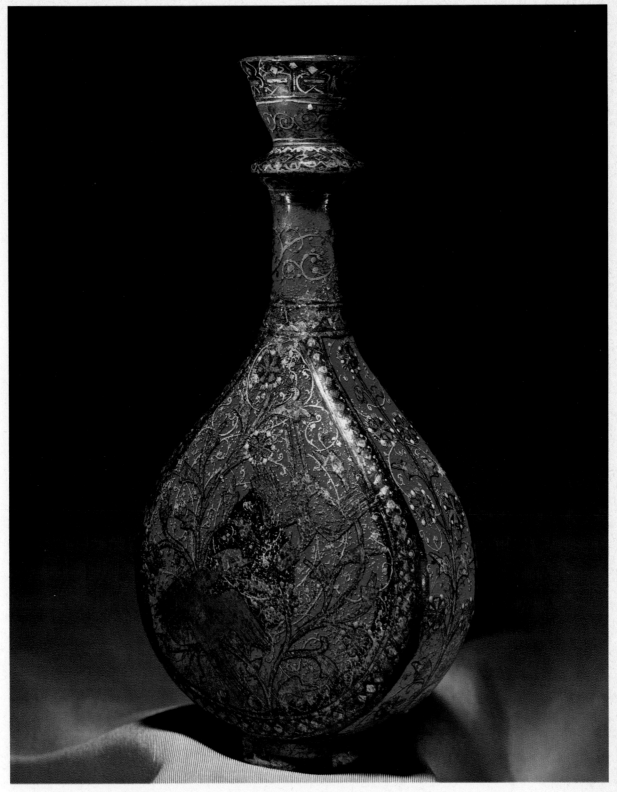

Fig 7 An Ilkhanid *lajvardina* flask, late thirteenth/early fourteenth century, 11⅜in
New York $8,500 (£3,696). 14.III.75

into a predominately overglaze-ornamented pottery called *lajvardina*, from the Persian word for lapis-lazuli. Seljuk underglaze and other techniques continued in use. The glaze on *lajvardina* ceramics is usually a very deep translucent cobalt blue, and a limited number of colours is applied over it. Particularly characteristic is the additional use of gold, which was applied in geometric shapes of gold-leaf. Like other Mongol techniques, and unlike most late *minai* pieces, the designs often show strong Chinese influence.

The Wolfe collection included a very fine and ornate *lajvardina* flask of unusual and possibly unique shape (Fig 7). Its relatively good condition, and clear glaze and colour, gives it as much the appearance of enamelled glass as glazed pottery.

Little is known about Persian ceramics during the later Mongol period under the Timirids; the little that survives would seem to indicate a sharp decline. At the beginning of the sixteenth century a native dynasty, the Safawids, came to power for the first time in almost 900 years. Some techniques of the Seljuk period were revived, but distinctly new styles emerged, often of great vigour and brilliance. The influence of Chinese ceramics was never stronger; other inspiration came from the Isnik pottery of Ottoman Turkey, and in the later Safawid period, from European porcelain. Little is known for certain about the sites of manufacture for Safawid wares. Attributions are usually based on occasional references by European travellers in journals and letters.

Like earlier Persian ceramics, Safawid pottery is seldom found completely intact. While the potters often made a good attempt at imitating true porcelain, the fabric remained relatively soft and the shapes were often better suited to a less brittle material. This is most evident in wares which closely imitate the imported Chinese blue and white porcelain, even to the placing of Chinese seal marks on the base. An excellent example (Fig 10) in the Wolfe sale was probably from Meshed. Of remarkable delicacy, it has survived intact except for a few minor breaks in the rim. The debt to Chinese porcelain is obvious and yet few would mistake it for anything other than Persian. Even when imitative, a certain spontaneity of line separates Persian wares from the more strictly formal conceptions of the Chinese.

The polychrome wares attributed to the city of Kirman have a style that is more distinctly Persian. Less is felt of Chinese influence than of Isnik, with its distinctive use of the coral-red colour known as Armenian bole, and the emphasis on purely foliate ornament. The Wolfe collection included two fine and well-known examples of Kirman polychrome (Figs 8 & 9), both water containers for the tobacco pipe (or hubbly-bubbly). They rely for their effect on the traditionally Persian qualities of warm colour and brilliant glaze. Originally the property of the Kevorkian Foundation, both first appeared at auction at Parke-Bernet in 1967 and fetched $900 and $1,100 respectively.

It is easy to imagine these pieces at home in the splendid and luxury-loving court of the Safawid Shahs, so exquisitely represented in miniatures of the period. This is even more the case with the lustre wine bottle (Fig 11), possibly made at Isfahan or Shiraz. The technique of painting in lustre over the glaze was a revival from the Seljuk period. Here the style has become somewhat awkward and naive. The glaze and the lustre pigment, with its mysterious reflections, are of much greater importance. Later Persian pottery gives more attention to pure form than earlier works, but the care with which the elegant profile of the wine bottle has been executed is exceptional. It appeared in the same Kevorkian sale as the two hubbly-bubblys and fetched $800.

The Wolfe sale concluded with a small but very fine group of Ottoman period wares from Isnik workshops, the finest being contemporary with the early Safawid period in Iran. Isnik

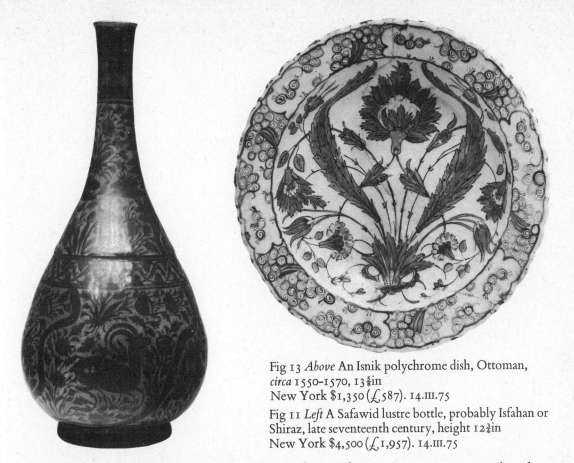

Fig 13 *Above* An Isnik polychrome dish, Ottoman,
circa 1550–1570, 13⅜in
New York $1,350 (£587). 14.III.75

Fig 11 *Left* A Safawid lustre bottle, probably Isfahan or
Shiraz, late seventeenth century, height 12¾in
New York $4,500 (£1,957). 14.III.75

has now been established as the site of manufacture for many wares once attributed to
Rhodes, Damascus, and Miletus.

Early Isnik pottery was also strongly influenced by Chinese blue and white – some pieces
being copied almost exactly – but it soon took its own course, and by the second quarter of
the sixteenth century developed into a highly individualistic style based on fluid patterns of
naturalistic flowers in brilliant colours. Fig 12 probably belongs to a narrow period immed-
iately following Isnik blue and white; turquoise is used with cobalt blue against a white
ground. Tulips, here in an unusual and vibrant swirling design, soon became the favoured
flower. The type is very rare; in 1967 it was purchased at Parke-Bernet for $1,800, a very
high price for Isnik at that time. At the Wolfe sale it sold for $9,500, just under the previous
record for an Isnik ceramic.

The addition of turquoise to the colour scheme was soon followed by other brilliant
colours, the most characteristic being Armenian bole, and the famous Isnik polychrome style
came into being. The best pieces seem to radiate their own light, and it is for this effective use
of colour that they are so highly prized. Fig 13 is probably an early example of the polychrome
style, painted before these new colours had reached their most successful realisation, and also
before the fluid designs had time to settle into more rigid patterns. An unusual piece, it was
sold at a conservative figure to the same collector as the blue and turquoise dish.

In conclusion, the Wolfe sale was a great success though of small proportions. The average
value per lot was less than $1,500 and the majority achieved less than $500–600. The sale was

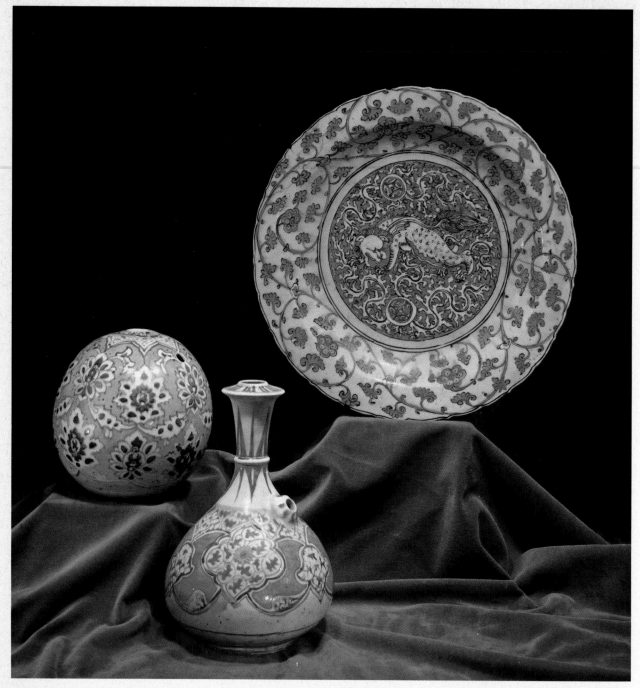

Fig 8 *Left* A Safawid polychrome *kalian*, Kirman, late seventeenth century, height 7⅜in
New York $3,750 (£1,630).
14.III.75

Fig 9 *Centre* A Safawid polychrome *kalian*, Kirman, late seventeenth century, height 10¾in
New York $7,500 (£3,261).
14.III.75

Fig 10 *Right* A Safawid blue and white dish, Meshed, early seventeenth century, 16in
New York $5,250 (£2,283).
14.III.75

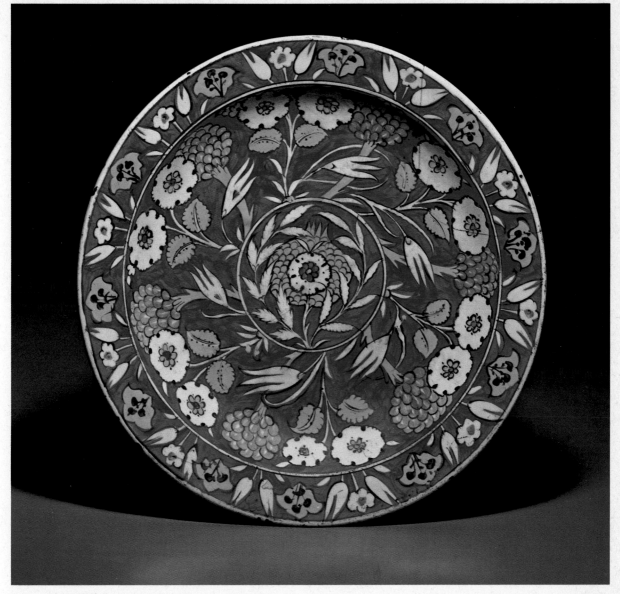

Fig 12 An Isnik dish, Ottoman, *circa* 1530-1550, 13in
New York $9,500 (£4,130). 14.III.75

significant for other reasons. While some of the pieces fetched dramatically high prices no
one suggested afterwards that the collectors and dealers overpaid, as so often happens with
sales which attract great attention. The wide variety of purchasers seemed to indicate a
future market on solid ground, rather than a transitory fashion based solely on the glamour of
the 'petrodollar'. The Wolfe collection, the last of its kind in America of which we are aware,
is now dispersed. While a great many of the pieces have appropriately returned to their
country of origin, a number have significantly added to, or possibly even formed the nucleus
of, potentially important private collections here in America and in Europe.

A Luristan bronze axehead, first millennium
BC, length 12¼in
£5,500 ($12,650)

A Luristan bronze finial, *circa*
850–650 BC, height 5¾in
£5,000 ($11,500)

The terminal from a Luristan bronze pin,
circa eighth/seventh century BC, height 3½in
£5,500 ($12,650)

A Luristan bronze pin, *circa*
eighth century BC, height 11½in
£1,900 ($4,370)

Left
A Luristan bronze horse's bit,
circa eighth/seventh century BC,
bar approximately 7¼in
£8,000 ($18,400)

These Iranian bronzes were sold
in London on 14 July 1975

A scarab with a
representation of Ramesses IX,
20th or 25th Dynasty,
steatite, 3.8cm
£750 ($1,725)

A private name scarab
of the *Chamberlain of the
Djedwy-bau, Kemes,* 12th Dynasty,
bright blue-glazed
steatite, 2.1cm
£1,100 ($2,530)

A scarab of Amenophis III
enthroned, called *The good
god, Nebmaatre,* late 18th
Dynasty, blue-glazed
steatite, 4.7 cm
£950 ($2,185)

A massive gold signet ring of the
*High Steward of the Divine
Adoratrice Sheshonk,* 26th
Dynasty, bezel 3.4cm
£8,200 ($18,860)

A *Lion-hunt* scarab commemor-
ating the shooting of one
hundred and two lions by
Amenophis III, late 18th
Dynasty, dark green-glazed
steatite, 7cm by 4.2cm
£3,200 ($7,360)

Right
A *Lion-hunt* scarab of
Amenophis III, late 18th
Dynasty, steatite with traces
of green glaze, 7.8cm by
5.3cm
£1,250 ($2,875)

A gold signet ring with
a text naming Mut, Libyan
Period, 22nd-23rd
Dynasty, *circa* 1000-700 BC,
bezel 2.4cm
£3,600 ($8,280)

An amuletic figure of a frog,
Upper Egypt, 1st or 2nd
Dynasty, diorite, 3.2cm
£4,000 ($9,200). 21.IV.75
From the collection of the late
Colonel N. R. Colville,
MC, FSA

The scarabs and signet rings
on this page are from the
collection of His Grace the
Duke of Northumberland,
KG, TD, FRS and were sold in
London on 21 April 1975

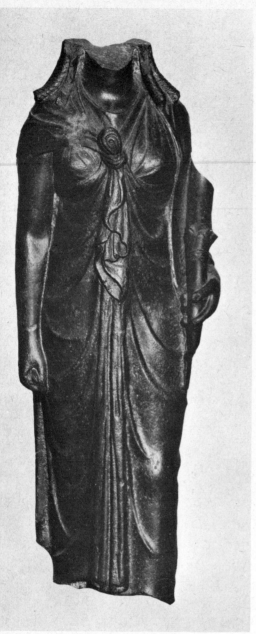

From left to right
A Romano–Egyptian black basalt figure of the goddess
Isis, *circa* first century BC/first century AD, height 38in
London £8,000 ($18,400). 9.XII.74

An Egyptian wooden figure of a concubine, 11th
Dynasty, possibly reign of Mentuhotep II, 2061–2010 BC
New York $2,600 (£1,130). 22.XI.74
From the collection of James Albright

An Egyptian bronze figure of Osiris, 21st/23rd Dynasty,
1080–720 BC, height 17¼in
New York $7,500 (£3,261). 22.XI.74
From the collection of the late Theodore Rousseau

A Pre-Dynastic speckled diorite vase with pronounced
pierced cylindrical lug handles on the shoulders, *circa*
3200 BC, diameter 11¼in
London £5,000 ($11,500). 21.IV.75
From the collection of the late
Colonel N. R. Colville, MC, FSA

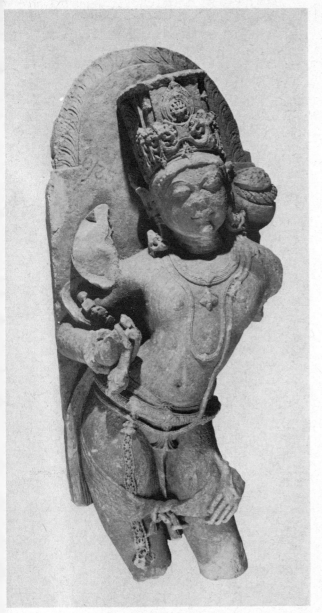

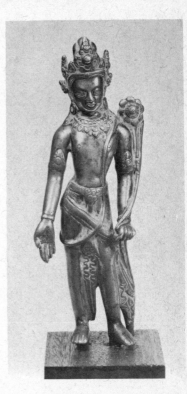

Right
A Nepalese bronze alloy figure of the Dhyanibod-hisattva Avalokitesvara, fourteenth century AD, height 6¾in
London £900 ($20,700). 19.V.75

A monumental Indian sandstone figure of a deity, possibly Madhya Pradesh, *circa* tenth century AD, height 5ft 3½in
New York $42,000 (£18,261). 16.VI.75

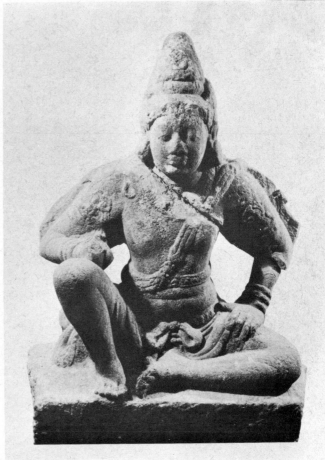

An Indian stone figure of Siva, *circa* twelfth/thirteenth century AD, height 4ft 5in
New York $22,000 (£9,595). 16.VI.75

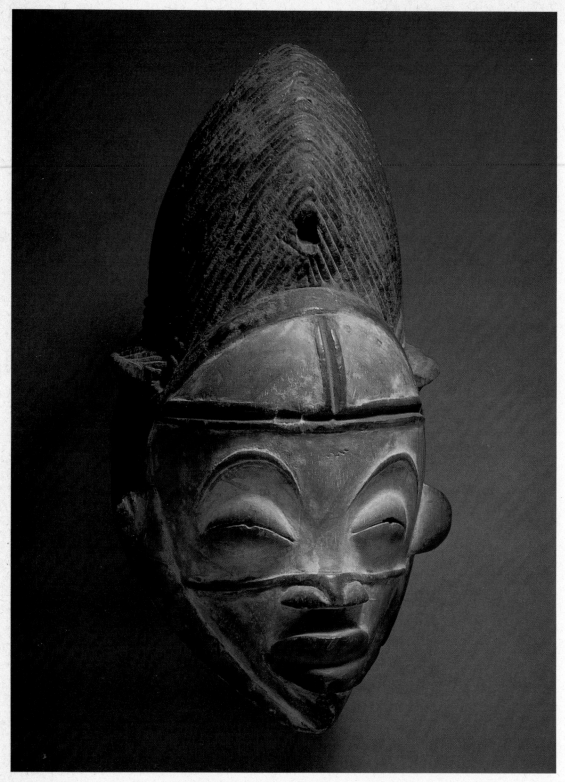

An Ashira-Bapunu wood 'white-faced' mask, Congo-Brazzaville, height 13in
London £20,000 ($46,000). 15.VII.75
From the Tara Collection

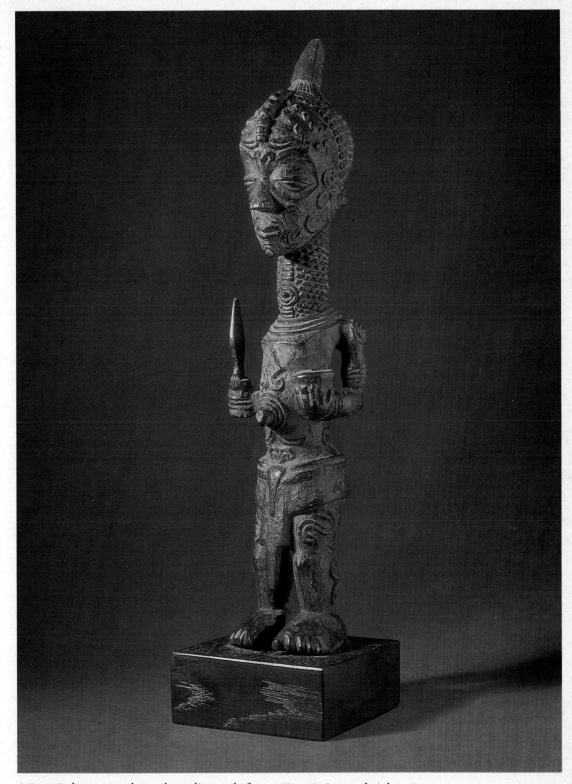

A Bena Luluwa carved wood standing male figure, Kasayi, Congo, height 12in
London £20,000 ($46,000). 15.VII.75
From the Tara Collection

From left to right
Above
A Tlingit wood mask of a
woman, height 9in
New York $20,000 (£8,696).
31.V.75

An Hawaiian wood 'stick'
figure, height 8in
London £2,600 ($5,980).
15.VII.75

A Veraguas gold pendant,
circa 800-1500 AD, height 4⅜in
New York $13,000 (£5,652).
11.X.74

A Zapotec pottery incensario,
Oaxaca, Monte Alban III B,
circa 550-750 AD, height 29½in
New York $11,000 (£4,783).
11.X.74

European Ceramics

367 ENGLISH POTTERY

372 ENGLISH PORCELAIN

376 CONTINENTAL POTTERY

383 CONTINENTAL PORCELAIN

387 NINETEENTH- AND TWENTIETH-CENTURY CERAMICS

A Staffordshire white saltglaze group of lovers, *circa* 1750, height 7¾in
London £4,600 ($10,580). 15.VII.75
From the collection of the late Sir Victor and Lady Gollancz

A documentary Wrotham tyg, signed and dated *I. E. 1703 Wrotham*, height 6¼in
London £2,000 ($4,600). 15.VII.75
From the collection of the late Sir Victor and Lady Gollancz

Opposite page
Wedgwood's 'Poole' copy of the Portland vase, solid black jasper decorated in low
white relief, late eighteenth century, height 10in
London £18,000 ($41,400). 27.V.75

The original Graeco-Roman vase is thought to have been found in a marble
sarcophagus, which was excavated under a tumulus known as Monte del Grano on
the outskirts of Rome in 1582. It occupied a place of honour in the library of the
Barberini Palace until, for financial reasons, it came into the possession of the Duke
of Portland who lent it to Wedgwood. The original vase was broken in 1845, but
pieced together and can still be seen in the British Museum.
Wedgwood received the vase on 10 June 1786 and began experimenting with
various grounds and modelling the reliefs. He took orders for the 'First Fifty' by
subscription at fifty guineas each, although it is known that the number actually
produced was nearer to half that figure.

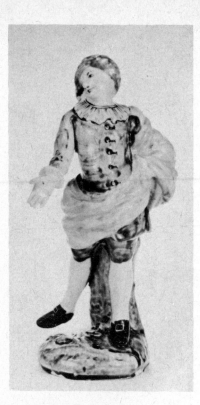

Left
A saltglaze figure of a piper, *circa* 1740-1745, height 7¾in
London £2,000 ($4,600).
1.VII.75
From the collection of
Mrs Stella Pitt Rivers

Right
A coloured saltglaze Italian
comedy figure of Mezzetin,
after a Meissen original, *circa*
1750-1755, height 4½in
London £1,500 ($3,450). 27.V.75
The figure is taken from a
Meissen original modelled by
Reinicke and Kaendler from a
series of *Commedia dell' Arte*
figures ordered for the Meissen
factory by Johann Adolf II,
Duke of Weissenfels. The source
of most of the figures was Luigi
Riccoboni's *Histoire du Théâtre
Italien,* first published in 1728

A Staffordshire saltglaze pagoda
figure, circa 1725, height 3in
London £580 ($1,334). 15.VII.75
From the collection of the late
Sir Victor and Lady Gollancz

A Suffolk Punch, a Whieldon
model of a horse with a
translucent glaze splashed in
manganese and iron tones, *circa*
1765-1770, height 7in
London £3,600 ($8,280). 22.X.74

A Staffordshire saltglaze turquoise-ground cream jug, *circa* 1755-1760, height 3in £720 ($1,656)

A Staffordshire teapot and cover, probably early Whieldon, *circa* 1740, height 5in £660 ($1,518)

Both from the collection of the late Sir Victor and Lady Gollancz sold in London on 15 July 1975

A Staffordshire slipware press-moulded dish, *circa* 1650, diameter 11¼in New York $4,000 (£1,739). 10.1.75

Left: A Worcester yellow-ground teapot and cover decorated in *famille rose* style, *circa* 1770, height 5¼in £1,800 ($4,140).
Right: A Worcester yellow-ground teacup, coffee cup and saucer decorated in the workshop of James Giles, *circa* 1770, £3,100 ($7,130).

Left: A Worcester yellow-scale milk jug and cover, *circa* 1768-1770, height 5½in £2,600 ($5,980).
Right: A Worcester yellow-ground armorial tankard, *circa* 1770, height 4¾in £4,500 ($10,350).

The objects on this page are from the collection of the late Mrs G. C. Stephens, sold in London on 1 October 1974

Three Chelsea 'Girl in a Swing' scent bottles, *circa* 1751-1754
Left A young girl, height 3¼in £2,500 ($5,750) *Centre* An oriental lady, height 3¾in £3,000 ($6,900)
Right A seated woman, height 4in £650 ($1,495)
Sold in London on 26 November 1974

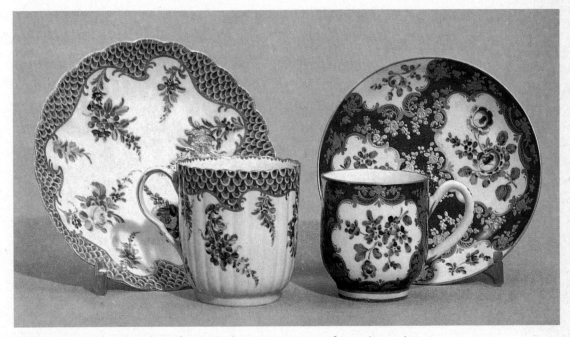

Left A Worcester pink-scale coffee cup and saucer, *circa* 1770 £1,700 ($3,910).
Right A Worcester claret-ground coffee cup and saucer, *circa* 1770 £900 ($2,070).
Both from the collection of the late Mrs G. C. Stephens sold in London on 1 October 1974

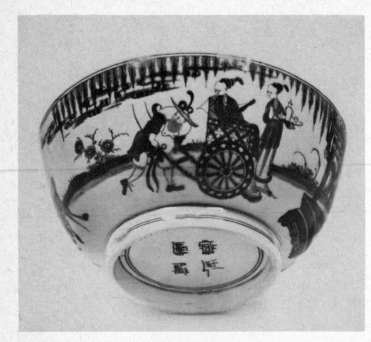

Left
A Worcester bowl, simulated four Chinese mark within a double ring, *circa* 1758, height 7½in
London £750 ($1,725). 8.IV.75
From the collection of the 2nd Viscount Chandos

Below left
A Lowestoft blue and white coffee pot and cover, painter's numeral 1 in underglaze blue, *circa* 1757-1760, height 9¼in
London £1,350 ($3,105). 8.IV.75
From the collection of the 2nd Viscount Chandos

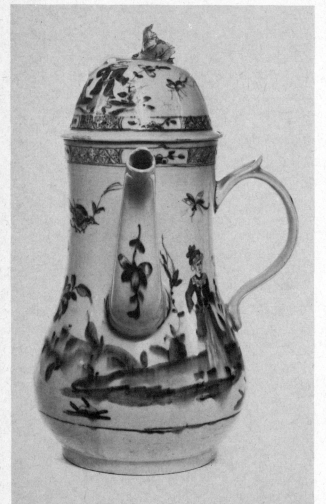

Left
A 'Girl in a Swing' gold-mounted *étui*, *circa* 1751-1754, height 2in
London £1,500 ($3,450). 6.V.75

Below
A Lowestoft blue and white loving cup, painter's numeral 3 in underglaze blue, *circa* 1760, height 3¾in
London £600 (£1,725). 8.IV.75
From the collection of the 2nd Viscount Chandos

Below A 'Girl in a Swing' figure of a
hound, *circa* 1751-1754, height 4¼in
London £3,600 ($0,000). 8.IV.75

A Bow chinoiserie group, marked 'E' in iron-red, *circa* 1750, height 7in
London £750 ($1,725). I.VII.75

Below
A Worcester blue-scale sauce tureen,
cover, stand and ladle, painted in the
workshop of James Giles, overall
width 9¼in
London £1,700 ($3,910). I.X.74
From the collection of the late Mrs G. C. Stephens

A Faenza dish, inscribed on the back with the date *17th November 1503,* diameter 11¼in
London £27,000 ($62,100). 18.III.75
From the collection of the late Sir Stephen L. Courtauld

A Gubbio Istoriato plate, painted by Maestro Giorgio Andreoli, signed on the back *MoGo* and dated *1522*, diameter 12¼in
London £55,000 ($126,500). 18. III.75
From the collection of the late Sir Stephen L. Courtauld

An Urbino Gubbio-lustred plate, painted by Nicola Pellipario, dated on the back *1531*, diameter 10½in
London £27,000 ($62,100). 18.III.75
From the collection of the late Sir Stephen L. Courtauld

A Castel Durante dish, painted by Giovanni Maria, *circa* 1515-1520, diameter 9¼in
London £16,000 ($36,800). 18.III.75
From the collection of the late Sir Stephen L. Courtauld

A Deruta wet drug jar, *circa* 1507, height 9½in
London £3,000 ($6,900). 18.III.75
From the collection of Paul Damiron

A Deruta wet drug jar, dated *1507*, height 9in
London £3,800 ($8,740). 18.III.75
From the collection of Paul Damiron

A Gubbio tondino, painted and lustred by Maestro
Giorgio Andreoli, with scenes from the story of the
Rape of Europa and the sequel to this story of Cadmus
being shown the site of the city Thebes by the heifer,
circa 1525-1530, diameter 10¼in
£6,800 ($15,640).

An Urbino Gubbio-lustred plaque,
painted in the manner of Francesco
Xanto Avelli, and showing the
Virgin supporting the Christ Child
and St John the Baptist on her
knee, *circa* 1530, 8¾in by 3in
£10,000 ($23,000).

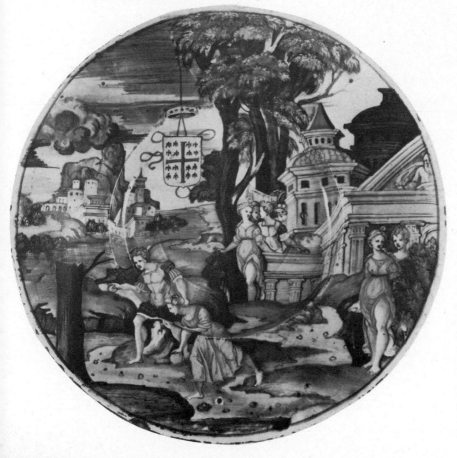

An Urbino Istoriato plate, from
the workshop of Guido
Durantino, part of the service
made for Anne de Mont-
morency and painted with the
story of Atalanta and Hippo-
menese, dated *1535*,
diameter 12in
£21,000 ($48,300).

The objects on this page are
from the collection of the late
Sir Stephen L. Courtauld sold in
London on 18 March 1975

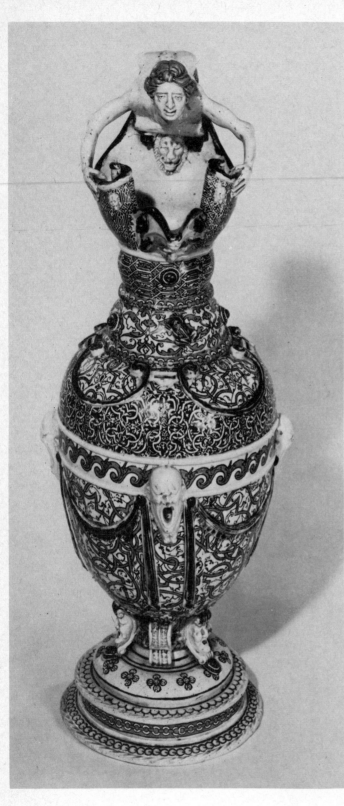

A Saint-Porchaire ewer, mid sixteenth century,
13¼in
London £44,000 ($101,200). 17.VI.75
From the collection of the late Colonel
N. R. Colville, MC, FSA

The first mention of this ewer is contained in
the 1774 edition of the description of the
contents of Horace Walpole's villa at
Strawberry Hill. On page 9, in the China
Room, we are told that 'in a niche, supported
by two columns of oriental alabaster, over the
chimney is a fine ewer of fayence design by
Guilio Romano'. The illustrated 1784 edition
of this work contains an engraving of the
chimney piece with the ewer in the central
position.
In the sale of the contents of Strawberry Hill in
1842 the ewer was bought by Sir Anthony de
Rothschild Bt for £19 19s 0d. It remained in
the Rothschild family until 1948 when it was
acquired by the late Colonel N. R. Colville.
In 1839 this type of ware was given the name
faience de Henri II because of the royal arms
that appear on a number of pieces. This
initiated a series of antiquarian disputes that
continued throughout the nineteenth century.
Subsequent researches into the exact nature and
origin of Henri II ware eventually established
it as French rather than Italian. It was not until
1888 that E. Bonaffé, after investigating a
number of sixteenth-century inventories,
published a paper entitled *Les Faiences de Saint
Porchaire* and later research has borne out his
theories.
The catalogue of the 1862 Special Exhibition of
Works of Art in the South Kensington
Museum refers to 'upwards of some fifty
pieces' surviving, to which a further ten have
been added, the majority now being in public
collections

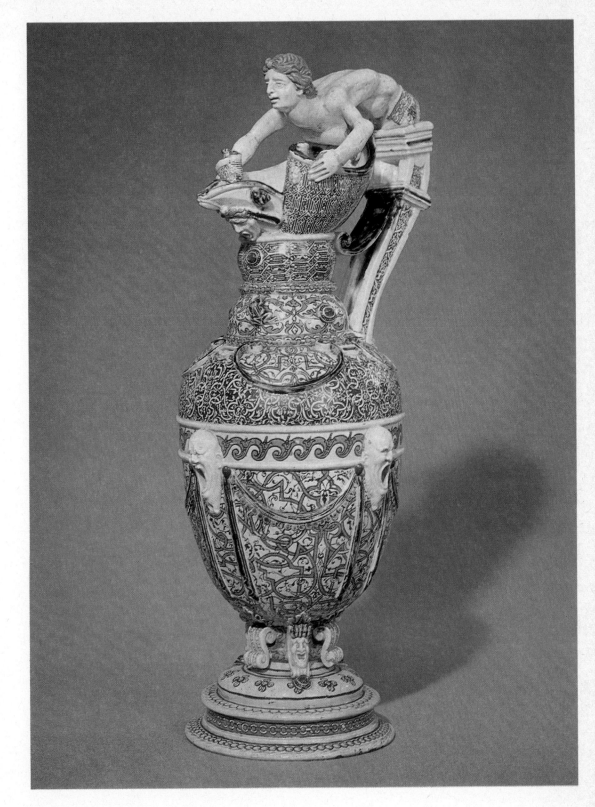

Right
A Lille faience candlestick
figure, *circa* 1740–1760,
height 8in
New York $2,700 (£1,174).
27.II.75

Above left
A German faience ewer, traces of a mark in blue
upon the base, probably Thuringian, *circa* 1740,
height 13in
London £1,250 ($2,875). 29.X.74

Above right
A Dutch Delft blue and white obelisk, potter's mark
and numeral 12 in blue (De Grieksche A factory),
circa 1700, height 14⅛in
New York $1,500 (£652). 27.II.75

One of two Venice faience storage jars with covers,
with fish hook marks in blue, *circa* 1640, height 40in
New York $7,500 (£3,261). 27.II.75

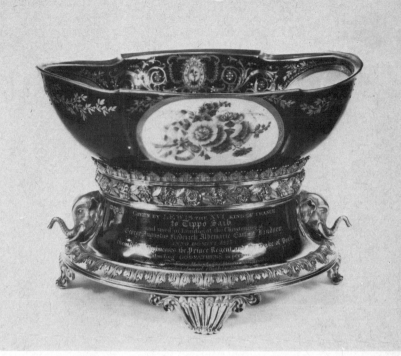

A Zürich allegorical figure
of a girl as summer,
attributed to the modeller
J.J. Mayer, mark Z and two
strokes in underglaze-blue,
circa 1770, height 8¾in
London £15,000 ($34,500).
10.XII.74

A Sèvres basin, marked with interlaced L's and the painter's mark of
Jacques-François Micaud in blue, LG in gilding, 22 incised, 1788, the silver-gilt
stand by Benjamin Smith, 1819, length of basin 13in
London £1,900 ($4,370). 10.XII.74
From the collection of Lady Muriel Barclay-Harvey

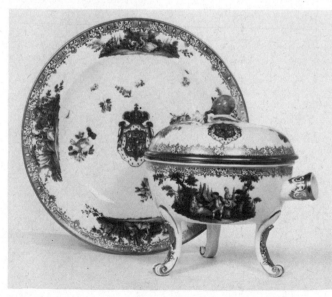

A Meissen royal skillet, cover and stand, crossed swords
marks and 22 impressed on the stand, *circa* 1745, overall
height 7½in
London £6,500 ($14,950). 17.VI.75

An early Meissen coffee pot,
painted in the manner of
J. G. Höroldt, marked R in
gilding, *circa* 1725, height 8in, and a
domed cover
London £1,000 ($2,300). 18.II.75

One of a pair of Meissen 'Seladon' bottles, crossed swords mark in blue enamel and Johanneum mark N=291—W, *circa* 1730, height 8¼in
London £20,000 ($46,000). 17.VI.75

A Meissen double-gourd vase, probably painted by Johann Ehrenfried Stadler, crossed swords mark in underglaze-blue and impressed numeral 21, *circa* 1740, height 15¼in
New York $18,000 (£7,826). 26.II.75
From the collection of the late Calvin S. Hathaway

Opposite below
A Marseilles faience tureen, cover and stand, unmarked, *circa* 1755, length of stand 17¼in $5,500 (£2,391)
A pair of Marseilles faience pot pourri vases and covers, unmarked, *circa* 1775, height 12¾in $4,500 (£1,957)
From the collection of Mrs Alan L. Corey sold in New York on 5 December 1974

Right
A Meissen landscape teapot and cover, painted in the manner of J. G. Höroldt, K.P.M. and crossed swords marks in underglaze-blue, *circa* 1723-1725, height 5¼in London £2,700 ($6,210). 17.VI.75

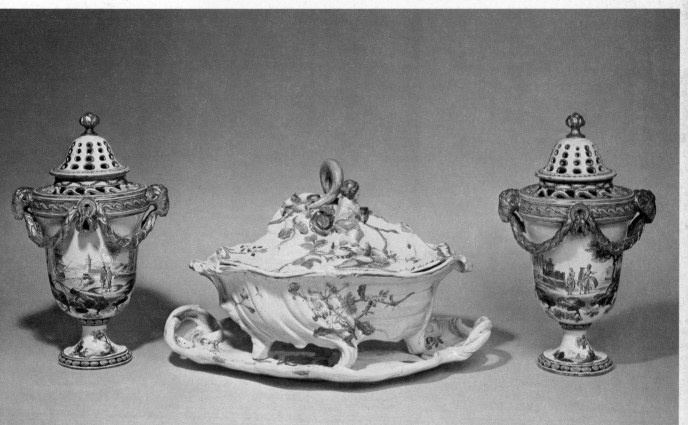

Above left
One of a pair of ormolu-mounted
'Sèvres' vases, *circa* 1850, height 18½in
London £3,100 ($7,130). 25.VII.75

Above right
Royal Vienna porcelain plaque *La
Martyre Chrétien* after a painting by
P. de le Roche, signed *S. Wagner, Wien*,
late nineteenth century, height 25in
Los Angeles $4,000 (£1,739). 24.VI.75

A pair of ormolu-mounted Sèvres
porcelain palace urns, signed
F. Ballanger, late nineteenth century,
height 75in
New York $19,500 (£8,478). 31.I.75

Above
A piece from a Royal
Worcester dessert service,
comprising six plates, a
circular dish, an oval dish
and a tazza, painted by
R. Sebright, signed, date
codes for 1917 and 1918
London £950 ($2,185).
14.XI.74

Below
One of a set of twenty-four
Coalport plates, painted by
P. Simpson, signed, early
twentieth century,
diameter 9in
London £1,450 ($3,335).
12.VI.75

Alma, a rare pot lid,
circa 1848–1858
London £460 ($1,058).
20.III.75

Above
A Royal Crown Derby
pierced eggshell 'Argyle'
plate, painted by
P. Taillandier, signed, date
code for 1893, diameter 9in
London £420 ($966).
20.II.75

Below
A Third International
commemorative Russian
plate, printed green mark of
Nicholas II, painted hammer,
sickle and eyebrow mark,
and dated *1922*, diameter 9¼in
London £85 ($195). 3.X.74

A high-fired Ruskin vase, impressed *Ruskin Pottery West Smethwick*, early
twentieth century, height 8½in
London £500 ($1,150). 3.VII.75

Chinese Ceramics and Works of Art

A ritual bronze axe-head cast with *t'ao t'ieh* masks, Shang Dynasty, 10¾in by 6¼in
London £22,000 ($50,600). 8.VII.75

A gilt-bronze tiger tally, Han Dynasty, length 4½in
London £8,000 ($18,400). 8.VII.75
From the collection of the late Colonel Norman
Colville, MC, FSA

Left
An archaic bronze axe-head (*ch'i*) cast with an owl
mask on each side, late Shang/early Western Chou
Dynasty, height 8⅜in
New York $8,100 (£3,522). 12.III.75

An archaic bronze basin (*p'an*), late Shang/early Western
Chou Dynasty, diameter 10¼in
Los Angeles $23,000 (£10,000). 17.III.75

A carved stone figure of a female musician, T'ang
Dynasty, height 12in
London £36,000 ($82,800). 8.VII.75
From the collection of E. Wolf

An archaic bronze ritual wine vessel (*ku*), Shang Dynasty, height 12½in
London £38,000 ($87,400). 8.vii.75

An interior-painted portrait snuff bottle by *Yeh Chung-san the Elder*, signed and dated second Autumn month, 1908
London £3,600 ($8,280). 24.VI.75
From the collection of J. E. G. Byman

An imperial enamelled white glass snuff bottle of *Ku Yüeh Hsüan* type, Ch'ien Lung
London £4,600 ($10,580). 24.VI.75

An interior-painted snuff bottle by *T'ing Erh-chung*, signed T'ing Yü-kêng and dated Winter month, 1904
London £1,800 ($4,140). 11.X.74

An interior-painted portrait snuff bottle by *Tzu I-tzŭ*
London £1,200 ($2,760). 11.X.74

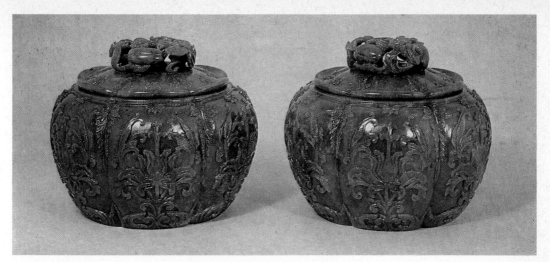

A pair of spinach-green jade covered bowls, Ch'ien Lung, height 5¼in
London £14,000 ($32,200). 12.XI.74

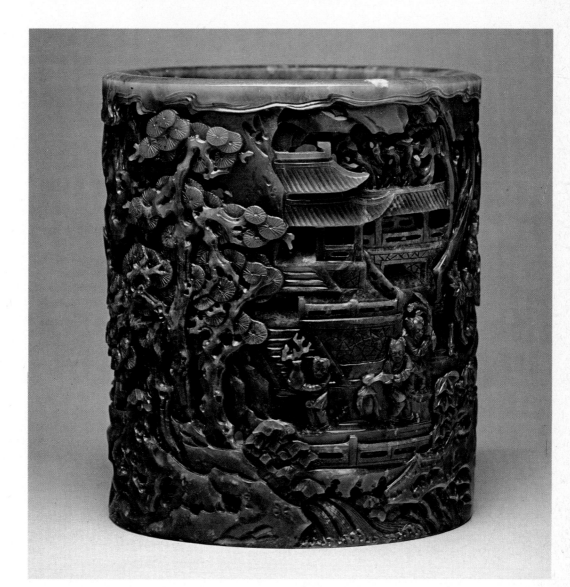

A spinach-green jade reticulated brushpot (*pi t'ung*), Ch'ien Lung, height 5¼in
New York $25,000 (£10,870). 17.X.74

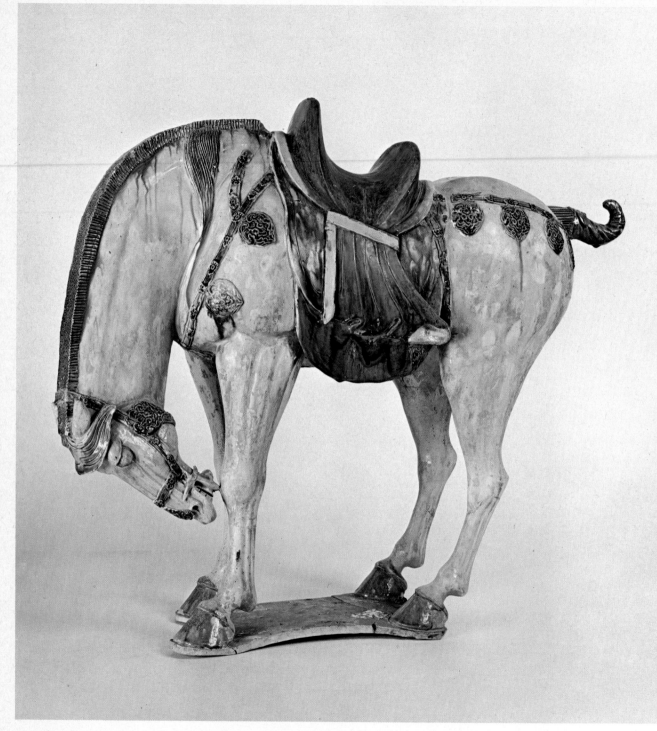

A glazed pottery figure of a Fereghan horse, T'ang Dynasty, height 24in
New York $95,000 (£41,304). 13.III.75

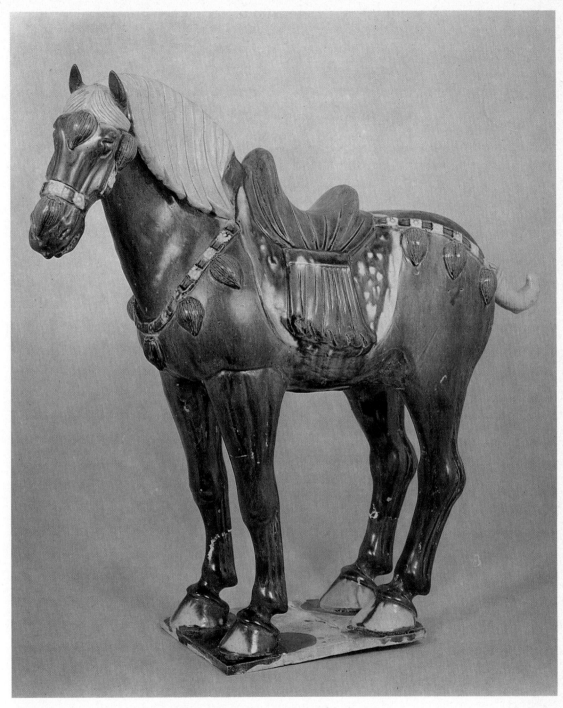

A glazed pottery figure of a Fereghan horse, T'ang Dynasty, height 19in
London £31,000 ($71,300). 8.VII.75
From the collection of Mrs C. C. Brinton

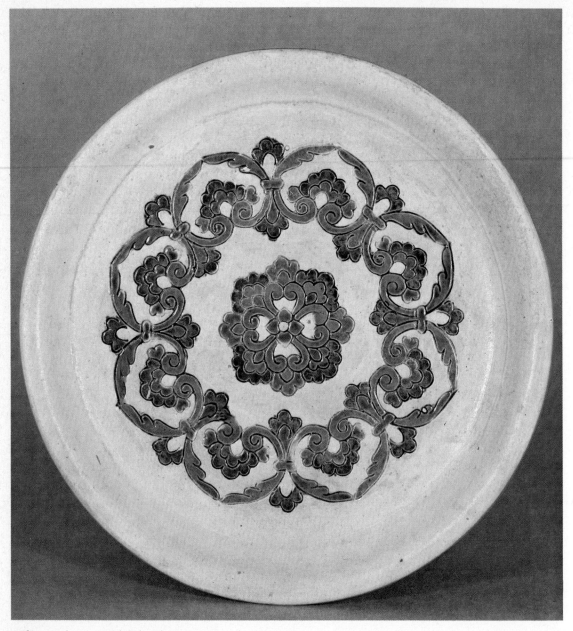

A three-colour tripod dish, T'ang Dynasty, diameter 11½in
London £24,000 ($55,200). 8.VII.75

Opposite above
A Ting-yao circular box and cover, Northern Sung Dynasty, diameter 6in
£5,500 ($12,650).

Opposite below
A carved Ting-yao conical bowl, Northern Sung Dynasty, diameter 7¼in
£46,000 ($105,800).

The two objects illustrated on the opposite page are from the collection of Mrs Alfred Clark
sold in London on 25 March 1975

A Honan black-glazed *mei-p'ing*, Sung Dynasty, height 10in
London £22,000 ($50,600). 25.III.75
From the collection of Mrs Alfred Clark
This vase was excavated at Ch'ing-ho Hsien, Hopei Province

A carved Ting-yao *mei p'ing*, eleventh century, height 12⅝in
London £44,000 ($101,200). 25.III.75
From the collection of Mrs Alfred Clark

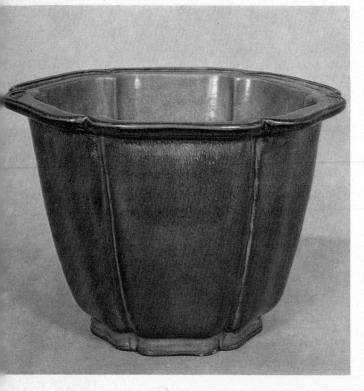

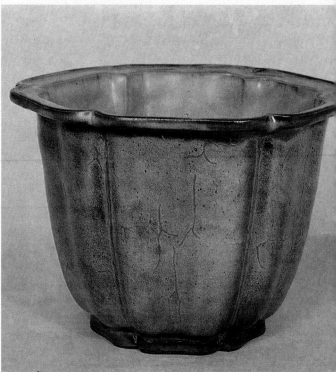

Two Chün-yao jardinières, Sung/Yüan
Dynasty, height 7½in each
London £32,000 ($73,600) and £27,000
($62,100). 25.III.75
From the collection of the University
Museum, University of Pennsylvania

A splashed Chün-yao fluted cup, Sung
Dynasty, diameter 3⅝in
London £11,000 ($25,300). 25.III.75
From the collection of Mrs Alfred Clark

A Chün-yao *mei p'ing*, Sung
Dynasty, height 14¾in
London £38,000 ($87,400).
25.III.75
From the collection of the
University Museum, University
of Pennsylvania

A kuan-yao octagonal vase, Sung Dynasty, height 9in
London £78,000 ($179,400). 8.VII.75
From the collection of John Henry Levy

A kuan-yao censer, Sung Dynasty, height 3¼in
London £30,000 ($69,000). 25.III.75
From the collection of Mrs Alfred Clark

Details of the scenes painted on the sides of the jar opposite

An early blue and white jar and cover (*kuan*), fourteenth century, height 13¼in
London £160,000 ($368,000). 25.III.75
The jar is the first example of this shape of which the lotus leaf cover has survived, and is painted with
scenes from a Yüan historical drama

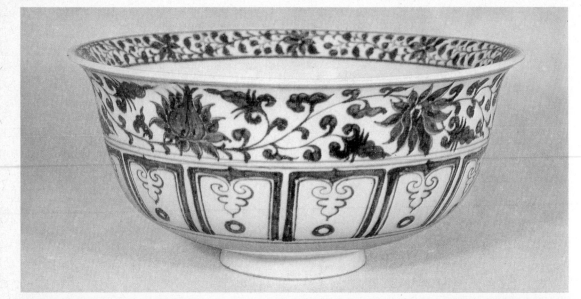

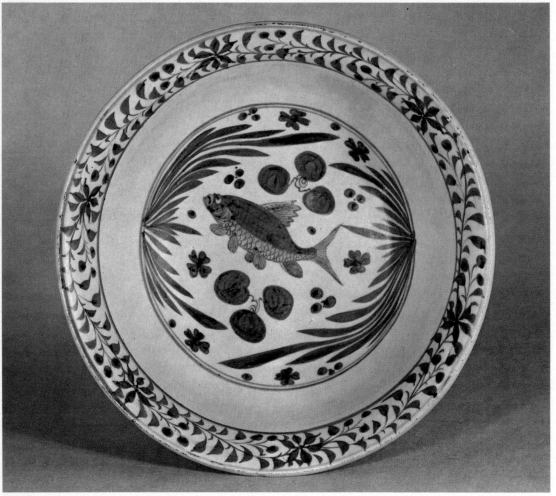

Above A blue and white bowl, Yüan Dynasty, diameter 11¾in
London £38,000 ($87,400). 3.XII.74

Below A blue and white bowl, Yüan Dynasty, diameter 11⅝in
London £44,000 ($101,200). 8.VII.75
From the collection of Sir David Home Bt

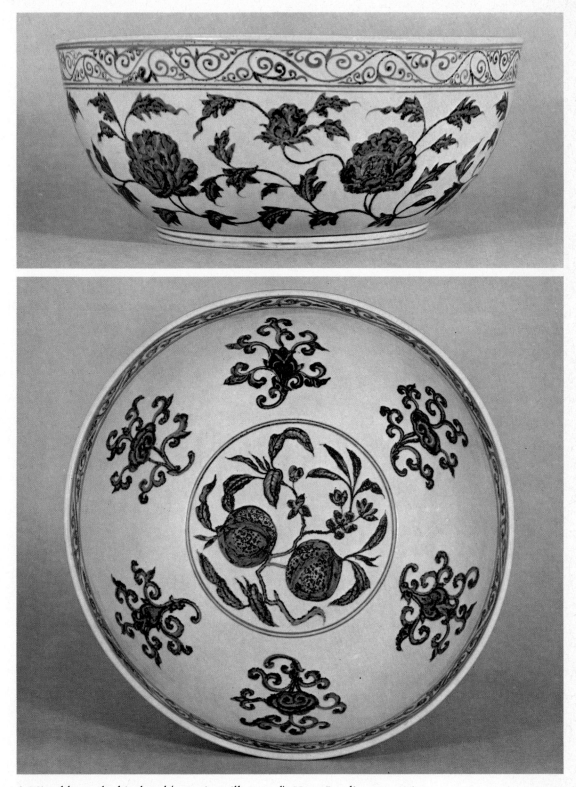

A Ming blue and white bowl (two views illustrated), Yung Lo, diameter 14⅞in
London £100,000 ($230,000). 8.vii.75
From the collection of Sir David Home Bt

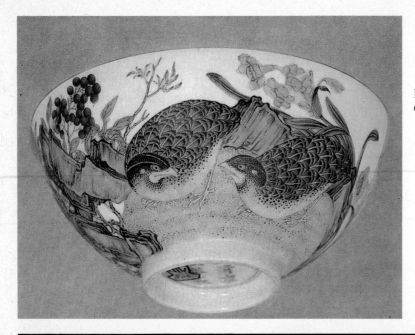

A *famille rose* bowl, six character mark
of Yung Chêng in underglaze-blue
within a double circle and of the period,
diameter 3⅞in
London £20,000 ($46,000). 25.III.75
From the collection of Mrs Alfred
Clark

An early Ming white *lien tzu* bowl,
Yung Lo, diameter 6¼in
New York $30,000 (£13,044).
13.III.75
From the collection of the late Rose
D. Seligsberg

One from a series of six plates (*Actienbordjes*), each
inscribed and painted with an Italian comedy subject
Amsterdam Fl12,400 (£2,234:$5,138). 6.III.75

A *famille rose* plate painted with the IJ in Amsterdam,
diameter 9in
Amsterdam Fl3,300 (£568:$1,306). 25.XI.74

Right
A *famille verte* vase, six character mark and period of
K'ang Hsi, height 17¼in
Hong Kong £8,500 ($19,550). 31.X.74
Now in the City Hall Museum, Hong Kong

Fig 1
A double-handled cup made for
the American market enamelled
with an eagle design derived from
the Great Seal of the United
States, *circa* 1795, height $2\frac{11}{16}$in
New York $2,500 (£1,087).
14.XI.74

Fig 5
One of a pair of royal armorial wine coolers made for William V,
Prince of Orange, after a pottery model produced at the
Marieberg factory in Sweden, *circa* 1790, height $6\frac{1}{2}$in
New York $8,000 (£3,478). 6.XII.74

Fig 2
A plate made for the American
market painted with an American
eagle perched on a cannon flanked
by flags among trophies of war,
diameter $7\frac{7}{8}$in
New York $9,000 (£3,913).
14.XI.74

The Discovery of a Century of Chinese Export Porcelain, 1682-1784

David Sanctuary Howard

'Born in America, in Europe bred
In Afric travell'd and in Asia wed,
Where long he liv'd and thriv'd, at London dead.
Much good, some ill he did, so hope all's even
And that his soul thro' mercy's gone to heaven. . . .'

In 1721 this inscription was engraved on the tomb of Elihu Yale, in Wrexham Church. Nearly forty years earlier on 2 April 1682, he had written from Fort St George at Madras to Joshua Edisbury at Erdig: 'I begg you and your good Ladyes acceptance of part in one of the vessells fil'd with our best Mango Atchar to yourself and to her a Japan Skreene which came upon this ship, Bengall Merchant.' Elihu Yale was subsequently to serve as a successful governor of Fort St George, return to his native Erdig, near Wrexham, with great wealth, give an annuity of £800 to help a struggling college in Connecticut (which now bears his name), prove himself less successful at commercial investment in England and die having lost £40,000 thereby. The mango atchar was long ago devoured; the Japan screen, recently restored, is still at Erdig after almost three centuries, but Elihu Yale left other memorials – his trust in an awakening trading empire, his belief in the future of both sides of the Atlantic, and, above all, his confidence in his own judgement.

It is not as easy to find in America evidence of the trade with China during the century up to 1784 – but this trade certainly existed. Colonial Williamsburg now has a fine record of Chinese Imari, *famille rose*, and even armorial porcelain (from the service made for the family of Virginia's last royal governor, Lord Dunmore), all found in the waste pits of the town which once housed the government of the State and now displayed in an archeological museum. The great bulk of export porcelain in America, and until recently the great bulk of interest in it, was concentrated on the period *after* 1784 and the first journey of the *Empress of China* from New York to Canton. This was the age of Washington's Cincinnati service, decorated with an underglaze blue border which in America has been called 'Fitzhugh' (not after the Fitzhughs who were relatives of Washington's family by marriage, but after Thomas FitzHugh a director of the Honourable East India Company in London). It was the age of porcelain decorated with initials and with eagles, or a representation of the arms of the State of New York or *rose medallion* or the *mandarin* taste – with gaudy Chinese figures standing on

terraces or behind balustrades – and culminating in the services, probably first made in 1836, to commemorate the sixtieth anniversary of the signing of the American Declaration of Independence.

Perhaps too, up till recently, the dominance of interest in Chinese export porcelain in the cities of the Eastern seaboard of America – Salem and Boston, Providence and New Haven, New York and Philadelphia, Baltimore, Charleston, Savannah and New Orleans – has focused attention on the wares brought back to those ports and still to be found there, sometimes in company with Chinese furniture of the nineteenth century.

Many of the great collections and museums felt the need to give undue weight to the end of the eighteenth century. Henry Francis du Pont concentrated to a very great extent on porcelain of that period in his great collection at Winterthur. The enlightened policy of training Winterthur graduates in the widest tastes of the fine arts contrasted with his own narrower preferences in porcelain and glass, but it is these very Winterthur graduates who are now in the forefront of widening the American field of export porcelain. Until recently, at least one great American museum had given so much space to the 'American period' that it had found it necessary to display a Yung Chêng teapot as 'c. 1785', in order, one feels, to justify displaying it at all.

But museums, through the bequests they receive, can only reflect the prevailing taste of collectors of the previous generation. Change is a very slow process in the appreciation of the decorative arts, and it can only happen on a wide scale when preceded by greater knowledge.

In 1956 John G. Philips published his *China Trade Porcelain*, the first book in America for twenty years to be devoted to export porcelain since Lloyd Hyde's *Oriental Lowestoft*, and this coincided with the wide distribution of the Helena Woolworth McCann collection to twenty museums from Salem to Seattle. The Metropolitan Museum in New York has pioneered an excellent and refined standard in export porcelain, and the recent publication of *Patterns of Exchange* by Clare le Corbeiller, has broadened understanding still further. Meanwhile, the detailed cataloguing of the Reeves collection in the care of Washington and Lee University, and the collection's continuing exhibition throughout the country, has brought interest to places which previously had little real knowledge of this subject. A catalogue of the Arthur and Ethel Liebman collection, the gift of Mr and Mrs John C. Cleaver, at Madison, Wisconsin, will soon be published, and at least one extensive book is expected in 1976. At the same time, a great expansion in the lecturing on export porcelain since 1970 has helped to widen interest. By comparison, little special attention has been paid to this subject by museums in England. Saleroom catalogues continue to provide more information than all other sources (although 1974 may have been an exception) and the few books which have been published in Europe during the last two decades probably owe half their sales to the American market.

As for the porcelain itself, it was only in the 1920s and '30s that some of the great collections of the nineteenth and early twentieth centuries first reached the market, and then only comparatively few pieces crossed the Atlantic. Their prices were within the purses of most European collectors who, moreover, were always at hand when there were sales in London. Thus, it was predominantly in the London market that the best appeared and was frequently retained for another generation in a European collection. This was particularly true of export porcelain of the K'ang Hsi and Yung Chêng periods, for these were most popular with European collectors nurtured on Hobson with a taste for Honey. However, since 1940, the change in relative wealth between the Old and New Worlds has allowed many of the finer pieces to sail westwards. Astute and knowledgeable Americans, during the 1940s and '50s,

Fig 3
One of a pair of armorial chargers painted
en grisaille with views of London and Canton,
circa 1735, diameter 14¾in
New York $4,000 (£1,739). 6.XII.74

were able to acquire in Europe fine examples of porcelain of the first half of the eighteenth century. It is now *these* collections which are increasingly appearing in the American salerooms and are being sold for the first time publicly in America.

Knowledge, interest, experience and purchasing power have been combined at last with porcelain of a calibre to match these assets, and the care with which lots have been researched and catalogued at Parke Bernet has kept pace with the quality of the porcelain. The sale of the Mr and Mrs Robert H. Gries collection of 1972 at Parke Bernet was a forerunner of more and better to come, although at that time some of the fine earlier pieces might have sold in England at higher prices.

At sales in 1974, culminating with the Corey collection in December, many finer pieces passed happily from one American collector to another without the long journey to London. Up till 1972 it had still been possible for the watchful buyer to purchase in New York and sell soon after in London, turning dollars into the same number of pounds. That time has almost passed, and when a single mug with the arms of Hogan sold in January 1974 for $1,200 (£500) this showed a handsome margin over the price that this same mug, with two others of the service, had fetched at Sotheby's in November 1970 (£260).

Early November 1974 saw the first 'Americana' sale of Parke Bernet's season – which category includes export porcelain. (Perhaps the same logic, although not without some reason, includes Chinese export porcelain in the Western Decorative Arts Department of the Metropolitan Museum.) Confidence was lacking at the start of the sale and buyers 'missed' fourteen iron-red and gold plates of about 1735 at $550 (£230 the lot). This is an indication that the Yung Chêng period is still too little understood. A number of pieces from European sources were more sought after, but it was not until a two-handled cup with an unusual American eagle was sold for $2,500 (Fig 1), and a plate with another eagle, similar to a piece at Winterthur, was sold more flatteringly for $9,000 (Fig 2), that one became aware of where confidence still lay! Of that section only 38 per cent of the 143 lots were made before 1780 (the start of the American period).

The sale of the Corey collection in early December was very different; the glamour of a

Fig 4
An armorial soup tureen, cover and stand with a Continental coat-of-arms, *circa* 1770, length of stand 14¾in
New York $5,500
(£2,391). 6.XII.74

fine collection being combined with a high percentage (58 per cent) of lots executed before 1780. More important, confidence had returned. The seventeen armorial dishes and plates of the Lee service totalled $15,600 (Fig 3), which can hardly be called expensive when the artistry and workmanship involved is compared with that of 'the eagle'. Frederick the Great's punch bowl with some damage, fetched $4,600, and a Continental armorial tureen and stand ($5,500, Fig 4) accompanied some good plates of the service made in 1773 for the great Earl of Chatham at $1,000 each. This would have pleased the Younger Pitt, had he been watching, for he left so many debts at his death that these had to be paid by a grateful nation. The fine pair of wine coolers which belonged to his ally, William V, Prince of Orange, did even better at $8,000 (Fig 5).

The January 1975 'Americana' sale at Parke Bernet proved that confidence had been regained. The Metropolitan sold some duplicates (a sensible way to fund new purchases) and 59 per cent of the 171 lots were from before 1780. (This probably compares with nearer 80 per cent in similar London sales.) Candlesticks are always interesting and a pair of *circa* 1735 were fairly priced at $2,600 (Fig 6), as were a pair of dishes with Meissen borders, *circa* 1735, at $1,400 (Fig 7). The 11in lotus-pattern saucer dish sold well at $800, but two milk jugs, 'Dutch-decorated' with scenes of the Crucifixion, were neglected at $375 (Fig 8). The really significant prices were paid for a K'ang Hsi *famille verte* armorial plate dated 1702 ($3,500, Fig 9) and for a pair of chargers, with underglaze blue rims, decorated about 1719 with the arms of Gough ($3,600, Fig 10), both from decades frequently neglected in New York.

The development of taste for the first half of the eighteenth century is still in its early stages in America. In time it will spread back to the seventeenth century and the period before export porcelain was thought of. I am sure that the stairs of 34-35 New Bond Street will be trodden eagerly by future generations of collectors, but they will be increasingly matched by the lifts at 980 Madison Avenue from where eighteenth-century export porcelain of the *whole* century will spread across America, until only the Pacific separates it from where it started.

There are, of course, already fine collections of *famille verte* and Chinese Imari, *rouge-de-fer* and gold and porcelain painted after European prints and paintings of the first half of the century – but these will no longer be the exceptions. In America it is still possible to be young and a great collector (something which taxation has made almost impossible in Britain).

Fig 8
Two 'Dutch-decorated'
milk jugs with scenes of
the Crucifixion and one
with unusual crown-of-
thorns border, *circa* 1750,
height 5⅜in
New York $375 (£163)
30.1.75

Fig 6
One of a pair of
candlesticks of English
silver shape, *circa* 1735,
height 8⅜in
New York $2,600
(£1,130) 30.1.75

Fig 7
One of a pair of chargers with a Chinese scene and rim with
gilt border of Meissen inspiration, *circa* 1735, diameter 14in
New York $1,400 (£609) 30.1.75

Above Fig 9
Armorial plate in *famille verte* palette
with the arms of de Vassey, dated 1702,
diameter 7⅝in
New York $3,500 (£1,522). 30.1.75
Right Fig 10
One of a pair of armorial chargers,
probably made for the wedding of
Captain Harry Gough in 1719, *circa*
1720, diameter 15in
New York $3,600 (£1,565). 30.1.75

Fortune has often smiled on the collector who has been able to spend a *lifetime* with his subject, has made and discovered his first mistakes by himself, and has outlived his early prejudices. So often the size and importance of a collection does depend on the age of the collector when he started and certainly the greater the passage of time the more comforting the effect on values. And this will not change in this finite field.

The art of collecting well (an art often as creative as the work of the artisan who made the original), is closely bound with nerve and knowledge, whenever and wherever opportunity exists. Many opportunities will come but once, and the greater the collector the less often he will regret the opportunities he missed. In the field of eighteenth-century export porcelain he is fortified by the knowledge that there is a steadily shrinking supply, due to museum acquisition as much as breakage, and a growing international market which is increasing in participants, taste and knowledge.

A single year is too short a period to make any sure judgement, or plot any certain path to the future – especially as the Western world tries to regain buoyancy on the new Arabian sea – but this year Madison Avenue has reason to be more cautiously optimistic than ever before. While for the buyer, as always, whatever his taste or purse, *he who dares wins*. And in a world of rapidly rising prices, one precious commodity, though increasingly scarce, is still entirely free: confidence, in the future, and above all in individual judgement. With all the different problems which Elihu Yale faced three centuries ago, he understood that well.

Japanese Works of Art

A shibayama and lacquer three-fold screen, each fold decorated on both sides with amusing scenes of animals and insects, late nineteenth century, 20cm by 355cm overall
London £1,700 ($3,910).
28.XI.74

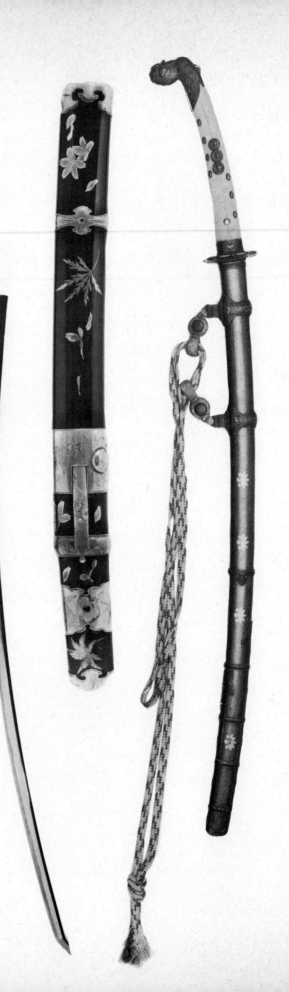

From left to right: Above
A *shakudo nanako tsuba* signed *Ishiguro Masatsune*,
mid/late Edo period, diameter 7.3cm
London £2,600 ($5,980). 20.v.75
From the collection of the late William Vincent
Bradford, CB

A *Tanaka tsuba* signed *Hojudo Toshikage, Manen
Koshin Riogetsu,* diameter 8.1cm
London £1,400 ($3,220). 20.v.75
From the collection of the late William Vincent
Bradford, CB

A *shakudo nanako tsuba* signed *Yanagawa Naohisa*,
mid-Edo period, diameter 7.4cm
London £1,500 ($3,450). 20.v.75
From the collection of the late William Vincent
Bradford, CB

A *shakudo tsuba* decorated with the Thirty-Six Poets,
signed *Kimpu ju zogan honkei Katsuki Ichinojo
Ujiyoshi*, mid-Edo period, diameter 7.5cm
London £1,900 ($4,370). 20.v.75
From the collection of the late William Vincent
Bradford, CB

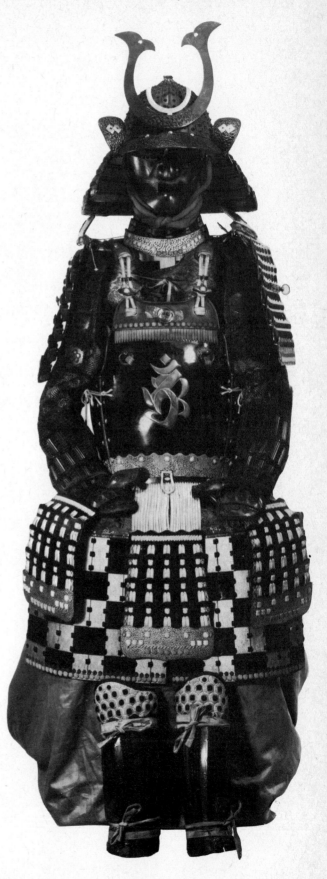

Opposite page
From left to right
A *Kamakura tachi* by *Ayanokoji Sadatoshi* in
shirasaya, signed, 71.6cm
New York $16,000 (£6,957). 16.VI.75
From the collection of Colonel Francis R.
Hoehl

A *Koto aikuchi* in silver mounts by *Nakagawa
Issho,* the blade signed *Morimitsu,* 29.5cm
New York $4,400 (£1,913). 23.I.75

A 'bird's-head' *tachi* containing *shinshinto* blade
by *Tokukatsu,* signed *Suifu ju Katsumura
Tokukatsu saku kore* and dated *Ansei san ki*
(third season, i.e. 1856) second month,
blade 80.6cm
London £3,600 ($8,280). 3.III.75
From the collection of Hugh Jackson

Right
Hotoke do tosei gusoku: A thirty-two plate
Kaga hoshibachi, the *zaboshi* and *do manju
shikoro* signed *Kashu no ju Munefusa,* the *ikada
gote* signed *Jurio Mitsunori,* eighteenth century
London £3,400 ($7,820). 3.III.75

From left to right: *Above*
KOKUSAI: A *Sashi* stagshorn *netsuke*
in the form of an octopus ghost
New York $4,300 (£1,870).
1.X.74

SHIGEMASA: A large model of a
horse
New York $7,500 (£3,260).
1.X.74

OKATOMO: A dog, *Kyoto*, late
eighteenth century
Honolulu $11,000 (£4,782).
24.1.75
From the collection of Max G.
Ritter

Left
GOHO: A boxwood study of a frog
on a tortoise.
Los Angeles $4,250 (£1,848).
10.VI.75

Below left
OKATOMO: A bitch and pup. London £6,500 ($14,950). 30.VI.75
Below centre
SHOKO: An ebony bat. London £5,500 ($12,650). 6.V.75
From the collection of Professor and Mrs J. Hull-Grundy
Below right
OKATORI: A small study of a hare. London £2,500 ($5,750). 6.V.75

A lacquer five case *inro* signed
Kokosai Shozan saku, nineteenth
century
Honolulu $2,900 (£1,261). 24.I.75

A *Shibayama inro* signed *Masayuki*, mid nineteenth century
Honolulu $3,400 (£1,478). 24.I.75

Above left
TOKOKU: An ivory study of a snail, signed, with
inlaid gold seal
London £2,400 ($5,520). 30.VI.75
Above centre
TOMOTADA: A stag and young, eighteenth century
New York $24,000 (£10,434). 19.VI.75
Left
GYOKUSO: A wood figure of Kiyohime, signed,
twentieth century
Honolulu $4,000 (£1,739). 24.I.75
Right
A boxwood three case *inro* with tortoise ojime, and a
wood *netsuke* carved in the form of an adult tortoise,
signed *Hidari Issan*
New York $2,700 (£1,174). 1.X.74

A *Tsuishu inro* carved with an elaborate scene, possibly an allegory of the expulsion of Adam and Eve from Paradise, unsigned, early to mid nineteenth century London £2,000 ($4,600). 6.V.75

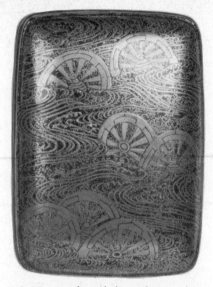

A *Muromachi Kobako* with Buddhist wheels amidst waves, late fourteenth century, 8.3cm by 6.2cm New York $4,800 (£2,087). 19.VI.75

A four case *inro* signed *Tsuishu Yosei* New York $2,700 (£1,174). 1.X.74

A carved green and red lacquer *inro* signed *Yosei saku* New York $3,500 (£1,522). 1.X.74

An export lacquer coffer, early Edo period, 63cm by 35.7cm
London £1,500 ($3,450). 30.VI.75

A *Momoyama bunko*, sixteenth century, 41.9cm by 31.8cm
New York $4,000 (£1,739). 19.VI.75

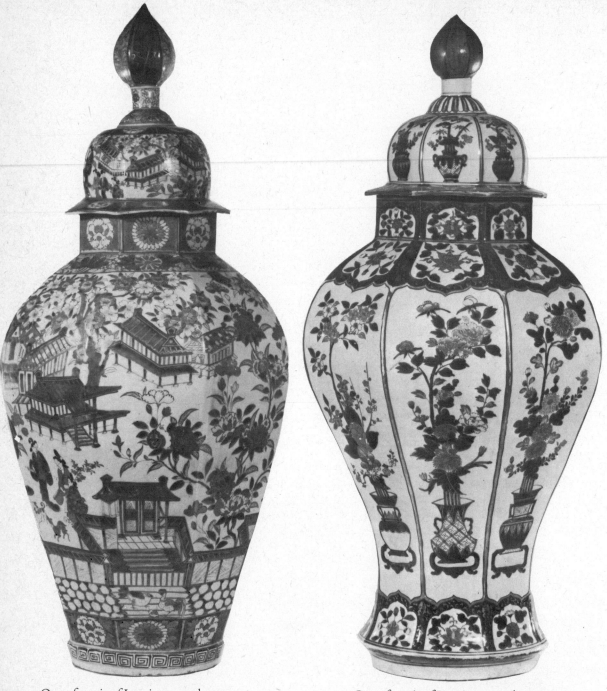

One of a pair of Imari vases and covers,
late seventeenth century, height 88cm
Monte Carlo Fr48,000 (£5,181: $11,916).
26.v.75

One of a pair of Imari vases and covers,
early eighteenth century, height 83cm
Monte Carlo Fr32,000 (£3,440: $7,912).
26.v.75

Right
A Kakiemon bowl, late seventeenth
century, 26cm
London £3,800 ($8,740). 30.VI.75

Below left
A *Ryozan* silver lacquer and shibayama
covered vase signed *Ryo-zan, circa*
1900, 16cm
London £1,050 ($2,415). 24.X.74

Below right
An Arita blue and white dish, late
seventeenth, early eighteenth century,
61cm
Amsterdam Fl7,700 (£1,387: $3,190).
6.III.75

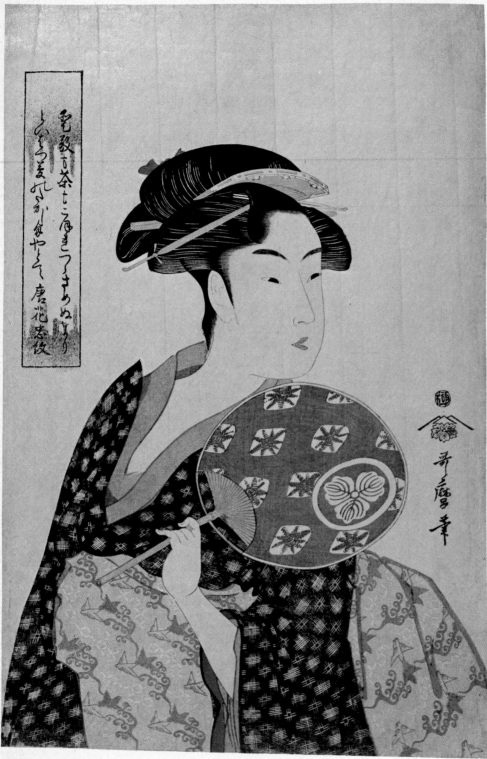

KITAGAWA UTAMARO
Portrait of Ohisa of Takashimaya. Colour print, signed
New York $70,000 (£30,435). 18.VI.75

KITAGAWA UTAMARO
Two women. Colour print, signed
New York $28,000 (£12,174). 18.VI.75

TOSHUSAI SHARAKU
Portrait of Arashi Ryuzo as the money lender in the play Hanaayame Bunroku Soga.
Colour print, signed
New York $25,000 (£10,870). 18.VI.75

TOSHUSAI SHARAKU
Portrait of Miyako Dennai III. Colour print, signed
London £11,000 ($25,300). 6.XI.74

SUZUKI HARUNOBU
A youth visiting his paramour clandestinely at night. Colour print, *circa* 1768
London £8,500 ($19,550). 26.III.75

The Henri Vever Collection of Japanese Prints, Illustrated Books and Drawings

Jack Hillier

America's somewhat peremptory insistence in 1853 on an end to Japan's self-imposed isolation from the rest of the world was actuated largely from mercantile motives, but it had repercussions on the pictorial art of both Japan and the West that could never have been envisaged. The confrontation of two aesthetic cultures, each with very little previous awareness of the other, at a time when both were unusually susceptible to new stimuli, led to cross-influences that are now commonplaces in any history of Impressionism, and subsequent movements in the West, and also of modern painting in Japan. Another quite separate outcome was the opportunity provided for a study of Japanese art, hitherto practically unknown in the West, and the formation of collections of paintings, prints, ceramics, lacquer, metalwork and a whole range of minor artifacts.

It needs to be stressed that although the medium of the most fruitful cross-fertilisation of Japanese art on Western painting was the colour print, it was not, by and large, the kind of colour print that devotees of *Japonisme* were beginning to collect. The evidence of the Japanese prints owned by van Gogh, for example, shows that what he admired and responded to were those of relatively late production such as the stridently coloured actor and wrestler prints of Kunisada, or the landscapes of Hiroshige, with their novel angles of viewpoint and reduction of natural scenes to patterns of flat colour. And the prints that appear in the backgrounds of paintings by Gauguin, Manet and others show that their taste, too, was for prints that, to the *cognoscenti,* were products of a moral and artistic decadence. The study of the development of the art of the colour print, and the bringing together of significant collections that illustrated the whole range of Ukiyo-e from its beginnings in the seventeenth century onwards, were the activities of an entirely different circle of men from the practising painters, and it is to them that we owe the wonderfully comprehensive holdings of Japanese prints in Europe and America: a wealth that far exceeds the numbers in the country of their origin, and which today is the envy of the Japanese, who blame their forebears for the indifference that allowed such vast numbers of fine prints to go abroad.

Far and away the most powerful centre of *Japonisme* was Paris, and it was there that collections were formed by connoisseurs whose names not only belong to the history of collecting, but are attached specifically to certain of the key prints of Ukiyo-e. High up on this list of French collectors, if not indeed first, is the name of Henri Vever. He was not the earliest in the field – others, like Louis Gonse, Theodore Duret and the de Goncourt brothers, were before him: but none was more dedicated, or amassed so numerous and comprehensive

TORII KIYONAGA
The actor Matsumoto Koshiro IV in private life studying tea-jars with his wife.
Colour print, *circa* 1783
London £1,500 ($3,450). 26.III.75

a collection, with so high a proportion of masterpieces and rareties. An amateur artist himself, of some attainment, and professionally a jeweller whose writings belong to the literature of *bijouterie*, Henri Vever was an omnivorous collector in a dozen spheres in all of which he showed unusual taste, appreciation and acumen. Born in 1854, he had already made important collections of Western prints and early printed books before he was thirty, and it was not until the late 1880s that he first became enthralled by Japanese art, and especially the Japanese print, a passion for which he possessed until his death in 1943. Memoirs of fellow collectors, like Raymond Koechlin's *Souvenirs d'un vieil amateur d'art de l'Extrême Orient*, reveal him as a single-minded, indomitable collector who would spare no pains and neglect no stratagem to acquire the prints he coveted. He was on intimate terms with the leading Parisian dealers of the day – S. Bing, Tadamasa Hayashi, and Boussod Valodin – and bought also from Ketchum in New York, and Yamanaka in London. His collection was universally known, and he encouraged authors to reproduce his prints: almost all the standard works of this early period, from von Seidlitz's *History* of 1897 onwards, relied heavily upon Vever for their illustrations.

Although, because of its size, it was impossible for anyone to appreciate the full extent of his collection, the great Paris exhibitions of 1909 to 1914 gave some indication of its scope. These exhibitions, given at the Musée des Arts Decoratifs on an entirely different scale from anything conceivable earlier and accompanied by catalogues that represented an enormous advance upon everything so far published on the subject, revealed the dominance of the French collections over those of the rest of the world, and also the superiority of the Vever over the rest of the French. To the first, 1909, exhibition of 'Primitives', for instance, Vever contributed no less than ninety-five of the total of three hundred and twenty-eight exhibits.

After the First World War there was a period when the majority of the notable French collections which had formed the basis for the Paris exhibitions were broken up. The Manzi was sold in three sales in 1920 and 1921; the Jacquin in 1921; the Rouart in 1922; the enormous Haviland collection in a series of six sales from 1922 to 1924; the Gonse in two sales in 1924 and 1926. It was at this time, in 1920 to be precise, that Henri Vever, for reasons never disclosed, parted with a large number of prints (a figure of 8,000 has been quoted) to Kojiro Matsukata, an industrialist and shipping magnate who, in 1943, presented the collection to the Imperial Household Ministry, from whence they were eventually transferred to the Tokyo National Museum and there comprise by far the greater part of the Ukiyo-e holdings.

At the time, many people assumed that Vever had disposed of his entire collection, but this was far from the case. He retained a considerable number of prints, including many of outstanding quality and state of preservation, and others for which he clearly had some special affection: many, in fact, that were described and illustrated in the memorable catalogues of the Paris exhibitions of 1909 to 1914, prepared by the leading authority of the day, Charles Vignier, in collaboration with a Japanese, H. Inada. To this important nucleus Vever began adding almost from the day the transaction with Matsukata was consummated. He bought prints in several of the major sales of the 1920s mentioned above, from the Manzi and Haviland in particular, always selecting with the keen, informed eye of one who had been studying prints for over thirty years and who was sensitive, above all, to qualities of design and impression. By the time the war started in 1939, the collection had once again grown to dimensions that many national museums might envy, and, miraculously, it survived the dangers of occupied France intact. Henri Vever, however, did not survive the war: he died in 1943.

TORII KIYOMASU
Full-length standing figure of a courtesan, whose dress is patterned with
scenes from a play of 1715. Ink print, coloured by hand
London £11,000 ($25,300). 26.III.75

ISHIKAWA TOYONOBU
Actors in a play performed at the Nakamura Theatre in 1751. The princess Taema is distracting
the magician-monk so that she can cut a rope with which he has cast a spell of drought over the
land. Colour print
London £5,600 ($12,880). 26.III.75

KATSUSHIKA HOKUSAI
Pilgrims on a path, with a view of Fuji beyond wooded
foothills. A preliminary drawing for 'The Hundred
Views of Fuji'
London £6,000 ($13,800). 26.III.74

TOSHUSAI SHARAKU
The actors Ichikawa Komazo II, Ichikawa Omezo and
Nakayama Tomisaburo in a play scene. Drawing in ink
and colour
London £4,600 ($10,580). 26.III.74

For many years subsequently the collection was stored in New York, and from time to
time rumours of its existence caused a flutter in the hearts of all true lovers of Ukiyo-e. But
when, finally, it did reach the Sotheby saleroom, and the first part of about four hundred
items was catalogued for the sale of the 26th March 1974, everyone – hardened dealer,
sceptical collector and experienced art-historian alike – was amazed and delighted at the
treasure trove revealed. Many, familiar with the Vignier and Inada catalogues, had yearned
for especially famous prints since unaccounted for, their only record a catalogue note and a
monochrome illustration; others dreamed of an auction comparable to the Jacquin, or the
first or second Haviland or any of the Manzi, of which the catalogues' tantalising descriptions
were often all we had known of certain rare prints. The two Vever print and drawing sales,
held on the 26th March 1974 and on the exact anniversary in 1975, were the answer to those
sighs, the realisation of those dreams. Both the sales were replete with prints that had been
exhibited in the Paris shows and since then lost without trace; and either sale was the equivalent
of any of those dispersals of the 1920s. We were able to re-live the sense of occasion, to savour
the *embarras de richesses* that only those active in the 1920s had been privileged to experience.
Suddenly, prints that before had been monochrome ghosts, emerged from the shadows in all
the splendour of their pristine colour. Others, whose existence had not even been hinted at
before, positively stunned the devotees, who progressed through portfolios with an
expectancy that must have matched that of Henri Vever himself when he was allowed by
Bing or Hayashi to run through the latest consignment of prints just unloaded from the ship
from Japan in the 1880s.

The catalogues of the two sales in 1974 and 1975 record in detail numerous prints in these
categories: two instances are provided among those illustrated here. The first, the full-length
figure of a courtesan by Torii Kiyomasu, is unique so far as we can tell and hitherto known
only by the monochrome illustration in the catalogue of the 1909 exhibition: no one could

have imagined from that the impact of the *tan* (red lead) hand-colouring, a characteristic embellishment of the earliest prints of beautiful women (p.434). The second, the superb theatrical piece by Ishikawa Toyonobu, was completely unknown before the Vever sale this year, and is further remarkable in that the colours of the *benizuri-e* (the name by which these broadsheets, the first in which colour was block-applied, are known) are in absolutely pristine state – a rare occurrence, since the vegetable dyes used for the pink and green are exceptionally fugitive (p.435).

Vever, like most of the pioneer collectors in the Japanese field, was primarily interested in prints, either in broadsheet *(ichimai-e)* or picture-book *(ehon)* form. (A selection of some of the outstanding *ehon* of the seventeenth to nineteenth centuries was included in each of the two sales.) But he was by no means unsympathetic or unknowledgeable with regard to paintings and drawings and owned notable groups of brush-drawings by two major artists, Hokusai and Sharaku, all of which were included in the first sale. Hokusai drawings, invariably unsigned, are notoriously controversial from the point of view of authentification, but the provenance of those in Vever's hands was generally unimpeachable. Many came via Hayashi, who is believed to have had them directly from Hokusai's pupils or their descendants, but quite apart from their source, they are vouched for either by their convincing quality or because they are obviously preliminary drawings for known prints or book illustrations. Of the latter type was the drawing, known erroneously as 'The Rape' (actually a study for a book illustration depicting a hero protecting a woman from danger), one of the most famous of all Hokusai's drawings and falling to a London dealer for the sensational bid of £28,000. Other sketches were first thoughts for what is generally considered the greatest of Hokusai's picture-books, 'The Hundred Views of Fuji', and for the *Manga,* the most popular of his books in Japan.

The Sharaku drawings were three in number: two from a group of eight thought to be designed for a theatre-book which never reached publication, acquired by Vever from the Barboutau sale in 1904; and the third, the sole survivor of a set of ten drawings of wrestlers, also made with prints in mind but never actually engraved, the remaining nine having been destroyed in the 1923 Tokyo earthquake disaster with the rest of the great Kobayashi Bunshichi collection.

It is the survival and reappearance of prints and drawings of such supreme importance that has brought new lustre to the name of Vever, already famous in the West, and revered in Japan because the national collection is largely of his making. To show their recognition of the significance of the newly-emerged prints, an exhibition of three hundred items was arranged before the second Sotheby sale by Nihon Keisai Shimbun, in Tokyo, Osaka and Hiroshima, and it is some measure of the drawing power of Ukiyo-e in Japan today (and especially of Ukiyo-e connected with Henri Vever) that a staggering total of over 70,000 people attended. In one article published in Japan the title 'The Second Vever Collection' was coined, but such a term is inaccurate for, as explained above, many of the prints in the two sales at Sotheby's were among the original acquisitions of Vever when he was first caught up in the wave of enthusiasm for Japanese art in the 1880s. Nothing bears stronger testimony to the unquenchable urge of Henri Vever to collect, than his searching out the finest prints in his rivals' collections, when they came on the market, to repair the depredations in his own caused by the Matsukata transaction. By such token, he takes his place in art history as a paragon of collectors, representing that rare conjunction of financial means, opportunity, competitive spirit, enthusiasm, knowledge and taste.

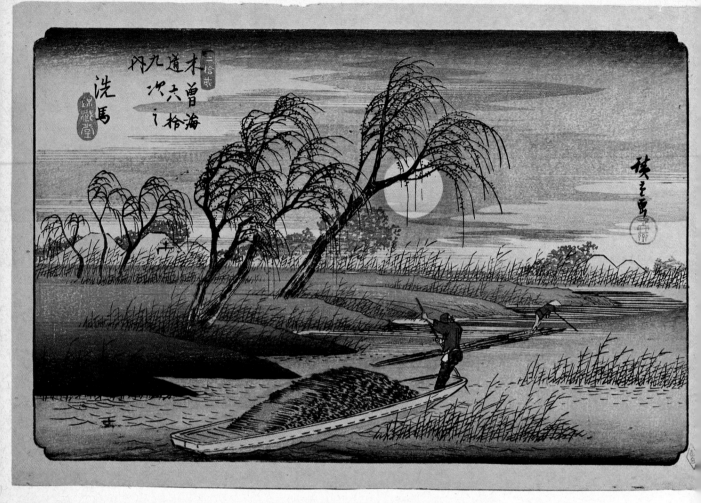

ANDO HIROSHIGE
Seba from the series *Sixty-nine stations on the Kisakaido.*
Colour print, signed
New York $15,000 (£6,522).
18.VI.75
Formerly in the Hans
Popper Collection

KATSUSHIKA HOKUSAI
*The Great Wave off
Kanagawa.* Colour print.
New York $21,000 (£9,130).
18.VI.75

Glass and Paperweights

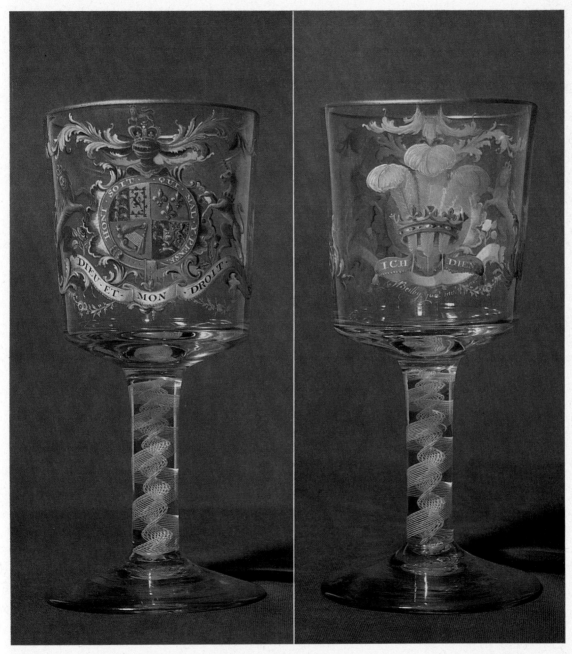

A Beilby armorial goblet (two views illustrated), inscribed *W Beilby jun*ʳ*. inv*ᵗ*. & pinx*ᵗ*., enamelled on one side with the Royal Arms and motto as borne by George III, flanked by a rose and a thistle, lion and unicorn supporters, the reverse with the Prince of Wales' feathers and motto between festoons and the signature, 1762, height 8⅜in
London £19,500 ($44,850). 14.VII.75

A cold-painted goblet, late seventeenth century, height 7⅛in
London £950 ($2,185). 6.I.75

An Irish decanter and stopper, the base marked *Armstrong Ormond Quay*, height 11in
London £680 ($1,564). 7.IV.75

An engraved Newcastle wine glass, eighteenth century
Amsterdam Fl 2,800 (£483: $1,111). 10.XII.74

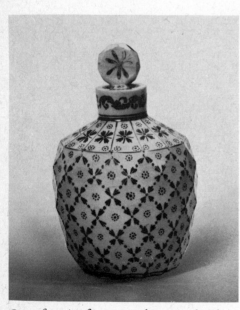

One of a pair of opaque-white scent bottles and stoppers, from the workshop of James Giles, height 5in
London £400 ($920). 6.I.75

A Jacobite wine glass, engraved below the rim *SIR WATKIN WILLIAMS WYNNE*, height 6⅞in London £1,100 ($2,530). 14.VII.75
From the collection of Peter Gosling

A colour-twist cordial glass, height 6½in
London £660 ($1,518). 7.IV.75

A Bohemian engraved tumbler, *circa* 1700, height 5⅛in
London £680 ($1,564). 14.VII.75

A German ruby-glass miniature bottle engraved with the arms of Saxony, *circa* 1694, height 3in
London £1,300 ($2,990). 6.I.75

A German enamelled flask, two sides with elaborate coats-of-arms, one with the initials *AIN AK*, the other *AB GB* and the date *1618*, height 6½in
London £1,200 ($2,760). 7.IV.75

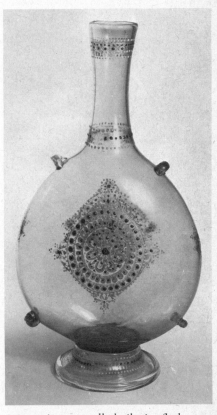

A Dutch goblet inscribed *Jacob Sang, Fec, Amsterdam, 1752*
Amsterdam Fl 10,000 (£1,724: $3,965). 10.XII.74

One of a pair of Russian engraved covered goblets, with the gilt monogram *EPI* on one side below an Imperial crown, the Russian eagle on the reverse, St Petersburg, *circa* 1750-1760, height 14¾in London £1,500 ($3,450). 14.VII.75

A Venetian enamelled pilgrim flask, engraved *Aō. 1658*, height 13¼in
London £2,600 ($5,980). 14.VII.75

From left to right
Three cameo glass tazzas, carved by J. Northwood: the first signed *J. Northwood* and dated *1878*, the second signed with monogram and dated *1880*, the third unsigned, diameter of each 9¼in
London £9,000 ($20,700), £8,500 ($19,550), £8,500 ($19,550). 24.VII.75
From the Pargeter–Northwood Cameo Glass Collection
The first two tazzas were shown at the 1881 Plymouth Art and Industrial Exhibition where they were awarded a First Silver Medal

A pair of cameo glass portrait medallions signed *Geo. Woodall:*
the first of S. Parkes Cadman, the second of his wife Esther Lillian Wooding, *circa* 1885, height of each 6in
New York $4,500 (£1,956), $6,500 (£2,826). 3.IV.75
From the collection of Mr and Mrs Samuel Cadman

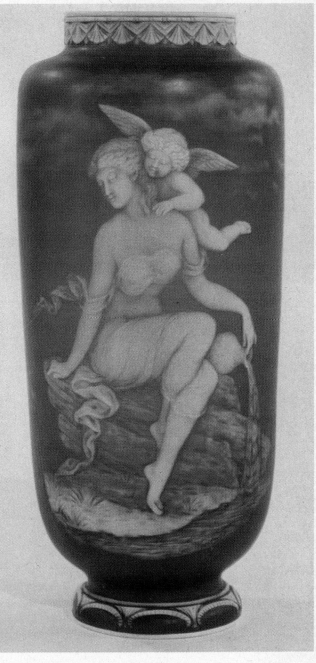

The Milton Vase, cameo glass, signed and dated
John Northwood 1878, height 13⅜in
London £26,000 ($59,800). 24.VII.75
From the Pargeter-Northwood Cameo Glass
Collection
The shape of the vase was designed by Philip
Pargeter and the decoration by Northwood and
Pargeter, the subject being taken from Milton's
Paradise Lost

A cameo-glass vase entitled *Mischief*, signed *Geo. Woodall*,
circa 1885, height 8⅜in
London £5,800 ($13,340). 24.VII.75

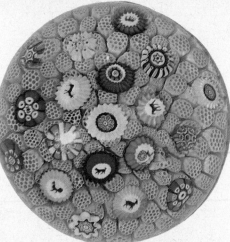

A Baccarat flat bouquet weight, 3⅝in
London £1,700 ($3,910). 27.1.75

A Baccarat turquoise carpet-ground
weight, inscribed *B1848*, 2¾in
London £1,400 ($3,220). 5.V.75
From the collection of Mrs E. Weldon

A Clichy flower weight, 2⅞in
London £2,100 ($4,830).
27.1.75

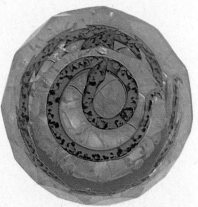

A Baccarat animal weight,
London £1,500 ($3,450). 5.V.75

A St Louis faceted snake weight,
3⅛in
London £1,100 ($2,530). 27.1.75

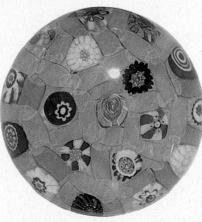

A Clichy green muslin weight,
signed *C*, 3¼in
London £2,600 ($5,980). 27.1.75

Art Nouveau and Art Deco

Tiffany Favrile glass and bronze wisteria lamp, impressed *Tiffany Studios, New York, 7879,* (1899–1920)
25in by 18in
New York $44,000 (£19,130). 3.IV.75

A *marqueterie-sur-verre* vase by Emile Gallé, with engraved
signature *Gallé*, and dated *1898*, 10¼in
Zürich SF18,000 (£3,103 : $1,349). 6.V.75

Iridescent glass and gilt-metal lamp attributed to Loetz
and Gustav Gurschner, *circa* 1900, height 21in
New York $4,900 (£2,130). 26.XI.74

A black lacquer four-panel screen signed *Jean Dunand Laqueur, circa* 1925-1930, 67in by 76in
Zürich SF22,000 (£3,793 : $1,649). 6.v.75

A Liberty & Co *Cymric* silver and
enamel mirror frame attributed to
Archibald Knox, Birmingham 1902,
height 18¾in
London £2,400 ($5,520). 13.III.75

Above right
A bronze and ivory figure signed
D. H. Chiparus, circa 1920, 22in
London £2,400 ($5,520). 2.VII.75

Right
A Wurlitzer juke box, model no 1015,
1946, designed to light up in changing
colours and with oil-filled bubbling
tubes; complete with twenty-four
78 r.p.m. records, height 59in
London £1,900 ($4,370). 20.XI.74

Jewellery

Above
A cushion-shaped sapphire mounted in a row of circular-cut diamonds as a ring, £3,300 ($7,590).

Centre left and right
A pair of antique ruby and diamond pendent earrings, early nineteenth century, £1,800 ($4,140).
From the collection of A. L. Bonnici

Centre
An emerald and diamond brooch, £11,000 ($25,300).

Below
An emerald and diamond three-stone ring, £3,000 ($6,900).
From the collection of Mrs R. F. Benoy
The jewellery illustrated on this page was sold in London on 16 January 1975

Above right An emerald ring, the emerald weighing 13.45 carats and flanked by two baguette diamonds $220,000 (£95,652).

Below right A sapphire and diamond brooch by Cartier, the sapphire weighing 29.75 carats and the two diamonds 3.25 carats $110,000 (£47,826).

These two pieces of jewellery were from the collection of the late Louise C. Morgan

Centre An emerald and diamond bracelet by Tiffany & Co. set with 220 old-mine diamonds weighing 4.35 carats and four cabochon emeralds $23,000 (£10,000).

Above left An emerald and diamond brooch by Tiffany & Co. set with fifty-six old-mine diamonds weighing 1.40 carats and an emerald weighing 3.30 carats $27,000 (£11,739).

Below left A pink diamond ring by Van Cleef & Arpels, the pink diamond weighing 9.90 carats, surrounded by ten round diamonds weighing 6.50 carats $260,000 (£113,043). From the collection of the late Barbara N. Thurston

The jewellery illustrated on this page was sold in New York on 14 May 1975

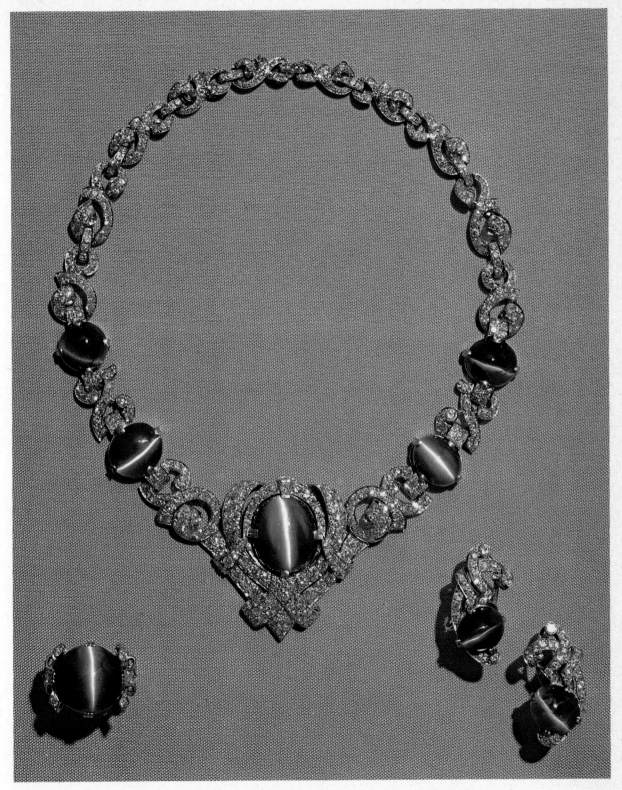

A cat's-eye and diamond suite, comprising a necklace set with 386 diamonds and five cat's-eyes, the centre cat's-eye weighing 38.50 carats; a ring set with thirty-two diamonds and a cat's-eye of 34.50 carats, and a pair of earrings of 46 diamonds and two cat's-eyes weighing a total of 16.50 carats New York $100,000 (£43,478). 27.XI.74

A necklace of imperial green jade, the clasp collet-set with a circular-cut diamond
London £62,000 ($142,600). 16.1.75
From the collection of the late Lady Edward Sassoon

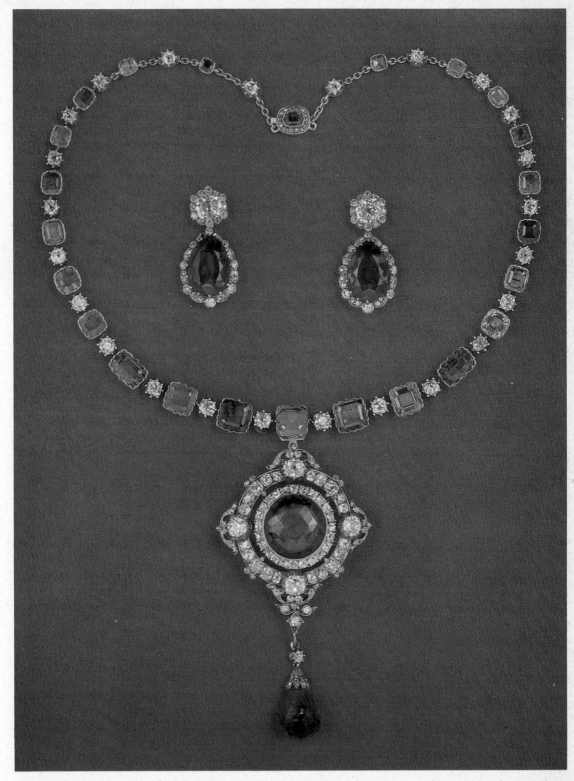

A Victorian necklace of emeralds and diamonds, £36,000 ($82,800), and a pair of diamond and emerald pendent earrings, £80,000 ($184,000), by London and Ryder.
The jewels illustrated on this page are from the collection of Mrs S. H. Gaskell sold in London on 19 June 1975

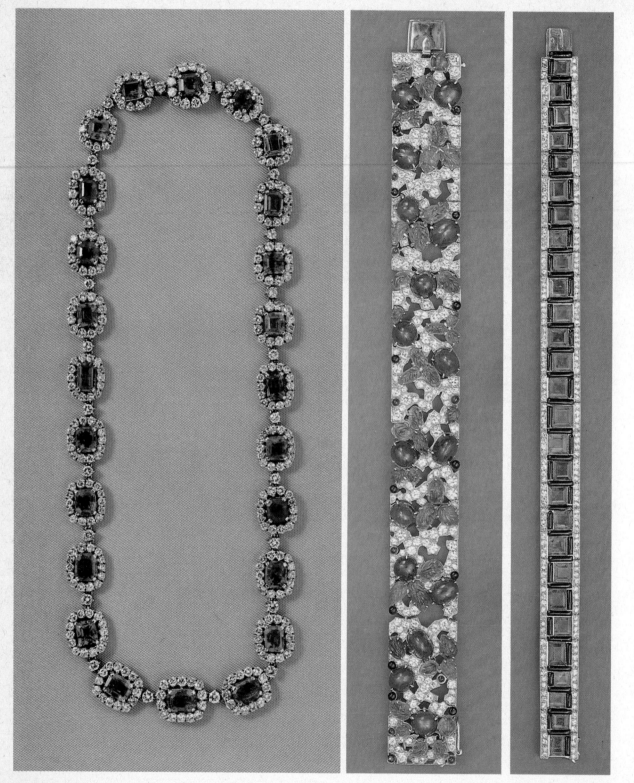

From left to right above

An emerald and diamond necklace set with twenty-four emeralds weighing 26.00 carats and 338 diamonds weighing 18.50 carats New York $48,000 (£20,870). 10.IV.75

An Art Deco flexible bracelet set with diamonds and carved emerald leaves and sixteen star rubies mounted at random SF35,000 (£6,034: $13,879).

An Art Deco bracelet by Cartier of platinum, emeralds and diamonds SF55,000 (£9,483: $21,810).

These two bracelets were sold in Zürich on 14 November 1974

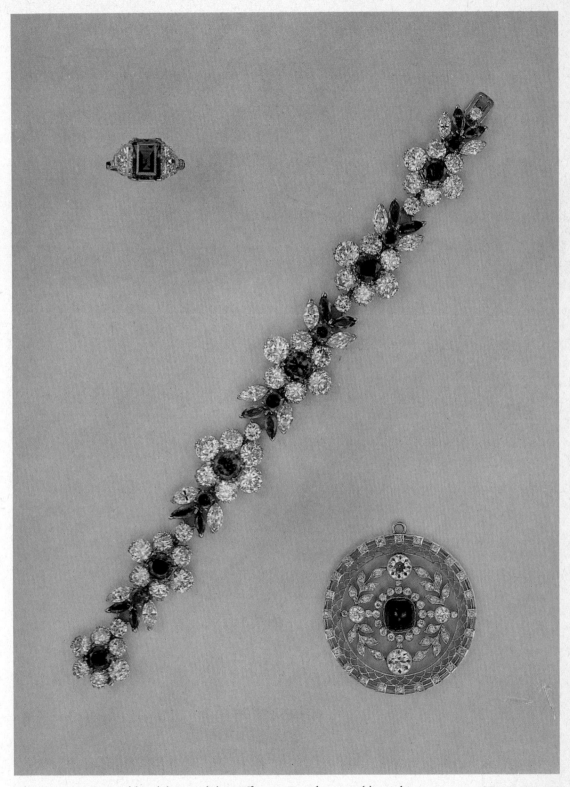

Above A ring in emerald and diamonds by Tiffany & Co., the emerald weighing 3.61 carats SF70,000 (£12,069: $27,759).
Centre A bracelet in emeralds and diamonds by Van Cleef & Arpels, set in 18 carat gold SF175,000 (£30,172: $69,396).
Below A pendant in emerald and diamonds SF32,000 (£5,517: $12,666).
The jewellery illustrated on this page was sold in Zürich on 14 November 1974

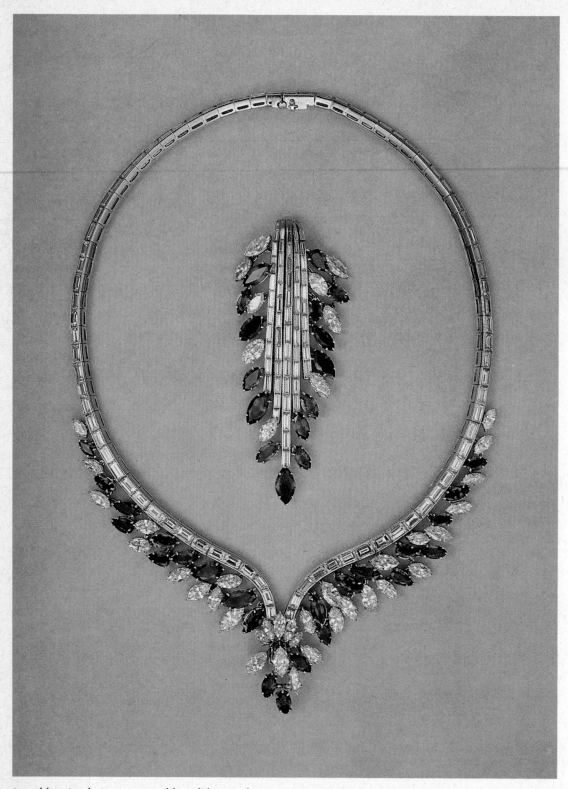

A necklace in platinum, emeralds and diamonds supporting a detachable pendant
Zürich SF110,000 (£18,966: $43,620). 14.XI.74

Wine Sales

Despite a further fall in wine prices during the season, the sales of the Wine Department have risen to reach a total of £1,001,648. The number of sales has increased to nineteen, of which three were held overseas. In October 1974 a second wine sale was organised in Zürich, achieving a total of SF256,400 (£38,269). In March a sale of Cape wines, conducted on behalf of Stellenbosch Wine Farmers at Stellenbosch, South Africa, had a turnover of R237,000 (£148,125). These were followed in April by a sale at Mak van Waay, the old established auction house in Amsterdam, now a part of Sotheby Parke Bernet. The total for the three sessions was Fl513,610 (£89,323). An additional sale was conducted in London to raise money for the Lord's Taverners on behalf of the Rhine and Moselle Shippers' Association of Great Britain. Many very rare and valuable wines were included.

From left to right
One bottle Napoléon, Grand Réserve Cognac 1811 Amsterdam £80 ($184). 14.IV.75
One bottle Château d'Yquem 1921 London £75 ($172). 21.V.75
Jeroboam Château Ausone 1918 London £100 ($230). 19.III.75
Half-litre Extrait d'Absinthe, pre-1910 from Couvet, Switzerland London £47 ($108). 2.X.74

Generally speaking, supply of fine wines has exceeded demand resulting in a falling market which only towards the end of the season has shown a slight sign of recovery. This increase in supply has been caused partly by a necessity to sell off excess stocks to achieve liquidity.

All over the world stocks are high, purchasing power has diminished and consumption cannot keep pace with production. In France, particularly, transactions at the properties have decreased and, without government support, many vineyards might become uneconomical units. This could in the long run lead to alternative forms of agriculture resulting in a drop in production, price increases and improvement in quality. In Portugal, a reappraisal of export policy may mean that Vintage Port with its specialised appeal and limited market will not continue to be produced.

During the season, some of the interesting items to have come under the hammer were four bottles of Château Margaux 1870, bottled by a north country merchant and in excellent condition, which sold for £185; a rare handblown double magnum of Château Lafite 1865, originally the property of the late Earl of Rosebery, at £420; a bottle of 1921 Château d'Yquem, £76; a magnum of Croft 1863 Vintage Port, the glass prunt embossed 'Croft 1863, Myers & Collett', £84; a bottle of very rare Vintage Madeira, Campanario 1846, £40; and six magnums of La Tâche 1948 at £175.

Corkscrews, old bottles and items of cellar equipment have increased in value. Many command high prices and attract bids from all over the world. From experience gained since the first sale in May 1973, the only items now included are rare, or particularly interesting and in good working order. The highest price for a corkscrew this season was £160 paid for a double action Thomason corkscrew of unusual design.

Wilmot, Roberts & Co Kings Screw with matching bone handles, cylindrical barrel and brass tablet showing royal coat-of-arms marked with maker's name and patent
London £80 ($184). 21.V.75

The first type of corkscrew to be registered, inscribed *Robert Jones & Son Birmingham Registered No. 423 8th Octr 1840*
London £84 ($193). 2.X.74

A Lund Patent London Rack Corkscrew patented by William Lund in 1855 with rare bottle grips
London £125 ($288). 2.X.74

Games and Gaming

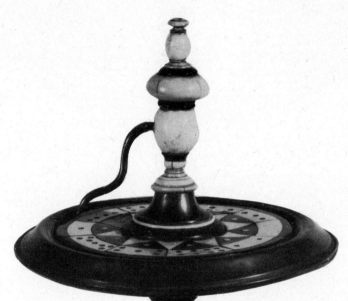

A German ebony and ivory roulette wheel
mounted in brass, seventeenth century,
height 16½in
Monte Carlo Fr56,000 (£6,022: $13,849).
26.V.75

A French faience
St George's chess set and
tray, nineteenth century,
length of tray 21⅛in
New York $5,200
(£2,261). 25.IV.75

An Austrian silver-gilt
tray for gaming chips,
makers mark PH, *circa*
1870, length 17in
Monte Carlo Fr42,000
(£4,516: $10,387).
26.V.75

A French Boulle games
board, the top set with a
chess board, the interior
for backgammon,
complete with fourteen
black and twenty-five
white South German
draughtsmen, early
eighteenth century, width
when open 21in
Monte Carlo Fr30,000
(£3,226: $7,419). 26.V.75

A set of South German ivory chessmen, one side as Turks,
the other as Europeans, eighteenth century; in an ormolu-
mounted case surmounted by the French royal arms,
circa 1820. Height of pawns 2in, kings 2⅜in, and of the
chest 35in
Monto Carlo Fr19,000 (£2,043 : $4,699). 26.v.75

Index

Aesop 167
Alyon, P. P. 199
Amati, Nicholo 341
Amman, Jost 153
Andreani, Andrea 158
Andreoli, Maestro Giorgio 377, 379
Andsell, Richard 56
Anker, Albert 78
Anthony, Joseph Jnr 263
Arita 424
Armstrong, James 440
Arp, Jean 137
Astor 343
Audubon, John James Laforest 196
Austen, Jane 186
Avelli, Francesco Xanto 379

Baccarat 444
Bachman, John 196
Baines, Thomas 86–89
Baker, Richard 339
Bakst, Léon 120
Baldwin, Thomas 340
Ballanger, F. 386
Balthazard 302
Bancks, W. 288
Barnard, Edward 272
Barye, Antoine-Louis 230
Basset 263
Batoni, Pompeo Girolamo 39
Beerbohm, Sir Max 66
Beilby, William 439
Bellows, George 166
Bergier, Pierre 257
Bergomensis, Jacobus Philippus
 Foresti 192
Béringer 259
Bernardi, Giovanni dei 229
Berthout, Fd. 334
Besler, Basilius 197
Bessarion, Cardinal 191
Bilston enamel 246
Birmingham enamel 246, 247
Bles, David Joseph 79
Bodendick, Jacob 262, 264
Bodington, Jonathan 261
Boethius, Anicius Manlius Torquatus
 Severinus 190
Bohm, Hermann 249
Bologna-Susini workshops 208, 226
Bonnard, Pierre 109
Bonneaux, C. 340

Boudin, Eugène Louis 102
Boulard, Jean-Baptiste 304, 305
Boulle, André-Charles 299, 303
Boutet, Nicholas Noel 253
Bow porcelain 375
Braith, Anton 81
Braque, Georges 122, 123, 141
Brauner, Victor 140
Breguet 338
Bridge, John 271
Britzin, Ivan 241
Brussels tapestry 317
Burch, Henry 252
Burne-Jones, Sir Edward 60, 62, 161
Burns, Robert 186

Calder, Alexander 150
Calin, Gio. Pietro 334
Cameron, Julia Margaret 205
Campagnola, Giulio 41, 154
Canaletto, Giovanni Antonio Canale,
 called 34, 44, 45
Cantonese enamel 246
Capt, Henry 334
Cardwell, Holme 231
Carlin, Martin 213
Carr, Emily 83
Carracci, Lodovico 28
Carroll, Lewis 207
Cartier 248, 450, 454
Carus, T. Lucretius 185
Cassatt, Mary 162, 163
Casson, Alfred Joseph 85
Castel Durante 378
Castiglione, Giovanni Benedetto, called
 Il Grechetto 40
Catesby, Mark 198
Cézanne, Paul 110
Ch'ien Lung 212, 393
Chiparus, D. H. 448
Chlebnikov, Ivan 233, 240
Clemens, Samuel Langhorne 188
Clett, Jean Paul 260
Clichy 444
Coalport porcelain 387
Cocteau, Jean 121
Collier, E. H. 260
Colt revolver 260
Columella, L. J. M. 181
Cominazzo, Lazarino 258
Cosway, Richard 250, 251
Cottey, Abel 334

Crespi, Giuseppe Maria 29
Crevelli, Carlo 12
Cumming, Alexander 334, 339

Da Carpi, Ugo 157
Degas, Edgar 108
De Ketham, Johannes 192
Delft 382
Della Robbia, workshop of 225
Derain, André 114
Derby porcelain 387
Deruta 378
De Staël, Nicolas 142
Devis, Arthur William 53
De Vlaminck, Maurice 19, 117
Devos, Jean-Baptiste 248
Dickinson, W. 160
Di Giovanni, Circle of Apollonio 23
Dine, Jim 164
Dingley, Robert 340
Disraeli, Benjamin 187
Dittman, Johann Gottlieb 210
Doré, Gustave 233
Dove, Arthur G. 96
Dubuffet, Jean 143
Dudley, Sir Robert 194
Dufy, Raoul 115
Duhamel du Monceau, H. L. 204
Dunand, Jean 447
Durantino, Guido 379
Dutertre, Charles 298
Dwerrihouse, Ogston & Bell 334

Edwards, John 198
Egg, J. 260
Elkington & Co 276, 277
Ellicott, John 334
Emilian school 40
Engleheart, George 250
Ernst, Max 126, 139
Estes, Richard 152

Fabergé 240, 241, 244
Faenza 376
Faïence 382, 384
famille rose 212, 408, 409
famille verte 409, 416
Fantin-Latour, Henri 103
Farrell, Edward Cornelius 272
Fernandez de Enciso, Martin 193
Fernandez de Oviedo y Valdez, Gonzalo
 195

Ferneley, John Snr 50
Fontana, Lucio 148
Fox, Charles 274
Freud, Lucian 72
Fritz, Johann 343
Frodsham, Charles 338
Fuchs, L. 197
Fuller, Crispin 270
Furhlogh, Christopher 296
Fuseli, Henry 166

Gallé, Emile 446
Garcia de Palacio, Diego 194
Garon, Peter 335
Garrard, Robert 270, 275
Gatchen, Sigmund 210
Gauguin, Paul 112, 113
Gertler, Mark 66
Giacometti, Alberto 127, 138
Gilbert, Sir Alfred 232
Giles, James 375, 440
Gilly, William 288
'Girl in a Swing' porcelain 373, 374, 375
Gobelins tapestry 318
Godwin, E. W. 313
Goltzius, Hendrik 158
Gouthière, Pierre 215, 289
Goya y Lucientes, Francisco José de 159
Graham, George 340
Gregorovius, Michael Christoph 75
Grice 259, 260
Grimalde & Johnson 334
Gubbio lustre 377, 378, 379
Gurschner, Gustav 446
Guys, Constantin 106

Hall, James 195
Hamilton & Co 275
Hamza, Johann 80
Han Dynasty 390
Hanson, Duane 151
Hardy, Heywood 63
Harnett, William M. 95
Harpignies, Henri-Joseph 81
Harris, Lawren Stewart 83
Hartung, Hans 147
Harunobu, Suzuki 435
Hassam, Childe 99
Hawthorne, Nathaniel 187
Hemingway, Ernest 203
Hennell, J. B. 274
Hepworth, Dame Barbara 137
Herez carpet 320
Herring, John Frederick Snr 58, 160
Higden, Ranalph 190
Hilliard, Nicholas 252
Hirji Kanji and Sons 308
Hiroshige, Ichiryusai 438
Hockney, David 165
Hofmann, Hans 149
Hokusai, Katsushika 436, 438
Holland and Sons 311
Homer 191
Höroldt, Johann Gregor 383, 385
Hoskins, John 252
Hunt, John S. 272, 273, 274

Ilbery, William 339
Il Pesellino, Francesco di Stefano, called 27
Imari 424
Issod, Joyce 262

Jacob, G. 214
James, Captain Thomas 196
Janvier, Antide 335
Jenkins, Thomas 265
John, Augustus 67
John, Gwen 67
Johns, Jasper 165
Jones, David 71
Jongkind, Johan Barthold 102, 106

Kakiemon 425
Kandinsky, Vasily 116
Kauffman, Angelica 296
Keats, John 201
Kiyomasu, Torii 434
Kiyonaga, Torii 432
Kline, Franz 144
Knight, Dame Laura 66
Knyff, Leonard 54
Koekkoek, Barend Cornelis 77
Kokusai 420, 421
Kornilov 238
Krieghoff, Cornelius 82, 85
Krug, Dibolt 268
Kurliukov, Orest 240
Kuzmitchev, Anton 240

Lalique 244
Lamb, Henry 68
Lanceray, Eugène 233
Langlois, Pierre 296
Lawrence, D. H. 188
Leleu, Jean-François 300
Lencker, Elias 222
Liberty & Co 448
Lichtenstein, Roy 165
Limoges enamel 218
Loetz 446
London and Ryder 453
López, Francisco 258
Lowestoft porcelain 374
Lysippus the younger 229

Mackennal, Edgar Bertram 232
McKenney, Thomas L. 195
Mackintosh, Charles Rennie 312
Magritte, René 141
Maingot, Pierre 339
Manini, Pietro 258
Maria, Giovanni 378
Maris, Jacob Henricus 75
Martin, John 161
Mascarone, Giovanni Batta. 339
Massenet, Jules 189
Master of the Genre Figures 227
Master of l'Osservanza 26
Matisse, Henri 111, 124
Mayer, J. J. 383
Mazza 260
Meissen porcelain 383, 384, 385

Micaud, Jacques-François 383
Michetti, Francesco Paolo 80
Migeon, Pierre 214
Mihr 'Ali 179
Ming Dynasty 407, 408
Mishukov, Yakov 237
Mondrian, Piet 119
Monet, Claude 100, 105
Monlong, Pierre 256
Moore, Albert Joseph 61
Moore, Henry 129-136
Moore, John & Sons 336
Moore, T. Sturge 202
Moran, Thomas 94
Moscow school 236
Mu'in 175

Nash, Paul 70
Neilson 318
Neroccio de'Landi 25
Neuber, Johann Christian 243
Newcastle glass 440
Nichols and Plinke 240
Nichols, William S. 263
Nicholson, Ben 71, 73
Norris, Josephus 340
Northern Sung Dynasty 397
Northwood, John 22, 442, 443
Novgorod school 234, 235, 236
Nys, Johannis 263

Okatomo 420
O'Keeffe, Georgia 97
Ortmann, Matthias 292
Oushak carpets 321
Ouwater, Isaak 74
Ovchinnikov, Pavel 237, 238, 257

Paine, Thomas 200
Panini, Giovanni Paolo 35
Pargeter, Philip 22
Patek Philippe 338
Pellipario, Nicola 378
Pennington 338
Perchin, Michael 240, 244
Phyfe, Duncan 295
Picasso, Pablo 125, 164
Pierneef, Jacob Hendrik 91
Piguenit, William Charles 84
Piranesi, Giovanni Battista 159
Piraube 258
Pissarro, Camille 101, 104, 162
Plimer, Andrew 251
Poe, Edgar Allan 200
Pollard, James 55
Potter, Beatrix 203
Prior, George 340

Quare, Daniel 335

Randolph, Benjamin 296
Ranney, William T. 92
Rauschenberg, Robert 145
Ravenscroft, Thomas 193
Read, Matthias 54

Redouté, P. J. 199
Rembrandt, Harmensz. van Rijn 156
Remington, Frederic 93
Renard, Jules 202
Renoir, Pierre-Auguste 107
Rexach, Juan 24
Robin, Robert 298
Robins, John 271
Roentgen, David 213, 215
Rollos, Philip the elder 265
Rubens, Sir Peter Paul 30
Rugendas, Johann Mauritz 82
Ruskin pottery 388
Russell, Charles Marion 84

Safonof, A. 233
St Louis 444
Saint-Porchaire 380, 381
Saltglaze 367, 370, 371
Sang, Jacob 441
Sargent, John Singer 98
Sarrazin 337
Satzger, Gottlieb 266
Schelfhout, Andreas 76
Schiele, Egon 118
Schissler, Christopher 337
Schotel, Johannes Christian 79
Schumann, Robert 189
Sebright, R. 387
Seifertold, Hans Jacob 288
Sèvres porcelain 211, 307, 386
Shang Dynasty 389, 390, 391
Sharaku, Toshusai 428, 429, 436
Shigemasa 420
Sickert, Walter Richard 69
Siegnior, Robert 335
Simpson, P. 387
Smart, John 250, 252
Smith, Benjamin 271
Smith, Thomas 288
Southall, Joseph Edward 64
Spencer, Sir Stanley 70
Spitzweg, Carl 78

Spranger, Bartolomaus 31
Stadler, Johann Ehrenfried 384
Staffordshire pottery 367, 371
Stanesby, Thomas Jnr 343
Steer, Philip Wilson 65
Steen, Jan 33
Stern, Irma 90
Stieglitz, Alfred 206
Stoer, Thomas the elder, 228
Storr, Paul 275
Stubbs, George 51
Sung Dynasty 18, 398, 400, 402, 403

Taillandier, P. 387
T'ang Dynasty 390, 394, 395, 396
Tanner, John 280
Tapies, Antonio 146
Tapley, John 273
Tchelitchew, Pavel 121
Thiout, Antoine 335
Thorburn, Archibald 59
Thorey, C. A. 199
Tiepolo, Giovanni Battista 38
Tiffany & Co 278, 445, 450, 455
Tokoku 421
Tomotada 421
Tompion, Thomas 332, 339
Tononi, Carlo 344
Tournai tapestry 316, 317
Toyonobu, Ishikawa 430
Turner, Joseph William Mallord 46–49
Tyler, James G. 95

Urbino 378, 379
Utamaro, Kitagawa 426, 427
Utin, André 288

Vachette, Adrien-Jean-Maximilien 247
van Beyeren, Abraham 36
Van Cleef & Arpels 450, 455
van der Neer, Aert 32
van de Velde, Esaias 42
van Slingeland, Pieter frontispiece

van Walscapelle, Jacob 37
Vardan 171
Varley, John Jnr 63
Venetian School 155
Veronese, Paolo Caliari, called 40
Vick, Richard 334
Vico, Enea 157
Vienna porcelain 386
Vinckeboons, David 43
Visbach, Pieter 334
von Mauer, Meister, circle of 221
Vrancx, Sebastian 43
Vuillard, Edouard 107

Wakelin, Edward 270
Webster, William 333
Wedgwood 368, 369
Weisweiler, Adam 301
Werder, Felix 259
Werner, J. H. 274
Western Chou Dynasty 390
Wheatley, Francis 52
Whieldon 370
White, E. 334
Wigström, Henrik 240, 241
Woodall, George 442, 443
Wootton, John 54
Worcester porcelain 372, 373, 374, 375, 387
Wordsworth, William 201
Wouwermans, Philips 32
Wrotham 368
Wurlitzer 448
Wynkoop, Benjamin 263

Yeo, Richard 280
Yüan Dynasty 405, 406
Yung Chêng 408
Yung Lo 407

Zürich porcelain 383

DATE DUE
